Photographic Chemistry and Processing

Titles in the Technical Pocket Book series

Photographic Chemistry and Processing

Series editor: Sidney F. Ray

Focal Press
An imprint of Butterworth-Heinemann Ltd
Linacre House, Jordan Hill, Oxford OX2 8DP

 A member of the Reed Elsevier plc group

OXFORD LONDON BOSTON
MUNICH NEW DELHI SINGAPORE SYDNEY
TOKYO TORONTO WELLINGTON

First published 1994

© Butterworth-Heinemann Ltd 1994

British Library Cataloguing in Publication Data
A catalogue record for this book is available from the
british Library

Library of Congress Cataloguing in Publication Data
A catalogue record for this book is available from the
Library of Congress

ISBN 0 240 51386 X

Composition by Scribe Design, Gillingham, Kent
Printed and bound in Great Britain by Clays, St Ives plc

Preface

The technical aspects of photography and imaging cover a wide range of ideas and topics drawn from optics, chemistry, engineering, electronics and visual perception, that bring together the mature technology of silver halide systems in the form of photographic materials with the newer and fast evolving technologies of electronic imaging and digital photography. Common to all such knowledge however are the additional craft skills required to produce a successful image as previsualised, involving or including controlled manipulation of images at the camera, recording and post production stages.

This book, as one of a related series, presents a specific topic or subject in detail to provide a balanced overview of relevant theory, practice and applications.

To ensure authoritative, contemporary information and details, the format and material is drawn from the Focal Encyclopedia of Photography, third edition, edited by Leslie Stroebel and Richard Zakia, published in 1993. This massive volume has entries compiled by 90 contributors and gives extensive coverage of most aspects of photography, movie production, video, electronic and digital imaging. The selected extracts are largely unaltered but some have been further edited in content to suit the overall subject of the Pocket Book or possibly modified in details to conform to European practices as distinct from those in North America.

The topic of this Pocket Book is photographic chemistry and processing.

Coverage includes the salient properties of chemcials and compounds used in a wide range of photographic materials and processes, chemical safety, developers and other solutions, processing routines, darkroom design and procedures. Related topics include process control, types of sensitised materials, aspects of the manufacture of sensitised materials, processing faults and effects, plus the permanence of photographic images. Where appropriate, suggestions for further reading are included in some of the longer entries.

Companion volumes in the Pocket Book series include Photographic Imaging and Electronic Photography, Photographic Chemistry and Processing, Photographic Data, Photographic Lenses and Optics, Photographic Technology and Image Science.

S.F. Ray

ABRASION REDUCTION Scratches and abrasions due to handling and/or processing and printing, may sometimes mar the appearance of photographs. Steps to minimize this problem include (1) design and use of equipment to avoid contact with the image surfaces of the materials during handling and storage, (2) treatment to lubricate the surfaces such as the application of waxes or other low friction materials like silicones, and (3) coating with lacquers or other protective materials. If the lacquer type coatings become scratched or abraded, they may be removed with suitable solvents. A new coating may then be applied to restore the unblemished image.

ABRASIONS AND SCRATCHES Abrasion marks are usually lines that are seen on processed film due to the sliding of the sensitized emulsion under pressure over surfaces before processing. They may appear darker or lighter than the surrounding area, depending on a number of factors including whether the abrasions occurred prior to or after exposure, and whether the processing was negative or reversal. Abrasion marks also occur on papers but are now less common due to improved surface coatings. The abrasion marks may or may not be visible as a deformity when viewed by reflected light. Dark lines on negatives will, of course, print as light lines on prints.

Scratches are visible physical deformities in the emulsion surface or base of photographic materials, and they may occur either before or after processing. The defect can be seen on the original and on any print or duplicate made from it. In some cases, scratches in the base may be rendered less visible by application of a material of similar index of refraction as that of the surface. Vaseline petroleum jelly, for example, when applied to base scratches in a negative, then buffed to remove excess, sometimes reduces their appearance on a print made from the negative. There are proprietary materials that serve the same purpose.

See also: *Kink marks: Pressure marks.*

ABRASIVE REDUCERS Fine abrasive materials, usually a mineral, used to reduce the density of silver in a local area of a negative. The particle size must be small enough not to reveal evidence of abrasion when the negative is printed or enlarged. The reducing action is most effectively accomplished by picking up a small amount of the material on a tuft of cotton and gently rubbing the area to be reduced. This method is often more

practical than attempting local reduction by chemical means.

ABSOLUTE HUMIDITY The amount of water vapour present in a given volume of air or gas; usually expressed in milligrams per litre. It is related to dewpoint and relative humidity in that it is a measure of the amount of water vapour present in the air. Absolute humidity is the most independent measure in that it is not dependent on barometric pressure or temperature. It is not the most commonly used measure, however, because it is not, by itself, a good predictor of condensation or the drying ability of the air.

ABSORPTION The process by which a material is assimilated into a substance, such as the absorption of a liquid by a gelatin.

ACCELERATOR Alkaline compounds, added to developing solutions, are called accelerators because they increase the rate of development. Alkalis, such as hydroxides and carbonates, convert the developing agent into the form that is the most efficient for transfer of electrons to the exposed silver halide. Other compounds, such as gelatin softeners, surface active agents, and electron transfer agents, also accelerate development.

ACETATE The term sometimes used for cellulose acetate, the material used to manufacture safety base for film. This type of material has largely replaced the highly inflammable cellulose nitrate base previously used.

The term is sometimes used in reference to a sheet of cellulose acetate used for an art overlay, or for a cel in motion picture animation.

ACETATE FILM BASE Usually called triacetate film base. The full name is cellulose triacetate. The support for most roll films. Formerly called safety base to distinguish it from nitrate base, which was flammable. A diacetate base made briefly in the 1930s proved to be chemically and dimensionally unstable.

See also: *Support.*

ACETIC ACID Clear, corrosive liquid (CH_3COOH, molecular weight 60.05) with a pungent odour resembling vinegar. Glacial acetic acid (99.5%) must be diluted with water first for most photographic uses. A photographic grade (28%) is more practical for acid and acid-hardening fixing baths, clearing and stop baths, toners, and other processing solutions.

ACETONE A highly volatile and flammable but pleasant smelling colourless liquid (CH_3COCH_3, molecular weight 58.05; also called dimethylketone) that mixes in all proportions with alcohol, ether, or water. Used in some

black-and-white and colour developers, film cements, and varnishes.

ACID/ACIDIC Certain chemical compounds, called *acids*, separate in aqueous solution to produce hydrogen ions, H^+ (electron acceptors). Acids react with alkaline substances containing hydroxyl ions, OH^- (electron donors), to produce a salt and water.

Water contains equal numbers of H^+ and OH^- and is said to be neutral. An excess of hydrogen ions, H^+, produces an acidic solution. On the pH scale, acidic solutions are represented by numbers less than 7.

See also: *Chemicals; Chemical symbols; Hydrogen ion concentration/pH.*

ACID- AND LIGNIN-FREE PAPER Acid- and lignin-free paper and mount boards are made from purified wood pulp that has had the lignin bleached out. Lignin is an organic substance that in the tree binds the cellulose together; essentially it is the woody fibre in paper made from wood. Lignin is present in large quantities in cheap paper products like cardboard and in low-quality papers and mount boards. When the lignin in paper breaks down, it releases acids and peroxides that not only make the paper brittle but also discolour the paper and transfer the acids to any photographs that may be in contact with the paper surface. The paper and mount board made from acid- and lignin-free wood pulp is archival and is available as conservation board. Photographic storage papers and boxes made from a lignin-free pulp are very high in alpha cellulose fibres.

ACID FIXER See *Fixing bath.*

ACID RINSE See *Stop bath.*

ACRYLIC TRANSFER One of the simplest, most direct methods of transferring a commercially printed image from one support to another. Acrylic or polymer medium is coated over the original image and once dry is lifted from the original paper support and transferred to any secondary surface, which includes fabric, acetate, paper, wood, glass and ceramics.

ACTIVATOR A chemical solution that promotes the development of an exposed photographic material that contains all or part of the developing agents in the emulsion layer. A simple activator may be only a water solution of a strong alkali, such as sodium hydroxide, but often contains a preservative to prevent discolouration and a restrainer to limit nonimage development.

ADHESIVE Bonding agents that attach one kind of material to another, such as to mount a photographic print

3

to a support surface or substrate. Photographic adhesives fall into two major categories—wet and dry. Dry mounting materials are available in two basic types, those that are applied with heat and those that are pressure-sensitive. Wet mounting adhesives include glues, pastes, rubber cement, and mounting sprays.

ADJACENCY EFFECTS Nonuniform densities in image areas when a region of great exposure lies next to one of low exposure. The cause is diffusion of fresh developer from a low-density area into one of high density, and the reverse diffusion of exhausted developer from the high-density area into the low-density area.

Proper agitation during development plays only an indirect role, since the adjacency effects are associated with movement of chemicals from the thin layer of developer that adheres to the emulsion (the laminar layer) and diffusion within the emulsion itself.

See also: *Photographic effects*.

ADSORPTION The concentration of a gas, liquid, or dissolved substance on a solid surface distinguishes adsorption from absorption, which involves a more-or-less uniform penetration. Spectral sensitizing dyes and developing agents need intimate contact with the surface of a silver halide crystal to be most effective.

AERIAL FOG Nonimage-forming density resulting from the oxidation by air of certain developing agents on the surface of the emulsion being developed. The effect is stimulated by frequent or prolonged removal of photographic material from the developing solution.

See also: *Fog, dichroic*.

AFTERRIPENING A chemical treatment in the manufacture of a photographic emulsion that consists of heating the emulsion in the presence of chemical ripeners, such as gold, sulphur, and other compounds. This digestion may last many minutes, resulting in chemical deposits on the surface of the silver halide crystals. This chemical sensitization improves the efficiency of latent image formation during exposure to actinic radiation.

AFTERTREATMENT Often synonymous with postprocessing, aftertreatment usually refers to methods of modifying the appearance of the finished photograph, and correcting errors in exposure and development. These methods include (1) wet chemical treatments such as with reducers, intensifiers, toners, dye treatments, and hardeners (2) work on the dry negative or print such as with abrasive reduction, spotting, retouching, opaqueing, local dyeing, varnishing, pressing, or straightening.

AGING The chemical, physical, and sensitometric

characteristics of the change in photographic materials with time, often adversely. A high-humidity, high-temperature environment in an incubator is used as an accelerated test to provide information on the aging or resistance of the material to change. An estimate of the natural useful life of the photomaterial is often indicated as a limit date on the package of the material.

AGITATION The primary function of agitation is to keep photographic solutions in motion during processing to guarantee uniformity of action.

THEORY Although agitation is an important factor in all processing steps, it is most critical during the image-forming stage. Agitation is one of the major factors—in addition to developer composition, time, and temperature—that affects the degree and uniformity of development.

In development, a stagnant layer of solution, called a laminar layer, forms on the emulsion surface. As the developer absorbed by the gelatin is used up, fresh developer must diffuse from the bath into the emulsion to maintain the rate of reaction. The laminar layer contains a high concentration of bromide, a restrainer, and other development by-products that slow down the diffusion of fresh developing agents into the gelatin. If this layer does not have the same thickness everywhere, different densities can result in uniformly exposed areas. Agitation increases the uniformity and decreases the thickness of the stagnant layer, therefore affecting the rate and uniformity of development.

An additional function of agitation is to maintain a random mix of both fresh and exhausted developer throughout the solution and to guarantee that each part of the emulsion is exposed to the same developer composition and temperature. Without agitation, the heavier development by-products tend to settle to the bottom of the processing unit.

Agitation is generally extremely important in the first few minutes of the developing process, because at this stage swelling of the gelatin occurs. The risk of uneven development can be reduced if an emulsion is presoaked before processing.

Agitation has a greater influence on the final result when the development time of a material is short. Density and gamma can be increased by 30 to 100% by high agitation. In general, uniformity is less of a problem with materials that are developed to gamma infinity, such as photographic papers and graphic arts films, than with materials developed to a low contrast index, as with most pictorial negative films.

Agitation is difficult to standardize and is highly operator-dependent, especially for tray and tank processing. The manufacturers' data about the speed and contrast index of emulsion-developer combinations are given in

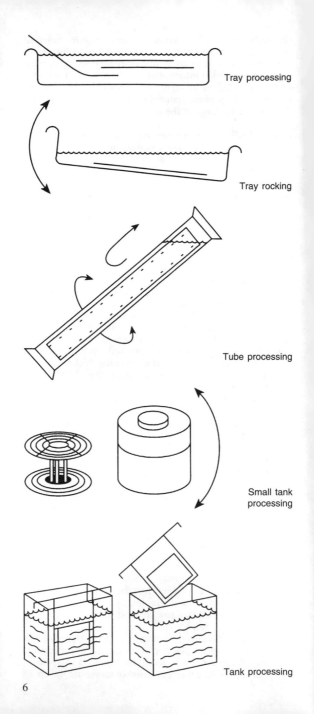

Tray processing

Tray rocking

Tube processing

Small tank processing

Tank processing

6

terms of time, temperature, and method of agitation. Developing time may need to be adjusted to compensate for personal agitation habits. In any case, the recommended guidelines should be followed. A good example is the difference between tray and tank processing for sheet film. Tray processing usually requires constant agitation, which results in a contrast gain. In order to offset this gain, the recommended developing times are shorter for tray processing than for tank processing, which requires intermittent agitation to obtain uniform development.

Although agitation is normally required to obtain good results, when using high-acutance developers, agitation has to be kept to a minimum as to not counteract the edge effect. Low contrast and compensating developers may also take advantage of the restraining action of developer by-products and be adversely affected by too much agitation.

METHODS OF AGITATION Correct agitation is dependent on the processing method used.

Tray Processing One of the most common ways to develop sheet films and paper. In tray shuffling, the sheets are immersed in the solution and then shuffled from bottom to top. This method provides good agitation and high throughput, but carries a high risk of emulsion damage through handling. Presoaking can diminish the sheets' tendency to stick together.

In tray rocking, a sheet of film or paper is immersed in the developer with the emulsion up. Agitation occurs through rocking the tray in a non-repetitive pattern to ensure random flow. If the agitation is directional, i.e., if only the same side of the tray is lifted, standing waves can occur that result in bands of different densities across the emulsion.

Tube Processing A film is inserted into a narrow tube that is then filled almost to the top with the processing solution. By gently rocking the tube, one can move the air bubble from one end to the other, allowing the solution to flow evenly over the emulsion surface. Tube rocking produces quite uniform development.

Small Tank Processing Roll films are wound on spiral reels and processed in light-tight tanks. Agitation occurs by lifting or tilting or inverting the tank, moving it in a swirling pattern, or rolling it back and forth. These tanks usually give good results with the proper technique. If the agitation is too vigorous and continuous, an unevenness of density can occur because of the streamlined flow of developer, leading to increased local agitation, especially at the perforation holes of 35-mm film. Some small tanks have a spindle that fits into the reel, and the film is agitated by twisting the reel. This agitation method requires that the tank remain upright.

Tank Processing Lines of tanks, each with a different processing chemical are set up in a temperature-controlled environment. Processing is accomplished by moving the film from one tank to the next at the appropriate time.

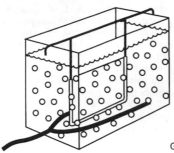

Gaseous burst agitation

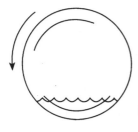

Drum processing (inside loading)

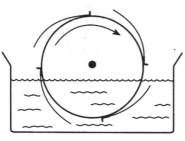

Drum processing
(outside loading)

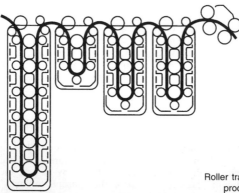

Roller transport
processing

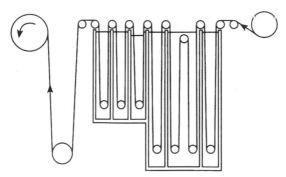

Continuous strand processing

With lift and drain tanks, agitation occurs by lifting the film out of the processing bath, letting it drain, and returning it to the tank, alternating the corners. This level of agitation is relatively low, requiring longer processing times. The perforation holes of film hangers can lead to streaking, especially with over-agitation.

With deep tank and the automated dip-and-dunk processors, the best way to agitate the solutions is using a nitrogen burst system. A perforated gas distributor grid called a plenum is placed at the bottom of the tank. Nitrogen, which has no chemical effect on the developer, is intermittently released. Compressed air can be used for other processing steps, such as the stop bath, fix, and water tank. The pressure of the gas is adjusted to cause an appropriate rise in the solution. The duration of the burst is dependent on the amount of solution a tank contains, as each burst should result in full turbulence of the bath. If the gas is allowed to flow continuously, the repetitive bubble pattern will result in streaks. The bubble pattern is determined by the gas pressure, the grid design, and the size of the perforation holes. Once pressure and duration are adjusted for a specific tank, agitation is controlled by the frequency of the bursts. This system provides vigorous and uniform agitation, provided it has been adjusted properly. Occasionally, the perforations in the distributing grid tubes become plugged, leading to uneven bubble patterns and nonuniform development.

Drum Processors With inside-loading drums, film or paper is loaded emulsion side facing in inside a cylindrical drum that rotates constantly on motor driven rollers. The immersion of the emulsion is only intermittent, as the small amount of chemistry used inside the drum stays at the bottom. Although somewhat directional, this method gives good results but usually requires an adjustment of temperature or developing time compared to the tray or tank processing. Some roller devices intermittently reverse the direction of rotation, which improves the randomness.

9

After loading the sensitized material in the dark, such drums can be operated with the room lights on, including adding and draining solutions.

With outside-loading drums, the film or paper is placed on the outside of the drum, emulsion facing out. The chemicals are then placed in a trough through which the bottom of the drum passes. Randomness is maintained by rotating the drum at a moderately high speed to cause turbulence. Different solutions are introduced by draining and refilling the trough.

Roller Transport Processing Used for both film and print material, these fully automated machines provide agitation by the continuous movement of the emulsion through the processing solutions. Although the transport and the squeezing effect of the rollers provide for vigorous agitation, it is somewhat directional. The small streaming effect is usually only apparent on sensitometric wedges and results in a small difference in contrast of two identical wedges when the leading end is reversed. It is therefore important that all processing control strips are fed through the machine in the same way in order to get consistent results.

Continuous Strand Processors Designed for long lengths of photographic material such as movie film or roll paper, only have rollers at the top and the bottom of each tank. In these processors, agitation through movement is usually supplemented with gas burst systems.

See also: *Developing; Fixing; Machine processing; Tank and tank processing.*

AIR BELLS Bubbles of air that adhere to the surface of film and printing paper. Unless removed, by brushing the surface or by sufficient agitation, these bubbles prevent the developer from carrying out its function, leaving spots of lower density with nonreversal materials and higher density with reversal materials. Bubbles on the surface during washing interfere with the removal of processing chemicals.

See also: *Processing defects.*

AIR KNIFE A jet of air from a slit aperture, used to remove the surface liquid from film as it leaves processing solutions or the wash.

Syn.: *Air squeegee*

ALCOHOL A class of organic compounds, containing an –OH group, whose liquid members are often used to hold chemicals of low solubility in water solution.

Ethyl alcohol (CH_3CH_2OH, molecular weight 46.05) is also called ethanol, grain alcohol, or alcohol. This clear, colourless, flammable liquid of characteristic odour can cause human disorientation if imbibed in sufficient quantity. The absolute grade is almost 100% ethyl alcohol, but many industrial grades are denatured (made unfit for

human consumption). Methyl alcohol (CH₃OH, molecular weight 32.03, also called methanol or wood alcohol) is a clear, colourless liquid that is volatile, flammable, and highly poisonous if ingested. It mixes with water, ether, and other alcohols. Methyl alcohol is used in small quantity with ethyl alcohol to make that alcohol unfit for drinking, thus avoiding governmental taxation. Methyl, ethyl, and other alcohols, such as isopropyl and benzyl, are useful in the preparation of photographic emulsions and in concentrated developers, where they increase solubility and activity, as well as for drying or cleaning photographic materials.

ALKALI Alkalis are compounds, often called chemical bases, that separate in water to produce hydroxyl ions (OH⁻) that act as electron donors. Alkalis react with acidic substances (H⁺) to produce a salt and water.

Water contains equal numbers of H⁺ and OH⁻ and is neutral, neither acidic nor basic. Alkaline water solutions containing excess OH are represented by numbers above 7 on the pH scale.

See also: *Chemicals; Chemical symbols; Hydrogen ion concentration/pH.*

AMERICAN NATIONAL STANDARDS INSTITUTE (ANSI) The national standardizing organization of the United States of America.

AMIDOL The common name for 2,4-diaminophenol dihydrochloride [(NH₂)₂C₆H₃OH.2HCl, molecular weight 197.07], whose fine white crystals are soluble in water or alkaline solutions or slightly soluble in alcohol. Amidol is a developing agent in water solution but is more rapid acting in weak alkaline solution, such as provided by sodium sulphite. Oxidizes rapidly in alkaline aqueous solutions. Greatly admired for its rich black image tones on bromide papers and transparencies for projection.

AMMONIA A colourless gas with a pungent odour, ammonia (NH₃, molecular weight 17.00) is dissolved in water to form ammonium hydroxide (NH₄OH, molecular weight 35.05), a colourless liquid with escaping ammonia gas that irritates the eyes. The concentrated solution contains about 30% ammonia (the photo grade is 27% minimum), miscible with water and alcohol with a strong alkaline reaction.

Ammonium hydroxide is used in the preparation of some photographic emulsions, as an accelerator or solvent in developing solutions, and for hypersensitizing silver halide materials. Ammonia gas is used for dry development of silver halide and diazo materials.

AMMONIUM BICHROMATE Used for sensitizing carbon tissue in carbon printing, carbro, gum bichromate,

and some photomechanical processes. In process work, it is largely used as a sensitizer with fish-glue for printing halftone images on zinc or copper. It is believed to be twice as sensitive to light as potassium bichromate. Formula $(NH_4)_2Cr_2O_7$. Molecular weight: 252. Characteristics: Orange crystals. Solubility: Freely soluble in water at room temperature.

AMMONIUM DICHROMATE Another name commonly used for ammonium bichromate.

See also: *Ammonium bichromate.*

AMMONIUM THIOSULPHATE The colourless plates or needlelike crystals of ammonium thiosulphate [$(NH_4)_2S_2O_3$, molecular weight 148.21] are readily soluble in water but not alcohol. A clear, colourless solution (56% minimum, 60% maximum) is the commercial form.

The ammonium salt often replaces the sodium salt for rapid fixing baths, reducing the fixation time to about one-quarter. Ammonium thiosulphate is more rapid acting than sodium thiosulphate at lower temperatures and in the presence of increasing amounts of iodide.

AMPHOTERIC Certain molecules can act either as an acid or a base. These molecules are said to be amphoteric (derived from the Greek word for both) and can accept or donate a hydrogen ion. Water is amphoteric, as are certain acids, such as HCO_3^-, HSO_4^-. Gelatin, for example, has both amino, $-NH_2$, and carboxyl, $-COOH$, groups that influence its solubility in water solutions.

ANHYDROUS A term used to describe solid chemical substances that are free of strongly held molecules of water (water of crystallization). *Desiccated* is a similar term, indicating the near absence of a hydrating compound. For example, sodium sulphite (Na_2SO_3, molecular weight 126.06) is the anhydrous form with about 98% sodium sulphite; the desiccated form is about 97% sodium sulphite.

ANISOTROPIC A transparent crystalline optical material that has different properties in different directions, for example, a material such as calcite, which is birefringent (doubly refracting) and polarizes transmitted light.

ANODE The positive terminal of an electrical load from which electrons flow in the external circuit. Inside the load device, however, the electrons flow toward the anode as in an electron tube. The negative terminal of a source, such as a battery, is its anode because it is the source of electrons for the external circuit.

See also: *Battery cathode.*

ANTIFOGGANT Antifoggants are compounds that limit nonimage formation (fog) during development of silver halide emulsions. Such compounds may be contained in the photographic material or in the developing solution. Antifoggants may act by combining with silver ions to produce compounds that are less soluble than silver bromide but also may inhibit development by adsorption to the silver of the latent image. Effective compounds include triazoles, tetrazoles, thiazoles, oxazoles, thiazolidines, and other organic compounds, usually containing sulphur or/and nitrogen. Certain noncarbon compounds, such as potassium bromide or iodide, in developers also limit fog formation during development. These compounds are often called restrainers.

ANTIHALATION COATING Most modern films have some form of protection from halation, the broadening of images of bright objects. In the absence of halation protection, light not completely absorbed by the emulsion is reflected from the interfaces of emulsion and base, base and air, or base and pressure-plate. The reflected light obscures image detail adjacent to bright objects.

There are several forms and positions of halation protection: within the emulsion itself (intergrain absorbers), between emulsion layers, under the emulsion, within the base material, and on the back of the film. Dyes, pigments, and colloidal silver are used. Except for those within the base itself, all agents are dissolved away or decolourized in processing. Absorbers within the base material work twice, first on the ray from the lens as it leaves the emulsion, and then on its diminished reflection from the back surface of the base.

Since reversal processing involves a silver bleaching stage, any colloidal silver halation protection automatically disappears during processing. For this reason some black-and-white reversal films may not be suitable for processing to a negative.

ANTIOXIDANT A chemical present in a photographic emulsion or developer to protect other chemicals from degradation is called an *antioxidant*. In emulsions, antioxidants such as sodium benzene-sulphinate help extend the useful life of the photographic material. In developers, sodium sulphite removes absorbed oxygen from the solution or limits the catalytic effect of the oxidation products of developing agents. Hydroquinone and some derivatives, or ascorbic acid, in small quantities are sometimes used as antioxidants.

ANTISTATIC An agent, grounding device, or electrostatic field intended to prevent or eliminate the accumulation of electrostatic charges. The slight friction resulting from the unwinding of a reel of photographic film or paper generates high voltage electrostatic charges, for example.

These charges may result in two types of problems: (1) static fog marks on unprocessed film or paper are caused by a spark discharge, and (2) dust attracted by the static charge on processed film will be printed in the photographic printer. Each problem is handled in a different way. For fog marks, an antistatic coating containing a hygroscopic or a conductive substance is applied to the back of the film to provide a discharge path and prevents the static charge from accumulating to a value great enough to cause a spark. For dust, the static charge on the processed film can be discharged by ionized air. The air is usually ionized by means of a corona discharge generated by a device known as a static eliminator.

ARCHIVAL Often used to imply as having long-lasting properties. The use of this term is discouraged. since it cannot be defined consistently for different applications.
See also: *Image permanence.*

ARCHIVAL QUALITY Meaning to have long-lasting properties, or similar implications.
See also: *Image permanence.*

ASCORBIC ACID L-Ascorbic acid ($C_6H_8O_6$, molecular weight 176.12; also known as vitamin C) occurs as plates or needles that are soluble in water and alcohol. A related compound, D-isoascorbic acid or its sodium salt, has only about 1/20 the biological activity of vitamin C but may be used as a developing agent to replace L-ascorbic acid.
Ascorbic acid acts as a strong developing agent at higher alkalinities but is often combined with Metol or Phenidone, where the combined developing action is greater than the sum of the individual activity alone, an effect known as superadditivity.

ATOM All matter on earth is composed of atoms so small that 10^{14} atoms are said to be required to cover the head of a pin. There are 109 distinctive structures of protons, neutrons, and electrons that compose the different atoms that cannot be separated into simpler substances by chemical means. Each of the 109 different atoms is called an *element.*

ATOMIC THEORY The concept that all matter is composed of tiny, indivisible particles was first proposed by John Dalton. All the elementary particles, called atoms, of one element have the same mass and properties but differ from all the atoms of another element. Atoms of different elements combine in whole number ratios but remain essentially unchanged. This was the atomic theory of Dalton but does not include any details of the internal structure of the atom, which is still being studied.

AUTOPOSITIVE A sensitized material for making direct positive images upon chemical development, rather than the normal negative images. This is different from the positive image obtained by reversal processing where a silver negative image is first formed, then bleached, and the remaining silver halide developed to form a positive image. (Note: Autopositive is a Kodak trade name, the first letter of which should always be capitalized.)

BALANCE, LABORATORY A device for accurately determining the mass (roughly, weight) of a small amount of substance, for example, a chemical used in making a solution for photographic processing.

BAND STRUCTURE Especially as related to electrons, the energy levels at which an electron can exist in a substance are called bands; the arrangements of these bands is the band structure. The highest band is called the conduction band and has an energy level of zero. An electron in the conduction band can travel freely within the substance, but cannot leave the substance without acquiring some positive energy. Lower bands are typically called valence bands, although the structure can get somewhat complicated, resulting in a variety of designations. Electrons in the lower bands possess negative energy, and are localized within the substance to varying degrees, but not necessarily to one atom.

BARIUM SULPHATE A white, heavy, odourless powder ($BaSO_4$, molecular weight 233.40) that is insoluble in water, alcohol, or dilute acids. A suspension in a gelatin solution can be spread to form a thin, smooth layer (baryta) on photographic paper, producing a surface suitable for coating with a photographic emulsion and for whitening and brightening that layer.

BARYTA COATING A white coating on most fibre-base (non-resin-coated) printing papers under the emulsion to impart smoothness to the image. It is a suspension of barium sulphate in gelatin. Dyes and fluorescent brighteners are often added for a greater appearance of whiteness.

BASE In photography, the support on which a light-sensitive emulsion is coated, e.g., the flexible plastic of films, the resin-coated or fibre base of printing papers, and the glass or rigid plastic of plates.

In chemistry, a base is an oxide or hydroxide of a metal or metalloid that can combine with acids to form salts. Bases that are soluble in water are alkalis.

BASE/BASIC See *Alkali*.

BATTERY Technically, a battery is an assemblage of two or more electric cells, although a single cell is now commonly called a battery. Cells are frequently connected

Battery. Comparison of Cells/Batteries

System	Carbon-zinc (Leclanche)	Carbon-zinc (heavy duty)	Alkaline	Silver Oxide	Lithium	Nickel Cadmium
Chemistry						
Anode	Zn	Zn	Zn (powered)	Zn	Li	Cd
Cathode	MnO_2	MnO_2	MnO_2	Ag_2O	MnO_2	$Ni(OH)_3$
Electrolyte	NH_4Cl and $ZnCl_2$	$ZnCl_2$	KOH	KOH or NaOH	$LiSO_2$ with organic solvent	KOH
Rechargeable?	No	No	No	No	No	Yes
Cell voltage	1.5 V	1.5 V	1.5 V	1.5 V	3.0 V	1.25 V
Energy density	Low	Low	Moderate	High	High	High
Shelf life	Fair	Fair	Good	Excellent	Excellent	Good
Cost	Lowest cost	Low	Moderate	High	High	High
Special characteristics	Intermittent uses such as flashlights	Designed for heavier output current	High energy and current capacity	Maintains a constant voltage	10-year shelf life; leakproof	Rechargeable; leakproof
Best suited for		General use performance better than regular zinc–carbon	Continuous heavy drain loads such as motor drives	Constant voltage applications; portable light meters, cameras, etc.	Still camera electronics, TV remote controllers, smoke detectors	Power packs for electronic flash, video cameras; portable
Limitations	Low energy density; prone to leak	Performance lower than alkaline batteries; prone to leak	More costly than zinc–carbon	Available in a limited number of sizes	Available in limited number of sizes	Does not retain its charge as well as non-chargeable batteries do

in series to increase the available voltage. An automobile battery consisting of six 2-volt cells connected in series has an output voltage equal to the sum of the cell voltages, or 12 volts. The output current capability of several (identical) cells connected in parallel is equal to the sum of the current rating of the cells. When current is drawn from a battery, the voltage measured at the terminals of a battery decreases. The drop in voltage is proportional to the current drawn because of a voltage drop across the internal resistance of the battery. With continued usage, the voltage (even without current flowing) will decrease because of the deterioration of the chemicals that generate the electromotive force. The two broad categories of batteries are primary batteries and secondary batteries. Primary batteries cannot be recharged and must be replaced when their voltage drops below a minimum working value. Secondary batteries can be recharged from an external power supply when they run down. Because some batteries may leak electrolyte, it is good practice to remove batteries from equipment whenever the equipment is not to be used for a couple of months.

The quality and diversity of portable batteries available to the public have vastly improved in recent years. These advances have been in response to the increased popularity of transistorized electronic products, including photographic equipment. The uses of batteries in cameras include providing power for energizing the motors that advance film and automatically focus the camera, firing expendable flash bulbs or electronic flash units, and operating the automatic exposure control mechanism. In video camcorders and electronic still cameras batteries provide power for a multitude of electronic circuits.

Energy density is the energy stored in a fully charged battery and is typically measured in watt-hours per unit weight. Shelf life is the length of time a battery can be stored without an appreciable loss in service life.

BEERS DEVELOPER Two developers, one containing Metol, the other hydroquinone, were formulated by Roland F. Beers to provide contrast control for the development of photographic prints. A progressive but limited range of contrasts can be obtained by varying the amount of the Metol and hydroquinone solutions with additional water.

BENZENE A clear, colourless, volatile, highly flammable liquid (C_6H_6, molecular weight 78.11) that has some solubility in water but is miscible with acetone, alcohol, carbon tetrachloride, chloroform, ether, and glacial acetic acid. Used as a solvent for oils, waxes, and resins and in the manufacture of lacquers and varnishes.

BENZOTRIAZOLE A white crystalline solid ($C_6H_5N_3$, molecular weight 119.13) with slight solubility in water but

greater solubility in alkaline solutions. Used as an organic antifoggant to decrease nonimage development by reacting with silver ions, forming silver compounds that are less developable than silver halides of the emulsion. Image tone may be shifted toward a colder tone.

BICHROMATE POISONING Painful rash or small ulcers wherever human skin has been subjected to prolonged exposure to potassium bichromate. It can be easily avoided by the use of rubber gloves.

BICHROMATE PROCESS Bichromate is the usual name for chromium salts of potassium, ammonium, or sodium of the Cr_2O_7 group, which are also called dichromates. Their light-hardening effect in association with organic colloids such as gum, glue, albumen, and gelatin in exploited in a number of photographic and photomechanical processes.

BINDER A group of chemicals that, when combined with magnetic oxide, form a complete magnetic coating for film and tape. The binder has multiple purposes, including long-term binding of the oxide to the base, lubrication to prevent friction at tape and film heads and guides, and reduction of the electrical resistivity of the oxide to prevent the buildup of static electricity, which can discharge at heads and cause crackling noises.

BIOLOGICAL CONTAMINANTS Many living organisms theoretically can cause harm to photographs, among them some common household pests. The only dangerous biological contaminants are fungi and other microorganisms that may feed on the gelatin present in the image layer of contemporary photographs. More likely to be encountered in tropical climates than in moderate zones, mould growth is capable of destroying an image irreversibly.

BLEACH A chemical or solution of chemicals used to convert image silver into a soluble or insoluble silver compound. Bleaching compounds are also used to remove unwanted dyes in some reversal colour processes. Bleach chemicals are often combined with silver-solubilizing agents, such as sodium thiosulphate, to form photographic reducers or bleach-fix solutions. Potassium ferricyanide has been widely used for bleaching silver images.

BLEACHOUT PROCESS Process for making hand drawings by going over a photograph with waterproof ink or a graphite pencil, then bleaching away the photographic image to leave the drawing. A pale image is easier to remove. Bleach may be prepared from 0.25 ounces each of flake iodine and potassium iodide dissolved in 5 ounces of water. The print is immersed in this solution until the

image disappears. A yellow or brown discolouration may remain. The paper is then rinsed in running water and then fixed in acid or plain hypo.

Line drawings for reproduction that closely resemble photographs can be produced by drawing over a blueprint made from a photographic negative. When the composite image is photographed with blue-sensitive film (or through a blue filter) the blue drops out.

BLEMISHES Blemishes in photographs are defects, marks, or flaws that are visible and detract from the value of an image. They may be quite small and sometimes become apparent only after magnification or enlargement, but they could be relatively large. They may originate in the subject photographed, such as pimples or scars. Or they may occur in the photographic process and consist of spots, hairs, dirt, scratches, bubbles, deformations, or other imperfections. Some blemishes are latent and become visible only after a period of time.

BLISTERS Blisters occur when processing fluids or gases are entrapped between the emulsion and the base of photographic materials, or within the base of photographic papers. When gas is evolved, such as when an acid fixer or stop bath reacts with carbonate from the developer to form carbon dioxide, it can be trapped between the emulsion and base causing them to separate and form blisters. These blisters sometimes break leaving a clear spot on the negative or print. Small blisters in film may escape detection until an enlargement is made. High processing temperatures, wide variations in temperature from one bath to another, and sometimes transfer from solutions having high pH to those having low pH without adequate rinses should be avoided to minimize these problems.

A similar reaction can cause gas to form a blister within a paper base in which water may accumulate. This defect may also be aggravated by or caused by excessive agitation and kinking during washing. Modern paper making and sizing techniques have virtually eliminated this problem.

BLIX A commonly used term to describe a combined *bl*eaching and *fix*ing bath for the oxidation and solubilization of a silver image. This is a proprietary term, however, so these solutions are often called bleach-fixing baths.

BLUEPRINT Print made by the ferro-prussiate process. It gives a white image on a blue ground. Sir John Herschel invented the process in 1842 and named it cyanotype.

See also: *Cyanotype*.

BLUE TONERS Toning processes that produce a blue image on black-and-white prints. One of the most

common, though less stable, consists of converting the silver image to prussian blue ferric ferrocyanide. A more stable and less brilliant blue-gold tone is produced by toning a print made with a warm-tone chloride or chloro-bromide paper using a formula containing gold chloride. A blue dye tone can also be made by converting a black-and-white image to a mordant that then attracts and holds a dye from solution.

BRITTLENESS Brittleness refers to the cracking that occurs in the surface of photographic materials when they are bent through a small radius. When it occurs, the problem is aggravated by low relative humidity, low temperature, or both. Under extreme conditions a film might be completely fractured. There is seldom a problem if temperature and humidity are maintained at satisfactory levels unless the angle of bending is extreme. In the past, humectants have been used as a final rinse after process-ing; however, modern thin emulsions are seldom, if ever, brittle.

BRITTLENESS REDUCTION The emulsion of a photograph or motion picture film can be fractured if bent backwards through a small radius. This was especially a problem with older materials under dry conditions, and in extreme cases the paper or film could be shattered. An effort to solve the problem was most often made by incor-porating wax-like materials during manufacture of the material, by using a rinse containing a humectant (moist-ening agent such as glycerin) following its processing, or by maintaining the moisture content of the ambient atmosphere. Present-day materials made with thin emulsion coatings and effective additives have practically eliminated problems with brittleness.

Once the emulsion of a print has been cracked, it is practically impossible to restore the surface integrity. If a print has been rolled or has a severe curl, no attempt should be made to straighten it until it has been thoroughly soaked in water, rinsed in a humectant solution, and redried.

BROMIDE PAPER A high-speed photographic print material, more commonly called enlarging paper. The sensitive salts in the emulsion are mostly silver bromide with a small amount of silver iodide. Invented and first produced in 1873 by Peter Mawdsley.

BROMIDE STREAK A region of lowered density in areas of a processed image adjacent to high-density areas. The cause is a flow of partially exhausted developer over the material during processing, in situations in which the agitation is inadequate. Bromide streaks were especially noticeable in earlier motion picture, and most especially in titles.

Syn.: *Bromide drag.*
See also: *Photographic effects.*

BROMIDE-STREAK EFFECT See *Photographic effects.*

BROMINE ACCEPTOR Bromine is released during exposure of silver halide photographic materials. To inhibit the attack of bromine on the few atoms of silver of the latent image, bromine acceptors such as gelatin, sodium nitrite, and silver sulphide are present in the emulsion layer. Generally, the term *halogen acceptor* is used, as most photographic emulsions contain halogens other than bromide.

BRUSH DEVELOPMENT A technique for agitating processing solutions, recommended for tray processing of plates, in which a soft brush or cotton swab is moved across the surface of the emulsion.

BUCKLE Buckle refers to the unequal shrinking in various areas of a negative or print. Shrinking may, for example, be greater at the edges of the sheet than at the center, or greater near the corners than midway between the corners. With film, this causes a ripple that prevents all areas of a negative from making contact with the paper when contact printed, or from being in focus in the print when enlarged. In some cases cupping more adequately describes the effect. This defect may appear only after months or years of storage and tends to be accelerated by poor storage conditions. Since there is a tendency for this to occur at the very edges of paper prints, the defect can be avoided by leaving a wide border around the exposed area until the print is dry, at which time the buckled edges are trimmed off.

The slight and uniform curling of films caused by the shrinking of the gelatin emulsion layers usually does not cause problems in printing but may create focus problems when projecting slides.

Buckle

DUFFER Changes in the alkalinity or acidity of a solution can be resisted over a small range by a buffer. A buffer consists of two chemicals: a mixture of a weak acid and a salt of a strong base combined with that acid, or a mixture of a weak base and a salt of a strong acid combined with that base. Such solutions of chemicals neutralize either an acid or a base. The combination of ammonia and ammonium chloride in water tends to maintain a pH around 9. A solution of acetic acid and sodium acetate resists changes in pH from 3.5. Buffer mixtures are often added to developing solutions to maintain developer activity.

CALGON A trade name for polymeric forms of sodium hexametaphosphate having the general formula $(NaPO_3)_n$, where n is 6 or greater. Calgon acts as an inorganic sequestering agent by removing calcium and magnesium ions from photographic solutions before insoluble calcium and magnesium compounds are precipitated. The white, flaky crystals or granules are soluble in water; in fact, unless protected, they may take water from the air and become sticky and start to hydrolyze.

CARBON TETRACHLORIDE A clear, colourless, nonflammable liquid (CCl_4, molecular weight 153.82; also called tetrachloromethane) with a characteristic and not unpleasant odour, but the fumes are toxic. Barely soluble in water but miscible in alcohol, benzene, chloroform, and ether. Formerly used as a solvent for cleaning film surfaces or solubilizing oils but now considered too toxic for such uses.

CAREY-LEA FILTER A coated suspension in gelatin of colloidal silver of such particle size as to appear yellow. Used in colour reversal materials to prevent blue light from reaching the red- and green-sensitive layers. Being metallic silver, it is removed along with the image-forming silver in the bleach and fixing baths.

CASCADE PROCESSING (1) Continuous processing method in which the solutions, and/or wash water, are applied as jets of liquid flowing down the strands of film or paper rather than by immersion of the material in tanks. (2) A washing system in which fresh water is fed into an elevated tank from which it flows to one or more lower tanks. The material being processed moves in the reverse direction, from the lowest tank to the highest.

CATECHOL Also called pyrocatechol, pyrocatechin, or 1,2-benzenediol, the colourless crystalline solid ($C_6H_4(OH)_2$, molecular weight 110.11) is soluble in water, alcohol, benzene, and ether. Contact with the skin or eyes or ingestion should be avoided.

This developing agent closely resembles hydroquinone in structure and activity. In the presence of low preservative in the developer, the oxidation products stain and tan the gelatin of the developed areas.

CEL/CELL/CELLULOID Sheets of cellulose acetate, called *cells* or *cels*, used for a variety of photographic

purposes including making image overlays in the process of motion-picture animation where each cell drawing represents a frame of the animation, and altering the colour of light from a light source. Originally, cel and cell were used as shortened forms of celluloid. Animation cells are sometimes referred to as *acetates*.

Celluloid (pyroxylin, low-nitrogen form of cellulose nitrate with various plasticizers) was used as an early flexible photographic base but was discontinued because of flammability.

CELL See *Batteries; Electric cell; Photoconductive cell; Photovoltaic cell.*

CELLULOSE A white insoluble material that is a polymer of 100 to 200 units of the anhydride of glucose, a sugar. All vegetable matter contains this essential substance, but cotton contains alpha-cellulose, the most desirable form for making collodion and film base. Photographic paper base is made from purified wood cellulose.

CELLULOSE ACETATE Cellulose can be modified by treatment with acetic acid to produce cellulose acetate, a substance that can be coated from solvents to form thin, transparent films suitable as a flexible layer or base for silver halide emulsions. The exact properties of the base are dependent upon the amount of acetic acid incorporated. Cellulose acetate, containing about 40 to 43% attached acetic groups, does not burn easily, unlike cellulose nitrate, the main constituent of collodion or nitrocellulose film base.

CELLULOSE NITRATE When cellulose, preferably in the form of purified cotton, is treated with fuming nitric acid and sulphuric acid, a product soluble in alcohol ether is obtained with a maximum content of about 14% nitrogen (about 12% is considered optimum). Nitrated cellulose, when combined with a plasticizer such as camphor or butyl phthalate, can be coated on a smooth surface to form thin, tough, and transparent films suitable as a flexible base for photographic emulsions. Nitrocellulose was the first practical film base but is highly flammable, sometimes catching fire spontaneously. This film base had better dimensional stability and less water absorption than the less flammable cellulose triacetate safety films.

CELSIUS SCALE (°C) The technical name for the set of temperature measurements based on the following fixed points: 0°C for the freezing point of pure water and 100°C for the boiling point of pure water. A Fahrenheit temperature may be converted to a Celsius temperature by the following formula: $C = (5/9)(F - 32)$.

Syn.: *Centigrade.*

CEMENT See *Film cement.*

CENTI- (c) A prefix denoting one one-hundredth (10^{-2}), as in centimeter (cm, one-hundredth of a meter) or centigrade (one-hundredth of the difference between the boiling and freezing points of water).

CENTIGRADE See *Celsius scale (°C)*.

CHARACTERISTIC CURVE The result, in the form of a graph, of a sensitometric test of a photosensitive material. The plot is variously called the characteristic curve, the H & D curve (named for Hurter and Driffield, the first investigators in this field in the 1880s), and the D-log H curve.

The horizontal axis of the plot is labelled log H (formerly log E). It displays the logarithms of the different exposures (measured in meter-candle-seconds, equivalent to lux-seconds) received by the test sample. These log-H values are related to the tones of the subject. The vertical axis displays the density values produced in the sample as a result of the exposure and development conditions.

CURVE PARTS A characteristic curve may be considered as having six sections. Beginning from the left, they are

1. *Base plus fog level.* For very small log-H values, the curve is horizontal, showing no change in density with increasing log exposure. Subject tones exposed here will not be recorded.

2. *Toe.* In this part of the curve, the density of the sample increases with increasing log exposure in a nonlinear manner. Subject shadows are usually recorded here and will have varying detail, depending on their location within the toe. Negative pictorial speed is based on a specified log exposure within the toe of the curve.

3. *Straight line.* Here the increase in density is directly proportional to the increase in log H. Subject tones

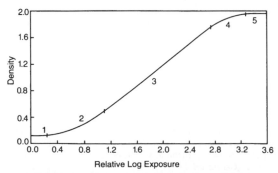

Characteristic (D-log H) curve, showing five of the six regions associated with different exposures.

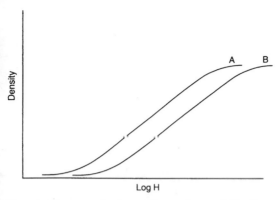

Characteristic curves showing a difference in speed. The film represented by curve A has a higher speed than that represented by curve B.

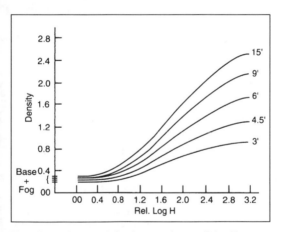

The effects of changed development time on D-log H curves.

exposed in this area will have uniform contrast in the image. For a subject of normal range, and with appropriate camera exposure settings, the midtones and highlights will give log-H values falling in this part of the curve. Gamma, one measure of development contrast, is the slope of the straight line. For black-and-white pictorial films, especially those with one or more emulsion coatings, this middle part of the curve may deviate considerably from a straight line. In part for this reason, contrast index (an average slope) is replacing gamma.

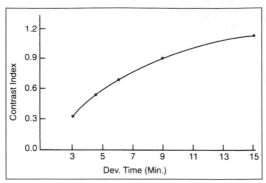

The effects of changed development time on contrast index.

4. *Shoulder.* The shoulder is the region above the straight line, where equal increases in log H produce decreasing density differences. Subject tones will be recorded here only with very large log-H values, caused by an extreme subject tonal range or by overexposure of a normal subject.

5. *Maximum density.* With still greater log-H values, the curve levels out. Any subject areas exposed in this region will have little or no detail in the image.

6. *Reversal.* For some negative materials, beyond the maximum density, density decreases with increasing log H. This area is also called the *region of solarization.* It may be used to produce positive images directly, without the need of reversal processing.

DATA OBTAINED FROM CHARACTERISTIC CURVES

1. *Speed.* Negative pictorial speeds are based on a log H value for a defined point in the toe of the curve. A subject tone giving the log-H value at the speed point will be the darkest subject area holding printable detail in the processed negative. When the curves for two different films are compared, a shift of the speed point to the left represents a decrease in the necessary log H, and thus an increase in speed. Speed points for other photographic materials are located at different positions on the D-log H curve because of special imaging needs. For example, speeds for photographic papers and colour reversal materials are based on middle regions of the curve; high-density speed points are used for films that record x-rays and for microfilms.

2. *Contrast.* Development contrast may be expressed as the value of gamma or, better, contrast index. For a fixed camera exposure level involving the central part of the characteristic curve, image contrast increases up to some maximum as development increases.

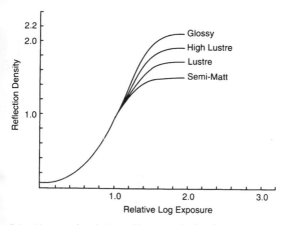

D-log H curves for photographic papers having the same grade but manufactured to have surfaces of different reflection characteristics. The data on the horizontal axis are related to the densities of the negative that will print on the paper. The vertical axis displays the tones that the paper can display and is related to the subject tones that the paper can, at least to some extent, reproduce.

Local contrast, that is, the extent to which detail is recorded in the image, may be measured by the difference in density between adjacent image tones or by the slope of the D-log H curve at a given log-H value. Total contrast is the difference in density between the lightest and darkest image areas. It will be affected by subject tonal range, camera optical system, camera exposure settings, and extent of development.

CHARACTERISTIC CURVES OF BLACK-AND-WHITE PAPERS The D-log H curve varies for photographic papers having the same grade but manufactured to have surfaces of different reflection characteristics. Glossy papers can generate a density range of about 2.0, or a reflectance ratio of about 100:1. For a semimatt paper the range is reduced to about 1.5, equivalent to only 20:1. Since a normal subject will have a luminance ratio of considerably more than 100:1, some compression of tones in the print is inevitable.

The different curves are further notable in that they show for normal development no fog and no straight line. The latter characteristic strongly influences the tone reproduction capabilities of the photographic system.

As development time increases, after a short interval the curve shape remains nearly constant, and the curves shift to the left, indicating an increase in effective speed. For this reason, paper exposure errors can be compensated for, to some extent, by a change in development time.

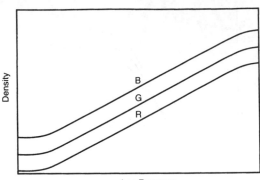

Density

Log Exposure

D-log H curves for an ideal negative colour film.

CHARACTERISTIC CURVES OF COLOUR MATERIALS Analysis of processed colour samples is complicated, since they consist of three dye layers. Colour density measurements are made with successive illumination by red, green, and blue light. Three characteristic curves are needed to represent each sample. Each of the curves for a colour or negative shows approximately the response of one of the dye layers cyan (red sensitive), magenta (green sensitive), or yellow (blue sensitive). They must be nearly parallel for a neutral image of proper colour balance. Speed and contrast of colour films and papers are found by using methods similar to those used for black-and-white materials.

See also: *Paper contrast grades; Paper speed.*

CHARBON VELOURS The name originally given to the paper known for its rich velvety appearance, introduced by V. Artigue in France in 1892. A pigment, for example, watercolour pigment, is rubbed into a stiff paste of starch and applied to the paper in a thin uniform coating. It is then sensitized in a 2% solution of potassium dichromate, exposed, and developed in a warm sawdust mixture, as in the Artigue process.

See also: *Artigue process.*

CHEMICAL COMPOUND A combination of two or more elements producing a substance with distinctive chemical and physical properties, such as silver nitrate, $AgNO_3$, or potassium bromide, KBr. A particular compound always contains the same elements in fixed proportions, regardless of the reactions used to form the compound.

CHEMICAL DEVELOPMENT The formation of a visible image from a latent image involving the reduction

of silver halide grains to silver by a developing agent that is simultaneously oxidized. Contrast with *physical* development, in which the silver that forms the image is supplied from the developer.

CHEMICAL DISPOSAL Treatment of chemical wastes from the manufacture and processing of photographic materials has become a vital concern in the preservation of a quality environment. Processing solutions are a potential source of chemical contamination of the water supply. The solutions discharged by the individual photographer need only be well diluted with water and added slowly to the sewer system. Solutions above pH 10 or below pH 4 should be neutralized first. Aeration and chlorination by the local sewage treatment plant can safely and effectively handle such volumes.

Larger volumes of chemical effluents, such as by minilabs, professional photographers, photoprocessing laboratories, or photographic manufacturers, may not be adequately treated by existing water treatment facilities.

Discharging inadequately treated photographic wastes into water sources may result in a depletion of absorbed oxygen, causing the death of aquatic life or the production of noxious gases. Survival of fish and other aquatic life requires about 5–7 mg of oxygen per liter of water. The biochemical oxygen demand (BOD_5) test measures the amount of oxygen consumed by biological degradation during a 5-day period. A chemical oxygen demand (COD) test requires only 2 hours instead of 5 days to run, but because it measures some chemicals that might not be degraded by microorganisms, the COD test results may not be equivalent to those of the BOD_5 test.

Benzyl alcohol, acetate, sulphite, thiosulphate, and ethylenediaminetetraacetic acid (EDTA) are the highest consumers of oxygen in either test. With the exception of EDTA, they, along with hydroquinone, undergo the most rapid biodegradation. Slower biodegradation is shown by ammonium salts, developing agents, citric acid, and formalin. The presence of these chemicals may require some hours of treatment in an activated sludge aeration tank before discharge into a sewer or surface water.

Borate, bromide, ferrocyanide, nitrate, phosphate, and sulphate (and EDTA) do not biodegrade. Manufacturers of photographic products have minimized or eliminated the use of many of these chemicals. Boron compounds have been replaced in fixing baths and developers, phosphates eliminated as alkalis, and ferricyanide replaced in many bleach baths.

Ferricyanide is especially objectionable because it is converted into highly toxic free cyanide upon standing in sunlit waters. Ion exchange and regeneration and reuse methods have been proposed to limit the discharge of this chemical.

Temperature, pH, chlorine demand, or suspended solids of most effluents are usually not an environmental threat. Strictly regulated by sewer codes are the presence of heavy metals: cadmium, chromium, cobalt, copper, gold, iron, lead. manganese, mercury, molybdenum, nickel, silver, and zinc. Of these metals or their compounds, only those of cadmium, chromium, iron, silver, or zinc are used in sufficient quantities to be of concern.

Silver is present as a thiosulphate complex in fixing and bleach-fix baths and is relatively nontoxic. The complex is converted into insoluble silver sulphide and precipitated through chemical or biological action at a wastewater treatment plant. Prior silver recovery by photoprocessors also minimizes the danger of silver as a pollutant.

Treatment of dichromate bleaches, such as by thiosulphate solutions, will precipitate trivalent chromium hydroxide, and this sludge can be removed. Iron is usually present as stable iron complexes that do not change the taste or appearance of water. Cadmium and zinc are present in such small quantities as not to pose any major threat. Mixed chemical contamination is always of concern, such as insoluble cadmium or mercury combining with water-solubilizing complexing agents.

Information on the exact details of the testing, treatment, recovery, reuse, and disposal of photographic chemicals is often available from the major manufacturers of photographic equipment and materials.

CHEMICAL FOG Unwanted density formed during image development, which may be the result of chemical action during manufacture, storage, or processing of photographic materials. Chemical fog occurs in both exposed and unexposed areas of the light-sensitive material but is most evident in areas of low exposure, where it obscures detail and lowers image contrast. Excessive development fog may be the result of over-energetic developing agents, the action of silver halide solvents, or the effect of oxygen or chemical fogging agents. A small amount of fog is commonly formed during the normal development of black-and-white films.

CHEMICAL SAFETY Safe handling of chemicals and solutions simply involves preventing any contact with human skin, eyes, or respiratory system or internal ingestion, safety glasses or shields, an apron or laboratory jacket, and keeping the hands away from the face and mouth, will greatly minimize some of the potential dangers. Not smoking or eating candy or food in work areas will also help to eliminate possible mishaps. A workplace with adequate ventilation, or the use of a respirator, will limit the inhalation of air contaminated with chemical dust, gases, vapours, or fumes.

Good laboratory and darkroom practices should be followed at all times. Label all bottles and containers, keep

them closed except when in actual use, and store them in cool dry areas away from sunlight (out of reach of children). Store liquids and processing solutions safely. Breaking a gallon glass bottle of glacial acetic acid is a major disaster. Always add acids and bases slowly and carefully to the surface of the water. Do not add water to strong acids and bases. Do not mix chemicals haphazardly, even during final disposal.

Accidents, spills, and mistakes do happen during chemical handling and photographic processing. Clean up promptly all spilled chemicals and solutions. Do not wear sandals, opentoed, or canvas shoes as these provide little protection against spills or dropped containers. Clean gloves, aprons, and clothing or shoes that have become contaminated. Gloves, inside and out, should be clean to avoid chemical contamination of the skin, face, or mouth.

Prompt removal of chemicals from the skin is essential. Wash thoroughly with plenty of water any part of the body that may have contacted chemicals. See a physician if any chemicals reach the eyes, as few substances are not irritating or painful. Chapping of the hands from the drying and cracking effects of alkali on the skin or breaks in the skin from cuts and bruises are major points of entry of poisons into the body. Acidic types of hand cleaners are sometimes recommended for the removal of highly alkaline solutions, such as colour developing solutions.

Certain photographic chemicals and solutions require greater caution because they may cause a skin allergy

Dangerous Mixtures of Chemicals

Do Not Combine	With
Acetic acid	Chromic acid, nitric acid, peroxides, and permanganates
Ammonia	Halogens or calcium hypochlorite
Ammonium nitrate	Acids, chlorates, nitrates; combustible materials
Cyanides	All acids
Hydrogen peroxide	Most metals (particularly copper, chromium and iron) and their salts
Iodine	Ammonia
Nitric acid	Acetic, chromic or hydrocyanic acids; flammable substances
Oxalic acid	Silver
Potassium permanganate	Ethylene glycol, glycerol, benzaldehyde, and sulphuric acid
Sulphuric acid	Chlorates, perchlorates, and permanganates

From *Modern Photographic Processing*, vol. 1, by Grant Haist (New York: Wiley, 1979).

called contact dermatitis and a skin sensitization of increased reactivity. Colour developing agents and colour developing solutions containing para-phenylenediamines. especially those of low water solubility, are primary causes of dermatitis. Black-and-white developers containing para-methylaminophenol (Metol) or tanning developing agents, such as pyrogallol, also require care in handling. Gelatin hardening agents, particularly formaldehyde, glutaraldehyde, and chromium compounds, are potential sources of irritation.

Certain chemicals that are relatively innocuous by themselves may react dangerously, even explosively, when combined with other chemicals. Other combinations of chemicals may emit poisonous gases, such as cyanide fumes or chlorine. Dangerous mixtures of chemicals are shown in the table.

CHEMICAL SENSITIZATION A chemical treatment of a photographic emulsion during the afterripening forms surface specks that are effective in increasing the light sensitivity of the silver halide crystals. Gold compounds (aurothiocyanate), sulphur compounds (thiosulphate), and reducing compounds (stannous salts) may be used alone during the heat treatment of the emulsion but are usually combined for maximum beneficial effect.

CHEMICAL-SPREAD FUNCTION A method to evaluate how photographic processing changes the size and shape of an ideal point exposure of a photographic material. The point-spread function measures both the chemical-spread function and the effect of light irradiation in the emulsion layer during exposure.

CHEMICAL SYMBOLS All the substances of photography are composed of just three elementary particles: *electrons*, *protons*, and *neutrons*, although protons and neutrons are believed to contain smaller components called *quarks*. There are 81 stable and at least 28 unstable distinctive structures of electrons, protons, and neutrons, called *atoms*, that cannot be separated into simpler substances by chemical means. These atoms are called *elements*. Each is assigned an atomic number, and the atomic weight is determined.

Each element is given a name, and a symbol is used to designate it. The symbol is a form of simplified notation, consisting of one or two letters, the first always being capitalized. The symbol Ag, which stands for silver, is derived from *argentum*, the Latin word for silver. Ag represents one atomic weight of the element silver, that is, 107.87 grams.

Some elemental gases, such as hydrogen (H) or chlorine (Cl), combine with themselves to form molecules consisting of two atoms of hydrogen (H_2) or two atoms of chlorine (Cl_2), the number of atoms being designated by

the subscript. Each molecule in this case is twice the atomic weight of each element. These two elements might interact with each other, illustrated by the following chemical notation called an equation: $H_2 + Cl_2 \rightarrow 2HCl$. Sometimes the equation is written $H_2(g) + Cl_2(g) \rightarrow 2HCl(g)$, the (g) indicating that the reactants and products are gases.

The equation, showing the nature, number, and combination of the elements, is simply chemical shorthand, showing in the example above that one molecule of hydrogen reacts with one molecule of chlorine totally to yield (\rightarrow) two molecules of hydrogen chloride. If a reaction is less than complete, two arrows (\rightleftharpoons) may be used, the shorter arrow indicating that a small quantity of reactants is still present; that is, there is an equilibrium between reactants and products.

Two or more elements can react to form a stable molecule called a compound. Compounds may interact with each other, as when sodium hydroxide (NaOH) reacts with carbonic acid (H_2CO_3). Such a reaction might be summarized by the equation $2NaOH + H_2CO_3 \rightarrow Na_2CO_3 + 2H_2O$. In water solution, however, the sodium carbonate (Na_2CO_3) splits into charged fragments, called *ions*, so that the following equation might be more representative of the true condition: $Na_2CO_3 + H_2O \rightarrow Na^+ + OH^- + Na^+ + HCO_3^-$. The $^+$ and $^-$ signs indicate the positive and negative charged ions, and the charges on each side of the arrow must be equal. Thus, in water solution a true representation of the neutralization of carbonic acid by sodium hydroxide is given by this ionic equation:

$$2Na^+ + 2OH^- + CO_3^= \rightarrow Na^+ + OH^- + Na^+ + HCO_3^- + H^+ + OH^-.$$

Rather than the ions being held by the attraction of opposite charges, atoms of an element such as carbon combine with other carbon atoms or with other elements by sharing electrons. The vast number of these carbon combinations are called *organic compounds*. Ethane, for example, may be shown as

```
    H  H
    |  |
H—C—C—H  or  H₃C—CH₃  or  C₂H₆
    |  |
    H  H
```

The lines (–) between the atomic symbols represent shared two-electron bonds. Double (four electron, or =) and triple (six electron, or ≡) bonds also exist, as in acetylene, $HC\equiv CH$ or C_2H_2.

When a hydrogen atom is removed from an organic compound, an organic radical is formed. Such a radical is much more reactive than the parent compound. Radicals

are given names somewhat resembling the compound, such as C_2H_6, ethane, whose radical, $C_2H_5^+$ is called ethyl.

Carbon forms various ring structures with other atoms, often with just hydrogen (hydrocarbons). The rings can have the maximum number of hydrogen atoms (saturated compound) or less than the maximum (unsaturated compound), as indicated by

Because it is present in so many compounds, benzene is often written as a hexagon,

(identical) or

with each corner angle assumed to have a carbon with a hydrogen attached to it. Atoms of other elements, especially oxygen, nitrogen, and sulphur, are often present in carbon compounds, either in the ring or on attached groups of atoms.

CHEMICAL TONING The chemical conversion of a metallic silver image into a coloured image that can be accomplished by the direct formation of a coloured silver salt or by depositing on a silver image, or by partial or complete substitution for the silver image by an insoluble metal compound that is coloured. Image tones can range from blue to red, including green, and a variety of browns.

CHEMILUMINESCENCE The production of light (at temperatures below those required for incandescence) by a chemical reaction.

CHEMISTRY See *Photographic chemistry*.

CHLORIDE PAPER A slow-speed photographic print material, more commonly called contact printing

36

paper. Its principle light-sensitive ingredient is silver chloride. Distinguished from bromide and chlorobromide papers.

CHLOROBROMIDE PAPER Photographic printing paper with speed and image tone intermediate to chloride and bromide papers. The sensitive salts of the emulsion are silver bromide and silver chloride in various proportions.

CHROME FILM Popular term for colour transparency film, the trade names of which usually end in *chrome*, e.g., *Agfachrome, Fujichrome, Kodachrome*. Before the 1930s the term meant any black-and-white film with orthochromatic or panchromatic sensitivity.

CHROMOGENIC DEVELOPMENT Development of a colour image that uses oxidized developer components to form dyes in the emulsion layers by combining with colour couplers incorporated in the emulsion during manufacture. Reduction of the latent image to metallic silver causes the oxidation; dye and silver formation are therefore nearly simultaneous. Bleach and fix remove the silver, leaving a dye image. In a tripack colour negative film, yellow, magenta, and cyan dyes are formed in the blue, green, and red sensitive layers, respectively. In chromogenic black-and-white negative film, black dye of varying density is formed. To inhibit the migration of dyes to neighbouring layers, couplers may be attached to long fatty chain molecules too large to be diffused, or they may be dissolved in organic solvents and dispersed in emulsions as oily globules in which the dyes will form upon development.

In 1895, Raphael Eduard Liesegang showed how different developers formed images of varying colours because of insoluble deposits that formed with the metallic silver image. When Alfred Watkins removed the silver image with bleach, a dye image remained. Benno Homolka formed blue indigo and red thioindigo dye images in 1907 by using developers containing indoxyl or thioindoxyl. (He found other developer compounds that yielded different dyes as well.) Potassium cyanide removed the silver image and revealed the dye.

Between 1912 and 1914, Rudolf Fischer took a series of patents that synthesized the work that went before him and laid the groundwork for most modern photochemical colour photography. The bleach of an image to silver halide and subsequent redevelopment to form a colour image, the process of secondary colour development in which oxidized developing agents react with colour couplers to form dye, three emulsion layer films with incorporated couplers to produce complementary dyes, and the first use of the word chromogenic are all part of Fischer's list of credits.

CHROMOPHORE Chemical group in a molecule of a colourant that is responsible for its colour.

CIBACHROME Originally a process for making colour prints from colour transparencies, the name is now used for other processes based on the silver-dye-bleach process (colour transparencies, graphic arts control systems, etc.). Respected for the permanence of its images. The name was changed to *Ilfochrome* in 1992.

CINCH MARKS Scratches on motion picture film or videotape caused by one turn on a roll rubbing against another.

CLUMPING A nonrandom distribution of elements, such as particles of silver in a photographic emulsion, such that groups of the elements are clustered together. Clumping contributes to the appearance of graininess in photographs, but some of the clumping seen in enlarged prints is due to the overlapping of shadows of grains that may be well separated in depth in the emulsion layer.

COLLOID A name for any class of substances— albumen, caramel, gelatin, glue, and starch—which, when dissolved in water, will not diffuse through a parchment membrane. The colloids mentioned here are used in numerous nonsilver process.

COLLODION PROCESS Early negative-positive processes used light-sensitive coatings on supports that were more opaque than transparent. As a half-measure, paper negatives were waxed to make them translucent, but glass, the obvious solution, was too difficult to use because the coatings could not be made to stay in place. The problem was solved by Frederick Scott Archer in 1851. He used a mixture of nitrocellulose dissolved in ethyl ether and ethyl alcohol called collodion (based on the Greek word for glue) as a vehicle for coating potassium iodide on glass. Silver iodide was formed by bathing the plate in silver nitrate. The collodion was waterproof when it dried, so the collodion plates had to be used while they were wet or sticky. Archer used pyrogallic acid as a developer before the plate dried, and fixed the plate in sodium thiosulphate.

Later modifications to Archer's process included the substitution of ferrous sulphate as a developer to triple the sensitivity, and the use of potentially dangerous potassium cyanide as a fixer because it worked, washed out faster, and left a fog-free plate.

Collodion was subsequently applied to making direct positives on glass, on the ambrotype, and on black lacquered metal, the tintype. Various methods for making dry collodion plates were basically unsuccessful because of substantial losses in effective sensitivity. In the twentieth

century, collodion plates were used in photomechanical reproduction for line and half-tone blockmaking. Plain, unsensitized collodion was used as a covering for wounds and surgical incisions, a glossy coating for albumen paper prints, and an adhesive in the theatre for applying false beards and moustaches.

See also: *Ambrotype; Tintype; Wet-collodion process.*

COLOURANTS Typically pigments or dyes that selectively absorb light of various frequencies, such as cyan, magenta, and yellow dyes or filters that are designed to absorb red, green, and blue light respectively.

COLOUR-BLIND MATERIALS Most light-sensitive chemicals are inherently sensitive only to blue and ultraviolet radiation. The silver halide emulsions up to the 1870s were of this type. (They were called *ordinary* after the invention of spectral sensitization by Vogel in 1873.) Noncolour-sensitized, and hence colour-blind, emulsions are still used for some graphic-arts films, contact printing materials, and non-screen x-ray films.

COLOUR COUPLERS Organic compounds that form dyes during chromogenic development of photographic materials and in diazo processes. Almost all photographic colour materials have substantive couplers integrated in their three emulsion layers, making it possible to use a single developer to produce the composite dye image. Image-forming couplers in photographic materials are colourless until a silver halide image is developed; then they couple with by-products of the chemical reduction to form cyan, magenta, and yellow dyes in proportion to the silver density developed in each emulsion layer. Most colour negative materials also contain colour couplers that form an integral mask to correct the printing deficiencies of the cyan and magenta dye images. These are destroyed in proportion to the silver and dye image produced in these layers, so their masking action affects only the other areas of the image layer. A few negative films use colourless couplers to form the corrective mask during development. In either case, it is these masking dyes that give colour negatives and overall pinkish-tan or orange-brown appearance.

COLOUR FILM A photosensitive material coated on a transparent, flexible support, and capable of making distinguishable records of most subject colours. Typically, colour films respond to the relative amounts of red, green, and blue light reflected or emitted by each point in the scene, and record these as a positive or negative image in cyan, magenta, and yellow dyes. Colour transparency films resemble the original scene in hue and lightness. Colour negative films are complementary in hue and inverted in lightness.

COLOUR FILM TYPES (A, B, F, L, S) Colour transparency films are available in versions for daylight (considered as 5500 K) and for two types of tungsten illumination: Type A (3400–3500 K) and Type B (3100–3200 K). Type F, no longer produced, was for expendable (chemical) flashbulbs (about 4200 K). Other films have been designated Type L, if their reciprocity characteristics favored the longer exposures, or Type S if the shorter.

COLOUR FORMER See *Colour coupler.*

COLOURING
A SHORT HISTORY From the beginning of photography through the invention of the first colour film, hand colouring was used to improve the quality and to add colour to original photographs. By the 1840s, just a few years after the invention of photography, people were looking for something beyond the black-and-white daguerreotype. Miniature portrait painters were hired to paint directly on the images, using fine-haired brushes to apply the powdered pigment. It was a difficult and tedious process to add the colours to the delicate surface, but the application proved quite lucrative. Portrait studios soon opened up in most cities in Europe and America.

Travel photographers hand tinted to enhance their photographs by colouring their slides for use in both lectures and books. By this time transparent oils or water-based paints were also in use. In the early 1900s hand-tinted photographs were made into postcards, with images ranging from landscapes to movie stars. People collected them and put them into albums to save on their shelves.

With the introduction of colour film, hand tinting went out of fashion for a few decades. However, in the 1970s colouring saw a large resurgence. Rather than trying to imitate what was produced with colour film, photographers began using hand tinting to enhance their images and to shift reality to influence the viewer's experience.

Today, colouring is not just used by the fine-art photographer but in magazine (print) advertisements, music videos, film advertisements (much like animated sequences), movie posters, postcards, notecards, and many other aspects of the art and commercial world.

MATERIALS USED Many different agents are being used, ranging from oil- or water-based colours to food dyes and markers. A darkroom is not needed, but instead a room with very good light is required.

Print selection is one of the most important choices, and because colouring will not improve a boring photograph, an interesting black-and-white image should be used. The print should have good tonal range, and it can be toned or bleached beforehand. Resin-coated or fibre-based papers can be coloured, as can either matt or glossy surfaces.

Colouring agents can be applied in different ways, depending on the medium used and the effect desired. For example, when the artist is using oils and would like the image to show through, cotton swabs may be better to work with than brushes, because the swabs can be made to fit in smaller areas. Wiping an area with a larger piece of cotton will take off a lot of the paint and make the oils look transparent, almost like a wash. For a more painterly effect, a brush can be chosen to apply the oils in a thicker manner. Done in this fashion, the oils will not allow the image to show through the paint and can produce an end product much like a photorealist painting. Oils can be removed with distilled turpentine, which will not harm the print when used sparingly. Many beginning painters choose to use this medium for that specific reason. Colourists have several chances to make decisions on the same print when using oil colours, oil pencils, or pastel chalks. With acrylics, however, only one application is possible, because they dry quickly.

Oil pencils can be applied in many ways. Drawing on the print will allow the viewer to see every stroke and add texture to the image. Adding just a slight amount of turpentine to the pencil marks and then rubbing them in with cotton will make the pencil colours look so much like oil paints that people cannot tell the difference between them. The choice between oils and pencils is up to the personal preference of the artist. The results could conceivably look the same.

The drying time of oil-based colourants ranges from a couple of hours to a couple of days, depending on how thickly the paint is applied. Oil-based paints and pencils have the greatest permanence of all hand-colouring materials.

Pastel chalks and Cray-pas are used much the same as oils and pencils. They are easily manipulated and are quite easy to remove just by rubbing with a hand or with the help of a cotton ball. However, chalk colourings must be sprayed with a fixative when finished to prevent smudging or other damage. Any fixative will do, including hair spray. All fixatives will yellow a print within a few years, but it is the only way to hold the chalks to the photographic paper. Both chalks and Cray-pas do not adhere well to glossy surface fibre or resin-coated papers, but if a coat of oil paint is first applied, the chalks can then be used on top for a different effect.

Water colours from tubes, food colouring, felt tip pens, retouching colours, as well as something as unusual as gentian violet, can all be applied with cotton swabs or brushes. The drier the brush, the less likely that the print will buckle. The intensity of the colours can be controlled by diluting them with water or Photo-Flo. If a mistake is made, some of the colour can be removed if the print is rewashed.

Acrylics can be applied with a brush and can be thinned down with water to help control the application. Water

can also be used to remove excess paint or unwanted paint, up to a point.

Hand-tinted photography has gained acceptance in the arts, in the commercial world, and in historical record keeping. The work of hand colourists can be found in major museums around the world and throughout various media. The technique enables the artist to add personal interpretation beyond the specific results of the camera.

COLOURING PHOTOGRAPHS Hand colouring or tinting of monochrome black-and-white photographs is sometimes a pleasing alternative to prints made by direct colour photography. Dyes soluble in water may be applied to moistened prints, or coloured oils may be applied to dry prints. The obsolete Flexichrome process made use of a gray dyed gelatin relief image similar to that of a dye-transfer matrix but on an opaque base. The controlled application of coloured dyes replaced the gray to produce an image not unlike that of a direct colour photograph.

Most subjects are suitable for hand-colouring, but simple colour schemes are often most desirable. It is best to work in soft daylight. It is more difficult to judge the effect of colour under artificial illumination.

MAKING PRINTS FOR COLOURING Photographs intended for colouring should be exposed using filters on the camera that will render dark colours lighter. Unless especially intended to be low-key or dark, prints should generally be of lower than normal density (lighter). For portrait work it may be desirable to use prints toned with one of the sulphide or selenium tones.

WATER COLOURING Transparent water-soluble dyes are available in sets similar to those used by artists, but designed specifically for hand colouring of photographs. They are also available in the form of "stamps" of paper coated with the soluble dyes that are dissolved in suitable amounts of water. Being transparent they do not obscure the details of the photograph.

Care should be taken to avoid finger marks or other oily smudges on the surface of the prints. If they have been dried, the prints should be thoroughly resoaked in water. One of the wet prints is then placed face up in a smooth support such as a sheet of glass. Excess moisture is blotted off. Then large areas should be coloured with diluted dye using a good quality brush, taking care to stay within the bounds of the image element being coloured. Size O brushes are suitable for small details, while sizes 2 and 4 are suitable for larger areas. The dye should be applied in successive washes until the desired tint is reached. Care should be taken to avoid excess dye density. Some dye reductions can be achieved by soaking the print in water, or sometimes with water containing dilute sodium carbonate. However, it is best to avoid over colouring.

OIL COLOURING The print, preferably on a semimatt paper, is prepared by applying the clear medium supplied

by the maker of the colours. It should then be attached by its corners to a smooth board covered with blotting paper. Transparent oil colours are supplied in tubes. They must not be mixed with white or opaque colour. A small tuft of cotton is wound around the tip of a small pointed wooden dowel. This is then placed in the colour, which is then applied to the area being coloured. The colour is worked into the surface with another piece of clean cotton. Excessive colour can be removed with cotton moistened with the thinning medium. When colouring is completed the print should be dried in a warm, dust-free atmosphere.

Heavy oil colouring involves the use of opaque colours much as those used by oil painters. Details and texture can be enhanced or added to the image. This is an advanced technique and requires more skill and artistry than when using transparent colours.

See also: *Colouring*.

COLOUR INTERNEGATIVE A negative colour film that is used to record images from other photographic records. For example, a transparency may be exposed on to an internegative film, to provide a negative image that is suitable for printing on to a nonreversal colour print material.

COLOUR MASKING Procedure in which a photographic image is combined in register with another image to achieve colour corrections or some other effect. For example, in graphic reproduction, a red separation negative may be combined with a low contrast green separation positive to correct for the unwanted green absorption of the cyan ink that is being used.

COLOUR NEGATIVE FILM A photographic film in which light and dark subject tones are reversed, and in which subject colours are represented as their complements. e.g., a blue object is recorded as yellow. This complementary colour relationship is partly obscured in most colour negative films by the presence of colour masking dyes, which improve the colour rendition of any print made from the negative.

See also: *Ektacolor; Kodacolor*.

COLOUR PAPER Photosensitive material on a paper (often resin-coated for rapid processing) base for making reflection prints from negative or positive colour films. Negative-working paper and a colour negative process are used with the former; positive-working paper and a colour reversal process with the latter. Colour paper processes are usually simpler and briefer than their film equivalents. As with most films, three layers on the papers receive red, green, and blue components of the exposure and render these in dye images of cyan, magenta, and yellow, respectively.

COLOUR PHOTOGRAPHY The final form of a colour photograph is normally either a reflection print on paper or a transparency; a transparency can be a slide film, a sheet film, or a motion-picture film. In all cases the original information from the scene is recorded in three photosensitive layers having different spectral sensitivities and coated on a convenient support. Reflection prints on paper are usually made by printing such records on to a paper having similar layers coated on it. In the case of transparencies, however, the film used in the camera may be used for displaying the final image directly or it may be used to make a print on to another suitable film. The requirements for accuracy of colour rendering are physically different for transparencies and for reflection prints because of their different viewing conditions, and the design of photographic materials must allow for this fact, among many others.

COLOUR VISION To produce the colours in a picture so that their relative distributions of light throughout the spectrum are the same as those for the colours in the original scene is not generally practicable. All modem systems of reproducing colour pictures, whether in photography, printing, or television, therefore, depend on the trichromatic principle, whereby colours can be matched by the additive mixture of red, green, and blue lights. This is possible because human colour vision depends initially on absorptions of light by photosensitive pigments having only three different types of spectral sensitivity; these pigments are situated in cells in the retina of the eye called cones. This makes it possible, in colour photography, for all the different colours in the picture to be obtained by using dyes of only three different colours. Each of these dyes absorbs light mainly in a different band of the spectrum, and these three bands are those mainly absorbed by the three different pigments of the retina. One of these three pigments may be regarded as absorbing mainly reddish light, another mainly greenish light, and a third mainly bluish light.

THE SUBTRACTIVE PRINCIPLE When white light is used for purposes of illumination, it normally contains all the colours of the spectrum. Because of the nature of the retinal pigments, however, we may regard the spectrum as consisting of three main bands; first, that comprising light of wavelengths over about 580 nm, which contains all the reddish part; second, that comprising light of wavelengths between about 490 nm and about 580 nm, which contains all the greenish part; and third, that comprising light of wavelengths shorter than about 490 nm, which contains all the bluish part. If the blended light from each of these three bands of the spectrum is viewed, the three colours that are seen are red, green, and blue. It therefore follows that white light can be thought of as an additive mixture of red, green, and blue components. In order to produce a wide range of colours in a beam of white light, all that is required

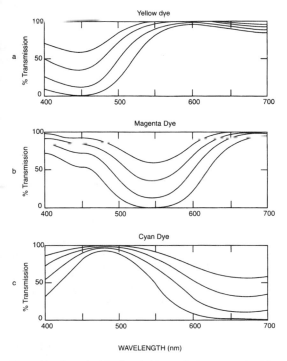

The subtractive principle. Spectral transmission curves for (a) yellow, (b) magenta, and (c) cyan, dyes at four different concentrations.

is some means of varying the amounts of the reddish, greenish, and bluish bands, independently of one another.

When the percentage transmission at each wavelength of a yellow dye, at four different concentrations, is plotted against wavelength, it can be seen that, for all the concentrations, the transmission in the reddish part of the spectrum is high, in fact nearly 100%. In the greenish part, the variation of transmission with concentration is not large; but, in the bluish part, the transmission depends markedly on the concentration of the dye. By varying the concentration of a yellow dye in a beam of light, its bluish content can be modulated nearly independently of its greenish and reddish contents.

Similar spectral-transmission curves for a magenta dye, at four different concentrations, show that the main effect of altering the concentration of the magenta dye is to modulate the transmission in the greenish part of the spectrum. It is true that the transmission in the bluish and reddish parts do alter also, but they do so to smaller extends. Similar curves for a cyan dye at four different

concentrations show that the main effect of varying the concentration of the cyan dye is to modulate the transmission in the reddish part of the spectrum, and to a lesser extent, the transmission in the greenish and bluish parts.

If, therefore, the concentrations of a cyan, a magenta, and a yellow dye are varied in a beam of white light, a wide range of colours will be produced. This is the subtractive principle of colour reproduction, because the dyes subtract from the white light those components that should not be there. It is clear that, although the colours of the dyes are cyan, magenta, and yellow, this is merely incidental to the fact that it is dyes of these colours that correspond, respectively, to a red-absorbing, a green-absorbing, and a blue-absorbing colourant. (In the graphic reproduction industry the colours of the inks used are sometimes referred to as blue (or process blue), red (or process red), and yellow, but their functions are still to act as absorbers of reddish, greenish, and bluish light, respectively.)

To produce a subtractive colour reproduction, all that is necessary is to be able to control the concentration of the three dyes independently, at each point in the picture, in suitable accordance with the absorptions in the three different types of pigments in the cones of the retina for the same point in the scene. Assuming that this can be done, the successive stages of subtractive colour photography are as follows.

1. Records of the original scene are made by means of red, green, and blue light in order to record the pattern of absorption of light by the three types of retinal cones.
2. Dye-image positives are made from the records, the red record giving a cyan image, the green record a magenta image, and the blue record a yellow image.
3. When superimposed in register, the three dye images are viewed in white light.

FORMING DYE IMAGES To form a dye image, as distinct from a uniform layer of dye, it is necessary for the amount of dye present at each point to be suitably dependent on the red, green, or blue exposure at that point. The most widely used method of achieving this result is by means of colour development. In colour development, the exposed silver halide in the photographic emulsion is reduced to silver, as in black-and-white development, but the developer, which becomes oxidized as a result, is then made to react with a coupler to produce an insoluble cyan, magenta, or yellow dye. This process can be represented as follows:

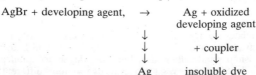

AgBr + developing agent, → Ag + oxidized
 developing agent
 ↓ ↓
 ↓ + coupler
 ↓ ↓
 Ag insoluble dye

Most developing agents, when oxidized, will not combine with couplers to produce dyes. This reaction, therefore, only works satisfactorily with some developing agents, notably para-phenylenediamine and some of its derivatives. It is clear that the dye is formed jointly from the coupler and the oxidised developing agent, and the colour of the dye formed depends on both these constituents. The amount of dye formed depends on the amount of oxidized developer available, and this in turn depends on the amount of silver that has been developed. Thus, the amount of dye is related to the amount of exposure given at each point and is therefore laid down as an image and not as a uniform layer. The reaction of the oxidized developing agent is localized around the silver halide crystals (or grains, as they are usually called) containing the latent image, so that, on colour development, blobs of insoluble dye are formed only around the silver grains developed; hence, the dye image obtained reproduces in a somewhat blurred manner the granular nature of the silver image from which it is derived. If three such dye images are produced, using couplers that produce cyan, magenta, and yellow dyes, and if the silver is removed by bleaching, a subtractive colour photograph is obtained by superimposing the three images in register. Alternatively, the dye images can be transferred to another support, but colour development is usually used to produce dye images of different colours in different layers of a single film.

INTEGRAL TRIPACKS If three pictures have to be exposed one after the other, only still life or very slow moving scenes can be recorded. In modern subtractive systems of colour photography, the three records are taken on three emulsions coated on top of one another, an arrangement known as an integral tripack.

The natural sensitivity of photographic emulsions covers only the blue part of the visible spectrum. Their sensitivity to the green and red parts requires the addition of sensitizing dyes. An ordinary, unsensitized, emulsion usually constitutes the top layer in a tripack, and in it is produced a negative that provides the blue record of the scene, but in this case no blue filter is necessary because the emulsion itself responds only to blue light. The bottom layer of the film consists of an emulsion sensitized only to red light. It still has its natural sensitivity to blue light, but this is rendered inoperative by means of a yellow filter layer situated immediately below the top layer. In this bottom layer, therefore, is produced a negative providing the red record of the scene, but once again no red filter is needed, because the yellow filter together with the red-sensitizing of the emulsion make the layer sensitive only to red light. Between the yellow filter layer and the bottom layer is an emulsion sensitized to green light only. This sensitizing, together with the yellow filter layer, constitutes a layer sensitive to green light only, and therein is produced a negative providing the green record of the scene, but without using a green filter.

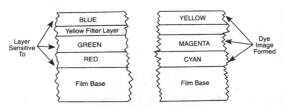

Integral tripacks. Structure of an integral tripack typical of those used for films of camera speed.

With such a three-layer film, a single exposure suffices to record the three images required, one being effectively taken through a red filter, another through a green, and a third through a blue. It remains to process the film in such a way that cyan, magenta, and yellow dye images are formed in these three layers, respectively. There are two main methods of achieving this by colour development. In one method, the couplers are incorporated in the film; in the other, they are in the three separate developers.

PROCESSING WITH COUPLERS INCORPORATED IN THE FILM The way in which an integral tripack material can be processed when the couplers are incorporated in the film can be shown diagrammatically. Each of four large circles depicts a highly magnified cross-section of the three emulsion layers and the yellow filter layer. Each small triangle represents a silver halide crystal, or grain, and the triangles with dots in them indicate grains that have been exposed and contain a latent image, while those without dots indicate grains that have not been exposed and do not contain a latent image. It is thus clear that in this example light has fallen on the right-hand part of the film but not on the left. The circles represent particles of couplers, those in the top (blue-sensitive) layer being capable of forming yellow dye, those in the bottom (red-sensitive) layer being capable of forming cyan dye, and those in the other (green-sensitive) emulsion layer being capable of forming magenta dye. The couplers are prevented from wandering away from their proper layers, either by attaching long molecular chains to them or by dissolving them in oily solvents and then dispersing them in the form of minute oil droplets, when oil droplets are used they are usually about one-tenth the diameter of the silver halide grains. On immersing the material into a solution containing a suitable developing agent, the developing agent converts the silver halide to silver wherever a latent image was present, and around each grain of silver thus formed, the oxidized developing agent reacts with coupler to produce dye: yellow (Y) in the top layer, cyan (C) in the bottom layer, and magenta (M) in the other emulsion layer. The dyes are deposited as very small clouds of molecules or droplets around each developed grain. It is now necessary to remove the unexposed silver

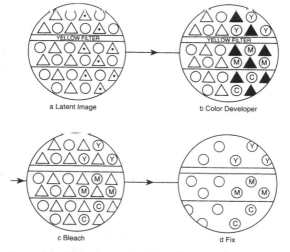

| a Latent image | b Color Developer |
| c Bleach | d Fix |

Processing with incorporated couplers. Diagrammatic representation of highly magnified crossections of an integral tripack material to give a negative image. Open triangles, unexposed silver halide grains; triangles with dots, exposed silver halide grains; filled triangles, developed grains of silver; cricles with Y, particles of yellow dye; circles with M, particle of magenta dye; circles with C, particle of cyan dye.

halide from the film, for this has a milky appearance and would gradually darken as the film was viewed. This fixing is carried out as in black-and-white films by means of a hypo solution, but it is also necessary to remove the silver image that otherwise would darken the result, and this is conveniently done by converting the silver back to silver halide by means of a suitable bleach, used before the fixing stage. In the remainder of the process, the bleach converts the silver to silver halide again and all the silver halide is removed by the fixer. (In some processes the bleaching and fixing steps are combined in a single solution known as a blix.) The yellow filter layer generally also disappears at the bleach stage. The unused coupler is harmless and is allowed to remain. In fact, in some colour films the unused coupler is actually used to improve the accuracy of the final results. and in these cases it is usually coloured yellow or pink, but otherwise it is colourless.

After the processing has been completed, the final result is that on the right-hand side of the film, where the light originally fell, all three dyes (cyan, magenta, and yellow) are produced (resulting in a dark area), whereas on the left-hand side, where no light fell, no dyes are produced (resulting in a light area). The result is thus a negative: light becoming dark and dark becoming light. In addition, colours will be reversed; red becoming cyan, green

becoming magenta, and blue becoming yellow, and vice-versa. That this is so can be seen by considering the following example. If the light falling on the film had been red, only the bottom layer would have been exposed; hence only cyan dye would have been formed. Conversely, if the light falling on the film had been cyan (blue-green), only the blue- and green-sensitive layers would have been exposed, and hence only yellow and magenta dye would have been formed and the superimposition of these could result in a red colour. To produce a colour positive from such a record, which is called a colour negative, it is only necessary to rephotograph or print the processed negative onto a similar piece of film or paper. Once again, by the same arguments, both the tones and the colours will be reversed and the final result will be in its correct colours.

REVERSAL PROCESSING If a separate negative stage is not required, the film exposed in the camera can be reversal processed to give a positive image directly. The way in which this is done can be shown diagrammatically. When light has fallen on the right-hand part of the film but not on the left, the latent image is present only on the right. The film is then immersed in an ordinary black-and-white developer, which converts the exposed silver halide to silver, thereby oxidizing the developing agent. Being an ordinary black-and-white type developing agent, however, its oxidized form does not react with the couplers and, hence, no dye is formed at this stage. The next step is to reexpose the film to a strong white light, or to immerse it in a fogging agent, so that a latent image is formed in all the undeveloped silver halide. The film then enters a colour developer that converts this silver halide to silver, and the oxidized developer formed in the vicinity of this silver reacts with the couplers to form cyan, magenta, and yellow dye images as before. The usual bleaching and fixing stages then remove all the silver to give, now, all three dyes (dark areas) on the left-hand part of the film, where the light originally did not fall, and no dyes (light areas) on the right-hand part of the film, where the light originally did fall. The result is thus a positive, as required. That the colours are also rendered correctly can be seen by the following example. If the right-hand side was exposed only to red light, only the bottom layer would have been exposed so that, in the black-and-white developer, silver would have been produced only in the bottom layer. The reversal exposure would therefore produce latent images in the top two light-sensitive layers but not in the bottom layer. On colour development, yellow and magenta dyes, but no cyan dye, would therefore be formed and hence a red colour produced on the film in the area in which the red light originally exposed it.

PROCESSING WITH COUPLERS IN THE DEVEL-OPERS An example of one way in which direct-positive colour images can be obtained using the other main method of colour developing, that in which the couplers

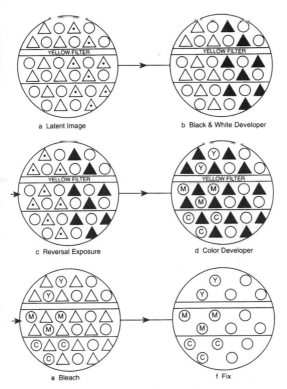

a Latent Image

b Black & White Developer

c Reversal Exposure

d Color Developer

e Bleach

f Fix

Reversal processing. The processing sequence necessary
(reversal process) to obtain a positive image directly on the
camera film.

are in three separate developing solutions, can be
visualised in the same way. Once again, light has fallen on
the right-hand part of the film and not on the left. An
ordinary black-and-white developer therefore produces
silver images on the right-hand part as before. The film is
then reexposed uniformly, not to white light but to red
light from the bottom. Because only the bottom layer is
sensitive to red light, a latent image is formed only in this
layer, so that on immersing the film in a colour developer
containing cyan-forming coupler, cyan dye is formed on
the left-hand part of the bottom layer only. The film is
next exposed to blue light from the top. and, because the
yellow filter layer protects the bottom two layer.s from all
blue light, a latent image is, at this stage, formed only in
the top layer, so that on immersing the film in a colour
developer containing yellow-forming coupler, yellow dye
is formed in the left-hand part of the top layer only. It is
now required to form magenta dye in the left-hand part

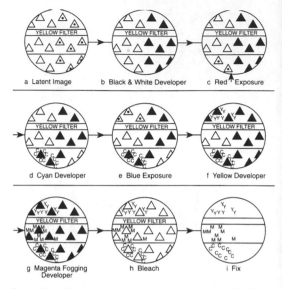

a Latent Image

b Black & White Developer

c Red Exposure

d Cyan Developer

e Blue Exposure

f Yellow Developer

g Magenta Fogging Developer

h Bleach

i Fix

Processing with developer couplers. Using the method where the three couplers are in three different developers instead of in the layers of the tripack. Y, particle of yellow dye; M, particle of magenta dye. C, particle of cyan dye.

of the other emulsion layer, and since it is only in this part of the entire film that there is any silver halide left, use is made of a colour developer containing magenta-forming coupler and of such a character that development takes place even when the silver halide has not been exposed. The final two stages are the usual bleaching and fixing steps. It will be seen that the final disposition of the dyes is the same as before so that a positive has been achieved, and by the same arguments as used previously, the colours as well as the tones are correctly reproduced.

Colour negative images cannot conveniently be obtained by this method of colour development because it is the reversal exposure step that provides the opportunity for the colour developers to affect each layer in turn independently.

It can be seen that this type of process is of considerable complexity and is, for this reason, only operated at a few large processing stations. In return for this complexity, however, the process can yield an extremely high resolving power, so that it can be used satisfactorily even for 8-mm cinematography, where the frame size is only 3.68×4.88 mm (or 4.22×6.22 mm in Super 8). The outstanding example of this type of process is that used for Kodak Kodachrome film.

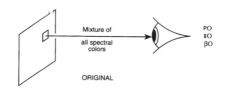

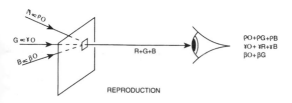

Unwanted stimulations. Diagrammatic representation of the effect of unwanted stimulations in a three-colour reproduction.

DEFECTS OF THE SUBTRACTIVE PRINCIPLE

Subtractive colour photographs produced by some modern commercial processes are often so pleasing to the eye that the impression is made that almost perfect colour rendering has been achieved. In point of fact, however, as far as colour rendering is concerned, all subtractive processes suffer from some important inherent defects.

Unwanted Stimulations We may regard it as necessary, for the moment, that the effective sensitivities of the three photographic emulsion layers used to record the three images should be the same as the probable sensitivity curves of the three types of cones, r, g, and b, used as the basis of colour vision. This can be achieved, but it is further required that the cyan dye controls a band of wavelengths to which only the r cones respond, the magenta dye a band to which only the g cones respond, and the yellow dye a band to which only the b cones respond. When we look at the approximate bands of wavelength controlled by the cyan, magenta, and yellow dyes, however, it is clear that the r, g, and b responses are not independently controlled by the three dyes; these unwanted stimulations can cause serious defects in the colour reproduction.

If the r and b curves did not overlap in the blue-green part of the spectrum, then a band of green light could be found that stimulated the g cones on their own, but since the r and b curves do overlap appreciably, the g cones cannot be stimulated on their own, and hence simple trichromatic means cannot achieve correct colour reproduction. This is not a difficulty peculiar to any particular

method or process but one that underlines all modern methods of colour reproduction, whether in photography, in graphic arts printing, or in the additive systems used in television. It cannot be avoided because it follows from the basic nature of human colour vision.

If some particular part of the original gives rise to responses ro, go, and bo, and if the strengths R, G, and B of the reddish, greenish, and bluish light composing this part of the reproduction are proportional to these responses, then the reproduction is spoiled because the reddish light gives rise to an unwanted g response, gR, the greenish light gives rise to unwanted r and b responses rG and bG, and the bluish light gives rise to unwanted r and g responses rB and gB.

The effect of this may be appreciated in the following way. The strengths, R, G, and B of the lights in the reproduction have to be reduced to renormalize them so that white is still reproduced correctly. This means that any differences between the r, g, and b responses then become smaller than the differences between ro, go, and bo, because of the addition of the unwanted stimulations. It may be assumed that, for whites and grays, the r, g, and b responses are equal; hence, reductions in differences between the responses result in the colours becoming less different from whites and grays. In others words, they become less colourful.

The unwanted stimulations by the bands of light controlled by the cyan, magenta, and yellow dyes also limit the gamut of colours that can be reproduced. This is also the case with the red, green, and blue light produced by the phosphors in colour television.

Unwanted Absorptions A further defect arises from the fact that the best cyan, magenta, and yellow dyes have appreciable absorptions in parts of the spectrum where they should have 100% transmittance. These unwanted absorptions result in colours being produced considerably darker than in the original scene unless corrections are made. These unwanted absorptions also reduce the gamut of colours that can be reproduced. Effective methods have been developed for correcting for the effects of unwanted absorptions. One method is to use interimage effects, whereby the amount of dye formed in a layer depends not only on the exposure in that layer but also on the exposure in another layer in the opposite direction. Another method is to use couplers that are coloured. These methods will be considered more fully later in this article.

Colour Gamuts Obtainable The chromaticity gamut of colours obtainable with the dyes used in a typical colour film can be compared with that obtainable with typical television phosphors and that covered by typical surface colours encountered in scenes. Both the film-dye and television-phosphor systems cover less than half the full area of chromaticity (enclosed by the spectral locus and the purple boundary); but the area for the typical surface colours is

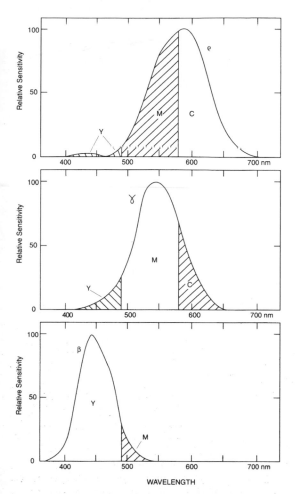

Unwanted absorptions. The areas labeled C, M, and Y, show the magnitudes of the retinal responses controlled by the absorptions of cyan, magenta, and yellow dyes, respectively. In an ideal system, the absorption of the yellow dye would control the response of the b cones only; the absorption of the magenta dye would control the response of the g cones only; and the absorption of the cyan dye would control the response of the r cones only.

only slightly larger, and it is for this reason that the limited gamut of these reproduction systems is successful for most scenes. The film-dye and television-phosphor systems are remarkably similar in their gamuts. The unwanted absorptions of the film-dyes, however, have a darkening effect on

Colour gamuts. Solid lines, the gamut of chromaticities that can be reproduced using, with Standard Illuminant DGS, the dyes of a typical colour film, using combinations of concentrations of dye corresponding to densities in the main absorption band of 2.0. Broken lines, the gamut of chromaticities that can be reproduced by the phosphors of typical television receivers. Dot-dash line, the gamut of chromaticites typical of surface colours present in scenes.

the colours that causes further restrictions on their gamut, but these cannot be shown on chromaticity diagrams because the luminance factor is not shown.

SPECTRAL SENSITIVITIES FOR COLOUR FILMS The spectral sensitivities that should be used for film must now be considered.

Spectral Sensitivities for Block Dyes For the sake of simplicity, consider first the case of a set of cyan, magenta, and yellow dyes having spectral transmission curves. These block dyes control bands of the spectrum that constitute red, green, and blue lights, or primaries, whose relative spectral compositions are the same at all concentrations of the dyes, thus providing stable primaries. To achieve correct colour reproduction, it is then necessary for one layer of the film to have a spectral sensitivity equal to the curve representing the amount of red primary needed to match each wavelength of the spectrum, another to be similarly related to the green primary, and the third to the blue primary. These curves are known as colour-matching functions.

As is to be expected, the amount of red light required is greatest in the reddish third of the spectrum, the amount of green greatest in the greenish third, and the amount of

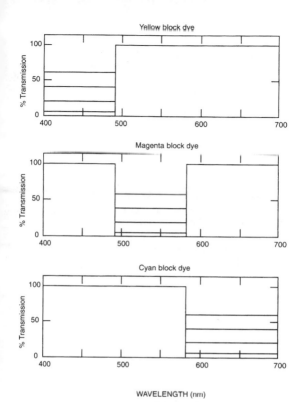

Block dyes. Spectral transmission curves of ideal subtractive dyes (block dyes) at four different concentrations.

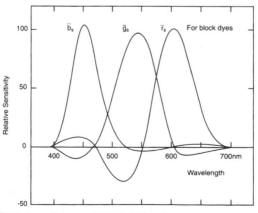

Block dyes. Colour-matching functions for the primaries modulated by the block dyes.

57

blue greatest in the bluish third. In some parts of the spectrum, however, negative amounts of light are required. Thus, at around 510 nm an appreciable negative amount of red light is required. The reason for this is that the band of the spectrum modulated by the magenta dye produces a large unwanted r stimulation, and although light of wavelength 510 nm also results in some r stimulation, it is not so great. In attempting to match the 510 nm wavelength, therefore, a mixture of the green and blue primaries can give the right amount of g and b stimulation, but even zero amount of the red primary gives too much r stimulation. In colorimetry, this difficulty is overcome by adding some of the red primary, not to the mixture of the green and blue primaries, but to the 510 nm light being matched. When this is done a match can be obtained, and the amount of red light is then plotted as a negative amount. In some other regions of the spectrum, negative amounts of the green and blue primaries are required.

The implication for colour film is that the red-sensitive layer should be such that light from the blue-green part of the spectrum should reduce the latent image formed by light from the reddish part of the spectrum; and similar reductions of exposure should occur in the other two layers of the film in accordance with the distribution of the positive and negative parts of the curves. Unfortunately, no accurate way of achieving these negative lobes of sensitivity has yet been found for colour photography. In colour television, where the same problem occurs because of unwanted stimulations caused by the phosphors, the negative lobes are realized by having an all-positive set of sensitivity curves corresponding to suitable combinations of the curves and then deriving the correct signals by suitable subtractions subsequently, a practice known as matrixing. Thus, if the red channel in the camera had a sensitivity curve corresponding to the red curve plus the green curve, the combined curve would not have any negative parts. Subtraction of the green signal from the combined signal would then give a red signal identical to that which would have been obtained from the red curve alone. Of course, negative light cannot be used in the picture, and so this procedure only gives correct colorimetric colour reproduction when the true red signal is positive or zero. It is this effect that results in the limited gamut of chromaticities reproducible by colour television. All colours lying outside the triangle representing the gamut for the television phosphors require either one or two of the three signals to be negative such negative signals are usually taken as zero, and the reproductions then lie on the edge of the gamut triangle. With matrixing, however, all colours lying within the gamut triangles can have correct colorimetry, and fortunately this includes most of the range of chromaticities corresponding to surface colours normally found in scenes. Hence, in colour

television, the unwanted stimulations caused by the red, green, and blue phosphors result in a limited gamut, but within that gamut the colorimetry can be correct. In colour photography, however, the unwanted stimulations caused by the bands of light modulated by the cyan, magenta, and yellow block dyes not only cause the gamut to be limited but also cause colorimetric errors because of the inability of film to incorporate negative lobes of spectral sensitivity or to have any analogue of matrixing (except in approximate and limited forms).

Spectral Sensitivities for Real Dyes The chromaticities of the effective reproduction primaries are easily calculated for the block dyes considered in the previous section, and these chromaticities define the appropriate set of colour-matching functions. Because real dyes do not absorb uniformly in each third of the spectrum, however, the chromaticities of the corresponding primaries vary as the concentrations of the dyes are altered to produce the various colours. The use of these unstable primaries means that there is no unique set of theoretically correct colour-matching functions and spectral sensitivity curves for colour-reproduction systems using real dyes. Although this is an unwelcome complication, one small bonus is that the nonuniform spectral absorption of the dyes does extend the chromaticity gamut somewhat, especially in the blue-green direction.

The instability of the primaries in colour photography means that accurate colorimetric reproduction of all matchable colours cannot be achieved by using a set of theoretically correct spectral sensitivity curves in the film. Instead, the approach has to be statistical, and the variables in the system have to be adjusted so that, if accurate colorimetric reproduction is the objective, the departures from it are minimized for ranges of colours typifying those most often encountered in practice and weighted according to their relative importance and the relative importance of different types of errors for them.

The spectral sensitivities that are optimum in practice depends on several requirements, some of which are conflicting. If possible, it is clearly desirable that the curves be a set of colour-matching functions, because only then will colours that look alike in the original always look alike in the reproduction, and colours that look different in the original will always look different in the reproduction. Spectral sensitivities with accurate negative lobes are not yet possible, however, and the curves of all-positive sets of colour matching functions require considerable subtraction of the three records from one another to obtain the correct result; moreover, this subtraction can normally be done, if at all, only to a limited and approximate extent by photographic means. All positive sets of colour matching functions also overlap one another considerably along the wavelength axis, and this tends to use the light available for exposing the three layers of the film in a tripack rather

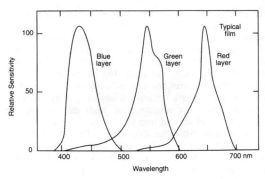

Spectral sensitivities for real dyes. Spectral sensitivity curves typical of those used in colour films.

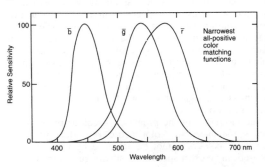

The narrowest possible set of all-positive colour-matching functions.

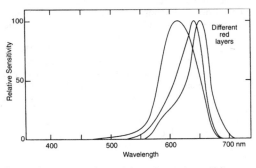

Spectral sensitivities for real dyes. Spectral sensitivity curves typical of those used in colour films.

inefficiently. For all these reasons, photographic systems are usually optimized with sensitivity curves that depart appreciably from any set of colour-matching functions. By using all-positive sets of curves that overlap one another

less, the levels of subtraction of the records required are reduced and the exposing light is used more efficiently. The penalty is that some pairs of colours with different spectral compositions that look alike in the original will not look alike in the reproduction, and some that look different in the original will look alike in the reproduction. Some colours with particularly unusual spectral compositions may reproduce with quite large errors.

When we look at a set of spectral-sensitivity curves typical of those used in films, it is clear that, compared with the colour-matching functions, the blue film curve peaks at slightly shorter wavelengths, the green film curve is narrower, and the red film curve is narrower and peaks at considerably longer wavelengths. Although the film curves depart considerably in shape from either set of colour-matching functions, it is found in practice that, for most colours, the colorimetric errors are not too large, even when no subtraction of the records from one another takes place. The shifting of the blue film peak to shorter, and of the red film peak to longer, wavelengths and the narrowing of the green and red film curves provides a crude substitute for the negative lobes that should really be incorporated. The small amount of overlapping of the curves also enables the exposing light to be used efficiently. The most serious problems can, in fact, all be traced to one cause: some colours, such as certain blue flowers and certain green fabrics dyed with particular synthetic colourants, exhibit high reflectances at the far red end of the spectrum, where the eye has very low sensitivity but the film has high sensitivity. These colours are therefore reproduced too red in colour photographs, so that the blue flowers can be rendered pink and the green fabrics may be rendered gray or even brown. Another effect is for reds of varying depths to be reproduced rather similar to one another. Attempts are made to reduce these effects by adjusting the position of the red film curve along the wavelength axis, but if the red curve is moved to short enough wavelengths to avoid the problems completely, then greens are reproduced too yellow, the colourfulness of reds is reduced quite severely, and the pink of Caucasian skin (which is an extremely important colour in photography in the Western world) is rendered too ashen and gray. These latter problems could be overcome by using enough correction by subtraction of the records from one another, but the level of correction required is so high that it is difficult to incorporate accurately and would result in a film that was somewhat precariously balanced in its interactions.

An alternative approach, used in one type of commercially available film, is to move the red film curve to shorter wavelengths, restore the loss of colourfulness in reds by raising the contrast of the red layer, and then using an interimage effect from an additional blue-green sensitive layer to restore correct contrast in grays and pale

colours. This type of approach reduces some errors usefully but falls short of providing sensitivities that are an accurate set of colour-matching functions.

CORRECTION OF UNWANTED ABSORPTIONS

As already mentioned, the cyan, magenta, and yellow dyes used in colour photography absorb not only the band of the spectrum that they are intended to modulate but also to a lesser extent the other bands. These unwanted absorptions result in the colours in pictures being darker than they should be, and the effect is particularly strong in the case of blue and green colours, because typical cyan and magenta dyes have appreciable unwanted blue absorptions, and typical cyan and yellow dyes have appreciable unwanted green absorptions. Such effects caused by unwanted absorptions can, however, be corrected in photographic systems, and two methods are important in practice.

Coloured Couplers The first method of correction is to form dye images from couplers that are themselves coloured. These coloured couplers are widely used to correct unwanted absorptions in films that produce colour negatives. If a magenta image is formed from a coupler that is itself yellow, then as more magenta dye is formed, more coupler will be used up and, consequently, the absorption of blue light will decrease because there will be less blue-absorbing yellow coupler present, but the increased amount of magenta dye will absorb more blue light. By balancing these two opposing effects, the layer can be made to have a blue absorption that is constant, whatever the amount of magenta dye present. The blue absorption is therefore uniform over the whole picture area and can be allowed for by a suitable increase in the overall blue content of the light used when printing the negative to form a positive. Similar correction for the unwanted green and blue absorptions of cyan dyes can be made by forming the cyan image from a coupler that is reddish, so that it absorbs the appropriate amount of green and blue light. The use of yellow magenta-forming and reddish cyan-forming couplers in colour negatives gives them their familiar orange appearance. (Other unwanted absorptions could be similarly corrected, but those mentioned are the most significant.)

Interimage Effects The second method of correcting for unwanted absorptions in by means of interimage effects. Coloured couplers can, unfortunately, only be used in materials designed to be printed or otherwise duplicated. For materials intended for direct viewing, the presence of the coloured couplers in light areas gives a pronounced orange cast, and the eye is not able to adapt sufficiently to compensate for it. For this reason, coloured couplers have no application to reversal films intended for viewing, and the brilliance of the colours in some of these is caused, at least in part, by interimage effects that have beneficial consequences not unlike those produced by coloured couplers.

In an interimage effect, the unwanted absorption of a dye is corrected by appropriately reducing the amount of dye in another layer. Thus, the unwanted blue absorption of a magenta dye can be corrected by arranging that increases in the amount of magenta-image dye formation are accompanied by suitable decreases in the amount of yellow-image dye formation, the two effects again being balanced to enable the magenta dye to be increased without any accompanying change in the absorption of the film to blue light. Of course, this is only possible if there is enough yellow image dye present to allow the appropriate reduction to be made in its amount, but for most colours this is the case. Corrections for other unwanted absorptions can be made in a similar way.

Interimage effects may be present whenever different development rates occur in adjacent layers. This can happen in several ways. For instance, as a developer penetrates a multilayer material, it will normally be partially exhausted by the time it reaches the bottom layer. Hence, if the development is not carried out to completion in all layers, in order to achieve a matched gray scale, it may be necessary to make the bottom layer faster or of higher contrast. When only the bottom layer is exposed (in the case of a saturated red colour for materials with the conventional layer order), however, the developer will not be partially exhausted on reaching the bottom layer because no development will have occurred in the upper two layers. Hence, the speed or contrast of the cyan image will be greater in reds than in grays, and this can be made to correct for the unwanted red absorption of magenta-image dyes, thus making reds lighter than they would otherwise be.

Interimage effects in a multilayer material can also be caused by the degree of development in one layer being affected by the release from a neighbouring layer of development-inhibiting agents. These agents can be bromide or iodide ions or special inhibitors released by developer-inhibitor-releasing (DIR) couplers.

Interimage effects that affect colour reproduction adversely can also occur. For instance, if some oxidized developing agent wandered from one layer to another in a coupler-incorporated material, dye of the wrong colour would be formed and the colour reproduction distorted. This type of contamination is usually minimized by having thin interlayers between the image-forming layers of multilayer materials, and these interlayers may contain chemicals that absorb or immobilize any oxidized developing agent that reaches them. Another adverse effect occurs if development in an unexposed layer occurs because an adjacent layer is very highly exposed. This type of effect has to be avoided by choosing emulsions that are as insensitive as possible to fogging as a result of vigorous development in an adjacent layer.

COLOUR QUALITY Enough has been said to show that there are fundamental limitations to the fidelity of

colour reproduction by subtractive photographic means. Because of the unwanted retinal stimulations, some colours are outside the gamut that can be matched by the dyes available, and all colours, whether matchable or not, may be reproduced to some extent erroneously because of the impossibility of incorporating negative lobes in the spectral sensitivities of the three layers. Furthermore, the unwanted absorptions of the dyes reduce the reproducible colour gamut and darken the colours unless corrections are made.

Real dyes have slightly larger chromaticity gamuts than block dyes, however. The shifting of the spectral sensitivities of the red and blue layers toward the ends of the spectrum, and narrowing that of the green layer, produces some compensation for the absence of the negative lobes for most colours; the unwanted absorptions of the cyan, magenta, and yellow dyes can be corrected by using coloured couplers and interimage effects. In consequence, the practical results achieved usually show errors in colour reproduction that are fully tolerable except for a few special colours, and the pictorial effects obtainable can be, and often are, extremely pleasing.

Books: Hunt, R. W. G., *The Reproduction of Colour*, 4th edition. New York: Van Nostrand Reinhold, and Surbiton, England: Fountain Press, 1987.

COLOUR PHOTOGRAPHY, HISTORY
The history of colour photography follows three strands. The first concerns the attempts made to reproduce the same spectral distributions of light in the reproduction as in the original scene. The second concerns the synthesis of colours in pictures by means of additive mixtures of separate red, green, and blue beams of light. The third concerns the use of cyan, magenta, and yellow colourants in a single beam of white light, the so-called subtractive systems. The first strand had the earliest beginning and the third strand is of by far the greatest current interest, but there is a considerable overlap in the periods during which the three strands have been active.

SPECTRAL COLOUR PHOTOGRAPHY To reproduce the same spectral distributions of light in the picture as in the original was an early goal in colour photography. As long ago as 1810, Johann Seebeck and others knew that if a spectrum were allowed to fall on moist silver chloride paper some of its colours were recorded, although the images soon faded, so that no permanent record was achieved.

An explanation for this phenomenon was given by Wilhelm Zenker in 1868. He reasoned that when light was incident on the layer of silver chloride, it passed through the layer and was then reflected back by the white paper on which the light-sensitive material was coated. This caused the formation of standing waves. At the nodes, the forward and backward beams cancelled each other, but at

the antinodes they supplemented each other. At these points the light intensity became sufficient to cause photo-chemical decomposition of the silver chloride. Hence, through the depth of the layer, there were formed laminae of silver whose distances apart were half the wavelength of the incident light. The laminae served as interference gratings for any subsequent light incident upon them, and these gratings resulted in the wave pattern of the original being reproduced.

The Lippmann Method In 1890 Otto Werner pointed out that it should be possible to replace the silver chloride layer with a fine grain photographic emulsion. Gabriel Lippmann did this in 1891, using a layer of mercury in contact with the emulsion to provide the backward travel-ing beam of light. He also obtained permanent images by fixing them with hypo in the conventional way.

Many colour photographs were produced by the Lippmann method in the following decade, and examples can be seen in photographic museums, testifying to the excellent permanence that was achieved. That the colours were indeed formed by interference has been demon-strated by cutting cross sections through the films and examining them under a microscope. In areas exposed by saturated light, distinct laminae were always present, but, in areas exposed by white light, the image was always more diffuse in depth. Where laminae were present, they were typically between four and eight in number.

Although quite elegant, the Lippmann method has not survived as a successful process for the following reasons. First, in order to resolve the laminae, which were only separated by half the wavelength of the exposing light, it was necessary to use extremely fine grain photographic emulsions, and these are of very low speed. Consequently, exposures of at least several minutes were necessary even in bright sunlight. Second, the use of mercury in the camera was a hazard both to the emulsion and to the photographer and it made the camera unwieldy. Third, because the picture had to be viewed by reflected light, it could not easily be projected, and it was too dark and too restricted in angle of view to be considered a reflection print.

The Micro-Dispersion Method An alternative method of reproducing the spectral distributions of the colours in the original is to disperse them through a prism. In this microdispersion method, the light from the lens in the camera is imaged on a coarse grating having about 300 slits per inch (12 per millimeter), separated by rather wider opaque interstices. The light that passes through the slits is then dispersed by a prism having a narrow angle of only 2 or 3 degrees. A lens then forms images of the slits on a suitable photographic material, but because of the prism, the light from each slit is spread out into a small spectrum. In this way recordings are made of the spectral composi-tion of the light from each point along each slit. The

photographic material is then processed to give a positive, repositioned in exactly the same place in the camera as when it was exposed, and white light is then passed back through the apparatus. Of the light that emanates from any point on the processed material, only that of the same wavelength as made the exposure at that point is able to retrace its path through the apparatus and emerge at the other end; all other light is blocked by the opaque interstices of the grating. In this way the spectral composition of the reproduction is the same as that of the original at each point in the picture. The method was developed by F. W. Lanchester in 1895.

The micro-dispersion method was not successful for the following reasons. First, very fine grain photographic material had to be used in order to record the very small spectra, and hence, as with the Lippmann method, long exposures were required even in strong lighting. Second, the grating reduced the resolution of the picture. Third, the photographic material had to be precisely registered in exactly the same position after processing. Fourth, the necessity for the prism and lens system, required to form the spectra, resulted in a very unwieldy camera.

ADDITIVE COLOUR PHOTOGRAPHY The idea that colour had some sort of a triple nature gradually became established in the eighteenth century, and by 1807 Thomas Young had correctly ascribed this to the light-sensitive properties of the eye. James Clerk Maxwell decided to use a photographic demonstration to illustrate the trichromacy of colour vision in a Friday Evening Discourse at the Royal Institution, in London, in 1861. The experimental work was done by Thomas Sutton, a prominent photographer of that time.

Maxwell's Demonstration The subject matter of Maxwell's demonstration was a tartan ribbon. Three photographs were taken of the ribbon, one through a red filter, one through a green filter, and one through a blue filter (a fourth was also taken through a yellow filter but was not used in the demonstration). A positive was made from the picture taken through the red filter, and it was then projected through a red filter on to a white screen. Similarly, positives from the negatives taken through the green and blue filters were projected through green and blue filters, respectively. The three projected images were positioned in register, and the result was the first trichromatic colour photograph.

Although the quality of the picture obtained was apparently not very good, the principle demonstrated was basic to all modern forms of colour reproduction, whether in photography, television, or printing.

One of the strange things about Maxwell's demonstration is that it was done at a time when the photographic materials available were only sensitive to blue light. This apparent anomaly remained unexplained for a hundred years. In 1961 Ralph M. Evans reconstructed Maxwell's

experiment and found that his green filter transmitted just enough blue-green light to make an exposure possible, and that the red filter transmitted ultraviolet radiation to which the photographic material was also sensitive. The three negatives were therefore exposed not to red, green, and blue light, but to blue-green and blue light and to ultraviolet radiation. The use of blue-green instead of green would not have vitiated the demonstration entirely, but the use of ultraviolet instead of red would at first sight seem to be disastrous. Evans drew attention to the fact that many red fabrics also reflect light in the ultraviolet, so that, by using a tartan bow as the subject, a colour reproduction was produced that was evidently sufficiently realistic to serve as a demonstration of the trichromacy of vision, which was Maxwell's objective.

Sensitizing Dyes It is clear from the above discussion that proper colour photography requires photographic materials that are sensitive to the greenish and reddish parts of the spectrum. In addition to the bluish part to which they naturally respond. Sensitivity to parts of the spectrum in addition to blue is obtained by the use of *sensitizing dyes* discovered by Hermann Wilhelm Vogel in 1873 for green light and in 1884 for orange light; the extension of the sensitivity to red light was achieved in the early years of the twentieth century. (Materials sensitized to green and orange were used for the Lippmann and microdispersion methods of colour photography described earlier.)

One-Shot Cameras Maxwell's method, involving three successive exposures through different filters and projection from three projectors in register, is inconvenient, and much ingenuity has been used to find better ways of carrying out additive trichromatic colour photography. Many different workers were involved, among whom Louis Ducos du Hauron and Frederic E. Ives were particularly prominent.

One way of simplifying the exposing step was to use a one-shot camera. In this device, after passing through the lens, the light was divided into three beams by semi-reflecting mirrors and focused on to three different pieces of photographic material, a red filter being used in one beam, a green filter in another, and a blue filter in the third. Similar devices, sometimes known as *Kromskops*, were also made for viewing the three positive images, by superimposing their virtual images seen in the semi-reflecting mirrors.

Mosaic Processes An alternative method was to cover the photographic material with a fine mosaic of small areas of red, green, and blue filters. The red, green, and blue records were then made on neighbouring areas of the same piece of photographic material, processed to a positive, and viewed at a sufficient distance for the red, green, and blue light from the small areas to blend together just as effectively as in triple projection. The

success of this method depends on the fact that the eye has only a limited resolution, determined by the optical properties of its lens system and by the finite size of the cones in the retina. The majority of modern colour television display devices depend on this same principle, the small areas in this case being occupied by phosphors that emit either red, green, or blue light when irradiated with electrons.

One of the earliest, and most successful, of the mosaic additive colour photographic processes was developed by the brothers Auguste and Louis Lumiere, and called Autochrome. It was introduced in 1907 and was still being sold in the early 1930s. It used a random mosaic of dyed starch grains to provide the filtration.

Another mosaic process that had a long life was the Dufay system, which was introduced in 1908 and was still being sold in the 1940s. It used a regular mosaic of rectangles of red, green, and blue areas.

The most recent examples of additive mosaic photographic processes are those introduced by Polaroid in 1977 (Polavision for movies) and 1983 (Polachrome for slides). These processes used a regular arrangement of red, green, and blue stripes, there being the astonishingly high number of about 60 triads of stripes per millimeter.

Lenticular Processes Another system of additive colour photography that met with some success, especially for cinematography, was the lenticular process. In this process the lens is covered by stripes of red, green, and blue filters. The film base has furrows, or lenticulations, embossed on one side, and the emulsion is coated on the other (smooth) side. The film is exposed in the camera through the base, and the lenticulations form, on the emulsion, images of the stripes of filter on the camera lens. The red, green, and blue records are therefore exposed on neighbouring strips of the film. The film is processed to a positive and projected with its lenticulated base toward the lens, which has a similar set of stripes of filter over it; this ensures that light transmitted by the area of the film exposed originally to red light passes through the red filter on the projection lens, and similarly for green and blue.

The lenticular system was invented by R. Berthon in 1909, developed by A. Keller-Dorian, and demonstrated as the Keller-Dorian Berthon process in 1923. In 1928 Kodak introduced a lenticular process for 16-mm movies called Kodacolour, which lasted until 1937. It used 22 lenticulations per millimeter.

SUBTRACTIVE COLOUR PHOTOGRAPHY The history of subtractive reproductions goes back to times before the invention of photography. For example, in 1722 Jakob Christoffel LeBlon was using a form of three-colour printing. The main credit for introducing the idea of subtractive colour photography, however, must go to Louis Ducos du Hauron, who described it in some detail

in 1868. The principle, which du Hauron had clearly grasped, is to modulate the reddish, greenish, and bluish thirds of the spectrum in a beam of white light by varying the amounts of a cyan (red-absorbing) dye, a magenta (green-absorbing) dye, and a yellow (blue-absorbing) dye.

Assembly and Transfer Processes Initially the red, green, and blue records were still obtained by making successive exposures or by using a one-shot camera. From these records, images in cyan dye were made from the red record, in magenta dye from the green record, and in yellow dye from the blue record. These three dye images then had to be assembled in register to make the final picture. Many methods for forming the dye images and assembling them in register were tried, with varying degrees of merit, but only two achieved appreciable commercial success: Carbro and Technicolor. Both processes ran for many years and only became obsolete when integral tripack materials became available.

In the Carbro process, gelatin layers were used in which the hardness of the gelatin could be made to depend on exposure to light or on contact with a silver image. On washing such exposed gelatin layers with hot water, the unhardened gelatin was removed, leaving the hardened gelatin as a relief (in-depth) image that could be dyed cyan, magenta, or yellow. The gelatin layers were then assembled by superimposing them in succession on a suitable support.

In the Technicolor process, gelatin relief images were also made and dyed, but instead of assembling the gelatin images, the dyes were transferred in succession to a suitable receiving material. One important advantage of such a *dye transfer*, or *imbibition* process is that the gelatin images can be redyed and used to make further copies; this was the way in which many copies of films were made by the Technicolor process. The Technicolor process also used a rather unusual form of one-shot camera. After passing through the lens the light was split by a prism into a green beam and a red plus blue beam; a single film was used to record the green record from the green beam, but the red plus blue beam was imaged onto a sandwich of a blue-sensitive film and a red-sensitive film. The blue-sensitive film was exposed through its base and incorporated a yellow filter to prevent blue light from exposing the other film in the sandwich. An imbibition process similar to Technicolor but for making reflection prints is the Kodak dye transfer process.

Integral Tripacks The Technicolor camera used a sandwich of two films, and attempts had also been made to use sandwiches of three films together. With three films, however, it is impossible to get all three emulsion layers in close proximity, and the presence of the thickness of a film base between some of the images made such tripacks impracticable because of the unsharpness of the resulting pictures.

The way to overcome this problem of getting three emulsion layers in intimate contact was foreseen by du Hauron as long ago as 1895; what was required was to coat at least two of the emulsions on top of one another on the same support. Karl Schinzel, in 1905, first proposed coating, on the same support, first a red-sensitive layer, then a green-sensitive layer, and then a blue-sensitive layer. It was in 1912, however, that the most complete description was first published of what has now become known as the *integral tripack*, which is used for the vast majority of all colour photography today. It was given in a patent granted to Rudolph Fischer, which contained the following statement: "Three positives may be obtained in one operation by the use of three superposed emulsion layers sensitized for the particular colours, and in which the substances necessary for the formation of the colours are incorporated. Intermediate colourless insulating layers are preferably used to prevent diffusion of the colours, and a yellow filter layer is used to reduce the sensitiveness to blue of the red and green layers." Fischer thus gave a full description of the integral tripack, including the yellow filter layer and the incorporation of *couplers*; he also described how the couplers should form dye images by combining with oxidized developer in proportion to the amount of silver developed. Current practice uses one of the two types of developing agents, and two of the five types of image dyes, described by Fischer.

Kodachrome The stage was set in 1912 for the integral tripack as we know it today. More than 20 years were to pass, however, before a successful integral tripack was produced. Among the difficulties that prevented earlier success was the tendency for sensitizing dyes, couplers, and other components to wander from one layer to another, thus spoiling the results.

It was left to two professional musicians, the pianist Leopold Mannes and the violinist Leopold Godowsky, Jr., to lead the way in finding solutions to these problems. Working at first in New York City as amateur hobbyists, in 1922 they caught the attention of C. E. Kenneth Mees, the Director of Research of the Eastman Kodak Company, who provided experimental coatings for their work. In 1928 the Kodak Research Laboratories discovered sensitizing dyes that were less prone to wander from one layer to another, and in 1930 Mannes and Godowsky moved to the Kodak Research Laboratories in Rochester, New York.

The problem of finding couplers that would not wander from one layer to another had still not been solved, so the first commercially successful integral tripack, Kodachrome film, did not incorporate the couplers in the layers but used them in three separate colour developers. The initial Kodachrome process was quite complicated. After developing negative images in all three layers, the remaining silver halide was developed in the presence of

a cyan coupler in the developing solution to form cyan dye in all three image layers. The cyan images in the top two image layers were then bleached, and the silver halide in these top two layers was redeveloped to form magenta dye images. After bleaching the magenta image in the top layer, this was then redeveloped to form a yellow dye image.

By 1938 sensitizing dyes had been discovered that did not wander from one layer to another, even when the film was being processed in aqueous solutions. It then became possible to form the dye images separately in the three layers and avoid the difficult dye-bleaching steps. In the revised process, after developing the negative images in all three layers, the film was exposed to red light through the have and then developed in the presence of a cyan-forming coupler; the cyan image was thus formed in the bottom layer only. The film was then exposed to blue light from the top and redeveloped in the presence of a yellow-forming coupler; the yellow image was thus formed in the top layer only. Finally, the film was developed in a fogging developer in the presence of a magenta-forming coupler; the magenta image was thus formed in the other image layer only. The Kodachrome process has remained basically the same ever since. The new process was not only less complicated and less critical to operate but also resulted in dye images of good stability, the original dye images being rather fugitive.

Agfacolor Meanwhile, in Germany, the problem of finding couplers that did not wander from one layer to another was being solved by the Agfa Company. Research carried out by G. Williams resulted in the attachment to the coupler molecules of long molecular chains that acted as a ballast and prevented the couplers from wandering. The first film of this type, Agfacolor Neue film, was introduced in 1936. It was thus the first successful reduction to practice of Fischer's 1912 patent. The processing steps in a film with the couplers incorporated are simpler than those for a film in which the couplers are in the developers. With the couplers in the film, only one developer is required for a colour negative image, or two for a reversal positive image.

Kodacolor A different solution to the problem of immobilizing the couplers was adopted by Kodak with the introduction of Kodacolor film, a negative film for making amateur reflection prints. The couplers in this product were dissolved in oily solvents and then dispersed in the form of tiny oily droplets in the emulsion layers. The oxidized developer was able to penetrate the droplets to form the image dyes, but the droplets were not able to move from one layer to another. The negatives obtained on the Kodacolor film were printed onto a similar integral tripack coated on paper to produce the final paper prints.

Ektachrome and Eastman Color Using the same principle of the oily droplets, a reversal film, called

Ektachrome film, was introduced in 1946, and a negative camera film and positive print film, Eastman Color Negative Film and Eastman Color Print Film, for professional motion picture production, were introduced in 1950.

Coloured Couplers The use of cyan, magenta, and yellow dyes twice in the negative-positive systems means that their unwanted absorptions take their toll twice, and the resulting colours can then be quite poor. In 1948 W. T. Hanson of the Eastman Kodak Research Laboratories introduced the concept of *coloured couplers*. By making the magenta-forming coupler have a yellow colour that was gradually reduced as it was used up during development, it was possible to correct for the unwanted absorption of the magenta dye; and by making the cyan-forming coupler have a pink colour that was gradually reduced as it was used up during development, it was possible to correct for the unwanted green and blue absorptions of the cyan dye. The use of coloured couplers was a very important advance in the technology of colour photography, and they are now widely used in the products of many manufacturers.

Printing Colour Negatives The appearance of colour negatives is too unfamiliar for it to be possible to judge by inspection how they should be printed in terms of their density and colour balance, but unless these variables are near optimum, the quality of the final pictures is considerably degraded. In professional work, whether for still photography or for motion picture production, it is often feasible either to make test pictures before making the final print or to use sophisticated control equipment for maintaining good density and colour balance. In the production of large numbers of reflection prints for the amateur market, however, some quick and reasonably reliable means of adjusting the printer setting is required for each negative.

Ralph M. Evans of the Eastman Kodak Company solved this problem in 1946 with the introduction of the principle of *integrating to gray*. In printers that use this principle, the transmittances of each negative to red, green, and blue light are measured, and then the exposures given to the red-, green-, and blue-sensitive layers of the paper are made inversely proportional to the appropriate one of the three transmittances. The effect of this is to make prints whose reflected light approximately integrates to gray. Although this is sometimes not the best thing to do (for instance, if the scene has a large area of blue sky in it, the print will tend to come out too yellow), it has been found that, for most scenes, the integrating to gray principle provides a simple, quick, and reasonably reliable method of making prints, and it has been an indispensable part of the technology that has made the mass production of prints for the amateur market so successful. The yield of good prints can be increased by introducing parameters that modify the integrating to gray principle, and these are used in many modern printers.

Coating Multilayers When integral tripacks were first manufactured, the three emulsion layers, the yellow filter layers, and any other layers required had to be applied one at a time in succession. This was a lengthy procedure that was not easy to control and was costly to operate. In 1955 T. A. Russell, of the Eastman Kodak Research Laboratories, was having difficulty in mixing together two different emulsions before coating. This gave him the idea that perhaps it might be possible to coat the two emulsions on top of one another by extruding them through a double hopper. The idea worked. In fact by incorporating appropriate surface agents, it was possible to coat four or even more layers at the same time. The component emulsions were extruded through hoppers and allowed to slide down a ramp on top of one another until they met the web on which they were to be coated, suction being applied at the coating bead to keep it on the web. It was then found that, using this technique, each emulsion layer could be much thinner than in the old one-at-a-time method, and this resulted in much thinner tripacks and hence considerably sharper pictures. The thinner layers also required less drying capacity in the coating machines, and faster coating was therefore possible. Finally, the application of the emulsions at the same time improved product consistency considerably.

Few inventions have incorporated so many advantages simultaneously as hopper coating did for the manufacture of photographic materials. The method gave pictures that were much sharper, manufacturing costs that were much lower, and products that were much more consistent.

The method was licensed to other photographic manufacturers all over the world, and it has undoubtedly been a major factor in the widespread use of integral tripacks in colour photography.

Image Stability In some of the early systems of subtractive colour photography, the stability of the images was only moderate. In recent years much effort has been spent on improving the stability of dye images for both dark keeping, and exposure to light. This has involved the synthesis of better couplers and the introduction into both the photographic materials and their processes of compounds that act as stabilizing agents. A dark life of 50 years or more and a room life of 10 years or more are now possible.

Dye-Bleach Systems Instead of forming the image dyes by colour development, it is possible to start with the maximum amounts of cyan, magenta and yellow dyes before the exposure is made and then to bleach away the unwanted dye in an image-wise way in each layer. Bela Gaspar developed this type of process in the 1930s. In 1953 Ilford Limited introduced its Ilford Color Print process, which was based on this principle, and it was a commercial success for several years. The CIBA company in Switzerland introduced another dye-bleach process in

1963, called Cibachrome (renamed Ilfochrome), which provides a reversal print system with good dye stability among its virtues.

Instant Colour Photography In 1963 Polaroid introduced its Polacolor system. In this system, a special film is processed within the camera so that the result is available in situ shortly after the exposure has been made. The system is similar to the dye-bleach system, in that maximum levels of cyan, magenta, and yellow dyes are present before the exposure is made, but the exposure, instead of bleaching dye, results in a change in mobility so that the cyan, magenta, and yellow dye images can migrate from their tripack to a receiving sheet. In the original version of this system, the receiving sheet had to be peeled apart from the tripack to obtain the print. In a revised version, introduced in 1972, the receiving sheet is integral with the tripack so that it is not necessary to peel the receiving sheet apart; the image is laterally reversed, however, so that the camera has to have a mirror incorporated in it.

In 1976 Kodak introduced a different system of instant colour photography, but it was withdrawn in 1986 because of patent litigation.

Photographic Speed A characteristic of the history of colour photography has been the steady increase in the photographic speed of colour systems. From the extremely slow Lippmann and micro-dispersion methods to the first integral tripack Kodachrome film, the speed had risen to the point where exposures of 1/50 second at an aperture of f/6.3 were recommended in sunlight. Today films having speeds more than 100 times as fast are available. This has come about as a result of improved methods of sensitizing photographic emulsions, both by means of better chemical sensitizers and also by the use of better sensitizing dyes. More sophisticated coating patterns made possible by the introduction of hopper coating have also played their part. For instance, by coating an emulsion in two parts, a fast layer on top of a slow layer, it has been possible to attain a higher speed for a given granularity than with a single layer. In some products, the fast red layer is coated on top of the slow green layer, and further speed increases can be obtained in this way. The use of tabular-shaped grains that have an increased surface-to-volume ratio has also resulted in increased speed.

There is an ultimate limit to the speed that can be attained in a colour photographic film for a given resolving power, but studies have suggested that existing films are probably short of this limit by a factor of about ten. There should, therefore, be room for further increases in the speed of photographic colour films in the future.

PHOTOGRAPHY AND ELECTRONICS The history of photography has been closely tied to silver halide products. The rise of television has introduced another principle of image capture, the all-electronic

camera. Both systems are confined ultimately by the basic laws of physics that set upper limits for speed, noise or granularity, and resolution. In spite of some confident forecasts in the past that silver halide was doomed to be replaced by electronic cameras, photographic film continues to hold its own, not only in its own fields of amateur and professional still photography and in professional motion picture photography, but also in broadcast television, where film is widely used for program origination. Only in the field of amateur movies has there been a significant move away from silver halide films to electronic cameras.

It seems that there is an inherent convenience and a superb information storage capacity in silver halide films that make it likely that it will still be around for many years to come. Hybrid systems, however, where both film and electronics are used together, can offer advantages over either system on its own, and it seems likely that, in the future, increasing use will be made of such cooperative technology.

Books: Coe, Brian, *Colour Photography*. London: Ash and Grant, 1978; Hunt, R. W. G. *The Reproduction of Colour*. 4th edition. New York: Van Nostrand Reinhold, and Surbiton, England: Fountain Press, 1987.

COLOUR PHOTOGRAPHY: IMAGE STRUCTURE

When a colour photograph is viewed without any magnification, the only structure visible may be that of the subject matter of the picture. If increasing degrees of magnification are introduced, however, it becomes apparent that, just as in the case of black-and-white photography, the image is composed of a granular structure.

MAGNIFICATION If a 35-mm slide is held in the hand and viewed at about 250 mm (10 inches) distance, no granular structure will be visible. In this case, assuming a visual resolution of 20 cycles per degree (objects down to about 1½ minutes of arc in diameter visible), the eye cannot see detail finer than about 5 cycles per millimeter, so that the smallest object visible, which would be half of a light-dark cycle, would be about 1/10 mm in diameter. If however, the slide is projected using a projection lens of 100-mm focal length, the magnification introduced will be 250/100, that is 2½ times, if the screen is viewed from near the projector, or twice this amount, that is 5 times, if the observer is half way between the projector and the screen; the limits of resolution on the slide then become 12½ or 25 cycles per millimeter, respectively. At these magnifications the picture is usually still largely free of granular appearance, but if the magnification is increased much further, some granular structure usually becomes apparent. If the screen is viewed from a distance equal to one-tenth the projector-to-screen distance, so that the magnification is 25 times, then areas that appeared uniform before will appear granular, much less sharp, and

Visual Resolution and Minimum Visible Detail at Different Magnifications

	High-Contrast Object		Low-Contrast Object			
Viewing Situation	Magnification	Cycles per mm[1]	μm^2	Cycles per mm[1]	μm^2	Structure Visible
Naked eye	1	5	100 (0.1 mm)	1	500 (0.5 mm)	None
Projected with 100 mm lens						
At projector	2½	12½	40	2½	200	None
Halfway from screen	5	25	20	5	100	Little or none
One-tenth distance from screen	25	125	4	25	20	Grain clumps
Microscope	250	1250	0.4	250	2	Single grains
Electron microscope	2500	12500	0.04	2500	0.2	Dye droplets

[1]Resolution
[2]Diameter of smallest visible detail

lacking in fine detail. Visual resolution is now down to about 125 cycles per millimeter (so that objects of about 0.004 mm, or 4 micrometers (µm), diameter are visible). If, by using a microscope, the magnification is increased by a further 10 times, to 250 times, the limit of visual resolution is now 1250 cycles per millimeter (0.4 µm objects visible), and the image will appear to consist of small blobs of different colours. A further increase of magnification to about 2500 times, using an electron microscope, so that the limit of resolution is about 12,500 cycles per millimeter (0.04 µm objects visible), might reveal that the blobs themselves consist of clouds of small droplets of dye.

The granular structure of most colour photographic images is caused by their derivation from silver halide photographic emulsions, which are themselves composed of discrete crystals, or *grains* as they are usually called. The average size of these grains varies from about 0.5 µm in diameter for slow emulsions such as are used in print films, up to about 1.5 µm in diameter for fast emulsions such as are used in x-ray films. In any one emulsion the grains usually cover quite a large range of sizes. Because the larger the grain the more light it can absorb in a given time, the range of sizes can be useful in providing grains having a range of sensitivities. This can result in an emulsion that can accommodate a wide range of exposures, that is, one that possesses good *exposure latitude*.

In emulsions used for camera films in colour photography, the mean grain size can be regarded as about 1 µm in diameter. Hence, the 25 times magnification involved in the close inspection of the 35-mm projected slide, with its 4-µm limit in resolution, does not enable the grains to be seen. The reason that the image looks granular at this magnification is that the grains are not present in a regular array but are distributed more or less randomly, and this results in clumps of grains and grain-free areas of much more than 4-µm diameter being present. It is these areas, sometimes extending up to about 40 µm in diameter, that make the pictures appear granular.

The developed silver grains and the undeveloped silver halide grains in colour images are usually all removed in the processing sequences, so that the blobs in the image are small volumes of cyan, magenta, and yellow dyes produced by the colour development step. If the couplers forming these dyes are uniformly dispersed in the emulsion layers or are provided from colour developing solutions, then the small volumes of dye formed around each developed silver grain have only molecular structure, but if the coupler is dispersed in small oil droplets, then the volumes of dye have a substructure of these droplets. These volumes of dye, which can be called colour grains, may be similar in size to, or slightly larger than, those of the silver halide grains. Thus, the separate volumes may

be about 1 μm in diameter (although they occur frequently merged together into larger volumes), but the individual droplets, when present, are usually about 0.1 to 0.2 μm in diameter. It is thus clear why magnifications of 250 times (giving resolution down to 0.4 μm) are necessary to see the colour grains, and 2500 times (giving resolution down to 0.04 μm) are necessary to see the oil droplets. These figures are summarized in the table, where limits for visual resolution are given for high-contrast detail, and also for low-contrast detail for which the resolution is much reduced; the granular structure in film images is often of medium contrast for which figures intermediate between the two sets given in the table will be applicable.

GRAININESS AND GRANULARITY The degree to which the granular structure of a photographic image is apparent to an observer is termed the *graininess*; the physical property of the photographic materials that causes graininess is termed the *granularity*. Graininess is thus a subjective term; granularity is an objective term. At a given magnification, a particular piece of film illuminated in a given manner has an invariant granularity, but its graininess at that magnification may vary according to the conditions of viewing For example, if surrounded by an area of much higher luminance, the graininess may become imperceptible. Graininess is usually objectionable in pictures because it results in uniform areas being reproduced with spurious texture (or motion, in cinematography) and because it results in fine detail being broken up.

In colour images, the total visual graininess is made up of superimposed cyan, magenta, and yellow grain patterns, and it might therefore be thought that the graininess would appear to consist of fluctuations in both brightness and colour. For most applications, however, films are used near enough the threshold of perceptible graininess for the colour fluctuations to be largely unnoticeable. To see colour differences it is necessary for each of the three types of retinal cones to be represented in each elemental area. To see brightness differences it is only necessary for one of the three types of cones to be represented (or, more precisely, any one of two of the three types, since the blue-absorbing cones contribute negligibly to the perception of brightness). Bearing in mind the random distribution of the cones in the retina, this makes the magnification at which luminance differences are visible about four times less than that at which chromaticity differences are visible. It has therefore been found that the graininess of colour films correlates well with just luminance fluctuations.

For black-and-white films, granularity increases with density. For colour films this is not always so. At high densities the dye clouds may merge together so that the granularity decreases.

SHARPNESS The degree to which fine detail and edges in pictures are clearly displayed is referred to as

sharpness. Loss of sharpness can occur as a result of various effects.

First, if the optical image that exposes the photographic material is blurred, then of course the resulting latent image will be unsharp. This blurring can be caused by incorrect focusing of the camera or printer, or by optical aberrations in the lens, or by movement of the image during the exposure, or by the inability of the camera lens to bring objects at different distances all into focus at the same time.

Second, because photographic emulsion layers diffuse the light as it passes through them, even if the optical image were perfectly sharp, the photographic latent image would be less sharp. In multilayer colour films, diffusion of the light by the upper layers often causes the sharpness of the images in the lower layers to be appreciably reduced. Sharpness can be improved by using emulsion layers of low turbidity, especially in the upper layers. Because the magenta image usually affects sharpness most, and the yellow layer least, sharpness can be improved by coating the magenta layer on the top and the yellow layer at the bottom, this can only be done with emulsions with little natural blue sensitivity, such as chlorobromide emulsions, and these are of slower speed, so this layer order can usually only be used for films intended for printing, where high photographic speed is often not important. Diffusion of light in emulsion layers can also be reduced by incorporating absorbing dyes in the layers; as these dyes reduce the speeds of the layers, they too can usually only be used with print films.

Third, when colour images are formed by chemical constituents, produced at the grains, and combining subsequently with couplers to form the dyes, then diffusion of these chemical constituents may result in the photographic image being only diffusely related to the latent image. These diffusion effects can be reduced by adding suitable scavenging compounds to the emulsions.

Fourth, the granular nature of photographic images can reduce their sharpness; however, this is usually only a minor factor compared with those described above.

Books: Hunt, R. W. G., *The Reproduction of Colour*. 4th edition. New York: Van Nostrand Reinhold, and Surbiton, England: Fountain Press, 1987.

COLOUR PHOTOGRAPHY: INSTANT

By processing the photographic material in the camera, it is possible to have a finished picture available within a few minutes of making the exposure. In these *instant* systems, the dyes are not usually formed by colour development but are present in the film as uniform layers before exposure. The result of exposure and processing is then to transfer to another layer different fractions of the dyes in order to form a dye image that is appropriately related to the exposure.

THE POLAROID SYSTEM In the Polaroid system, called *Polacolor* and introduced in 1963, the cyan, magenta, and yellow dye molecules are attached to hydroquinone molecules. After exposure, the material is passed through rollers that break pods of alkaline activator that enables the hydroquinone to develop the exposed silver. This development activity renders the hydroquinone insoluble so that the dyes in developed areas remain *in situ*; where development has not occurred, the dye-hydroquinone compounds can migrate to a receiving sheet where the dye is mordanted to form a permanent image. In the earlier version of the system, the receiving sheet was peeled away from the rest of the materials, but in 1972, a new, integral, version of Polacolor was introduced in which it was not necessary to peel apart the receiving sheet. Because the image in the Polacolor system is viewed from the lens side of the material, it is necessary for Polacolor cameras to incorporate a mirror to avoid lateral reversal of the image.

THE KODAK SYSTEM In the Kodak instant system, which was introduced in 1976, special emulsions are used that can be processed to give positive images by development of the unexposed areas instead of the exposed areas. In the unexposed areas the developing agent is oxidized, and this renders incorporated cyan, magenta, and yellow dyes diffusible; the dyes then diffuse to a receiving layer, where they are mordanted to give a permanent image. In the Kodak system the image is viewed from the nonlens side and, hence, no mirror is necessary to avoid lateral reversal (although some cameras using this system incorporated a pair of mirrors to make the cameras more compact). The Kodak system was withdrawn from the market in 1986 as a result of patent litigation.

ADDITIVE INSTANT SYSTEMS Rapid processing of black-and-white emulsions coated beneath a mosaic of red, green, and blue filter areas can also result in systems in which the final image is available a few minutes after exposure. Polaroid introduced such a system for instant movies in 1977 called *Polavision*, and a similar system for instant slides in 1983, called *Polachrome*. These systems use triads of red, green, and blue filter stripes, having the remarkably small size of 60 triads per millimeter.

CHARACTERISTICS OF INSTANT SYSTEMS To have the image available within a few minutes of the exposure is an important advantage in many applications, such as instrument recording, microscopy, and other scientific work. For more general applications, instant systems have several disadvantages. First, the instant picture is the same size as the camera frame, so that the absence of an enlarging step results in a compromise between having either small prints or large cameras. Second, the technology needed to achieve the instant feature of the systems generally results in the photographic speed, sharpness, and colour rendering being inferior to that obtainable in

conventional colour photography. Third, the cost per picture is generally higher than for conventional systems. Fourth, in amateur photography, the accumulation of prints while photographing can be inconvenient, and a delay before seeing the pictures can actually heighten the sense of reliving an occasion that is part of the fascination of photography. Fifth, conveniently located one-hour or less colour processing labs are readily available. These disadvantages have resulted in only a limited use of the instant systems for amateur photography.

Books: Hunt, R. W. G., *The Reproduction of Colour*. 4th edition. New York: Van Nostrand Reinhold, and Surbiton, England: Fountain Press, 1987.

COLOUR POSITIVE A colour image in which the tones and the colours are all reproduced naturally, as distinct from a colour negative in which the tones and the colours are all reversed (whites becoming blacks, blacks becoming whites, yellows becoming blues, etc.).

COLOUR PRINT FILM Photosensitive material on a flexible, transparent support for making colour transparencies from colour negatives by projection or contact printing. There are no masking dyes in colour print films.

COLOUR PROCESSING Development of silver images is a common denominator in the production of colour images by photographic means. In some cases, such as in additive systems, simple silver images modulate the red, green, and blue light reaching the viewer. Development of silver is also associated with colour image formation with subtractive systems, even though very little is left after the process has been completed. In all of the processes, various secondary processing steps, such as stop baths, fixers, and bleaches, are involved.

SUBTRACTIVE COLOUR PROCESSES

Dye Transfer The dye transfer printing process uses gelatin matrices produced by developing films coated with a simple emulsion in a tanning black-and-white developer such as pyro. After fixing, the undeveloped, untanned part of the emulsion is washed away with hot water, leaving a tanned relief positive that is immersed for a time in the appropriate dye solution. When rolled into contact with a paper receiver, the image is transferred. A complete subtractive colour image results from the transfer in register of matrices dyed with cyan, magenta, and yellow dyes corresponding to negatives exposed with red, green, and blue filters.

Transparency subtractive colour photography systems make use of an integral tripack of emulsions balanced to record the red, green, and blue images. A blue-absorbing filter layer beneath the blue-sensitive layer prevents blue light from being recorded in the green- and red-recording layers which retain blue sensitivity. After exposure, simple

negative development produces a silver image in each of the layers. A second colour-forming development of the remaining undeveloped emulsions produces cyan, magenta, and yellow dye images that control the red, green, and blue light reaching the observer. A silver bleach then removes the silver in the original negative, as well as any formed with colour development, leaving the positive dye images.

Kodachrome The Kodachrome process starts with a black-and-white negative first development of all three of the exposed emulsion layers. The bottom, red-sensitive layer is then exposed to red light, followed by a colour-forming development that produces a cyan image. The top blue-sensitive layer is then exposed to blue light and the film is developed in a developer that produces a yellow dye image. The film is then processed in a fogging developer that forms a magenta image in the remaining green-sensitive layer. After bleaching to remove the silver, the yellow, magenta, and cyan dye images are left for viewing.

Negative Incorporated-Coupler Films Subtractive colour negative processes use a developer that forms dyes corresponding to the three image layers, at the same time that silver images are formed. After the silver is removed by bleaching and fixing, the three integral dye images are available for printing on a positive three-colour emulsion system. These negative films also incorporate preexisting coloured masking dyes that are destroyed in proportion to the amount of negative development taking place. The parts that remain of these incorporated dye images produce dye masks that correct for the unwanted absorptions of the image dyes that are formed.

Reversal Incorporated Coupler Films Subtractive colour reversal films that can be processed by the user, such as Kodak Ektachrome films, go through two development steps. The first development produces a negative silver image in each of the three emulsion layers. The remaining unexposed and undeveloped silver halide grains are then fogged and developed in a developer that forms a positive silver image and a positive dye image in each emulsion layer. The negative and positive silver images are removed by bleaching, leaving the cyan, magenta, and yellow dye images.

Colour Printing Processes Reversal and negative colour printing processes using red-, green-, and blue-sensitive layers are processed in a fashion similar to those used for colour films. With print materials on an opaque base for viewing by reflected light, each layer absorbs light twice, once when light enters the image, and a second time when it exits after being reflected from the base. Thus, the emulsion layers need to be only half as thick as those on transparency films, permitting more efficient transfer of the processing solutions.

Dye-bleach reversal colour printing materials such as Cibachrome (Ilfochrome) are made with emulsions

containing cyan, magenta, and yellow dyes of a strength equal to or greater than that of the maximum density of the final image. Black-and-white development is employed to produce a negative silver image. This is then treated in a low pH bleach that destroys the dyes in proportion to the amount of silver that was formed and removed, thus leaving a positive image.

Books: Current, Ira, *Photographic Color Printing, Theory and Technique*. Boston: Focal Press, 1987; Krause, Peter, and Shull, Henry, *Complete Guide to Cibachrome Printing*. Tucson: H. P Books, 1982; Stroebel, Leslie, Compton, John, Current, Ira, and Zakia, Richard, *Basic Photographic Materials and Processes*. Boston: Focal Press, 1990; Stroebel, Leslie, Compton, John, Current, Ira, Zakia, Richard, *Photographic Materials and Processes*. Boston: Focal Press, 1986.

COLOUR REVERSAL FILM Photosensitive material on a flexible, transparent support that reproduces the tones and colours of the original scene in their correct relationships. The term seems contradictory, however, in that nothing is reversed. All the early photographic processes were negative-working; thus, a process that "reversed" the negative to produce a positive was called a reversal process, and films specially designed for such came to be called reversal films.

Syn.: *Colour transparency film.*

COLOUR SENSITIVITY The measurement of the response of a colour photographic material to the various wavelengths of energy in the visible part of the spectrum. One method of measurement involves the use of a wedge spectrograph. More reliable data can be obtained with a monochromatic sensitometer, which exposes the sample to carefully monitored amounts of narrow-band radiation and provides the data needed for constructing a characteristic (D-log H) curve for each tested wavelength.

The term *spectral sensitivity* involves similar measurements, including exposure to invisible radiation, such as ultraviolet and infrared.

COLOUR SENSITOMETRY Colour sensitometry is the technology of measuring the response of colour photographic materials to exposure and processing. The requirements for such a procedure are more severe than for black-and-white materials because colour photography involves at least three emulsion layers and because the processing consists of several additional stages.

The aims of colour sensitometry vary with the questions to be answered. In manufacturing, some of the questions are: Does this product meet specifications? Is a presumed better product indeed better? Questions for the processor are: Is the process stable? Does the system conform to specifications? Finally, the consumer of the colour material

is interested primarily in the appearance of the image and cares little about the process by which the image is generated. Sensitometric test methods will therefore vary with the data required to answer the appropriate questions.

EXPOSURE Sensitometers that are adequate for exposing black-and-white materials may need modification for use with colour materials. The light-source-filter combination of a 2850 K tungsten lamp and a gelatin Wratten 78 AA filter, although a sufficient match for standard daylight for black-and-white film, is inadequate for testing colour films. More appropriate filters for use with a tungsten lamp are (1) Corning glass 5900 and (2) Davis-Gibson liquid filters. These are more stable with use than gelatin filters but may show changes in absorption with temperature.

Practical tests are needed for colour films that are to be used with fluorescent lamps or with speedflash, since the spectral characteristics of these sources can hardly be matched by any tungsten-lamp-filter combination.

If only a single emulsion layer of a colour material is to be exposed, very narrow-band filters, such as interference filters, are needed. With their use, exposure times will be quite long and thus remote from practice.

Reciprocity effects are serious problems with colour materials because the emulsion layers vary in their responses to changed exposure times. For this reason, the exposure time used in the sensitometer must closely correspond to that used in practice. For slow colour materials, the illuminance at the test sample must be very high, and the light source in the sensitometer may need to be redesigned.

Testing a colour film or paper only to white light exposures gives little information about the ability of the material to simulate the many different colours of a typical scene. One technique involves the use of a real subject as input, but visual examination of the resulting image is difficult to interpret. An alternative method uses a Macbeth ColorChecker, which approximates real colours, such as skin tones, blue sky, and foliage. The image may be measured under standard viewing conditions for fidelity to the original.

Filters used to adjust sensitometric light levels must be neutral in their absorption of different wavelengths. Gelatin filters absorb short wavelengths more than longer ones and therefore should be replaced by carbon or inconel filters. For the same reason, silver step tablets are reasonably satisfactory for producing different levels of exposure, but ones made of carbon are more nearly neutral.

PROCESSING Development of colour images is complex, involving several stages. Development by-products diffuse not only laterally but also from one emulsion layer to the others, giving rise to vertical adjacency effects that alter the image. Processing solutions

need to be mixed with great care and stored under controlled conditions to avoid deterioration.

Agitation during processing presents particularly difficult problems. It is essential that sensitometric processing be checked to avoid even minor changes in the effectiveness of agitation and that the processing conform to practice at each stage of the process, not simply over all.

When exposed sensitometric strips are supplied by a manufacturer of colour films to be used in monitoring processing, the strips must be stored in a frozen condition to avoid unwanted changes with time. When they are used to check a processing system, undesirable results merely indicate that a change has occurred in the process and do not indicate the nature of the change or the source of the error.

MEASUREMENT Densitometers suitable for measurement of colour images must have a stable light source that produces sufficient energy in the blue, green, and red portions of the visible spectrum. Infrared radiation must be removed by an appropriate filter to avoid instrument instability.

Filters are used to isolate spectral regions. For many colour measurements, Wratten 92, 93, and 94 filters are often used. Such filters need to be checked periodically because they may change in absorption characteristics with time.

Stable colour check plaques should be used to determine densitometer error and instability. Twice-daily measurements of the plaques, plotted on a control chart, assist in identifying densitometer variability and error.

Colour images, because they consist of dyes, scatter less light when they are measured than do particulate silver images. For this reason, optical problems typical of black-and-white samples are less severe for colour dye images. Complications found in the measurement of dye images, however, arise from the spectral absorption of the dye layers. Every dye has significant unwanted absorption for wavelengths other than those it is intended to absorb. For this reason, every measurement of an area of a colour film is affected simultaneously by all three dyes, as well as by fog or steam.

Colour densities are basically of two types: (1) integral and (2) analytical. Integral densities are measures of the absorption of the three superimposed dye layers. Analytical densities are intended to estimate the effect of a single dye layer and are found by physically or optically separating the layers. Analytical densities are most often needed by the manufacturer of the material and are rarely needed by the user.

Integral densities are of several types: (1) spectral, which indicate the absorption of energy wavelength by wavelength; (2) printing, which indicate the effect of the sample when used with a specific printer and printing material; (3) visual, indicating the effect on a human

observer; and (4) three-filter, used ordinarily to discover whether or not a sample matches a standard.

DATA ANALYSIS Because each patch of a processed sensitometric strip will have been measured separately with blue, green, and red light, the presentation of the results will involve three characteristic curves. Although the test samples may be visually neutral, the three curves will not exactly coincide, even for a correctly exposed and processed test sample.

If, however, for example, the blue-density curve has higher densities throughout than the green-density and the red-density curves, the inference is that the image is yellowish, indicating an excess of yellow dye—the one that is sensitive to blue light in the original exposure. Such an excess could result from incorrect manufacturing or from a faulty light source.

Although the reproduction of neutrals by a colour photographic material is important, no colour material can reproduce all grays—including whites and blacks—perfectly. Furthermore, correct reproduction of neutrals does not ensure excellence of other colours. If departure from neutrality is consistent throughout the scale, correction is possible by the use of a corrective filter in future exposures of the material. If, however, the hue shifts with the colour lightness, this is an indication of a crossover of the characteristic curves of the film or paper, and no exposure correction is possible.

COLOUR SEPARATION (1) The process of obtaining three (or more) monochrome images from a colour image or from a colour scene. Such images are used to produce printing surfaces. (2) One of the monochrome images obtained in (1).

COLOUR SLIDE FILM A colour transparency roll film in a small format intended for projection, usually 35-mm or square 120 size.

COMPOUND See *Chemical compound*.

CONCENTRATION The concentration, or amount of a chemical dissolved in a liquid, can be expressed as grams of solid dissolved in a litre of liquid (weight per volume), as grams of solid in grams of liquid (weight per weight), as volume of liquid in a volume of liquid (volume per volume), or percentage solutions (parts per hundred). Avoirdupois measures may be used in place of the metric weights and volumes.

CONDENSATION The process whereby water vapour from the air gives up its heat of vapourization and forms droplets of liquid water. This process occurs whenever air containing a sufficient amount of water vapour is cooled sufficiently (to a temperature below the

dewpoint). Condensation can be very troublesome on film and photographic and electronic equipment that is brought from a cold environment into a relatively warm or humid environment. The liquid water that forms on surfaces can interfere with the operation of film, lenses, mechanical equipment, and electronic circuits. Condensation of this type can be avoided by warming the equipment to a temperature higher than the dewpoint of the environment the equipment is about to enter. If condensation occurs, it can be removed by gradually heating the equipment in a safe manner. It is important to remember that the liquid water will have to reabsorb its heat of vapourization to vapourize; moderate warmth over a period of time is more effective than strong heat. Dehumidifiers are effective at lowering the dewpoints of areas where condensation is a particular problem. Fog is a result of condensation occurring in the air. Condensation occurs on surfaces more easily, however, because of surface tension effects.

CONDUCTION BAND The lowest-energy band of a crystal that is either partially filled with electrons or is empty. Is degree of occupancy determines whether the material is an insulator or a conductor. Because it is only, at most, partially filled, the electrons in this band are free to move around the crystal and are able to "conduct" electrical current.

CONTAMINANTS Photographic processing materials must be guarded to prevent environmental contamination. Dust and other aerial pollution is a major photographic contaminant. Dust must be kept off the surface of films and papers from exposure through processing and drying, and even in storage. Water often contains particles, organic matter, and a variety of other contaminants that may embed in soft emulsion layers during processing and washing of films and papers. Poor laboratory technique in weighing and handling of photographic chemicals can cause insidious and persistent chemical effects, such as emulsion fogging, that can make darkrooms unsuitable for photographic processing.

CONTAMINATION CONTROL The air and the water are two major sources of contaminants in photography. Filtration of the air and water, plus dust control in photographic work areas, will do much to control or avoid problems caused by physical contamination. Even so, filtering photographic solutions just before use will add an extra measure of prevention. Cleanliness in the darkroom is a necessary practice to prevent chemical contamination. Some chemicals are fogging agents and can easily be transferred by human hands to photographic emulsion layers. High humidities in work and storage areas should be avoided as moisture stimulates biological growth.

CONTAMINATION, PHYSICAL Physical contamination results when some foreign material is allowed to collect on the surfaces of negatives or prints before, during, or after processing. These contaminants can include sludges and scum from wetting agents, aluminium or calcium precipitates, iron or rust, ink or paint, organic material such as biological growths, and dust. Filtering of water and processing solutions, replacement and maintenance of rinses, removal of excess water before drying, filtering of drying air, and care in handling material at all stages can generally prevent contamination.

CONTRAST The variation between two or more parts of an object or image with respect to any of various attributes such as luminance, density, colour, or size. Examples of subjective descriptions of contrast include low contrast (or flat), high contrast (or contrasty), and normal contrast, terms that are variously applied to photographic subjects, lighting, film, developer, printing paper, and prints. Examples of objective measurements of contrast include a 3:1 lighting ratio, a 160:1 scene luminance ratio, a 3.0 log exposure range, and a print density range of 2.0. Ratios with conventional numbers correspond to differences when the numbers are converted to logarithms, so that a luminous ratio of 100:1 corresponds to a log luminance range of 2.0 (2.0-0.0). Other measures of tonal contrast include gamma and contrast index, which are based on the slopes of straight lines on D-log H graphs, where a value of 1.0 represents the slope of a line at an angle of 45 degrees to a horizontal line.

We should make a distinction between local contrast and overall contrast in photographic images. In terms of the characteristic curve of a printing paper, the local contrast varies for subject tones represented on the straight line and on different parts of the toe and the shoulder, which correspond to the middle, highlight, and shadow subject tones, respectively. This difference is especially pronounced in prints that are commonly described as being too contrasty. In such a print the middle tones are contrasty but the lightest highlight and darkest shadow areas typically have no detail and therefore no local contrast.

The perceived contrast of a given photograph can change dramatically with changes in viewing conditions. It is well known that a print appears darker when it is viewed with a white surround than with a black surround, a perceptual effect known as *simultaneous contrast*, and also when it is viewed under a low level of illuminance, with corresponding changes in local or overall contrast. The contrast of a colour transparency appears to be much higher when it is viewed by transmitted light in an otherwise darkened room than when the room lights are on or the area around the transparency on the illuminator is not

masked off, due to simultaneous contrast and the effects of flare with a light surround.

CONTRAST CONTROL There are a number of ways of altering tonal contrast when photographing a subject, including changing the lighting on the subject. In studio situations, a fill light is commonly used near the camera to lighten shadows created by a main light. A lighting ratio of 3:1 is considered appropriate for most formal portraits, for example, but higher and lower ratios are used for different effects. Outdoors there is less control, but electronic flash can be used to reduce the lighting ratio by filling in shadows created by direct sunlight for subjects that are relatively close. For more distant subjects, such as landscapes and buildings, it may be necessary to select a different time of the day, or a day on which the weather conditions are different to obtain a less contrasty lighting effect.

FILM AND PROCESSING The contrast of black-and-white negatives made on general-purpose film can be altered within limits by the choice of developer and the time, temperature, and agitation of development. The degree of development, which includes all of these factors, is commonly calculated from D-log H curves as contrast index or gamma. In the zone system, plus-1 development and minus-1 development are used to expand or contract the tonal range by the equivalent of one exposure zone.

Because of reciprocity effects, negative contrast tends to be higher with long exposure times and lower with short exposure times such as are encountered with electronic flash. Adjustments in the degree of development are recommended for film exposed under these conditions. Some films, such as lith films, have inherently high contrast, and other films, such as extended-range films, have inherently low contrast. Changes in the degree of development is not a practical procedure for controlling contrast with colour films. Colour filters can be used on the camera lens to control local contrast with black-and-white films, such as using a yellow or red filter to increase the contrast between white clouds and blue sky. A polarising filter can be used to produce a similar effect with colour films.

PRINTING In black-and-white printing, print contrast can be controlled to compensate for variations in the contrast of negatives by the choice of paper contrast grade or the choice of colour filter with variable-contrast paper. Condenser enlargers also produce slightly higher contrast prints than diffusion enlargers. Toning black-and-white prints can alter image density and contrast in addition to colour, changes that vary with the choice of paper and toner. Selenium toner is sometimes used with cold-tone papers to increase image density and contrast with only a subtle change in image colour. There is much less variation in contrast among colour printing papers

than black-and-white papers. Other methods of altering contrast in printing include binding a mask in register with a negative or transparency to either increase or decrease contrast, and the use of controlled flashing to reduce contrast. Some slide duplicators have built-in provisions for flashing to reduce the contrast with reversal colour films, and some duplicating colour films have inherently less contrast than conventional reversal films.

DISPLAY Viewing conditions can have a significant effect on the appearance of density and contrast of a photograph. Increasing the illumination level on a normal print tends to make the print appear to be too light overall with a decrease in detail and contrast in the highlights. A low level of illumination tends to make the print appear to be too dark overall with a decrease in detail and contrast in the shadows. However, a print that has been printed slightly darker displayed under a higher-than-normal level of illumination appears to have a greater range of tones than a print having normal density displayed under normal room illumination.

Slides and motion pictures projected on a screen in a darkened room appear more contrasty than when there is ambient light in the room, because the ambient light lightens the dark areas proportionally more than the light areas and because the dark surround in the darkened room produces a simultaneous contrast perceptual effect.

COLOUR MATERIALS With colour materials the best way to control contrast is to control both the lighting ratio and the colour temperature. Little can be done during development without destroying the colour balance of the print or transparency. Care in how the prints are mounted and displayed will have an effect on contrast, colour temperature, light level, and surround are also important.

CONTRAST GRADES
The numbering system relating to black-and-white photographic printing papers indicating (in inverse order) their exposure scales. The numbers are consecutive integers with 0 representing a high exposure scale (about 1.70) and 5 representing a low exposure scale (about 0.70). When printing a given negative, the higher the paper contrast grade number, the greater the contrast in the print. The ideal pictorial negative should make a pleasing print on a number 2 paper. Variable contrast papers use a similar numbering system for the filters that change their effective contrast.

CONTRAST INDEX (CI)
The preferred measure of development contrast in a negative film sample. It is the slope of a straight line drawn between two defined points on the film characteristic curve.

Contrast index may be found by either of two methods: (1) Place a transparent CI template so that the characteristic curve intersects the right and left arcs at the same numerical value—the CI; (2) locate a point on the toe of

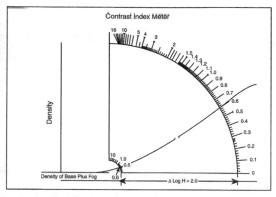

Contrast index. The use of a contrast-index meter, showing a CI value of 0.60.

the curve at 0.10 above the base-plus-fog density, and from that point strike a circular arc with radius 2.0 in log-H units that intersects the upper portion of the curve; the slope of a straight line between the lower and upper points approximates the CI value.

Contrast index is preferred to gamma (the slope of the straight line of the D-log H curve) because some modern films do not have a single straight line and because subject shadow tones often fall in the toe of the curve.

Contrast index is often used in monitoring a development process for stability. A fixed contrast index, however, does not ensure that all processed negatives with the same CI value will have the same printing characteristics, because other factors (camera exposure level, camera flare, and scene contrast) will affect the resulting negatives.

CONTROL CHART A graph showing the performance of a process, based on measurements over time, and intended to detect unwanted changes in the process. For example, in monitoring photographic processing systems, standardised exposed test strips are periodically sent through the system and measured and the results plotted.

CONTROL LIMITS Lines on a control chart showing the highest and lowest test measurements to be expected of an unchanged process. Data falling outside the limits are signs that action should be taken to restore the process to its normal characteristics.

CONTROL STRIP A small piece of photographic film or paper, exposed in a standard manner (as in a sensitometer), that is sent through a chemical process and then measured. The results are often plotted on a control chart.

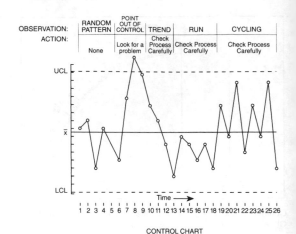

CONTROL CHART

Control chart. Horizontal lines show the expected process average and upper and lower control limits.

COSMIC RADIATION FOG Cosmic rays are mainly enlarged particles from outer spare that can have a measurable effect on photographic materials even at considerable depths below ground or water. They are mostly composed of positively charged atomic nuclei, which on entering the atmosphere collide with other atomic nuclei to form nuclear fragments. The fogging effect is relatively insignificant during the useful life of most practical photographic films. However, the cumulative effect on high speed films, even at low temperatures, can be significant. This effect can be minimized by storage at depths well below the earth's surface.

CRONAR BASE Trade name of DuPont Corporation for polyester film base.

CRYSTAL A crystal is a solid form of a substance in which the atoms or molecules arc arranged in a regular repeating three-dimensional structure, the size and shape of which may depend on the conditions during formation. Each substance develops a form with precise plane surfaces that result from their internal structure. Crystals form from a liquid as the saturation of the ions of a compound begins to exceed the solubility of the compound in the liquid.

CUBIC CENTIMETRE (cc, cm³) In the metric system, a unit of volume equal to that of a cube 1 cm on a side. In practice, a cubic centimetre is equivalent to a millilitre, which is now preferred as a unit of liquid volume.

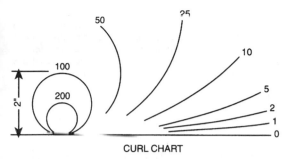

CURL CHART

Curl chart. Chart for measuring curl in values equal to those covered by American National Standard PH1.29 *Curl of Photographic Film, Methods of Determining*. The diameter of the circle representing a value of 100 should be drawn with a dimension of 2 inches. The formula for the curl values is 100/radius in inches.

CURL In the simple case of a gelatin emulsion coated on a flexible support, changes of temperature and (especially) humidity will cause the material to curl because of differential expansion of the base with respect to the emulsion. (Simple hygrometers work on this principle.) Manufacturers design their films and papers to minimize this effect. Polyester films and resin-coated papers have greatly reduced curl. Fibre base papers are perhaps the most troublesome contemporary materials in this regard. Low humidity in the workplace often causes *face curl*, i.e., emulsion concave. *Back curl* due to high humidity is less often encountered. Humectants added to the final rinse are useful in some cases.

Archivists working with prints and negatives made before the 1940s need to be especially careful in straightening curled pictures.

CURL REDUCTION Because the gelatin-emulsion coating of films and papers tends to shrink to a greater extent than does the support, the material tends to curl toward this coating on drying. Manufacturers have traditionally compensated for this curl tendency of films by coating a gelatin layer on the reverse side of the material. This is not possible with conventional papers since the extra coating would inhibit the removal of water on drying. Resin-coated (RC) papers or papers with other treatments that prevent absorption of water during processing can be back coated to compensate for any curl. Present-day materials are manufactured with much thinner coatings than in the past, so curl is now much less of a problem.

In critical applications, if curl of films is a problem the control of drying conditions may be of help. A low relative

humidity and higher temperature can be employed while the material is still wet, since evaporation will tend to cool the emulsion. As drying progresses, higher relative humidity and lower temperatures will minimize excess hardening and shrinking of the emulsion and/or gelatin coatings. Long rolls of film should be wound emulsion facing out, if possible, to induce a set that would counteract curling.

In some instances the flatness of a film can be restored by rewetting, treating with a humectant rinse, and carefully drying. When the base of an old sheet film loses solvents near the cut edges, shrinkage causes a form of curl known as *cupping* that may interfere with good contact when printing. This is practically impossible to correct.

Fibre-based papers will generally tend to curl even with thin emulsion coatings due to the *baryta* or other rawstock coatings. Carefully pulling the backside of the curled dry sheet across a small diameter such as the rounded corner ol a table can straighten dried prints. This should be done with caution since there is a risk of fracturing the gelatin emulsion or gelatin coating. Also placing recently processed prints back to back under a letter press (or unheated dry mounting press) for a day or more will also usually flatten them. If possible, prints should be stored with emulsions facing one another or back to back. Placing previously dried prints individually under a heated dry mounting press for a few seconds will also "iron" out curl of some papers. Prints dried on heated dryers generally do not curl, but instead have a tendency to buckle at the edges. Some of this is eliminated if 1/4 to 1/2 inch of paper can be trimmed off.

CUSTOM FINISHING *Custom finishing* is a phrase that is typically used to describe the production of individualized photographic prints by hand. This is in contrast to amateur photofinishing, where prints are mechanically reproduced at a relatively high speed.

Prints that are custom finished, either black-and-white or colour, are made to specific requirements provided by the photographer or client. They usually define the colour balance, print density, and negative cropping that are needed to meet the final use of the photograph. To produce a custom print, the lab will enlarge the negative or transparency using a conventional enlarger and make modifications such as increasing the amount of exposure in particular areas, referred to as *burning*, or decreasing the amount of exposure in particular areas, referred to as *dodging*, to achieve the desired effect. The custom finishing of a print is very labour intensive and requires a skilled operator.

Custom prints are usually 8 × 10 inches in size or larger. They can be made up to 40 inches wide by 6 feet or even larger. The smaller prints are used for such applications as magazine reproduction or counter-top display, whereas

the larger prints are commonly used for wall display. A photographer who desires a perfect rendition of the subject will choose this method of printing. If the photograph is to be made from a black-and-white negative, the photographer can choose from a variety of silver image tones and photographic paper surface textures. This is done to ensure that the final image is suitable for the intended use. An example of this would be a portrait, for display, being made on a soft looking matt-surface paper, versus a photograph of a building, for photomechanical reproduction, that is made on a glossy-surface paper.

Because of the variations and requirements of individual pictures, custom finishing labs produce prints in a much smaller number than the amateur labs, and great care is taken to ensure that the photographic image shows exactly what the photographer wants. These prints are typically processed one at a time, by the printer/operator, Often the printer will be the only person to work on the photograph.

The custom finisher no longer has to depend completely upon a hand production process. Recently, some custom finishing labs have turned to the computer to aid them in making the perfect print. To use the computer, the negative is scanned to convert the image into digital information that can be manipulated, stored, and displayed on a monitor much like a television screen. The operator will provide the computer with exact directions to modify the image on the screen, until it appears as desired. This modified computer information is then made into a new negative through a digital image writer. The new negative will now reflect the modified image that was displayed on the monitor. A print is then produced in an enlarger from this modified negative. While still a labour intensive process, it does provide the ability to view the finished image before the actual print is made. Sometimes, the photographer will be present as the image is modified, to provide direction, ensuring that the print will have the desired quality. This method of custom printing allows the custom finisher a way of making a perfect print without having to go through the difficult processes of hand retouching the negative and burning and dodging the print.

Since custom finishing sometimes involves making very large prints, the lab also may specialize in many other services, such as mounting the final photograph for display. As with the print, the lab will mount the photograph in a method that is requested by the photographer or client. Various methods are used for mounting the print, such as heat sensitive dry-mounting tissue, which looks like wax paper, or special glues that have been made for this purpose. The print, depending on size and final use, can be mounted on a stiff fibre board or on a special display board that has a foam core. Some professional photographers do their own custom finishing to ensure

that they have control over the production of the print. Determining the most appropriate qualities of a final print is a subjective process, and this control allows them to make their own corrections to the photograph, resulting in a photographic print that has been made by them through all stages of the process.

CYANOTYPE Invented by Sir John Herschel and presented in a paper to the Royal Society of London entitled "On the Action of the Rays of the Solar Spectrum on Vegetable Colours and on Some New Photographic Processes" in 1842. From the Greek word meaning dark blue impression, cyanotype is a simple process based on combining ferric ammonium citrate with potassium ferricyanide, resulting in a final image that combines ferrous ferricyanide and ferric ferrocyanide. Each chemical is mixed separately with water to form two working solutions, which in turn are mixed in equal parts to form the light-sensitive solution that is then coated on a paper or cloth support. Dried in the dark and then contact printed by exposure to ultraviolet radiation through either a negative, to make a print, or in direct contact with an object, to make a photogram. It is then washed in a bath of running water to permanently *fix* the image and develop its characteristic *cyan* blue colour. The image is embedded in the fibres of the paper or cloth and accounts for its matt print surface. A very dilute solution of hydrogen peroxide can be added to the wash water to intensify the blue colouration. Also called blue-print process, or Prussian-blue process. The process was used to illustrate the three volumes of *British Algae: Cyanotype Impressions* in 1843 by Anna Atkins. This is considered to be the earliest example of a book illustrated by a purely photographic process. The process was little used after this until the 1880s.

DAGUERREOTYPE The daguerreotype was presented to the world in August, 1839. It was, without question, the first workable photographic system. Its progenitors lacked sharpness or tonal range or controllability. By comparison, within days of Arago's demonstration of the process, a legion of daguerreotypists was established. In the 1840s, the world generally understood photography to mean daguerreotype. The images were remarkably sharp and grainless, even when viewed with a magnifying glass. Their size was precious, as were their silvery sheen and the cases they came in. True, the images were laterally reversed, but that was, after all, what people saw in the mirror each morning. Yes, it was expensive and could not be duplicated, but the daguerreotype established the mercantile aesthetic, and communicative foundations of photography.

In L.J.M. Daguerre's original iteration, a sheet of copper plated with silver was prepared by polishing it with pumice powder in a muslin bag, then with cotton balls and olive oil. Three times, nitric acid was spread on the plate and it was heated, cooled, and polished. The plate was then sensitized by placing it in a light-tight box containing iodine vapour until the plate turned a "fine golden yellow colour" (a door was left ajar in the otherwise dark room), indicating the formation of silver iodide. As soon as possible, but within an hour at most, the plate was exposed in a camera obscura for between 3 and 30 minutes in daylight. It was then developed immediately in a box containing 2 pounds of mercury heated by a burner to 60° C. The mercury formed an amalgam with the silver, making the highlights and middle values visible. The unused silver iodide was then removed with a saturated solution of water and common salt, or, by the spring of 1839, "hyposulphite of pure soda." Washing was performed in a quart of distilled water. The positive image was now permanent but fragile. The highlights and middle values were creamy white but plainly visible; the shadows were plain polished silver, making the level of viewing light important. The plate was covered with glass immediately and placed in a case.

Soon, improvements to the process were made. A second electroplating of silver was added to the stock plate. Buffing procedures were enhanced. A second sensitization using bromine fumes made the plates much more responsive. Faster lenses also reduced exposure times. Gold chloride toner improved the appearance of the image and slowed the tarnishing or oxidation of the plate.

Reversing mirrors were sometimes added outside the camera to make the image laterally correct.

A full plate measured 6.5 in. by 8.5 in. and sold for $30 or more. Quarter and sixth plate sizes were much more popular because they could cost as little as $2, still a substantial sum in the 1840s, and because the exposure times were much shorter, smaller plates meant shorter focal length lenses closer to the plate.

By the time the wet collodion plate, the ambrotype, and the tintype replaced it in the 1850s, the daguerreotype had caused the idea of photography to become fixed in the collective consciousness of Western society.

DARK REACTION A progressive hardening of light-sensitive materials in the absence of light.

DARKROOM A lightproof room for the handling of light-sensitive photographic materials. Throughout the history of photography, it has been necessary for the photographer to have access to a darkened space in which to prepare, handle, and process imaging materials. At one time, when photographers were using the collodion wet-plate process, it was necessary to coat the plate with an emulsion in the dark and, while it was still wet, load it into a holder, take the photograph, and process it. If the plate dried at any time, it would lose sensitivity. It was therefore necessary to have a dark space at the actual site where the photograph was being taken. This seems an impossibly cumbersome method to us, with our handy enclosed film cartridges. However, the Crimean War, the Civil War, and the early scenic vistas of the West were all photographed with this process. Eventually, dry-plate processes were introduced, and the photographer was able to roam freely through the world without the burden of having a dark room for a companion.

Even with the convenience of dry plates there was, at first, no way to enlarge the camera image once it was recorded. If a large final image was desired, then a large plate had to be used. The first enlargers used the sun as a light source, directing its rays through a set of mirrors into the darkroom. It was said that cloudy days were actually the best for printing. With the advent of electricity enlargers could be powered by light that the photographer could call upon whenever needed. We now have the modern darkroom with provisions for developing film and making enlarged prints—both black and white and colour. It is even possible to purchase processing equipment to assist in all these tasks that is reasonably priced and small enough to be used in a commercial photographer's in-house darkroom, or even a home darkroom.

DESIGN AND CONSTRUCTION Because of the variety of different operations that will be performed in the darkroom and because of its usually limited size, it is

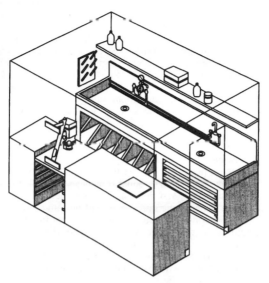

Typical linear darkroom design showing features discussed in this section.

necessary to carefully look at work patterns to ensure efficient layout of the space. Even though photographers may think they know which processes they will use the darkroom for, it seems that as soon as the photographer builds a darkroom without provisions for a certain process, that process becomes necessary.

Darkrooms are often perceived as small dim places that are squeezed into some corner unusable for anything else. This preconception results in darkrooms that are unpleasant and inefficient to use, making darkroom work— a wonderfully creative aspect of photography—unpleasant and inefficient. A darkroom is like any other work room. It should fit the needs of the work being performed and take into account the human needs of the worker.

Most darkrooms have a workbench, a sink, a lightproof entry, and perhaps film and print-drying facilities. The simplest design for a darkroom is a linear one, with a workbench for the enlargers and dry equipment on one side, and a sink and all the wet equipment on the other side. This *wet side, dry side* division is obviously necessary to keep dry equipment dry. Although with careful work habits this distinction may be violated, it is not a good idea.

A major consideration in darkroom design is the need to keep the darkroom clean and dust-free. All materials used in the darkroom should be nonabsorbent and easily cleaned. Spilled chemicals that are not quickly cleaned will

dry to a powder that will settle on equipment and negatives causing their deterioration. It will also create an unhealthy situation since the powder will be breathed by any workers in the darkroom. Since dust is a great problem in printing, it is necessary to prevent dust buildup in the darkroom.

Photographers will have to make their own decision as to size and shape of the darkroom, often constrained by the location. The following sections will provide some guidelines as to possible size, location, and exterior space near the darkroom to be used for finishing work. The final design decisions can be greatly facilitated by making a scale drawing of the available space on grid or graph paper. Each square will represent a unit of length, for instance, one square might equal 6 inches. Then all the tables, workbenches, and sinks that are designed can also be drawn to scale on the same paper, cut out, and moved around in the drawing to see how they may best fit. If the placement of the darkroom walls is not fixed, that is, it is not an already existing room, their positions may be selected to accommodate the desired arrangement. In any event, a scale layout will give a much clearer idea of what the final result might be.

Size Darkrooms come in all sizes from large professional and photographic school darkrooms to the closet darkroom of the occasional amateur. The size of the darkroom will depend on how many different operations are to be performed in it, how many enlargers are needed, how large final prints will be, how many people are to use it, and how much time is to be spent in it. The size should allow easy performance of all necessary operations and enough free space to prevent a claustrophobic feeling. It should not be so large as to waste effort in moving from one operation to another. The decision about size must take into consideration the possibility of expansion of operations or the increase in size of enlarging or processing equipment. A darkroom as small as 10 x 12 x 9 feet high will provide ample room for colour as well as black-and-white processing, several enlargers, prints as large as 16 x 20 inches, and two workers, and is comfortable enough to spend the long periods sometimes required.

Location Darkrooms are often hidden away in odd and dark corners that are not suited for any other purpose. This prejudice against darkrooms should be reconsidered. The professional photographer will want a darkroom that is accessible to other work areas. In this way the darkroom can be used at the same time as other areas. For instance, when printing with a processor there is a finite time when the photographer is not needed to oversee the activity. This allows other activities to be done at the same time. The darkroom is also used in conjunction with other kinds of activities. For instance, when photographing in a studio with sheet film, the darkroom should be close enough to allow for easy loading and unloading of film holders.

The other main consideration for locating a darkroom is accessibility to building services such as water, drainage, and electrical power. The choice of location should also take into consideration ease of ventilation.

For the professional photographer, a darkroom location is largely a matter of choice; for the amateur, it might be a matter of finance or availability of space at home.

Walls Darkroom walls are usually of standard construction. Sheetrock painted a light tone is most common. One of the great myths about darkrooms is that they should be painted black. Black paint on a wall that is behind an enlarger may be necessary if the enlarger leaks some light, since this will help prevent the light from scattering around the darkroom. It is convenient to have a wall or an area of a wall that material may be pinned to temporarily. Work in progress, chemical mixing information, material processing steps, or just fun images can be pinned to a piece of Homesote that is attached to a wall. Homesote is a pressed paper board that accepts push-pins. It is an excellent way to have a bulletin board in a darkroom. Materials, such as cork boards, that shred are unacceptable in the darkroom because of the possibility of particles on film. At least some walls will have to be strong enough to support shelves or perhaps wall-mounted enlargers. There is an interesting wall material called tile board, which is covered with a hard tile-like coating, that allows easy cleaning in those areas where chemicals may be inadvertently splashed.

If the darkroom is a temporary one or if a final decision on size or location cannot be made at once, then walls can be made out of light-tight plastic or other material that can be removed or altered at a later date.

Floor The type of floor the darkroom has will depend to some extent on where the darkroom is located. The existing floor in the space to be turned into a darkroom may be satisfactory, but there are basic considerations for a darkroom floor. The floor should be smooth and without any abrupt changes in height that might trip a person in the dark. The floor should also be of a nonabsorbent material since there is always the chance of a spillage of chemicals or a leak in the water or drain systems. The floor should also be of a softer material than concrete to help alleviate fatigue. Even though all floors seem hard, a wood or asphalt tile floor is softer and less tiring to stand on than a concrete floor. Wood, unfortunately, is not a good substance for a darkroom floor because it is too absorbent, and it stains, swells, and even splits if wet. Asphalt tile is a good floor covering if there is little or no spillage. Asphalt tile does stain from spilled chemicals, however, and the tiles warp and come away from the underflooring with excessive wetting. A continuous roll of linoleum fitted to the floor, if seams are kept to a minimum, is a good flooring material. No matter what is on the floor, the photographer may consider the installation of antifatigue mats.

They come in several types, but have the problem of being higher than the existing floor, creating the possibility of tripping over the raised edges when working in the dark.

The floor should be as level as possible to help create the proper drainage in the sink and to facilitate levelling enlargers and workbenches.

Before laying any floor over an existing floor, one should make sure that there is no incompatibility between them that will cause problems, such as buckling or trapping of water and chemicals between them.

Ceiling The darkroom ceiling should be level and smooth to prevent dust from accumulating (as it would if there were exposed pipes or beams). The ceiling should also be strong enough to support safelights, and should be painted flat white.

If the existing ceiling over the space chosen for a darkroom is not smooth, a good solution is the installation of a drop ceiling. This gives the required smoothness and creates a space above the ceiling for running wires for safelights. Drop ceilings also provide sound-proofing, which helps to dampen the noise of processors and running water in the darkroom's confined space. Drop ceilings are normally strong enough to support safelights unless the lights are unusually heavy, and they allow the safelights to be positioned almost anywhere using clips that are designed for drop ceilings. Since most darkrooms are small, a drop ceiling can be installed by the photographer.

The ceiling should be high enough to allow the enlargers to be raised sufficiently to make the required size prints. In cases where the ceiling must be low, an enlarger table that can be raised and lowered is a possible solution. This requires the enlarger to be wall-mounted. (See the section on Dry-Side Workbenches.) The alternative is to buy specially designed wide-angle lenses for enlargers.

Power Requirements All electrical work done in the darkroom generally must be performed by a licensed electrician and must conform to local building codes. These codes are designed to ensure that the installation of the electrical system is safe. It is not a good idea to try to circumvent these codes. This section should provide enough information to enable photographers to tell the electrician what is needed and to answer any questions the electrician may have.

The power requirements of a darkroom are relatively small. The only machines that draw significant power are dryers. The total power required for a darkroom is easily calculated using the formula:

Watts = volts × amperes

where watts are the measure of electrical power, volts are the measure of electrical force, and amperes are the measure of electrical flow. Since these terms are often somewhat hard to understand, water can be used as an analogy. The volt is equivalent to water pressure, and the

ampere is equivalent to the flow rate of water. The amount of water flowing at a certain pressure gives the power of the water. Calculating the power requirement for the darkroom is done by adding up the wattages of all lights and heating elements and using the formula above to calculate the amperage. The amperage will determine what size wire is needed to carry the power (or load) safely. For example, if the total wattage of the lights and dryers in your darkroom is 700 watts and, using 240 volts (the usual voltage delivered by electrical companies), then:

$$700 = 240 \times amps$$
$$amps = 700/240$$
$$amps = 2.92$$

When rounding to the nearest whole number, always round up for safety. This then is the minimum amperage the wires must be able to carry, but a safety factor should be added.

One of the main considerations in planning darkroom electrical layouts is the proximity of water to all areas of the darkroom. Electrical outlets must be placed in such a way that no water is likely to reach them. This is especially important on the wet side of the darkroom. There are usually few outlets necessary for use on the wet side, but, depending on the processes to be used, there may be some. Timers, rotating motor bases, constant temperature baths, and automated processors will all require access to electricity. This creates a necessary but dangerous electrical hazard. The best way to deal with this is by installing the electrical system with a fault interrupt circuit. This is a device that senses an open circuit, or grounding of the electrical system. An open circuit results from a sudden shorting of the electrical system to ground. This is typically caused by worn insulation or accidentally cutting through a wire. In the darkroom, it may be caused by water getting into an outlet or by wet hands touching an open circuit. The fault interrupt switch will automatically shut off the electricity before it can reach the outlet or hand that is causing the problem, which can save a life. These devices are commonly seen in modern bathrooms, and for the same reason they should be used in darkrooms.

A handy feature that can be designed into the electrical system and that may help prevent problems is to have a single switch at the outside of the darkroom that shuts off all power. By throwing this switch when leaving the darkroom, the photographer can be sure that no electrical device has been left on inadvertently. Since the amount of electricity in the darkroom is small, this can be a simple wall outlet switch.

Light Trap The entrance to the darkroom, when closed, must keep out all light. This can be achieved by installing a common household type door. The frame should be lined with weatherproofing material that compresses when the door is closed to prevent light from

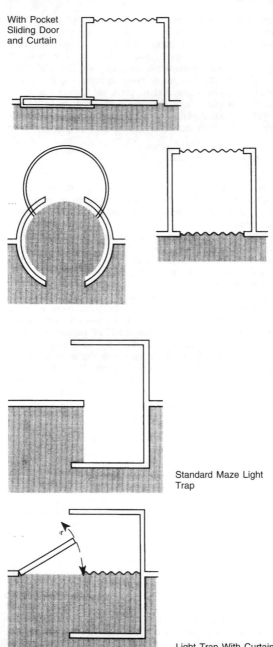

With Pocket
Sliding Door
and Curtain

Standard Maze Light
Trap

Light Trap With Curtain
and Equipment Door

104

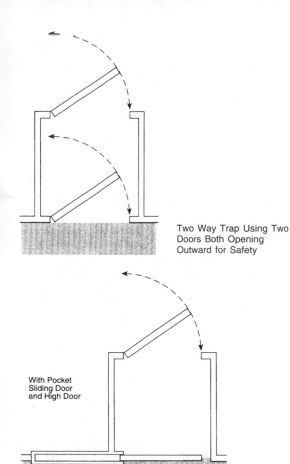

Two Way Trap Using Two
Doors Both Opening
Outward for Safety

With Pocket
Sliding Door
and High Door

With Pocket Sliding Door and High Door

leaking around the edges of the door jam. A sliding door
that hides in the wall is an alternative when space is at a
premium, but it involves a more complicated installation.

The most convenient entry to a darkroom is through a
light trap. This is an opening that is constructed to prevent
light from entering the darkroom without preventing a
person from entering. The basic principle is based on the
fact that light travels in straight lines. An entry with flat
black surfaces that leads around a corner can prevent light
from entering without a door. Entry to the darkroom is
then possible without disrupting darkroom operations. A

105

light trap also allows for easy escape from the darkroom during an emergency, and it is a great help in ventilating the darkroom. This type of entry requires considerably more construction and space. The addition of curtains to block most of the light at each end of the trap will reduce the space required. The curtain material should be dark and heavy enough to hang properly. A material called black-out cloth, designed for this use, is available.

Other types of light traps use two doors with a small dead space between them. A person opens one door, steps into the enclosure, and closes the first door. Then the second door can be opened to enter the darkroom. Curtains instead of doors will work if the person entering is careful, and curtains will save money and time by eliminating the need to buy two doors and build two doorways. The curtains should be hung so they open in the middle with a generous overlap at the centre and at all sides. A heavy dark cloth that will hang by its own weight works best. The use of a light trap labyrinth or curtains will also help alleviate any claustrophobic feelings that working behind closed doors in a small space may cause. The dead space between curtains or doors should be painted flat black to reduce light scattering. A white line can be painted on the walls to help people orient themselves.

There are commercially available prefabricated light traps. These are large cylinders that come in several sizes and fit into the doorway of the darkroom. One enters the cylinder through an open slot in the cylinder and then rotates the cylinder until the slot is facing into the darkroom. The cylinder portion is on wheels and is easy to turn. It is also removable, so that large equipment can be added to or removed from the darkroom conveniently, or for ease in cleaning the darkroom. These units work very well and take up little space, but are quite expensive.

Windows A window in a darkroom may at first seem like a problem, but it is actually an asset. A window makes ventilation much simpler and can provide light for cleaning and other white-light activities. It also provides a more enjoyable atmosphere when not actually working with light-sensitive materials. The window can be darkened with opaque shutters or by hanging a dark cloth or black garden plastic over it. There are commercially available black-out curtains, but they are expensive.

Dry-side Workbenches The dry side of the darkroom is the side that the enlargers occupy, as well as any other equipment or materials that must be kept dry. This equipment generally requires countertops for its use. The size of the countertop depends on the equipment to be placed on it, but it must not be so deep that it is difficult to reach the back. Most standard size (ready-made) counters are 24 inches deep. However, even a small enlarger could easily have a baseboard deeper than that, and a 4 x 5 enlarger could have a baseboard as deep as 34 inches. This requires the photographer to build a custom-sized countertop. The

countertop can be as deep as 30 inches and still allow the back to be easily reached. The baseboards of the enlargers may overlap the edge a bit, but this is better than making access to wall shelves inconvenient.

Enlargers may be wall-mounted to help alleviate this problem, and most enlarger manufacturers sell wall-mounting brackets. This type of enlarger mounting keeps the countertop clear and at one level. Care must be taken to ensure that the negative stage of the enlarger is perfectly parallel to the countertop. Failure to do so will result in distorted images and prints that are sharper on one side than on another. When wall-mounting, it is a good idea to fasten the enlarger to the wall at the top and the bottom to increase the stability of the enlarger. If a cable is used for fastening the top, a turnbuckle can be installed in the line to assist with levelling the enlarger. A wall-mounted enlarger allows the photographer to construct a base that can be lowered below the countertop to obtain a wide range of print sizes, even in a room having a low ceiling. This can be as simple as a large version of a book shelf with adjustable brackets. Again, keeping the base level with the enlarger is most important. The movable baseboard must be strongly constructed to prevent any chance of warping.

Simple countertops may be constructed from plywood that is framed and mounted on legs. It can also be mounted directly to the wall or on commercial kitchen bases. These bases come in a variety of models and can provide such conveniences as a set of drawers under the counter. They will provide a standard counter height of 36 inches. If a different height is more convenient, then one of the other mounting methods must be used. No matter which way the counter is mounted, the construction must be strong enough to prevent the counter from having any give. The top of the counter should be smooth and easy to clean. Covering the counter with Formica or a similar plastic material is ideal, but a simpler and less expensive method that works well is to give the plywood several coats of a good floor paint. This paint is thick and will fill any small cracks in the wood and provide a hard, durable surface that is easy to clean. Any spaces between the countertop and the wall should be covered by moulding to prevent dust from accumulating or objects from slipping behind the workbench.

Having a small light box in the darkroom is a great help in examining negatives and transparencies and positioning them in a negative carrier. The light box can be built into the counter so it is flush to the working surface. The bulbs and wiring can actually be mounted in one of the drawers under the bench for ease of maintenance. Open space under the counter can be used for storage, a trash receptacle, or print-drying racks.

Wet-side Sink The wet side of the darkroom is usually occupied by a long sink in which materials are processed.

The size of the sink depends on the type of work to be done in it. Making large black-and-white prints requires a large sink for the processing trays. (An automated print processor can be an alternative to a large sink.) If space allows, having the print washer in the sink is convenient. The sides of the sink are usually high enough to prevent chemicals from splashing outside the sink. The front side also provides the photographer with a convenient place to lean while processing. The back of the sink can also be made higher than the front to provide a splashboard. A small shelf on top of the splashboard is a convenient place to keep timers, thermometers, print tongs, etc. Before deciding on a sink size and depth, the photographer may want to try out the design on a mock-up or use an existing darkroom as a test.

Ready-made darkroom sinks are available from several manufacturers. Since they are designed primarily for commercial use they are usually constructed of stainless steel. This makes them very durable and easy to clean but they are also expensive and noisy when hit. There are also a variety of plastic sinks available. All of these sinks come in standard sizes. If cost is a factor, or if none of the standard sizes is correct, a custom darkroom sink can easily be constructed of wood and then waterproofed. Plywood is a good construction material for the bottom of the sink. The plywood does not have to be very thick since the sink does not have to support much weight, but the base should be well braced to prevent low spots and warping. Remember to build in ample slope towards the drain hole. The side can be built from one-inch planks of the correct height. Remember to give the front edge a thick top for resting on. To facilitate moving the sink to a new location, the basin should be separate from the legs. Underneath the basin and between the legs, a rack may be installed to store unused trays and film developing equipment. This rack can be made from thin slats of wood. Because of the availability of inexpensive processors, the wet side may also have one or more small countertops to set processors on. Most processors are "table top" and do not have to be set in a sink or even on a waterproof surface.

There are many types of waterproof coatings for wood on the market. Polyurethane is a plastic coating that is painted on the surface. It is not completely waterproof and must be reapplied at regular intervals. Fibreglass fabric and liquid coating gives a permanent and completely waterproof finish. There are industrial neoprene (rubber) coatings that provide a seal that is also slightly cushioned to help control the noise of trays. A marine supply store is a good resource for waterproofing materials. All of these materials give off very toxic fumes and must be applied outdoors or in a highly ventilated space.

Plumbing As with the electrical system, plumbing must conform to local building codes. This usually means

that a licensed plumber must do the work. There are many technical details that must be considered—such as vents and vacuum breakers. A good home improvement book that features plumbing will be helpful. Many areas require the installation of a back flow prevention valve. (See the section on Environmental Consideration.)

The complexity of the plumbing depends on the processing operations that will be used. The size of the sink and the need for availability of water at different places in the sink are also factors. The addition of a temperature control valve to the plumbing system is not only a convenience, it is almost a necessity for the more exacting processes such as film developing and colour processing. A filter on the outlet of the temperature control valve is also valuable, if not a necessity. If there is no temperature control valve, then two filters are needed: one on the cold water inlet and one on the hot water inlet. The outlet from the temperature control valve is connected to a pipe that has a series of valves in it called a header. These valves are placed at intervals to allow film and print-washers and processors to be connected to them where needed. There should also be one or two uncommitted valves for use in supplying water for mixing chemicals and for washing equipment and hands. Flexible tubing is often attached to the supply valves in the sink to prevent splashing and to allow water to be directed where needed. Care must be taken that the tubes do not produce splashing. Tubing is also used to attach film and print-washers and processors to their respective valves.

The plumbing that contains the valves to control water in the sink can be attached to the splashboard. The sink plumbing can then be attached to the building plumbing through pipe unions. These are devices that allow the pipe to be disconnected without cutting it. In this way the entire sink, complete with plumbing, can be moved to a new location. Plumbing the darkroom in the new location is then simply a matter of attaching the built-in sink plumbing, through unions, to the building water supply.

As with all other aspects of darkroom design, considerable thought should be given to the plumbing. It is expensive to install and to alter.

Lighting The darkroom should have white lighting that will give overall illumination for activities that do not involve sensitized materials, including cleaning up. This can be any type of general lighting, such as fluorescent. It should have a separate switch in the darkroom that allows it to be shut off for the safelight and dark activities without affecting any of the other electrical circuits. The switch should be in an out-of-the-way place or covered to prevent it from being accidentally thrown when light-sensitive photographic materials are in use.

Safelights come in many styles and sizes. They should emit enough light to provide adequate visibility but not enough to fog light-sensitive emulsions. A simple test can

be performed to see if the safelights provide safe illumination. Shut off any overhead lights and place a sheet of exposed but undeveloped photographic paper on the workbench. Cover the paper and turn on the safelights. Expose the paper to the safelights in test-strip fashion with the longest time longer than any that would be required by exposing and processing. Develop the paper in complete darkness and see if there is a density difference between any of the steps. If there is no difference, then the safelights truly are "safe." Safelights are usually used only for black-and-white printing, but there are some special uses such as film development by inspection. Special safelights should also be tested with the materials they are going to be used with to make sure they will cause no fogging to the exposed emulsions. All the safelights should be on the same circuit and attached to a switch that cannot be accidentally thrown.

The other kind of lighting that is used in a darkroom is for print-viewing. This is a light of the proper intensity to judge if the print is of the desired density. The white room lights can be used for this purpose if the illuminance at the print surface is approximately 800 LUX (4 foot candles). A stronger light is useful for checking prints for sharpness, defects, and the maximum density. This print-viewing light can be positioned in such a way as to shed light locally on the final print. It can be hung at the far end of the sink over the fixing or washing tray, or a spotlight can be aimed at the vertical backboard of the sink on which the wet print is placed. The print-viewing light can be attached to a footswitch so it can be turned on and off without touching a switch with wet hands.

Ventilation Proper ventilation is important in the darkroom for several reasons. Breathing concentrated chemical fumes of any kind is unhealthy. Working in a humid, enclosed space is uncomfortable and counterproductive. Any equipment or materials kept in a space filled with fumes or humid air can be adversely affected.

Ideally, the air in the darkroom should be changed every 6 to 8 minutes. This can be accomplished with an exhaust fan of the correct size used in conjunction with inlet vents. Exhaust fans are rated in cubic feet per minute (CPM) of air that they can move. The cubic feet of the darkroom space is easily calculated by multiplying the height times the width times the length. Dividing the calculated cubic feet by 6 minutes (the suggested exchange rate for the air) gives the CPM required of the fan. Inlet vents must be placed in the walls to admit fresh air. Both the vents and the fan need to be light tight.

A circulation pattern that draws the air out over the sink is necessary to maintain the wet/dry integrity. This is accomplished by placing the fan above the sink and the vents as low as possible on the dry side.

Drying Facilities for drying both prints and negatives are commonly in the darkroom itself. This makes it unnec-

cssary to carry wet materials out of the darkroom, lessening the chance of a wet floor hazard or of getting dust on wet materials.

An enclosed film-drying cabinet allows film to be hung to dry without risk of dust in the air settling on the film. Commercially made cabinets are available. They usually contain some facility for heating the air moderately to quicken the drying process. These are often quite expensive, and photographers may wish to build one for themselves. A 100 watt bulb can be placed near the bottom of the cabinet to safely dry the film when quick turnaround time is important.

Prints can be dried on a set of racks covered with plastic window screening. The screening can be stretched over painter's canvas stretchers. These will slide on runners attached to a frame. Depending on its size, the frame can go under the sink or under the dry-side workbench. An RC print dryer is handy for quick drying of rush-order prints or, when colour printing, for the immediate evaluation of colour. Again, such devices are commercially available at considerable expense or one can be constructed with a hairdryer and an enclosed screen-covered rack.

Colour Darkroom Simplified colour chemistry and the availability of various kinds of colour print processing equipment have made it possible for any darkroom to be used as a colour darkroom.

Colour processors come in a variety of sizes and types from print drums with light traps for pouring chemicals in and out to fully automated machines that deliver a completely processed and dried print. Frequency of use, cost, and space are determining factors. An effective compromise between the labour-intensive drums and the fully automated processors are the "table top" machines. A print is placed in the machine, a light-tight lid is closed and nothing more needs to be done until the wet print drops out. It must then be washed and dried by hand. The processor can be placed on a workbench with the end of the machine slightly overhanging the sink. The print then drops into a waiting tray of water and the processing can be completed from there. Once the print colour is corrected, all the copies can be washed and rack-dried at once. These machines do not require the high electrical input, the overhead storage tanks of chemistry, or the constantly running water of the fully automated machines. Models of the *table top* machines that make relatively large prints—up to 20 inches wide are available.

To help in judging the colour of prints, a *daylight* print-viewing box can be constructed. This makes use of fluorescent tubes that are rated at 5000 K, the correlated colour temperature of daylight. Judging the print under any other colour light will give a cast to the print that makes it difficult to form a correct judgment of its colour. If the overhead lights are fluorescent, these 5000 K tubes can replace the normal fluorescent tubes, which often have a

greenish cast. Then the entire darkroom is illuminated with the recommended quality of light for viewing colour prints. However, the overhead light may not have the proper intensity for judging the print's density. Also, it helps to judge final prints against a standard print and the previous test print. For these reasons a viewing box may be desirable. This is simply a box mounted on the wall large enough to hold the largest print to be made. The inside is surrounded by fluorescent fixtures that allow the print to be viewed with white light of the proper quality and intensity. A clip akin to the ones doctors use to hold X-rays can be installed so the print or a series of test strips can be viewed simultaneously. It also gives the photographer the opportunity to step back and view the print as a whole before making a final judgment.

Storage Because of its normally confined space, storage in the darkroom must be carefully planned. All equipment that is necessary to the various processes used in the darkroom, as well as all chemicals, is normally stored in the darkroom. They should be stored so that they are out of the way when not needed but easily accessible. Because of the humidity and chemical fumes, it is not advisable to store negatives in the darkroom.

Equipment Dry-side equipment consists of enlarger accessories—lenses, negative carriers, focusing magnifiers, as well as print trimmer, lupes, flashlight, sheet film holders, etc. The lenses should be stored where they cannot be broken and are shielded from any accidental spills. Drawers under the dry-side workbench are ideal for this. They can be cushioned so the lenses in their lens boards can rest in the drawer safely. The best place to store enlarger lenses is on a three-lens turret that is attached to the enlarger in place of a single lens board. Changing lenses is then a simple matter of rotating the turret to bring the desired lens into place. This system keeps lenses safe and accessible. Negative carriers can also be kept in drawers under the workbench but they tend to slide around and become a jumble. Hanging them on a peg board near the enlarger is very handy. Rubber-coated peg board hangers are available that will not scratch the negative cut-out. Most of the other smaller accessories are used so often that they are left out where they can be easily reached, but leaving them on the workbench surface can result in a cluttered work space. Small shelves near the enlarger can be constructed to hold these items and keep them out of the way until they are needed. Sheet film holders and the collection of film boxes needed to transport exposed film to the lab are also easy to store in drawers.

Wet-side accessories consist of developing trays of various sizes, film developing tanks and reels, thermometers, print tongs, etc. The equipment drying racks under the sink (see the section on Wet-Side Sink) are perfect for storing as well as drying items such as trays and tanks.

Smaller, more delicate equipment such as film and thermometers are conveniently stored on a small shelf above the sink's splashboard. (See the section on Wet-Side Sink.)

Chemistry Because the darkroom is the place in which chemicals will be mixed and used, chemicals are often stored in the darkroom, but professional processing labs usually have separate chem-mix rooms.

Unmixed chemistry comes in all sizes and types, both liquid and powder, making standardizing storage difficult. Powders must be kept dry, of course. Shelving in out-of-the-way places works well. They can be under the processor bench, above the sink, even under the dry-side workbench

Mixed chemistry can be kept under the sink, on shelves above the sink, or in the sink itself along the back edge.

ENVIRONMENTAL CONSIDERATIONS Because darkroom work by its very nature produces waste products, the photographer should be aware of the nature of these products and what can be done to minimize their impact on the environment.

Waste Disposal The factors affecting waste management are volume of effluent (the waste flowing out of the darkroom), temperature of effluent, types of chemicals used, and the ratio of chemical waste to wash water. The effluent from personal darkrooms may be within most established sewer codes. The pH (measure of relative acidity or alkalinity of a liquid) is between 6.5 and 9, the temperature is less than 90°, and there are very few suspended solids. Most commercially available processing solutions contain no grease or oils, nothing flammable or explosive, and they do not have much colour or odour. Photographic chemicals are generally biodegradable and will not harm municipally run biological treatment systems. It is not advisable to discharge darkroom wastes directly into a septic tank and/or leach field unless the amount is small in comparison to domestic discharge volumes or has been greatly diluted.

The installation of a back-flow prevention valve in the inlet water supply of the darkroom prevents chemicals from being sucked back into the domestic water supply if a vacuum is accidentally created in the municipal system.

The silver in the waste water is in the form of soluble silver thiosulphate from the fixing bath. It is not in the form of toxic, free-ion silver. The thiosulphate is converted by municipal processing plants into insoluble silver sulphide and some metallic silver. These are removed with other solids during clarification.

Recycling Since the earth and its resources are finite, photographic chemicals should be conserved and recycled whenever possible. The use of replenishers instead of one-shot chemistry is advised where feasible. The main darkroom chemical that is recycled is silver. It can be removed from fixing baths by several methods—metallic replacement, electrolytic recovery, and ion exchange. For

larger, commercial darkrooms with high flow rates, electrolytic or ion exchange are economically reasonable. For personal darkrooms with much lower flow rates, metallic exchange makes the most sense.

Metallic exchange is a very simple process in which a more active metal than silver (usually iron) replaces the silver and goes into solution. The insoluble silver metal settles out as a solid. There are several commercially available systems on the market. Photographers can make their own by placing steel wool in a drum and pouring the fixing bath into it. The silver will form a sludge in the bottom. This sludge is sold or given to a recycling company that recovers the silver. The silver content of the sludge is hard to determine so most companies will not pay for it. They pick it up for free and make what profit they can. Even though the photographer receives no monetary compensation, the feeling of having made an effort to help the environment is payment enough.

DECOMPOSITION Decomposition reactions involve the separation of a compound into simpler compounds or elements. Water, for example, can be decomposed into molecules of hydrogen and oxygen by a process called electrolysis, involving an electric current. Gallic acid, an early developing agent, was heated to produce pyrogallol, a more active developing agent formed in the decomposition.

DEFECTS Defects in photographs can have a wide variety of causes, and this can be multiplied by the diversity of formats and purposes of the work. Defects can include those that are physical in nature, such as curl and dimensioning, that might affect intermediate handling as well as final product performance. These physical attributes may also cause optical and imaging problems, such as excess density resulting from pressure, marks due to kinking of the film, etc. The defects can also be due to such causes as improper photographic processing, contamination of solutions, improper temperature, and inadvertent light fog, to name a few.

PHYSICAL DEFECTS Physical defects such as improper dimensioning, excessive curl, brittleness, or excessively high or low coefficient of friction can have a pronounced effect on processes depending on mechanical handling such as for motion pictures or other continuous processes. Dimensional failures can also be important in applications such as aerial photography for mapping.

Physical problems may also influence the image quality of photographs. Film that is buckled can yield incomplete contact with a printing material or variations in enlarger focus causing a loss in image quality. If dimensions are not properly maintained, loss of pictorial image quality or of optical sound quality can occur due to slippage when

printing motion picture or other continuous films. Glossy surfaces of negatives in contact with pressure glass in enlargers, for example, can cause the interference effect known as *Newton's rings*.

Other physical defects in original images, such as scratches and abrasions, ferrotyping of the emulsion surface, frilling, and the presence of dirt, dust, or other unwanted material will have obvious deleterious effects on photographs printed from them.

PHOTOGRAPHIC DEFECTS Physical problems such as those mentioned above may result in photographic defects that would not in themselves be considered "physical." In addition, however, are defects that are photographic in nature from the beginning. These include image fog, either uniform or nonuniform. Nonuniform fog is more apt to be seen because of the localized changes in density, whereas uniform fog produces an overall reduction in contrast. Fog may be due to improper storage or excessive age of the sensitized material before use, improper processing, cosmic radiation, inadequate safelights, or stray light.

Other photographic defects include stains, areas of uneven density, streaks, and spots due to improper photographic processing. Changes in tone or density of prints, such as plumming, can result from improper drying.

The source of defects may be in the unexposed photographic material itself, although this is very rare. Defects can arise during any of the steps involved in making photographs, including exposure of the film in the camera, processing of the film, exposure or processing of the prints, or during handling, storage, or use of the final image. Care at all steps to prevent defects is usually less costly than later correction.

Defects in the crystal lattice of silver halide grains in emulsions are responsible for higher sensitivity, which is actually a beneficial characteristic.

DEFINITION A general term identifying the microcharacteristics of an image. as distinct from the characteristics of larger areas that are associated with tone reproduction—such as those presented in *D*-log *H* curves. Image definition of photographic images is a combination of the more specific subjective characteristics—sharpness, detail, and graininess—or the corresponding objective characteristics—accutance, resolving power, and granularity. These characteristics can be evaluated subjectively at different criteria levels by examining the image at a normal viewing distance, at close range, through a magnifier, and through a microscope. Objectively, resolving power is measured by examining the image of a test target consisting of parallel black bars on a white background and identifying the smallest set where the bars are still discernible. The results are recorded as lines/mm, for example, 100 lines/mm. Acutance and granularity are

measured by scanning suitable test images with a mathematical interpretations to the resulting data. The highest definition results with a combination of low granularity and solving power and acutance. The separate characteristics are not completely independent, however. An increase in granularity, tends to have an adverse effect on resolving power and acutance.

DEGREE (°) A unit on a scale of temperature.

DEHUMIDIFIER A device that removes humidity from the air by first passing the air over refrigerated coils to condense out the water vapour, and then, in some units, over heated coils to warm it up again. The condensed water is channelled off into a reservoir that must be emptied periodically, or into a drain. Air conditioners also serve as dehumidifiers in warm climates, with the refrigerated coils removing the water vapour and the warm surroundings heating the air back up again.

DEIONIZE Water is deionized by passing the hard water through separate columns that remove the detrimental metallic ions and the acidic ions. Deionized water can be as pure as distilled water, produced by vapourization and condensation of impure water. Water softeners, however, pass impure water over a resin, such as sodium aluminum silicate, that exchanges sodium ions for the calcium and magnesium ions of the hard water.

DENSITOMETER An instrument used for the measurement of the extent to which an area of a photographic image absorbs light. Densitometers are of several types:

Visual, in which the eye compares a sample with a calibrated reference.

Photoelectric, in which a photocell measures the amount of light from a standard source transmitted or reflected by the sample

Transmission, used for the assessment of a transparent material, such as a negative or positive film sample

White-light, whereby the sample is illuminated with the entire spectrum of light

Narrow-band, in which the sample is illuminated with various sections of the spectrum, used in the measurement of colour photographic images

Automatic, which give a printout or a graphical plot of the data from a sample exposed in a sensitometer.

DENSITOMETRY The measurement of the photographic effect in a processed sample. A known illuminance (light level) is caused to fall on the sample, and the transmitted illuminance (for a transparent image) or the reflected illuminance (for a print) is recorded. For a transparent image, photographic density is defined as the logarithm of the ratio of the initial light level to the light

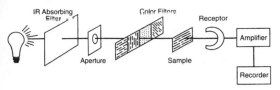

Densitometer. The sample is placed at the right of the aperture.

level after being affected by the sample: $D_t = \log I_o/I_t$. For a print, the reflection density is usually defined as the log of the ratio of the light reflected by the base to that reflected by the sample: $D_r = \log I_b/I_r$.

Theory and experiment have shown that such a definition of density provides numbers that are

1. approximately proportional to the concentration of silver or dye in the image;
2. for pictorial images, related to the visual response of the eye of the viewing person;
3. for negative images, approximately inversely related to the log exposure values they will produce in the printer;
4. additive, so that when a mask is added to a negative in a printer, the total density for each area is the sum of the individual densities.

The preceding statements are correct only if the sample is measured appropriately. The nature of the image strongly affects the effects it will have on received light or other energy, for two reasons: (1) silver images, and to a much smaller extent dye images, scatter light because of their microscopic structure; (2) silver images, and certainly dye images, differently affect energy of different wavelengths; a resulting change in the colour of the original light must be taken into account. For these reasons, measurement of the light transmitted or reflected by the sample involves complex problems of optics and receptor spectral sensitivity.

OPTICAL CONSIDERATIONS An instrument for measuring density—a *densitometer*—consists of two basic parts: the source of energy and the receptor—the eye, or more commonly, a photoelectric cell and associated electrical apparatus.

If the source is, for example, a small lamp and the energy is focused on the sample, the illumination is called *specular*. The scattering effect of silver images causes the light to be dispersed over an angle of nearly half a hemisphere; some of the light is even returned toward the source. If the receptor is placed at an appreciable distance from the sample, only the directly transmitted light is recorded. Such a density is called *specular*. If, however, the receptor is placed in contact with the sample, almost all

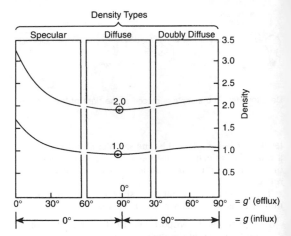

Optical considerations. Variation in film density for a single film sample with angle of illumination and angle of collection. The specular density, at the left, is approximately 3, the diffuse density, at the centre, is close to 2, and the doubly diffuse density, at the right, is more than 2.

the transmitted light is recorded, giving what is called a *diffuse* density. Specular densities are larger, for a given sample, than diffuse densities, the difference being greater for high densities than for low ones.

Following the law of optical reversibility, an alternative method of finding diffuse densities involves providing the sample with diffuse light, as from a ground or opal glass in contact with the sample, and measuring only the directly transmitted light.

A third type of optical system provides diffuse energy to the sample and records the diffusely transmitted energy, giving what is called a *doubly diffuse* density. For a given sample, such a density is intermediate in value between the specular and the diffuse measurement.

Given the variation in measured density with the optical system, the problem of the user is what type of density to measure. The answer is found in the phrase *conform to practice*. For predicting the printing behaviour of a negative, the optical system of the densitometer must be similar to that of the printer. If a condenser-type of projection printer is to be used, the illumination is specular, the collection is also specular, and thus a specular density measurement method would be appropriate. Diffusion-type projection printers, however, provide diffuse light to the negative and collect mostly specular light; for these printers diffuse density measurements are apropos. For a contact printer, doubly diffuse densities would be the most useful predictors.

International standards define diffuse density, and commercially available densitometers provide such data. The predictive value of such measurements is clearly related to the manner in which the negative is to be printed. Practical testing will, to some extent, indicate the reliability of the measured values in determining contrast and exposure characteristics. Such testing may well give different results for negatives of different characteristics, since grain (fine or coarse) affects the amount of scattering.

A further optical consideration involves the size of the aperture in the densitometer. If a very small aperture is used. the sensitivity of the photoelectric system may be impaired. If a very large aperture is used instead, minor defects in the image area may give false readings. The optimum aperture size must be found by trial.

SPECTRAL CONSIDERATIONS A silver image, although nominally said to consist of a set of grays, is in

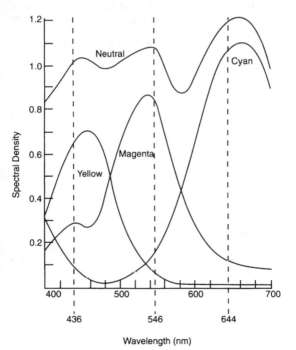

Wavelength (nm)

Spectral considerations. Spectral absorption of the dyes of a positive colour film. The spectral absorptions of the three superimposed dyes and the absorption characteristics of the dyes are shown separately. The measured sample was visually neutral and had a net density of 10 when measured with a conventional densitometer and with white light.

fact rarely neutral in its absorption of radiation. Absorption is greater for short wavelengths (ultraviolet and blue) than for long ones (red and infrared.) The measured density of the sample therefore depends on the spectral characteristics of the radiation source and those of the receptor.

For density values that reliably predict the printing behaviour of a negative, the spectral response of the densitometer must match that of the print material. Print emulsions usually have a greater response to short wavelengths than to long ones. The mismatch between an unmodified densitometer response and that of the print material requires the use of a filter in the densitometer to provide a correlation between the measurement and the effect of the negative in the printer. A perfect match is hardly obtainable, because print materials differ in their response to different wavelengths. Careful testing is needed to assure the reliability of density measurements in predicting negative printing characteristics.

REFLECTION DENSITOMETRY Print samples present special difficulties in measurement because the appearance of a print depends on the nature of the illumination and the way in which the print is viewed. Print samples reflect light diffusely, the reflected light level varying with the angle of illumination, the angle at which it is viewed, and the nature of the surface, whether matt or glossy or textured.

The current standard for print density measurement specifies specular illumination at an angle of 45 degrees and specular collection at an angle of 0 degrees. This method eliminates the glare reflection from a glossy print. Furthermore, since most prints are viewed straight on, the collection method specified by the standard is appropriate. Prints, however, are illuminated in a variety of ways and rarely only at an angle of 45 degrees; thus, the standard may not invariably predict print appearance.

Prints are not often neutral spectrally. For this reason, cautions such as those mentioned previously for negative materials must be applied to print measurement.

An alternative method of estimating print density calls for the use of a calibrated reflection step tablet and a visual comparison of the print area with the tablet. Density values of the tablet are usually given in intervals of 0.10 in density, and careful comparison can estimate the density of a sample to within a few hundredths. An aperture should be made in a sheet of gray paper and placed so that only the image patch being measured and a single patch of the tablet are visible at one time.

COLOUR DENSITOMETRY Each dye of a colour transparency has some absorption for every wavelength of light; thus, every density measurement is affected by all three dyes, as well as by possible fog or stain. The situation is even more difficult for a colour negative, which usually contains coloured masks as well as the other dyes.

Therefore, the spectral characteristics of the light source and the receptor used in the densitometer are especially important.

There are two basic types of colour density:

1. Integral, in which the effects of all three dyes are measured simultaneously.
2. Analytical, obtained by estimating the spectral absorption of each of the dyes separately.

TYPES OF INTEGRAL DENSITY

1. Spectral densities are obtained by using an instrument that subjects the sample successively to narrow bands of wavelengths of light throughout the spectrum.
2. Printing densities are obtained with an instrument that is designed to measure the effect that a sample will have when it is used in a specific printer and with a specific print material. Such a densitometer must be carefully tested so that the results will have useful predictive value.
3. Visual densities indicate the effect that the image will have on a human observer. Again, the densitometer must match a typical viewer in spectral response.
4. Three-filter densities are made by successively introducing into the light path of the densitomeler a blue, a green, and a red filter, usually Wratten 92, 93, and 94. Such measurements are often used in processing control to discover whether or not a processed sample duplicates a standard and therefore to detect a change in the processing system. Such measurements show that a change has occurred but do not identify the cause of the change.

DENSITY A measure of the light-absorbing characteristics of an area of a photographic image, filter, etc. Density is defined as the common logarithm of the ratio of the light received by the sample to that transmitted or reflected by the sample. $D = \log (I_o/I)$, where D is the density, I_o is the illuminance (light level) on the sample, and I is the illuminance falling on the receptor after being affected by the sample.

There are very many types of photographic density, depending on the optical system used in the measuring instrument (the densitometer), the type of image (negative or positive, neutral or coloured) and the colour of light used in the measuring instrument (densitometer).

DENSITY-LOG EXPOSURE CURVE See *Characteristic curve.*

DENSITY RANGE The difference between the densities of the lightest and darkest areas in a photographic image. For a negative, the density range is a measure of

the total contrast of the image and is related to the scale index (tolerable log-H range) of the appropriate printing material. For a positive, the density range is a measure of the extent to which subject tones, from the darkest shadow to the lightest highlight, may be reasonably well recorded.

DENSITY SCALE The range of transmission densities (in negatives and transparencies) or reflection densities (in prints) from unexposed areas to the maximum density (nonreversal materials) or the minimum density (reversal materials) the material can produce. That portion of the density scale that is of practical use in printmaking is called the *useful density scale*.

DENSITY TABLET See *Optical wedge*.

DERMATITIS Inflammation of the skin that can include cracking of the surface and bleeding. Dermatitis can result when an individual becomes sensitized to a certain chemical or group of chemicals after repeated exposure, and the ailment is sometimes identified as contact dermatitis. In photography likely offenders include developing agents, solvents (that tend to remove protective oils), and several chemicals. Some people are more likely to become sensitized than others, but everyone should take care to prevent the problem by avoiding contact with suspect chemicals. If inflammation occurs, consult a doctor.

DESENSITIZER Some dyes act to desensitize or block the normal effect of light upon silver halide materials. After the exposed material is bathed in a dye solution, or the dye is added to the developer, visual inspection of a developing image may be made under dim lighting conditions. Desensitizing dyes must be nonstaining, must be stable in solution, must not attack the latent image, and must not interfere with the processing cycle. Pinakryptol green with low staining properties has been useful for desensitizing.

DESICCANT/DESICCATED Certain substances. called desiccants, have the capacity to absorb water or dehydrate photographic materials. A product called *silica gel*, for example, can absorb up to 50% of its weight in water from atmospheric humidity, then be regenerated by heating.

Photographic chemicals may contain strongly held molecules of water that can be almost completely removed, producing compounds that are termed *desiccated*.

DEVELOPERS The latent image of an exposed silver halide crystal consists of submicroscopic clusters of metallic silver, from a few atoms to a few hundred atoms,

located at various sites that are not randomly distributed. Some silver specks are on the surface, some just under the surface, and others throughout the depths of the crystal. These metallic silver aggregates were formed when photo-electrons, released by light in a tidal flood during the instant of exposure, were trapped fleetingly on impurities or crystal defects. The negative charge of the electrons attracted mobile silver atoms of positive charge, forming neutral atoms of metallic silver. The latent image then grew by the atom-by-atom addition of metallic silver in the split second of light exposure.

The latent image is of no direct use, for it is far too minute. The exposing burst of light, unfortunately, generated only enough electrons to provide the centres of nuclei. More silver atoms are needed to make the nuclei visible and useful. If the light exposure could have been continued, a visible silver image would have resulted. When a silver halide photographic paper, rich in silver ions, is placed behind an image, then given a massive exposure to light energy, a visible metallic silver image is produced on the paper. This is a printout image that strongly suggests that a latent image could be made visible if electrons could be supplied to the unseen silver nuclei.

Electrons cannot exist unbound but are contained in every atom or molecule on earth. Any potential source, however, must supply electrons only to those silver halide crystals that have a latent image. This eliminates all those substances that are too energetic in giving up electrons. Certain compounds are electron rich but less energetic in freeing their electrons. These compounds need the help of the catalytic effect of the silver of the latent image, as less energy is then required for an electron transfer. These compounds are suitable electron donors (in chemistry, reducing agents) to amplify the invisible light-formed image to a visible one. These image amplifiers are called *developing agents* because they grow or develop the latent image to a useful size, finishing the image formation started by the exposing light.

The exposed silver halide crystals receive the electrons first and grow larger first. Some molecules of the developing agent may possess sufficient energy to donate electrons to unexposed crystals. Once a nucleus of silver atoms is formed on the crystal, less energetic molecules can transfer electrons, and nonimage silver may be formed more quickly. The formation of nonimage silver, called *fog*: obscures image detail and limits the degree of image amplification that is possible.

Developers continue the series of events that occurred during the light exposure. After millions of silver atoms have been formed by development, the image becomes visible. If all the silver comes entirely from the silver crystal on which the latent image is located, the visible image is said to have been formed by chemical development.

The latent image can be amplified in another manner. After exposure, all of the unused silver halide in the crystal can be removed, leaving only the silver atoms of each latent image in place in the gelatin layer of the photographic material. A solution containing a developing agent and a soluble silver salt, such as silver nitrate, then is used to treat the gelatin layer. The developing agent donates its available electrons to the silver ions so that metallic silver is catalytically deposited from solution on the silver nuclei of the latent image. This slow form of image amplification is called *physical development* and the solution is a *physical developer*.

Silver salts are not present in the formulas of modern, practical developing solutions. Such solutions do contain, however, compounds that dissolve and etch the silver halide crystals during the initial period when chemical development occurs. The quantity of silver ions in the developing solution will increase with time. Some of the silver ions solubilized from any silver halide crystals, exposed to light or unexposed, will be deposited as metallic silver upon the silver formed by chemical development of the latent image. This combined chemical and physical development, which often occurs as a result of modern development, is called *solution-physical development*.

DEVELOPING AGENTS A wide range of substances have been reported to possess developing activity: polluted lake and river water, old red wine, citrus fruit juice, and even human urine. Thousands of compounds might serve as electron donors to convert exposed silver halide crystals to metallic silver. Metal ions, such as ferrous salts, give up or gain electrons easily in a reversible manner. Many organic molecules can be electron sources, but the reverse action is different. Most of today's developing agents were found between 1880 and 1900 by testing under practical developing conditions. Uncounted organic derivatives have been synthesized in this century, especially for use as colour developing agents.

Most of these early practical developing agents were derivatives of benzene. Benzene itself does not have enough energy to cancel any of its electrons. although its unsaturated condition makes some of its electrons more loosely held than others. The useful compounds had two or more hydrogens of the benzene ring replaced by $-OH$ or $-NH_2$, each or in combination. Two of these groups were usually adjacent on the ring carbons (*ortho*, or 1,2-configuration) or separated by two carbons of the benzene ring (*para*, or 1,4-configuration).

One substitution of only $-OH$ or $-NH_2$ on the benzene ring was not active as an electron donor. Benzene compounds with only $-OCH_3$ and $N(CH_3)_2$, that is, the active groups with their hydrogens replaced, were not developing agents. Substitution of three $-OH$ and NH_2 on the benzene with one ring carbon between (the 1,3,5-configuration) yielded compounds that are not active as

developing agents. Multiple group substitution on benzene, such as the 1,2,3-configuration, produced quite active developing compounds.

Substitution of the hydrogens of the benzene ring with $-OH$ or $-NH_2$ groups provides electron-rich substituents that increase the electron density of the molecule. Both oxygen and nitrogen have electron pairs that are loosely held and are not used for bonding. These mobile electrons convert benzene from a relatively inactive solvent to a molecule that is an active electron donor, a developing agent. This neat electronic explanation of the developing activity of compounds, however, fails to explain why at least two substitutions on the benzene ring are necessary or why the 1,3- or 1,3,5-configuration of groups is not active.

Factors other than electron release must be satisfied to characterize a practical developing agent. The active form of a primary developing agent must be able to adsorb strongly to the surface of the exposed crystal. Compounds with poor surfactant properties, either high water solubility or structural hindrances, are poor or slow developing agents. A stabilized intermediate after losing one electron must be formed; otherwise the free radical may attack the silver in the latent image. Partially oxidized intermediates that have two 1,2- or 1,4-substitutions have the desired stability. Unless the intermediate has sufficient stability, it may instantly reverse the reaction with no net effect. Some compounds that lose two electrons may form an oxidized molecule that can catalyze the development activity of the developing agent.

Many developing agents have been made, but only a very few are used today, ranging from pyrogallol (1850) to ascorbic acid, a sugar derivative (1930s), and Phenidone (1940s). The table gives more details of practical compounds but does not indicate the many derivatives of p-phenylenediamine made in this century that make colour photography possible. After developing the latent image, the oxidized p-phenylenediamine is reacted further with colour-forming compounds to produce the dyes of the colour image. The structure of the developing agent thus affects the colour and stability of the dye. The p-phenylenediamines are poisonous and cause contact dermatitis, so much effort has been made to modify structure to lessen these undesirable properties.

DEVELOPER CONSTITUENTS Developing agents supply the electrons to amplify the latent image, but, unfortunately, will give electrons to other than the latent image. Certain sites on the silver halide surface called fog centres compete for the electrons. Oxygen dissolved in the water avidly seeks electrons. Oxidized forms of the developed agent may interact or stain. Often a second source of electrons, or an electron transfer agent, may be needed to secure the desired developing action.

Developers are more than simple solutions if a developing agent but may also contain

Properties of the Major Developing Agents

Common Name	Hydroquinone	Chloro-hydro-quinone	Catechol	Pyrogallol	para Ammophenol	Amidol
Scientific names	1,4-Dihydroxy-benzene; para-dihydroxy-benzene	2-Chloro- 1,4-di-hydroxyben-zene; 2-chloro-1,4 benzenediol	1,2-Dihydroxy-benzene; ortho-dihydroxy-benzene	Pyrogallic acid; 1,2,3-trihy-droxy-benzene; 1,2,3-benzene triol	4-Amino-1-hydroxy-benzene hydro-chloride; para hydroxyaniline	2,4 Diaminophenol dihydrochloride
Commercial names	Quinol, Tecquinol, Hydroquinol	Adurol, Chloroquinol	Pyrocatechin	Piral, Pyro	Activol, Azol Kodelon, Para, Rhodinal	Acorl, Dianol
Form	Needle-shaped crystals	Needles or leaflets	Needles from water	White crystals	Free base: plates from water. Hydrochloride salt: crystalline.	Crystals
Molecular weight	110.11	144.56	110.11	126.11	Freebase:109.12. Hydrochloride salt: 145.5.	197.01
Melting point (°C)	170	103	105	131.133	Free base: 190. Hydrochloride salt: decomposes about 306	205

Solubility in water (g in 100 ml at 20°C)	8	92	30	40	Free base: 1.2. Hydrochloride salt: 10.	25
Solubility in solvents	Soluble in alcohol and ether. Slightly soluble in benzene.	Soluble in alcohol. Slightly soluble in ether and chloroform.	Soluble in alcohol, benzene, chloroform, ether, pyridine.	Soluble in alcohol and ether. Slightly soluble in benzene and chloroform.	Free base soluble in alcohol and ethyl methyl ketone, slightly soluble in ether, almost insoluble in benzene and chloroform. Hydrochloride salt is soluble in alcohol and slightly soluble in ether.	Free base is slightly soluble in alcohol and acetone, very slightly soluble in ether and chloroform. Hydrochloride salt is soluble in alcohol.
Human toxicity	Relatively safe in very low concentrations. Ingestion of 1g or more may cause serious complications. Contact with skin may cause dermatitis.		Can cause eczematous dermatitis. Ingestion can cause very serious complications. Avoid contact with large areas of skin.	Severe poisoning may result from percutaneous absorption. Inhalation can cause asthma.	Can cause dermatitis and skin sensitization. Inhalation can cause asthma.	Pure compound or oxidation products may cause eczematoid contact dermatitis or bronchial asthma.

Properties of the Major Developing Agents

Common Name	Metol	Glycin	para-Phenylene-diamine	L-Ascorbic Acid	Phenidone
Scientific names	Monomethyl-para-aminophenol sulphate; para-methyl-amino-phenol sulphate	para-(Hydroxyphenyl) glycine; para-hydroxy-phenyl-amino acetic acid	para-Diamino-benzene; 1,4-diaminobenzene	L-Xyloascorbic acid; hexuronic acid	1-Phenyl-3 pyrazolidone; 1 phenyl-3-pyrazilidinone
Commercial names	Elon, Genol, Graphol, Pictol, Photol, Rhodol	Athenon, Glycin, Monazol, Iconyl	Free base: Diamine, Paramine, Metacarbol. Hydrochloride salt: Diamine H, P.D.H., p.p.d .	Vitamin C, many pharmaceutical names such as Ascorin, Cevitex, Cevimin	Phenidone, Graphidone
Form	Crystal	Leaflets from water	White crystals	Crystals (plates or needles)	Leaflets or needles from benzene
Molecular weight	344.38	167.16	108.14	176.12	162.19

128

Melting point (°C)	Free base: 87 Sulphate salt: 260 with decomposition	Browns at 200, begins to melt at 220, completely melted at 247 with decomposition	Freebase: 145-147. Hydrochloride salt: Decomposes without melting.	190–192 some decomposition	121
Solubility in water (g in 100 ml at 20°C)	4	0.02	1	30	2
Solubility in solvents	Freebase very soluble in alcohol, ether, and hot water. Sulphate salt slightly soluble in alcohol and ether, insoluble in benzene.	Low solubility in alcohol, acetone, ether, and benzene.	Freebase solution in alcohol, chloroform, ether. Hydrochloride salt soluble slightly in alcohol and ether.	Soluble in alcohol and propylene glycol. Insoluble in ether, chloroform, benzene.	Soluble in alcohol and benzene. Almost insoluble in ether.
Human toxicity	Can cause skin irritation or sensitization.		Pure compound or oxidation products may cause eczematoid contact dermatitis or bronchial asthma.	Essential vitamin in human nutrition.	Low oral toxicity. No reported cases of dermatitis.

- an alkali to activate the developing agent so that electron transfer is most efficient
- a preservative to protect the developing agent from losing electrons through undesired reactions
- a restrainer or antifoggant to limit image formation to the latent image of exposed silver halide crystals developers
- other chemicals, such as sequestering agents, to inhibit side reactions that might interfere
- special chemicals for specific purposes, such as colour film processing

Preservatives Sodium sulphite is almost universally used to protect the developing agent from oxygen in water and for removing the oxidized forms of many developing agents. Sulphite has many other functions as well. It is mildly alkaline sometimes serving as the sole alkali. It is a solvent for silver; halide crystals, enhancing emulsion speed and promoting fine grain development. Ascorbic acid and sodium isoascorbate, sugars, mercaptoamino acids (cysteine), hydroxylamine, and small quantities of other developing agents have found some use for preserving developing solutions.

Alkalis Developing agents are acids because of the –OH group, bases because of the presence of –NH$_2$, or amphoteric because both are present. The desired form in developers is the one that is most electron-rich. With the acidic group this is the negative charged ion, formed by the loss of the hydrogen ions. With the alkaline group, it is the uncharged –NH$_2$OH form. Each of these forms is produced by making the solution alkaline. Suitable alkalis include sodium and potassium hydroxide, sodium or potassium carbonate, sodium metaborate, ammonia or ammonium salts, and organic amines.

Restrainers and Antifoggants Photographic materials may inherently contain centres (not formed by light) that are developable. Such centres may form during storage, or an active developing agent may in time reduce silver halide crystals that have not had light exposure. Such developed silver is undesirable as it degrades sharpness or fogs the desired image. To prevent this, organic or inorganic antifogging compounds are added to the solution to form hard-to-develop silver compounds. Potassium bromide and iodide and organic compounds, such as benzotriazoles or mercaptotetrazoles, are often present in developers.

Sequestering Agents Calcium and magnesium salts in the water of the developer, or compounds contained in the photographic material itself, may precipitate a sludge from the solution. Sometimes the scum forms on the delicate surface of a photographic emulsion and is difficult to remove. Sequestering compounds combine with the calcium ions to form water-soluble ions to prevent any precipitation. Sodium hexametaphosphate, or ethylene-

Kodak Developer D-76

Order of Addition	Name of Ingredient	Quantity	Purpose of Ingredient
1	Water, about 50°C (125°F)	750 ml	Solvent
2	Kodak Elon developing agent	2 grams	Developing agent
3	Sodium sulphite, desiccated	100 grams	Preservative
4	Hydroquinone	5 grams	Developing agent
5	Borax, granular	2 grams	Alkali
6	Water to make	1 litre	Solvent

diaminetetraacetic acid and its sodium salts, are two examples of compounds, often sold under trademarked names, that are effective in keeping a developing solution free of precipitates.

Special Compounds Colour photography is essentially black-and-white photography using a carefully selected developing agent whose oxidized form reacts with a special compound, called a coupler, to form a coloured dye. In the Kodachrome colour reversal process, the film has three superposed silver halide emulsion layers, each sensitized to a different third of the spectrum. The film contains no colour-forming components. The three developers, one for each layer, contain both the p-phenylenediamine derivative as developing agent and the colour-forming coupler. In a colour negative process, such as Kodacolour, the coupler is dispersed in the film emulsion layer and the developing agent is in the developer. The developing agents and the couplers are chosen as a pair with utmost care so that the optimum dyes are as stable as practical.

The formulas of developers list the chemicals to be added to water in order and the exact amount of each. Each compound should be added slowly and dissolved completely before the next one is added. If the total volume of water is only specified as the last item in the formula, about 3/4 of that amount should be used to dissolve the chemicals, then enough water added to make the final volume.

TYPES OF BLACK-AND-WHITE FILM DEVELOPERS General-purpose photographic films are a compromise among speed, graininess, and sharpness. A high speed film will be grainier than a fine-grain film at the same contrast. A fine-grain film will have less speed and may have less sharpness than the high-speed film. A suitable developer maintains the inherent character of the film without destroying the built-in compromises. As Ansel Adams has noted, "Variations in developers are, in truth, so small that with certain adaptions of exposure and use, almost any developing formula can be used with almost any negative material." In fact, a formula such as

Kodak developer D-72 can be used as a paper print developer and as a rapid-acting or contrast film developer.

Standard or general-purpose developers maintain full emulsion speed, often at the expense of graininess and other image characteristics. These developers were a necessity in the past when photographic films and photographic lenses were slow in speed. Such formulations, such as Kodak developers DK-50 and D-23, are still popular with portrait, scenic, and art photographers who use large-format negatives. The modern approach, however, is to consider the film and the developer as parts of a single system in order to secure the maximum results with the fewest compromises.

Photographic films are designed for specific purposes. Developers are formulated to best achieve those purposes, usually fine grain or high definition or maximum film speed. Separate developers for each of these goals are needed, as one solution cannot satisfy all three at once to a maximum. Successful developers for these purposes optimize one goal by compromising with the other two. Besides the three major groups of developers—fine grain, high definition, and high energy—there are many specialized developers for specific purposes, such as high contrast, tanning, x-ray film, and photographic paper developers.

Fine-Grain Developers A fine-grain developed silver image is more than the result of using a special developing solution. The image formed by development is a nonhomogeneous dispersion of metallic silver filaments of varying size, the larger masses of silver being formed from the large crystals. Fine grain, therefore, starts with the emulsion maker, who must provide a very thin layer of small silver halide crystals with as high a sensitivity as can be obtained. The efficient fine grain developer seeks to maintain these desirable emulsion characteristics.

Graininess is that mottled or mealy appearance that is most evident in the middle densities of the developed silver image, caused by a lack of uniform distribution and size of the silver filaments. Thick emulsion layers increase the possibility of greater graininess because of the overlapping of the filaments in depth. Full or maximum exposure also causes the image to penetrate deeper into the layer. Developing an exposed image to high contrast, or trying to achieve maximum amplification, produces larger deposits of silver. Even high definition development has edge effects that increase the mass of silver in the image. Fine grain silver images are thus a result also of minimum exposure and moderate degrees of development by solutions of low alkalinity.

Most fine-grain developers are one of two general types: (a) Metol or Phenidone solutions of low alkalinity that product low contrast images with near normal emulsion sensitivity, or (b) Metol solutions of low alkalinity containing a silver halide solvent that usually results in some loss

	ID-68	ID-68R
Warm water (50°C (125°F))	750 ml	750 ml
Sodium sulphite (anhydrous of desiccated)	85 g	85 g
Hydroquinone	5 g	8 g
Borax	7 g	7 g
Boric acid	2 g	–
Phenidone	0.13 g	0.22 g
Potassium bromide	1 g	–
Cold water to make	1 litre	1 litre
Dilution	0	Add to ID-68 to maintain level
Time	8 to 10 min, 20°C (68°F)	

of emulsion speed. Kodak developer D-76 is an example of (a) and Metol-sulphite formulas, such as Kodak developer D-23, are examples of (b). Early fine-grain physical developers based on the solvent effect of p-phenylenediamine are not used today because of the great loss in emulsion sensitivity.

The D-76 developer combines low alkalinity and high sulphite concentration to produce fine-grain images. No restrainer is present, so optimum emulsion speed is obtained. D-76 is actually the free base of Metol in 10% sodium sulphite, the borax being used to neutralize the acid that was part of the Metol salt. Hydroquinone is an ineffective developing agent at the pH of this developer solution. The formula of D-76 developer is given in the table on the left.

Phenidone (1-phenyl-3-pyrazolidone) has been used to replace Metol in fine-grain developers. Very small quantities are needed, as this developing agent is regenerated by the larger amounts of hydroquinone. Phenidone has low toxicity and low skin irritation. Ilford developer ID-68 is a buffered borax Phenidone-hydroquinone solution that is said to give emulsion speed as good as D-76 with only a small increase in graininess.

The small contribution of hydroquinone in D-76 can be replaced by simply increasing the amount of Metol, thus eliminating the need for borax. Kodak developer D-23 is representative of the many formulations of Metol with high concentrations of sodium sulphite. The formula of D-23 is simplicity itself: 7.5 grams of Metol and 100 grams of desiccated sodium sulphite in a litre of water. Image graininess is slightly less than that given by developer D-76, but the film emulsion speed is 10 to 20% less. Some of the speed loss can be made up by adding small quantities of an alkali, such as sodium metaborate (Kodak). One such variation is MCW Rapid Developer: 5.5 grams of Metol, 75 grams of anhydrous sodium sulphite, and

5 grams of sodium metaborate in 600 ml water. Development times at 25°C (77°F) are about half those in D-76 at 20°C (68°F).

High-Definition Developers Clarity of detail is an impression of the human mind of the visual appearance of the photograph. Definition is a composite of many factors: graininess, resolving power, sharpness, and contrast being the most important. Sharpness is thought to be the major determinant, as this is the impression that a human being gets when viewing fine image detail. The final image of a sharp edge is also affected by the scatter of the exposing light in the emulsion depth as well as the graininess of the developed image. Objective methods of measuring sharpness, such as acutance or modulation transfer functions, have been used but are subject to some modification by development edge effects.

Definition is influenced by adjacency or edge effects that cause irregular changes in the density of the developed silver image. Such changes are most evident at the boundaries between high and low development. Active developing agents diffuse from areas of low exposure of the exposed material to areas of high exposure, producing increased contour silver at the interface. Development byproducts diffuse from areas of high to low exposure, inhibiting the developing activity.

Edge effects are caused by local chemical changes in the developing solution. Often there is an increase of the silver deposit on the dense side of an abrupt image edge (border effect) or a decrease on the less dense side (fringe effect). The density of the developed image may be related to its size (Eberhard effect). Small images have higher densities than images of larger size, even though both have had the same exposure and development times. In addition, in large areas of high exposure, the local exhaustion of the developing agent plus a drop in the alkalinity causes a decrease in the rate of developing action, a compensating effect that limits the total amount of developed silver in that area.

Fine-grain developers give finely divided silver with a loss of image sharpness; high-definition developers achieve their goal by some increase in graininess. This negative result can be offset by using fine-grain, thin-layer photographic films of low or moderate film speed. These develop image contrast easily, so soft-working developing agents, such as Metol or Phenidone, can be used in solutions of low or moderate alkalinity. Because the developer is used in dilute solution, the solution exhibits a compensating action to limit the amount of metallic silver in areas of high exposure.

High-definition developers are often concentrated solutions or consist of two solutions but are used in diluted form, then discarded after one use. A conventional fine grain developer, such as Kodak D-76, can be diluted with water to form the working solution. The two-solution

developer of Willi Beutler is of the high-definition, one-use type. The formula is listed in the entry "Surface Development." See also the high-acutance formula for the POTA developer that is used for high-contrast, very fine-grain photographic films.

High-Energy Developers Fine-grain and high-definition developers are especially suited for processing small film sizes, such as the 35 mm format. Such developers may also be used for larger-sized films but are not really necessary. High-energy developers are formulated for large format photographic materials because such solutions are rapid acting and produce high emulsion speed. Some high-energy developers are made to yield desired high-image contrast, such as for copying or process work .

High-energy developers usually consist of a single or a superadditive pair of developing agents in highly alkaline solution. Hydroquinone produces high contrast in caustic solution. Two developing agents are combined in developers to yield a full range of image tones with good shadow detail. Maximum emulsion speed is obtained with high-energy Metol-hydroquinone or Phenidone-hydroquinone developers. Neither the Metol nor Phenidone in highly alkaline solutions is restrained by the bromide or iodide ions that are produced during development.

High-contrast developers normally use about 4-10 times as much hydroquinone as Metol or up to 2 grams per litre of Phenidone combined with high concentration of hydroquinone. Rapid acting developers also have high concentrations of developing agents in solution. Some of these formulas are listed in the table. Note that Kodak D-72 may be used as a rapid film developer but is used primarily (when diluted with two parts water) as a developer for black-and-white photographic papers. Kodak developer D-8 is a caustic solution of hydroquinone that yields high contrast but has a short life in solution.

For many years, photographic films did not have enough sensitivity to record images of low light scenes. Developers were often compounded to secure any image under dim illumination. Today, photographic films are available that have speed indexes in the thousands. The preferred route for maximum film speed is by using these films designed for recording the dimly lit scenes, not by using overactive developers to push slow speed films to higher sensitivity. Such attempts trade off desirable image characteristics for the higher speed and contrast.

Generally, as G.I.P. Levenson has stated, full development in D-23 or D-76 gives the highest emulsion speed that the emulsion can give. Levenson concluded, "In my experience, D-76 has always equalled, and has sometimes surpassed, the sensational proprietary super-speed developers, not only for speed but for fineness of grain."

Books: Haist, G., *Modern Photographic Processing*. Volumes 1 and 2. New York, John Wiley, 1979.

DEVELOPERS, COMPENSATING A developing solution that has less than normal activity in high exposure image areas but normal activity in image areas of low exposure. Image contrast is reduced without appreciable loss of detail in the low density areas. Compensating developers are often very dilute solutions in which the developing agent is exhausted in the areas of high exposure.

DEVELOPERS, FILM Chemical solutions containing suitable reducing agents and other compounds that convert the latent image of an exposed photographic material into a visible image. Film developers may be formulated for a specific purpose or may be of more general use.

DEVELOPERS, FINE-GRAIN These chemical solutions are formulated to produce silver particles of minimum size from the latent image of exposed photographic films, especially the 35-mm size. Generally, such developers contain a weakly activated developing agent with considerable amounts of a silver halide solvent, such as sodium sulphite. Fine-grained photographic images are the result of using a fine-grain developer with a photographic film of inherently fine grain.

DEVELOPERS, HIGH-ACTUANCE Chemical solutions can be compounded to secure developed photographic images of high acutance, the objective correlate of sharpness. High acutance images are secured when fine-grain photosensitive film is developed in solutions having a low concentration of a developing agent with a minimum of silver halide solvents. Edge effects are produced that enhance the edge sharpness between areas of different density.

DEVELOPERS, HIGH-CONTRAST Developing solutions can be specially formulated to produce maximum density differentiation between areas of low and high exposure of exposed photographic films. Such energetic developers may consist of high concentrations of a developing agent or agents in highly alkaline solution. Hydroquinone solutions with very low free sulphite concentration also yield high-contrast silver images when used with lithographic films. Maximum contrast is obtained by using high-contrast developers with films designed to produce high-contrast images.

DEVELOPERS, PAPER Chemical solutions that are carefully formulated to produce desirable tone scale, image contrast and colour, and other image characteristics when used to develop paper prints. Paper developers are usually in concentrated form so the stock solution can be diluted with water for use. Paper developers have

Contrast Developers

Ingredient[a]	Kodak D-19	Kodak D-72	Kodak D-8	Ilford ID-13	Ilford ID-72	Wiedermann Document	Wiedermann PQ X-Ray	Willcock No. 2
Water (52°C[125°F])	500 ml	500 ml	750 ml	750 ml	750 ml	750 ml	750 ml	750 ml
Metol	2.0	3.0	—	—	—	—	—	—
Sodium sulphite, desiccated	90.0	45.0	90.9	—	72.0	120	150	100
Potassium metabisulphite	—	—	—	12.5	—	—	—	—
Hydroquinone	8.0	12.0	45.0	12.5	8.8	26	20	30
Phenidone	—	—	—	—	0.22	1.0	1.0	1.5
Sodium carbonate, monohydrate	52.5	80.0	—	—	48.0	—	—	—
Potassium carbonate	—	—	—	—	—	110	75	—
Sodium hydroxide	—	—	37.5	25	—	—	—	25
Potassium hydroxide	—	—	—	—	—	—	—	—
Potassium bromide	5.0	2.0	30.0	12.5	4.0	15.0	8.0	3.4
Benzotriazole	—	—	—	—	0.1	1.0	0.5	1.0
Cold water to make	1.0 litre	1.0 litre	1.0 litre	1.0 litre	1.0 litre	1.0 litre	1.0 litre	1.0 litre
Dilution	None	None	2:1	None	None	1:2	1:2	None
Time (min at 20°C)	5	1 to 3	2	3 to 5	5	2 to 4	5	1/2 to 1

[a]All quantities are in grams unless indicated otherwise.

sometimes been used as film developers, especially for rapid development of larger-sized negatives.

DEVELOPERS, RAPID Developing the latent image of a photographic material in the shortest possible time is the purpose of certain developing solutions. Such developers often contain high concentrations of superadditive developing agents in solutions of high alkalinity.

DEVELOPERS, STAINING Certain low-sulphite developing solutions containing polyhydroxybenzenes (pyrogallol or pyrocatechol, for example) stain and harden (tan) the gelatin in areas of image development of exposed photographic materials. The oxidized forms of the developing agents crosslink the gelatin molecules, decreasing the solubility of the gelatin of the emulsion layer. A stain image also reinforces the silver image when low-sulphite pyrogallol developers are used.

DEVELOPERS, TROPICAL Developers can be used at the higher temperatures of the tropics if formulated with a high salt content to minimize the swelling of the emulsion layer of the photographic films. An inert salt, such as sodium sulphate (not sulphite), may be added to the usual chemical ingredients, or the formulation may contain a high concentration of a normal compound, such as sodium sulphite. Hardening developers containing aldehydes or other hardeners allow high temperature development in the tropics but increased fog may be obtained.

DEVELOPERS, UNIVERSAL Chemical solutions suitable for developing latent images on both photographic film and paper materials have been called universal developers. Most of these are Metol-hydroquinone formulations compounded for processing photographic prints, which can be diluted with water to make less concentrated solutions useful for film development. This compromise developer is less desirable than developer solutions compounded for specific purposes.

DEVELOPING The term *developing* is frequently used as an informal designation for the procedure for the processing of photographic films and papers. More formally, development is the first processing step, which amplifies the latent image to make it visible.

THEORY Basically, photography consists of the exposure of some light-sensitive material to form a latent image and the subsequent processing of this image to form some type of reproduction of the image. In conventional photography, the processing of the image is accomplished through the use of a series of chemical baths. The most important of these is the developer, so the chemical processing of photographic film is sometimes referred to

as developing. Typically, the other processing steps include fixing and washing, and sometimes a stop bath. Colour processes also require a bleach and have two kinds of developers—silver and dye.

The developer is the most important step in developing because developing is the step that converts the latent image formed by the exposure to a visible, useful image. The other processing steps ensure the permanence of this image; the fixer removes the undeveloped silver halides, and the wash removes residual chemicals from the emulsion. The final image in a black-and-white negative or print is made up of grains of metallic silver. These grains resemble steel wool when viewed with an electron microscope. The image appears black because of the scattering of light by the filamentary structure of the grains. Colour films and papers work differently; the image is in the form of dyes that absorb the incident light as opposed to scattering it.

DEVELOPER FUNCTIONS When film is exposed to light (or other form of radiation to which it is sensitive) a chemical change occurs in the silver halide crystals in the emulsion—the silver ions in these crystals gradually begin to change to silver atoms. The amount of light (photons) required to change one ion to an atom varies with the sensitivity and efficiency of the emulsion but is generally quite small. Additional amounts of light convert more ions. After exposure, when the film is placed in the developer, the developer acts to convert the remaining silver ions in certain crystals to metallic silver atoms. The developer selects the crystals to convert by the number of silver atoms previously formed on each crystal by the exposure (latent image). It is said that the silver grains making up the latent image catalyze the development of the entire grain when it is placed in the developer. The rate of development is therefore dependent on the number of silver grains forming the latent image. It is also dependent on the arrangement of the atoms in the grain.

The amplification of the latent image accomplished by the developer is quite large. Typically, a latent image centre on a crystal will contain between three and a few hundred silver atoms. The entire crystal, however, may contain trillions of silver ions. The amplification produced by the developer is the number of silver atoms in the final grain divided by the number of silver atoms in the latent image. As development is allowed to proceed, this amplification increases, initially because the proportion of silver ions converted increases, and subsequently because crystals with smaller and smaller latent image centres are developed to completion. The developer cannot distinguish between the grains perfectly, however, and if development is allowed to proceed too long, significant numbers of unexposed grains may begin to develop.

FACTORS AFFECTING DEVELOPMENT Factors (other than the latent image) that affect the rate of devel-

opment are the developer composition, development time, developer temperature, and agitation. It is the control of these variables that is generally the major concern in development, the exposure having been determined previously.

Developer Composition Developers contain a variety of chemicals, but these chemicals can be grouped into the following functional types.

Developing Agents Developing agents are selective reducing compounds that are responsible for changing the silver ions to silver atoms in the presence of a latent image centre. Different developing agents develop emulsions to different contrasts and at different speeds. Developing agents working in combination can also have a different effect than the additive effect of the agents used individually. The choice of developing agents has a great effect on the behaviour of the developer. (See also: *Developer; Superadditivity.*)

Accelerators The higher the pH of a developer, the faster development occurs. Buffer systems, such as sodium borate or carbonate, are primarily used to raise the pH because they are able to maintain it at a certain value throughout development. The use of a strong alkali such as sodium hydroxide ensures fast development but decreases the useful life of a developer, as strong alkalis tend to oxidize in the presence of air. The choice of alkali is generally dependent on the desired developer activity level and the developing agents used. The pH of most developers is between 7.5 and 14. (See also: *Developers.*)

Restrainers Restrainers serve to limit the rate of reduction of the silver ions and prevent the spontaneous development of unexposed silver halide crystals. These somewhat different functions result in there being two classes of restrainers, general restrainers like potassium bromide and antifoggants such as benzotriazole. In both cases, the purpose of the restrainer is to ensure that the crystals containing a latent image are developed first and that the developed image is free of such artifacts as fog and bromide streaks. (See also: *Developers.*)

Preservatives Preservatives reduce the oxidation of the developing agents due to atmospheric oxygen. They have little effect on the developed image except for helping to ensure that the developer is active when it is used. The most common preservative is sodium sulphite, which also acts as a mild silver halide solvent, thereby reducing the appearance of graininess in the emulsion. (See also: *Developers.*)

Development Time The duration of development determines the degree of completion to which the development is carried out. Longer development times result in the more heavily exposed crystals being more fully developed, and the less heavily exposed crystals beginning to develop. As a result, longer development times result in an increase in speed, contrast, and graininess. Development times are generally chosen to give the most

appropriate contrast, the film choice being a better way to balance speed and graininess.

Development Temperature The rate at which development occurs is highly dependent on temperature. Changes in temperature have much the same effect on the developed image as changes in development time. Different developing agents respond differently to changes in temperature, so it is necessary to know which developer is being used to precisely compensate for a change in temperature with a change in time. A general-purpose equation providing an approximate relationship between changes in development time and temperature is as follows:

$$t_2 = [0.7(T_1 - T_2)] + t_1$$

where t_1 is the original development time; t_2 is the new development time; T_1 is the original temperature in degrees Celsius; and T_2 is the new temperature in degrees Celsius.

Development temperature also affects the developed image in other ways, so there are limits to the range of temperatures that can be used. Older film emulsions, for example, become soft at higher temperatures, resulting in an increase in grain size. At extreme temperatures the emulsion can wrinkle or crack or even peel off the base. Newer emulsions use harder gelatin and are more resistant to these effects, but extreme temperatures can still cause problems. The best results are obtained by adhering to the manufacturers' recommendations. (See also: *Reticulation; Tropical processing.*)

Agitation The type and amount of agitation used during development can have a significant effect on the developed image. (See also: *Agitation.*)

Film manufacturers generally provide guidelines for the development of their products. These guidelines are typically the result of extensive testing and, when followed, give good results for most conditions. There are, however, some general techniques for developing film, a knowledge of which may be assumed by the manufacturer. Also, special conditions may require the use of special techniques and some deviation from the manufacturers' recommendations. (See also: *Zone system.*)

DEVELOPING FILM EXPOSED FOR EXTREMELY LONG OR SHORT TIMES The duration of the exposure affects how the latent image forms in a silver halide crystal and subsequently how the crystal will develop. Long exposure times tend to form one large cluster of silver atoms per crystal. Short exposure times tend to form a number of small clusters on each crystal. It turns out that the size of the cluster is more important than the number of clusters, so films exposed for very long times develop faster than films exposed for very short times. As a result, development should be reduced for very long exposures and increased for very short

exposures to produce normal contrast. The specific amount of change depends on the exposure time, film, and to some extent the developer, but a rule of thumb is to reduce the development time by 10% to 20 for exposures that require correction for low-intensity reciprocity law failure and increase development by the same percentages for exposures that require correction for high-intensity reciprocity law failure. (See also: *Photographic effects*.)

MAINTAINING PROCESSING SOLUTION ACTIVITY An important consideration in subsequent developing runs is the maintenance of processing solution activity. This can be accomplished in several ways.

One-Shot-Processing The simplest method for ensuring proper activity in processing solutions is to use them once and throw them away. The advantage of this method is its simplicity and reliability. Disadvantages include the cost of the chemicals and the environmental impact. A variation on complete one-shot-processing is to use fresh developer each time but to reuse the fixer. This reduces the cost and environmental impact somewhat while retaining most of the advantages. The fixer is tested for exhaustion and is discarded (preferably into a silver recovery system) when exhausted.

Compensating for Activity Changes with Time Changes The most economical way to deal with chemical activity changes in small scale processing is to compensate for the decrease in developer activity with use by increasing the development time accordingly. Most developers contain recommendations for development time increases based on the number of rolls processed. An additional advantage to this technique is that some developers produce slightly superior results when partially used. The disadvantages of this technique are the undesirable effects which may be obtained with colour processes, the slight change of developer characteristics with use, and the reduced shelf life of partially used developers.

Correcting for Activity Changes with Replenishment The most economical way to deal with chemical activity changes in larger scale processing is to correct for the decrease in developer activity with replenishment. Replenishment is accomplished by adding appropriate amounts of specially designed solutions called *replenishers* as film is run through the process. The replenishers compensate chemically for the effects of the use of the processing solutions. An appropriately controlled replenished system can be used indefinitely with good results.

DEVELOPING BLACK-AND-WHITE FILM Development by Inspection The oldest method of development is based on observing the growth of the image. Sheet films are placed in a tray or tank and developed until they have a suitable density range. The development is stopped when the highlights appear dark gray or black and the shadows light gray, judged by looking at the back of the

emulsion. The darkroom has to be illuminated by a suitable safelight that will not further expose the films. To be able to judge the density and contrast of an image under these dim conditions requires considerable experience. Although development by inspection allows for a great amount of control over the development process and consequently the appearance of an image, it is rarely practiced with modern panchromatic films, which do not allow for even the smallest illumination in the darkroom.

Tray Development Sheet films are placed in a tray of developer, emulsion up. They should be immersed quickly, with the immersion followed by good agitation to ensure an even wetting of the surface. The films can also be presoaked in water to prevent air bubbles from being trapped on the emulsion surface, causing uneven development. A safelight may be used during development of blue-sensitive and orthochromatic emulsions, but panchromatic films require total darkness during most of the development step. The development time is predetermined according to the developer composition, temperature, agitation method, and desired development contrast. Two methods of agitation are commonly employed— shuffling and rocking. In tray shuffling, the sheets are removed one at a time from the bottom of the stack and immersed at the top. In tray rocking, the films lie at the bottom of the tray, and the tray is rocked in a somewhat irregular fashion (although some regularity in the rocking is generally necessary to ensure repeatability of the results). The result in both cases is a relatively continuous and random flow of developer across the emulsion surface. With tray shuffling, it is important to place the films in the developer separately to avoid sticking, to take care to avoid scratching, to remove the films from the developer in the same order and at about the same rate they were

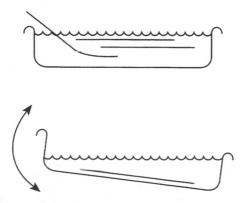

Two methods of tray processing

See-saw agitation method.

immersed, and to always develop the same number of films each time for consistent results. With tray rocking, it is important to maintain even wetting and agitation of all the film surfaces, to prevent the films from overlapping or sticking to each other or the tray, and to agitate in a consistent manner from batch to batch. A flat plate that holds the films apart is quite useful with this type of developing, and temperature control is important as the solutions in trays are sensitive to changes in temperature of the external environment. In all types of processing, the best results are obtained if all of the processing steps are carried out at the same temperature.

By using a see-sawing agitation method, roll films can also be developed in a tray. The two ends of the film are alternately lowered and raised so that the bottom of the loop passes continuously through the solution.

As the end of the development step approaches, the film is drained and placed in a water rinse or stop bath so that immersion in the second solution coincides with the time designated as the end of the first step. The draining time should be regular, and should be determined according to the time necessary for the stream of developer running from the films (and their holder, if one is used) to turn into drops (typically about 10 seconds). Agitation in the subsequent processing steps should be carried out in the same fashion as in the developer. If tray shuffling is used, care should also be taken to prevent cross contamination of the chemicals, as it will be necessary to agitate films in more than one solution at the same time. After rinsing or stopping, the films are placed into a tray containing a fixing solution. The room light can be turned on after the films have been fixed for a few minutes. After fixing, the films should be washed for 30 minutes (or 5 minutes if they are first rinsed in a sodium sulphite solution) in running water at the same temperature as the processing solutions, then immersed in clean water that contains a wetting agent, and then hung up to dry. (See also: *Fixing; Washing; Drying.*)

144

Small tank development.

Small Tank Development Small tanks for roll films usually consist of small, light-tight containers that hold up to eight spiral reels (although tanks that hold more than four or five reels tend to take a long time to fill and drain, thereby giving inferior results). The film is loaded onto spiral reels that hold it in a compact space but allow the developing solutions easy access to all the film surfaces. An older design of tank used aprons with corrugated edges rolled up with the film to accomplish a similar purpose. Many different tanks have been designed for small tank development. Some permit daylight loading although the majority require darkroom loading. The actual loading procedures vary depending on the type of tank used and may require some practice. The manufacturer's instructions should be consulted.

There are basically two different types of spiral reels available, self-loading and centre-loading spirals. In case of the self-loading type, the reel consists of two disks connected by a spindle, with a spiral groove running on the inside faces of each disk until it reaches the spindle at the centre. The separation of the disks is sometimes adjustable so that films of different widths can be processed. The film is pushed into the grooves just past a gripping mechanism. By rotating the disks back and forward, the film is drawn into the spiral. Centre-loading spirals have fixed disks; the film is clipped to the central core. By rotating the entire spiral in one direction and holding the film in a curved position so that it clears the grooves, the film is loaded from the centre toward the outside. These spirals are sometimes provided with a device that maintains the film in a curved position to facilitate loading.

After the film has been loaded onto the reels, the reels are placed into the tank, the tank is closed, and the room lights may be turned on. All processing steps can be

carried out in white light, with the chemicals being poured into and out of the tank through a light-tight baffle (note: these baffles are not always completely light tight, and "daylight" processing tanks should not be used in extremely bright surroundings).

Before processing, the temperature of all the chemicals and the water for rinsing and washing should be adjusted to the desired value. The developing procedure is as follows:

1. Pour in the developer, and tap the tank on the counter several times to dislodge air bubbles.
2. Agitate by either tilting or inverting the tank, rolling the tank back and forth, shaking the tank up and down, or by twisting the reel (see the tank and film manufacturers' instructions). (See also: *Agitation*.)
3. Develop for the predetermined time, allowing for drain time.
4. Pour out the developer so that all the developer is out at the end of the development time.
5. Fill the tank with clean water or an acid stop bath, and agitate for 30 seconds. Repeat if water is used.
6. Pour out the rinse.
7. Pour in the fixer and fix for the required time with agitation. (See also: *Fixing*.)
8. Pour out the fixer. The fixer can be reused until exhausted.
9. Wash, either with running water or changes of water. (See also: *Washing*.)
10. Soak in clean water that contains a wetting agent for about 30 seconds.
11. Dry, preferably at room temperature, in a dust free place. (See also: *Drying*.)

Note: Some films require that the developing solution be placed in the tank and then the reels containing the film added in the dark. Specific agitation techniques may also be required for particular films and tanks. A prewetting step and solutions that allow for extended processing times may also be desirable. Development times of less than 5 minutes generally give inferior results with small tanks.

Large Tank Development Tank, sink, or basket lines are processing arrangements where each tank is filled with a different processing solution, and the films are placed in holders or baskets and moved from tank to tank. These arrangements can be used for larger scale processing than small tanks or trays and are less expensive than processing machines. The tanks are set up in a temperature controlled environment (usually a water bath) to maintain the temperature of the processing solutions at the correct value. The most common size for large tank lines is 3½ gallons or 15 litres, although larger and smaller size tanks are used. Sheet films are kept separated in sheet film hangers, and roll films are wound on spiral reels and

Film developing procedure.

147

Large tank development.

placed into a basket. Agitation occurs by lifting the basket or sheet film holders out of the processing bath, letting them drain, and returning them to the tank, and through the use of nitrogen bursts. After the appropriate processing time, the films are transferred to the next tank for the next processing step. For most panchromatic film materials, the processing must occur in total darkness. (See also: *Agitation.*)

Large tank lines are the smallest scale processing setup where replenishment of the processing solutions is commonly used to maintain solution activity. This allows for more economical processing. To minimize atmospheric oxidation, the tanks are covered with lids, either by covering the top of the tank or floating the lid on the solution.

There are also a number of half or fully automated processing machines with various capacities available. (See also: *Agitation; Automatic processing.*)

DEVELOPING BLACK-AND-WHITE PAPER Experiments have shown that for good reproduction of an average scene in a photographic print, the nonspecular highlights should be reproduced at a density 0.04 above the base white of the paper and the shadow areas should be reproduced at 90% of the maximum density. Unlike negative films, however, the contrast of photographic papers is not readily controlled by development. Some resin-coated (RC) photographic papers, as well as some fibre-based papers, have developing agents incorporated into their emulsions that speed up development, thereby preventing the control of contrast through developer composition and dilution. Even in nondeveloper-incorporated papers, the limits imposed by the minimum and maximum density requirements prevent large amounts of contrast control from being achievable. (See also: *Developer; Tone reproduction.*)

To compensate for different negative contrasts and enlarger characteristics, photographic paper emulsions

148

come in different contrast grades. A grade 0 emulsion, sometimes referred to as a very soft emulsion, can appropriately reproduce a larger negative density range than a grade 5 (extremely hard) emulsion. A grade 2 emulsion is usually referred to as a normal contrast or *medium* paper. These different contrast grades can either be bought separately or, in case of variable contrast papers, be achieved by filtering the enlarger light. To obtain a good print reproduction with a correct contrast range depends primarily on the correct choice of paper grade and the correct exposure. To help determine the correct combination, paper control strips showing a representative part of the image should be exposed and developed. The goal in the developing of black-and-white paper is optimization of the density range and consistency.

Development Characteristics Most commonly used paper developers are Metol-hydroquinone (MQ) or phenidone-hydroquinone (PQ) developers. The normal development temperature for photographic paper is between 18° and 24°C (65° and 75°F) for manual processing. The normal development time at 20°C in a common paper developer is 30 to 90 seconds for RC paper and 90 seconds to 3 minutes for fibre-based paper. Dilution of the developer prolongs the development time accordingly. Excessively short development times should be avoided because the maximum image density cannot be achieved, the image colour may be poor, and the development may not be uniform over the whole print. On the other hand, developing too long carries a risk of fog and staining.

Image Colour The colour of an untoned photographic print is dependent on the manufacturing of the emulsion and the choice of developer. The three components in a developer that affect the colour the most are the developing agent, bromide restrainer, and any organic antifoggant. PQ developers tend to give a cold, bluish image, as they usually contain organic antifoggants. A high bromide content results in a warmer, reddish-brown image. By choosing the appropriate dilution of the developer and adding extra potassium bromide, this effect can be enhanced. (See also: *Developers.*)

Tray Development Most black-and-white photographic print materials are developed on the basis of the developer composition, temperature, and time method, and the inspection method. The correct exposure and paper grade should first be determined by using control strips that are developed with the appropriate time-temperature combination. By using the method of inspection, the development time can be adjusted to compensate for slight under- or overexposure. The type of safelight that can be used for processing is usually indicated in the paper manufacturer's data. Tray development for paper is basically the same as tray development for films. (See also: *Agitation.*)

The procedure for tray development of black-and-white papers is as follows:

1. Each print is immersed face down in the developer and submerged so that the solution flows rapidly over the surface, providing good agitation and preventing any air bubbles from being trapped on the emulsion surface. If more than one print is processed at one time, the prints should be shuffled from bottom to top to ensure even development. Prints can also be processed in pairs, back to back. Prints can be handled using gloved hands (processing chemicals can cause contact dermatitis) or tongs. If tongs are used, care should be taken to prevent scratching of the emulsion.
2. During the required developing time (the time necessary for a completely exposed sheet of the paper to reach its maximum density), the tray may be rocked gently by lifting one edge to ensure even development over the whole surface. Alternatively, the prints may be shuffled, or if there is only one print, it may be flipped over and over. Some local control over print density is also possible by increasing the agitation and development temperature by manually rubbing a particular area of a print. After the specified development time has elapsed, development may be extended if visual inspection reveals the print to be too light (note that the appearance of the print will be different under safelight illumination than under room light). The maximum development time is the maximum time an unexposed sheet of paper can remain in the developer without a significant increase in its base plus fog density.
3. After development, the prints are lifted out of the developer, drained, and placed in an acid stop bath for 10 to 30 seconds. A vigorous, one minute, running water rinse may be used if necessary in place of the stop bath, but this is not desirable as paper fog levels may be increased. The transfer can be done by hand or by using tongs. In any case, care should be taken that the developer is not contaminated by either acid stop bath or fix from a previous processing run.
4. The prints are then drained and transferred into the fixing bath and fixed for the appropriate time. The tray should be agitated regularly. White light can be turned on after this stage is halfway complete. (See also: *Fixing.*)
5. The prints must be washed in running water or changes of water. (See also: *Washing*).
6. The prints are dried by air or by using an appropriate dryer. RC and fibre-based papers usually require different types of dryers. (See also: *Drying, Dryers.*)

When prints are too large for normal developing trays, they may be developed by either see-sawing them through a tray, by processing them in one single large tray and draining the solutions after each step, or by applying the processing solutions with a swab or spray.

For large quantity print processing, various half and fully automated print processing machines are available.

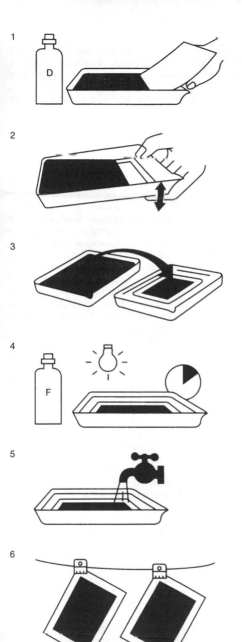

Tray development of black-and-white papers.

DEVELOPMENT A process for producing a visible image from a latent image formed by radiation is called development. With photographic materials, electron donors called developing agents convert exposed silver halide grains to metallic silver. In electrophotography, loner particles are applied to a charged surface to form the visible image.

DEVELOPMENT EFFECTS See *Photographic effects.*

DEVELOPMENT THEORY There are many types of development, but they all rely on the detection by the developing agent of a small nucleus of silver. The agent transfers electrons to this silver nucleus. The electron-rich nucleus incorporates silver ions, causing additional silver metal atoms to form, thereby enlarging the nucleus. One way to classify development is by the source of these silver ions. If they are obtained from the silver halide grains in the coating, it is called chemical development. When they are obtained from a silver salt dissolved in the developer solution, it is called physical development. The latter can take place either while the silver halide grains are present, known as prefixation physical development, or after they have been removed, known as postfixation physical development. The silver solution transfer process is based on the principles of physical development.

CHEMICAL DEVELOPMENT Reducing agents in commercial developers are usually drawn from three classes of aromatic organic compounds: (1) polyphenols, (2) aminophenols, and (3) polyamines. In typical developer formations, these reducing agents will, given enough time, reduce all the silver halide grains to silver metal, whether they have been exposed or not. What makes discrimination between exposed and unexposed grains possible is the presence of the latent image. This centre provides a lower-energy pathway for transfer of electrons from the developing agent to the grain, i.e., the latent image catalyzes the development process. Thus, development of exposed grains occurs at a much faster rate than the development of unexposed grains and, by proper choice of development time, good discrimination between image and fog is achieved.

Developer formulations usually are aqueous-based and include components other than the developing agent. The more-reducing forms of the developing agents are the ionized versions where one or more protons have been removed from the molecule. Thus, high pH (typically 9 to 12) is a characteristic of developer formulations and this is maintained by using buffering agents, such as metaborate/tetraborate, carbonate/bicarbonate, or phosphate/monohydrogen phosphate. The developing agents also can be oxidized by oxygen, so sulphite salts are usually included as a preservative, as well as a scavenger for

oxidized developer, which could retard development. A third common ingredient is bromide ion. This species tends to slow down the development reaction, but it does so more for the unexposed than the exposed grain and thus decreases fog.

It is often convenient to view the development reaction as an electrochemical cell composed of two half cells. In one half cell the silver ions are being reduced to silver metal and in the other half cell reduced developer is being converted to its oxidized form. An electrochemical potential can be calculated or each half cell and the overall potential for the cell is just the difference of the two half cell potentials. If the potential is zero, the system is at equilibrium. If it is positive, then silver is reduced; if it is negative, then silver is oxidized. The latter condition is due to oxidized developer buildup. This can be prevented by incorporating an oxidized developer scavenger, such as sulphite.

The majority of commercial noncolour developing solutions actually contain two developing agents. It has been found that when two agents are present in the right proportion a synergistic effect often occurs. The exact mechanism of this effect is not easily discerned, but it does appear to be some sort of regeneration effect. One of the agents transfers an electron to the growing silver nuclei and is in turn oxidized. This oxidized form then interacts with the reduced from of the second agent and is converted back to the reduced form, ready for another electron transfer to the growing silver nuclei. The oxidized second agent is presumably removed in a sulphite reaction.

Commercial developers are almost exclusively capable of detecting only surface latent image. If the latent image forms more than a few atomic layers below the surface it will go undetected. This is usually not a problem since commercial emulsions are ordinarily made and sensitized so that the latent image forms at or very near the surface. In cases where the latent image, either unintentionally or by design, forms at a location that is unreachable by the developer, the developer formulation must be modified to include a silver halide solvent or recrystallization reagent. These compounds allow the slow dissolution of the silver halide or the disruption of the surface with inward-pointing channels that allow the developer access to internal latent image centres. The optimization of internal latent-image detection involves optimizing the level of these reagents. In favourable cases the efficiency of internal latent-image detection can be as high as that for surface latent image.

PHYSICAL DEVELOPMENT In physical development, the dissolved silver salt is slowly reduced to form a supersaturated silver solution. The presence of the latent image nuclei causes the silver to be deposited from solution, so that the nuclei virtually become silver plated.

In time the physical developer will plate silver at random onto the walls of the development chamber and over the surface of the emulsion coating. Thus, physical developers are inherently unstable and must be mixed just before use.

Chemical development includes to some extent physical development. Even though no silver salt is intentionally added to the developer formulation there are components in the typical developer formulation that can act as silver halide solvents, most notably sulphite because it is present in such large quantities. These solvents can transport silver ions to the site of development whereupon they are reduced to silver. These silver ions may originate elsewhere on the developing grain or form adjacent grains in the coating. This phenomenon is present to some extent in all developers and is known as solution physical development. The extent of solution physical development will depend on the region of the characteristic curve under examination. In the toe (shadows) many grains are undevelopable and they serve as a source for silver ions to take part in solution physical development. In the shoulder (highlights) most grains are developing and the supply of silver ions for solution physical development is low.

COLOUR DEVELOPMENT In colour development the final image is due to a coloured image dye. This is produced by the interaction of the oxidized developer, usually from the paraphenylenediamine class, with a dye precursor to generate the final dye image. Except in the Kodachrome system where the precursor is in the processing solution, the precursors are in the film in the form of oil droplets in the aqueous coating. Each colour record—blue, green, red—contains the precursor for the yellow, magenta, or cyan image dye, respectively. If the developed silver were retained in the coating it would cause unwanted hue shifts in the dye images. For this reason, it is bleached back to silver halide and fixed out along with the undeveloped silver halide. These are the essentials of the colour negative system. Colour reversal systems have a more complicated process, using two developers. The first developer is a noncolour developer—its oxidised form will not react with the image dye precursors. The remaining undeveloped grains are made developable with a fogging solution and then developed with a colour developer to generate a positive dye image. As with colour negative development, all the developed silver is bleached and fixed out.

Books: Haist, G., *Modern Photographic Processing*, New York: John Wiley, 1979; James, T. H., ed.; *The Theory of the Photographic Process*, 4th ed.; New York: Macmillan, 1977 Carroll, B. H., Higgins, G. C., and James, T. H., *Introduction to Photographic Theory*. New York: John Wiley, 1980; Jacobsen, C. I., and Jacobsen, R. E., Developing, 18th ed. London: Focal Press, 1980; Cox, R. J., ed., *Photographic Processing*. London: Academic Press,

1973; Mason, L. F. A., *Photographic Processing Chemistry* London: Focal Press, 1966.

DEWPOINT The temperature at which the water vapour in a particular volume of air or gas will begin to condense. Dewpoint is related to absolute and relative humidity in that it is a measure of the water vapour present in the air. It is dependent on barometric pressure but not on temperature. The dewpoint predicts at what temperature condensation will begin to occur, and can be used to indicate the drying ability of the air when compared to the actual temperature.

DICHROIC FOG The nonimage-forming density produced when some of the silver halide in an emulsion is dissolved during the developing process, migrates to a different location, and is subsequently reduced. The resulting silver deposit often appears to change colour with changes in viewing conditions.

DICHROMATE PROCESS See *Gum bichromate printing process; Carbon process.*

DIFFERENTIAL HARDENING PROCESS Any process in which exposure causes a material to harden in proportion to the amount of radiation that strikes it. Niépce used bitumen of Judea for his 1820s heliographs. Gelatin hardens in the carbon and carbro processes. Photopolymerization is central to many photomechanical printing processes.

DIFFERENTIAL REEXPOSURE In processing nonincorporated-coupler reversal colour film, the procedure of making all remaining silver halides (after formation of the negative images) developable, one layer at a time, by fogging with light. For example, red light can be used to fog one layer because only one layer is sensitive to red light. After each of the two layers has been reexposed and developed in an appropriate coupler developer, the third layer can be fogged chemically.

DIFFUSE DENSITY The result of the measurement of the absorption of light by a film sample using either of the following two optical arrangements:

1. The sample is illuminated by specular (focused) light, and nearly all the light transmitted by the sample is recorded.
2. The sample is illuminated with light incident through nearly a hemisphere, and only the directly transmitted light is recorded.

Such a measurement is useful for predicting the printing characteristics of a negative in a diffusion enlarger and is the standard method for negative measurement.

DIFFUSE REFLECTION Reflection of light in many directions. A subject producing a perfectly diffuse reflection would have the same luminance regardless of the angle from which it is viewed. Although no surfaces produce perfect diffuse reflections, matt white paper approximates the effect.

DIFFUSION TRANSFER Diffusion transfer is a reversal process yielding positive prints or transparencies in black and white or colour. There are three essential components: a silver halide emulsion with or without dyes, an image-receiving layer, and a processing solution. The emulsion is exposed; a negative image is developed; the remaining unsensitized positive image diffuses in the processing solution and transfers to the image-receiving layer where the positive image forms. The process takes as little as 15 seconds, or as much as a few minutes, depending upon the material employed and the conditions of use.

While the process has its roots in the nineteenth century, its development and application stand as a touchstone of innovation in photochemical imaging in the mid-twentieth century. In 1857, Belfield Lefevre moistened a processed daguerreotype plate with thiosulphate and pressed it against gelatin-coated paper, causing all the particles forming the image to transfer to the paper. In 1899, the German colloid chemist Raphael Eduard Liesegang caused diffusion transfer by coating a glass plate with a gelatin-gallic acid mixture and pressing it against a silver chloride print that contained silver nitrate. The silver nitrate diffused from the print to the plate where it was reduced by the gallic acid, forming a negative image.

The fundamentals of the diffusion-transfer process in use today were arrived at independently, and virtually simultaneously, by Andre Rott, working for Gevaert in Belgium, and Edith Weyde, of Agfa in Germany. In 1939, they took patents for silver diffusion-transfer copying systems, the first of which was marketed in 1940 by Gevaert as Transargo. Diffusion transfer was adapted to become a practical, in-camera photographic process by Edwin H. Land and his colleagues at Polaroid. They began the design of a one-step system in 1943, published their first photograph in 1946, gave their first public demonstration in February of 1947, and introduced the first one-step camera, the Model 95, in late 1948.

In black-and-white, peel-apart diffusion-transfer imaging, the negative-material has a silver halide emulsion, the effective speed of which may be very slow for reflex copying, or as high as ISO 3000 for motion or low-light work. The gelatin has hardening agents added to limit swelling during processing and antifoggants to ensure that all unexposed silver is retained for the positive image. A highly alkaline developer is incorporated in the emulsion. Its components may include metol, hydroquinone, phenidone, gallic acid, or

pyrogallol, selected to produce development fast enough to be complete before the solubilization of the silver halide begins.

The positive material is not light sensitive. Its functions are to receive diffused silver complexes as they transfer from the negative material and to provide the development nuclei around which silver will be deposited. Substances used to form these catalytic sites include several sulphides of metals colloids of silver and some organic sulphur compounds. Additional developing agents to speed up the process may be incorporated in the receiving material.

The alkaline processing solution activates the developer and provides the silver complexing agent that separates the silver halides of the positive image from those that were developed to form the negative image, enabling the transfer by diffusion of the undeveloped positive to the receiver. Common complexing agents are sodium thiosulphate, ammonium thiosulphate, sodium thiocyanate, ammonia, and sodium cyanide. The processing solution usually contains viscosity enhancers to promote even spreading, and restraining agents to minimize fog. Additives also increase the rate of silver transfer, improving image density.

After exposure, the peel-apart process requires that the negative and receiver be pulled between rollers, forcing the sheets together and bursting a pod containing the processing solution. The solution activates the developer, wherever it is located. The negative image develops quickly; the remaining positive-forming silver halides form complexes that diffuse into the processing solution and migrate to the receiver where they are attracted by the development nuclei, forming the positive image. When the sheets are peeled apart, the negative sheet covered with processing solution is discarded and the print remains.

Some diffusion-transfer materials are one piece, integral picture units that do not require peeling. Alter exposure, the sealed assembly passes through rollers, bursting the pod. The light-sensitive emulsion must be protected from fogging by ambient light as it exits from the camera. An opacifying layer is incorporated in the processing solution; it protects the negative below and then reverses itself; becoming transparent by the conclusion of processing. Development and diffusion-transfer products must be concealed when processing is completed because they cannot be discarded. To separate the negative and consumed chemicals from the positive image, a white pigment interlayer forms beneath the image, becoming the reflective surface against which the image will be viewed.

Colour prints are produced by the dye diffusion transfer process. The multilayer films have red, green, and blue sensitive layers interleaved with their respective metallized dye developers that form cyan, magenta, and yellow subtractive dyes. Development in exposed areas is begun

157

as in black-and-white processing: the material passes through rollers that burst the pod containing the viscous processing reagent, spreading it across the negative. In colour, there is a separate developer for each emulsion layer. Developed dye/developer molecules are immobilized; undeveloped molecules migrate through the emulsion to the mordanted receiver, forming the positive image.

In areas exposed to red light, cyan dye developer is concealed beneath the white pigment; the yellow and magenta dye developers transfer to the receiver where they absorb blue and green but reflect red, so that area appears red. In areas exposed to blue light, yellow dye developer is immobilized; magenta and cyan dye developers transfer to the receiver where they absorb green and red, making the area appear blue. Magenta dye developer is immobilized by exposure to green light; yellow and cyan dye developers transfer, absorbing blue and red, making the area appear green. Exposure to white light causes all the dye developers to be immobilized; no exposure causes all the dye developers to transfer, forming black.

Diffusion transfer is the basis of an interesting variety of materials. Polaroid makes an additive screen 35-mm colour transparency film called Polachrome that is reminiscent of screen process and lenticular products of the 1920s. Exposure is through a screen consisting of 3000 parallel red, green, and blue lines to an emulsion that forms a black-and-white positive image by peel-apart diffusion transfer. White light projected through the back is modulated by the emulsion densities and broken into its primary colour components by the screen to form an image that is positive and colour correct. Polaroid also offered a colour additive screen motion picture film called Polavision.

Kodak's Ektaflex system offered peel-apart diffusion transfer printing materials consisting of films for printing from positives or negatives, receiver paper, and alkaline activator solution. Agfachrome Speed was a single sheet, self-contained material, tray processed in activator, for printing from transparencies. Kodak Instant Print Color Film used fast, direct-reversal emulsions exposed from the base side. The oxidation of the processing chemicals caused dye releasers to release, rather than form, dyes which then diffused to the receiver.

Current diffusion-transfer materials include 35-mm peel-apart colour, black-and-white and white-on-blue transparency films, colour, and black-and-white pack films whose speeds reach 3000, sheet films that yield both a print and a negative, colour and black-and-white integral films, sheet x-ray and radiographic films, and colour print materials to 20 × 24 inches and beyond. Large diffusion-transfer prints have been very popular with photographers who sell prints and with the people who collect them because each print is unique.

DIFFUSION TRANSFER REVERSAL See *Diffusion transfer.*

DIGESTION In the manufacture of silver halide emulsions, after grain precipitation and growth followed by the removal of undesired chemicals, the emulsion is given a second heat treatment called *digestion*. During this afterripening period, the emulsion sensitivity is increased by the formation of more effective surface centres on the surface of the silver halide crystals.

DILUTION (1) The act of adding water to a stock or other solution for use. (2) In adding water to weaken a solution, the volume ratio of stock solution to water, for example, 1:2 (1 part stock solution to 2 parts water).

DILUTION FORMULA See *Appendix D.*

DIMENSIONAL CORRECTION Expansion of fibre-based paper during the wet processing and washing stages tends to be largely permanent if the print is ferrotyped during drying and the material is thus not allowed to return to its expected lower dimension as the result of drying. Similar failures in expected dimensional changes can occur with other materials if they are restrained during the drying process. In cases of this kind, the normal expected dimensions can be approached if the material is reprocessed, or resoaked in water followed by the corrected drying procedure. Complete correction is not usually achieved, however.

Permanent changes in dimension can result from losses in solvents or stabilizers, or to stress changes during drying or storage. Materials subjected to these kinds of conditions are not restored by reprocessing or reconditioning.

Shrinkage at the edges of sheet films due to greater loss of solvents than in the other areas may cause a *cupping* of the sheet that could prevent uniform contact when printing. This difference in dimension would also introduce problems where the image is used for making measurements. This type of defect is practically impossible to correct.

DIMENSIONAL STABILITY The ability of a material to resist changes in size or shape caused by changes in temperature, humidity, processing, or age. It is normally expressed as a percentage change in length or width of the material. (Even length and width stability can differ; fibre-base paper is notorious for shrinking more in width than in length.) The commonly available materials can be ranked in order of decreasing dimensional stability: glass plates, polyester film, acetate film, resin-coated paper, fibre-base paper. For most materials, wet chemical processing is the greatest influence on stability, but environmental influences cannot be ignored.

For work of the very high dimensional accuracy, glass plates are the outstanding choice. (Some ultra precise work has necessitated fused quartz, with its even lower index of thermal expansion.) Masks used in semiconductor manufacture and plates for positional astronomy (sky mapping) are always glass. Photogrammetric mapping from aerial surveys, formerly done on glass plates, now uses polyester film for both the original aerial photography and for the diapositives in the stereogrammetric plotters. Some manufacturers publish extensive data on the dimensional stability of their materials.

With the general availability of many emulsions on polyester support, most needs for metric accuracy are now easily met. For ordinary pictorial photography, acetate roll film is adequate, and the polyester base of many sheet films is far more stable than required.

DIRECT POSITIVE (1) Applied to films and papers that yield a positive image of the subject following reversal processing. Typically the major processing steps are: image exposure (forms negative latent image), first developer (forms visible negative image), bleach (destroys visible negative image), general nonimage exposure (fogs remaining silver halide), second developer (forms visible positive image), fix, wash. (2) Identifying a photographic process that yields a positive image directly from a positive original without the intermediate formation of a negative image, for example, *Autopositive, dyeline, Thermofax*, and *xerographic* processes for document copying.

DISLOCATION A crystal defect in which part of a plane of ions is missing.

DISPERSITY A distribution of properties or sizes. As applied to photographic emulsions, it can relate to its distribution of grain sizes. Emulsions possessing a broad range of sizes are said to be polydisperse, whereas those possessing a very narrow range of grain sizes are said to be monodisperse. With regard to latent-image formation, it refers to a distribution of silver photoproduct. The silver nuclei form at many sites on the grain surface, rather than at a single site. Depending on the minimum developable size of the latent image, the dispersity can be an inefficiency in the image-recording stage.

DISSOCIATION In water solution, compounds may come apart or dissociate into negatively and positively charged particles called ions. Ions, which may contain one or more elements, take part in chemical reactions, sometimes merely interchanging and in other cases undergoing electronic changes. Sometimes certain compounds form ions by a process called ionization. This is a type of dissociation in which the water separates and surrounds the ions of the solute.

DISTILLED An adjective that describes a liquid that has been vapourized and then condensed to a liquid. Distillation purifies liquids by leaving the impurities behind or separates mixed liquids with different boiling points. Water, for example, is converted to steam by heating, then condensed by cooling to produce distilled water. This purified water is especially suitable for making photographic solutions because any interfering impurities have been removed.

DOCTOR BLADE That part of a coating machine that regulates the thickness of a liquid layer being spread on a support.

DOPE (FILM-BASE) Film base in liquid form before removal of solvents in the manufacturing process. Usually cellulose triacetate and plasticisers dissolved in a mixture of organic solvents to the consistency of a syrup.

DOPE, RETOUCHING Retouching *dope, fluid,* or *lacquer* is a commercially available medium in a spirit or essential oil solvent, which when applied to the surface of a negative imparts a "tooth" that accepts pencil retouching. A drop or so of the fluid is applied to the surface of the negative and rubbed with a tuft of cotton until dry. Most negative materials are manufactured with surfaces intended to accept retouching, but in some cases additional treatment is needed. The fluid can also be used to remove retouching marks if the first results are not correct.

DOUBLE-COATED In camera negative films, describes the coating of two emulsions on one side of general-purpose films, usually a fast component over a slower one, to extend tonal range and exposure latitude. Since this is now the usual practice, it does not often serve to differentiate one film from another. Seldom used.

 In x-ray films, describes the coating of emulsion on both sides of the base, allowing extremely high amounts of silver halide to be carried. Putting such a large amount on one side would lead to coating and processing problems and to excessive curl. High silver content is necessary for efficient capture of x-ray energy.

DOUBLE DECOMPOSITION *Double replacement* and *metathesis* are other names for this reaction in which two reactive compounds interchange their negative ions. In order for the reaction to complete, one of the products must be a precipitate, a gas, or not an ionic compound. For example, during emulsion making, silver nitrate reacts with potassium bromide to form precipitated silver bromide crystals in gelatin solution: $AgNO_3 + KBr \rightarrow AgBr \downarrow + KNO_3$. This double decomposition or replacement reaction completes, that is, removes all the silver ions to make silver bromide.

161

DOUBLE JET A method of formation of silver halide crystals for a photographic emulsion that consists of adding a solution of silver nitrate from one stream or jet and a solution of a halide compound from another jet into a stirred gelatin solution. Many factors or variations in technique influence the nature of the crystals precipitated, such as rate of addition, the presence of excess halide, temperature and stirring variations, and the presence of other addenda.

DOUBLE-WEIGHT (DW) Photographic printing paper thicker than medium-weight, single-weight, and lightweight papers, but thinner than premium weight. Paper thickness standards vary among manufacturers.

DOUBLY DIFFUSE DENSITY The result of the measurement of the absorption of light by a negative illuminated with scattered (diffused) light when all the transmitted light—direct and scattered—is recorded. Such a method usefully predicts the printing behaviour of a negative in a contact printer, but no commercially available densitometer measures negatives in this manner.

DRUM PROCESSOR A device containing a rotating cylinder used for processing exposed photosensitive materials. With one type, the sensitized material and a small quantity of processing solution are placed inside the drum. The solution remains on the bottom and the sensitized material rotates through it. With another type, the sensitized material is attached to the outside of the drum, the bottom of which rotates through a shallow tray of processing solution.

DRYING The final step of film or print processing is drying. Careful handling during this step will prevent any last-minute defects that can damage the work. With film or paper, a complete washing of the material must be performed just before drying. Drying should commence immediately; it is important to not prolong the wet time beyond what is required. This is especially true with resin-coated papers, as they will begin to swell and separate if overwashed. The use of excessive heat when drying any photographic material is not recommended because of the potential for cracking the emulsion.

Just before drying, film should be treated with a wetting agent such as Kodak Photo-Flo to prevent water spots. Water spots or streaks can cause uneven density that may be impossible to remove once dry. If a wetting agent is not used, the film must be gently wiped with a photo chamois or soft rubber squeegee. Extreme care must be used to prevent scratching the emulsion.

Film can be hung from a line in the darkroom or can be dried in a heated drying cabinet. In either case, a dust-free environment is essential. A weighted clip must be attached

to the bottom of roll film to prevent curling. Sheet film is hung from one corner with a clothes pin or clip. Wooden clothes pins are recommended; they grip film better than plastic and are less likely than metal to damage the emulsion. Drying cabinets provide a faster and more controlled alternative to line drying. Heated air is forced through the cabinet with a small fan. The air can be filtered, preventing any dust from sticking to the film. Larger drying cabinets can be configured to hold several rolls of film and/or multiple sheets.

Print drying can be accomplished in several ways, depending on the type of paper and the surface finish desired. Resin-coated paper can be hung on a line, laid on racks, or run through an RC print dryer. Before drying, RC prints must be squeegeed on both sides to remove surface water. To line dry RC prints, one should hang them from one corner in the same fashion as sheet film. Drying racks made of nylon screen stretched across a frame are an alternative to line drying. RC prints should be placed face-up on the screens. Depending on temperature and relative humidity, these two methods will result in a drying time of several minutes to an hour. Heated RC print driers will provide drying times of one to two minutes. These driers first press the print through rubber rollers, removing all surface water. A series of alternating racks or rollers will then move the prints through a stream of heated air. Regardless of the method used, RC prints will normally lie flat because of the dimensional stability of the material.

Fibre-based prints are generally air dried on screens or in heated print driers. To screen dry, excess water is squeegeed off and the prints are laid face-down on the screen. Depending on the weight of the paper, a certain amount of curling will occur. This method of drying is preferred for maximum archival stability, because the screens are easily cleaned and provide less chance of contamination.

Heated fibre-based driers are available in two configurations: flat-bed and rotary. Flat-bed driers consist of a heated, polished metal surface with a cloth apron that holds the prints in place. Rotary driers use a motorized, polished, circular drum with a continuous apron. Glossy or matt surface papers can be dried in both types. Glossy prints are soaked in a flattening/glossing solution and are then placed facing the metal surface. This solution helps reduce curl and produces a high gloss finish on the print. Matt-surface prints should be placed facing the cloth apron. Lower heat settings will reduce the amount of curl.

DRYING MARKS Marks left on the surface of film or paper as a result of uneven drying. The marks take the form of patches of plus, or more commonly, minus density. Drying marks can be prevented by adding a wetting agent to the final rinse or by carefully sponging all the water drops from the surface of the film or paper.

DRY MOUNTING A process of attaching a photograph to mount board or other substrate using a sheet of dry-mount tissue or dry-mounting adhesive. The dry-mount tissue can be a thin glassine tissue coated on both sides with shellac or a similar permanent adhesive, or it can be a self trimming heat-activated adhesive sheet, or a sheet of porous tissue coated with a thermal adhesive that may or may not be heat activated. The purpose of mounting the photograph is to protect it, to keep it flat, and to display it. The mounted photograph and mount board can then be further protected or enhanced by window matting and framing.

Cold pressure-sensitive mounting adhesives may require a combination or cold mounting press to help strip a protective backing from the adhesive material while the adhesive material is being attached to the back of the photograph and pressed against the substrate.

Heat-activated dry-mount tissues or dry-mounting adhesives require a dry-mount or combination press that applies heat and pressure to the photograph and the mount board during the mounting process. The heat-activated dry-mount materials are placed into either a vacuum or mechanical thermostatically controlled dry-mount press. The shellac type of dry-mount tissue melts at temperatures in the 185-225°F range, which is appropriate for fibre-based papers. Other dry-mounting adhesives are designed for use with colour and resin-coated papers; these tissues have lower melting temperatures so there is less chance of damaging the print because the dry-mount press is too hot.

The mounting adhesive melts and is absorbed into the back of the print and into the surface of the mount board. As the adhesive cools (under weight or pressure) the bond sets. Some dry-mount adhesives can be reheated so that the print can be removed from the mount board; some mounting materials are permanent bonds and cannot be reversed.

The process of attaching the print to a mount board with dry-mount tissue is a simple one, but it is necessary to use a dry-mount press. First, preheat the print and the mount board, separately, to drive out any moisture. Then tack the dry-mount tissue to the back of the print with a tacking iron. The photograph and the dry-mount tissue are trimmed after they are tacked together so the dry-mount tissue and the photograph to which it is attached are the

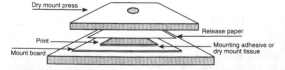

Mounting a print.

exact same size. It is important to maintain square edges and corners when preparing the print or it will appear crooked on the mount board.

After the print and mounting material are trimmed, the dry-mounting tissue (or mounting adhesive) is tacked down at each of the tissue's corners to the mount board surface with a tacking iron. (To prevent melting a hole through a sheet of the nontissue-type solid adhesive mounting material, a Teflon- or silicone-treated release paper should be used between the tacking iron and the adhesive surface.) Since the tissue is not tacked down to the print at the corners they are free to expand over the dry-mount tissue when the two are heated together in the dry-mount press. This is done to ensure that the print will cover the tissue and that the tissue will not extend beyond the edges of the print during and after the mounting process.

The placement of the print and tissue on the mount board is determined by the mounting style selected: flush mount, border mount, or over-matted. For a flush or bleed mount, the print is mounted to the mount board and the two are trimmed square to the desired finished size. With hardboard or other hard surfaced mounting material, the board is first trimmed square to the finished size of the print. Then the print is mounted to the hardboard surface, and any over-hanging print area is trimmed off with a mat knife. The cut edges of the print and mount board can be finished off and sealed with tape or paint.

The bordered print can be positioned in several ways. Centre-finding rulers and T-squares help align the print to the mount board; some of these devices even build a signature space into the lower portion of the mount. Another technique is to visually align the print on the mount board and make the final adjustments with a ruler to ensure squareness. Measuring down from the mount board edge with a ruler and marking the mount board with a pencil dot at two points which will be used to line up the corners of the print, will also provide correct print positioning.

The window mat mounting technique can be done in two ways. The reveal-matted method requires that the window opening is cut larger than the print size so that when the

Dry mounting. Tacking down the dry-mounting tissue.

mat is placed over the mounted print, a small amount of the mount board around the print shows through the window opening. This method needs to be much more accurate than the overlap window method since the area around the print will accentuate any off-squareness.

For the overlap window method, it may be more convenient to tack the dry-mount tissue to the back of the print and trim the print to size first. Then position the print on the mount board to determine how much overlap is needed to just barely cover the edges of the print. Use a scribing tool, mark the mat board, and then cut the window mat opening using exactly the same size board as the print is mounted on. Position the print with the dry-mount tissue attached, so that it is positioned under the window opening with the correct amount of overlap. Then, carefully remove the window mat and tack the dry-mount tissue to the mount board and place the print into the dry-mount press for the required length of time. Remove and cool the print and attach the window mat with linen tape to the mount board.

Whichever method is used, after tacking the four corners of the dry-mount tissue (with the print tacked to it in the centre) to the mounting surface, cover the face of the print with a sheet of Teflon or silicone release paper or a sheet of kraft paper. Then place the print and mount board into a hot dry-mounting press. Close the press for the desired length of time, approximately 10–15 seconds. The time that the print and mount board should remain in the press will depend upon the kind of dry-mounting adhesive used the size of the print, the thickness of the mount board, and the temperature of the mounting press.

The mounted print is removed from the dry-mount press and immediately placed under some weight and allowed to cool; after it has cooled for a few minutes, the mounted print should be flexed (assuming that the mount board is a nonrigid board). If the print has not adhered properly to the mount board, it will pop and begin to separate. Should this happen, to properly readhere the print to the mount board place the *mounted print* back into the hot press and repeat the process, increasing the time in the press.

The type of mounting materials used will determine the degree of archival permanence of the photograph. Acid-free archival boards and archival dry-mount adhesives will provide the greatest print permanence. In general, dry-mounting adhesives will help protect the back of the print rom chemical substances in the mount board.

Cold-mount adhesives require only pressure to attach the photographs to mount boards and other substrates. Although a hand burnisher will be useful in mounting small prints, a roller cold-mount press is highly desirable for larger-sized prints. Some cold-mount tissues are easily removable; some are designed to be repositionable for short periods of time, but most cold-mount adhesives bond

permanently. It is important to know the tissue character-
istics before the process begins. Some colour prints should
not be heat mounted, in which case cold-mount adhesives
are the only choice.

DRY PROCESS In photography, a dry process is one
that requires no water in any of its steps. Electro-
photography copiers and laser printers are dry, as are
diazonium salt, or diazo processes. Several photothermo-
graphic processes are dry as well. Printing-out-paper
(POP) produces an image by exposure alone, but the
image is not permanent. No dry silver halide imaging
process has been devised.

DRY-TO-DRY (1) Identifying a processor that auto-
matically wet-processes exposed photographic material,
including the removal of water. (2) Indicating a complete
processing cycle with any of various wet processes, as, for
example, in dry-to-dry time.

DULLING SPRAY A liquid sprayed on polished metal
and other glossy surfaces that dries to a matt finish and
diffuses reflections from those surfaces. Commercially
available dulling spray does not harden as it dries and is
easily removable from most surfaces, but smears easily.
Matt varnish produces a similar effect and is more easily
handled, but permanent.

DYE BLEACHING Dye bleaching sometimes offers a
method for lowering the dye strength of images. Formulas
have been provided for selective bleaching of specific dyes
in a subtractive colour image in order to bring it into
colour balance. The bleach formula depends on the partic-
ular type of dye used to produce the image; thus there is
no general information available. Non-selective dye bleach
formulas have been used to remove black spots from
prints, for example, then the resulting white spot can be
retouched with dye to match the surrounding area.

DYE-BLEACH PROCESS See *Silver-dye bleach
process*.

DYE COUPLING Almost all modern colour films are
coupler incorporated, meaning that part of the material
that forms dyes upon development is included in the
emulsion when the film is manufactured. During develop-
ment, oxidized developer components react with these
couplers to form dyes in proportion to the amount of
silver deposited at each development site. The silver is
removed by bleach and fixer, leaving just the dye image.

DYE DESENSITIZER Dyes can be used to decrease
the light sensitivity of silver halide materials after
exposure. The desensitizer is thought to act by displacing

the sensitizing dye on the surface of the silver halide crystal or by competing for photoelectrons when light strikes the crystal. Phenosafranine and pinakryptol green, yellow, or white, are examples of dye desensitizers.

DYE DESTRUCTION PROCESS Colour system that depends upon the selective bleaching of dyes existing fully formed in a sensified material rather than by forming dyes during processing.

See also: *Silver-dye bleach process.*

DYE IMBIBITION Assembly process for making colour prints from matrices produced from three separation negatives. The matrices are gelatin relief images that are soaked in yellow, magenta, and cyan dyes and transferred in register to a support. A mordant on the support helps the dye to adhere. In the Technicolor process, the assembly is made on positive motion picture film. Jose Pé introduced a workable dye imbibition process in the 1920s, some forerunners of which were E. Edwards' system of 1875, the Tegeotype, Pinatype, and hydrotype. In the mid-1930s, Eastman Kodak developed a unified dye imbibition system called washoff relief, later changed to dye transfer.

DYEING Dyeing refers to the application of dye to an image, generally uniformly, but in some cases selectively. Dyeing is different from dye toning where the dye is taken up only in image areas that have been mordanted or otherwise treated. In its simplest form, the paper print or film transparency (as in early motion pictures) is dyed to the desired colour. The black-and-white image is unchanged. Hand colouring is an example of selective dyeing of monochrome images.

Colour photographs may be uniformly dyed to balance an unwanted stain or tint that is most evident in the highlights. Colour prints or transparencies may also be selectively dyed to modify or correct specific areas of the image.

DYE MORDANT Chemical substance that adsorbs dye to a support and reduces its solubility. It is often used in dye-imbibition and dye transfer processes.

DYE RETOUCHING Colour negatives, transparencies, and prints can be retouched with dyes to correct or modify details. The dye solutions are applied to the areas to be treated by means of a small brush. The dye densities of the three images are adjusted to balance surrounding areas. Dry dyes can also be applied to prints until a desired result is obtained, then fixed by applying moisture in the form of team to the print. Black-and-white negatives and prints can also be retouched by means of dyes. Neococcine dye allows the corrected areas of negatives to be visually identified due to its pinkish colour.

DYE REVERSAL See *Appendix A.*

DYES Soluble colourant, as distinct from pigments, which are insoluble colourants (although the term *pigment* is used generally for colourants in the tissues or cells of animals and plants).

DYE SENSITIZER Silver halide crystals are sensitive only to blue or more energetic radiation, but dyes can be added to the crystal surface to extend the sensitivity to radiation of less energy, such as green and red light. Dye sensitisers make possible orthochromatic (blue and green light response), panchromatic (sensitive to all colours), and infrared photographic materials.

DYE TRANSFER The dye transfer process is a subtractive imbibition assembly process for making colour prints from colour positives or negatives. Forerunners of the system date from 1875 and include dye imbibition materials first marketed in 1925. Eastman Kodak offered a process called wash-off relief in 1935, which was improved by photographers Louis Condax and Robert Speck and released by Kodak in 1946 as the dye transfer process. The many controls available in this process, combined with the beauty and permanence of the dyes employed, make dye transfer the finest of all colour printing methods despite the care and effort it requires.

There are currently two kinds of matrix material available, Kodak Matrix Film 4150, which is orthochromatic, and Kodak Pan Matrix Film 4149, which is panchromatic. The first set of procedures in the dye transfer process is determined by the choice of matrix material. The panchromatic film is designed for making separations from colour negatives directly onto the matrix, eliminating the need for making separation negatives first, and simplifying registration problems later because only one negative, fixed in place, is used. On the other hand, significant control over the final image can be exercised while making separation negatives, whereby red, green, and blue filters are used to expose suitable film stock, such as Kodak Super-XX 4142.

Neither matrix film has an antihalation backing, permitting exposure through the base. This procedure is necessitated by the dichromated gelatin of the matrix film emulsion that is subject to hardening when it is struck by light. After exposure in registration, development is accomplished in a tanning (hardening) developer that can be constituted to produce a wide range of contrast levels. The silver image produced and the degree of tanning are proportional to each other. The silver image is then fixed in a non-hardening fixer. As an alternative procedure, the silver image may be formed by a conventional reduction developer, rinsed, fixed, and then bleached in a sulphuric acid-ammonium bichromate solution. The silver is removed while the gelatin is tanned. Preparation of the

matrix is completed by washing in hot water, which removes the soft surface gelatin and reveals the hardened relief of gelatin that was exposed through the base. Care must be exercised at every wetting and drying stage to avoid distortions that would cause a loss of registration.

Dye transfer prints are made on double-weight photographic paper that has been mordanted during manufacturing to make dyes adhere, or on regular photographic paper that has been fixed, washed, and treated in Kodak Mordanting Solution M-1 containing aluminum sulphate and sodium carbonate. Both papers must be bathed in Dye Transfer Paper Conditioner, a 5% solution of sodium acetate, half an hour or more before transfer.

The sequence for applying the dyes in registration to the paper is cyan (red separation negative), magenta (green separation negative), and yellow (blue separation negative). Each matrix is soaked in dye for about 5 minutes and placed in a 1% acetic acid rinse to remove excess dye. This rinsing bath may be altered to control contrast. Sodium acetate will reduce contrast in the middle and shadow tones. Calgon will clear highlights by removing surplus dye. Reducing the strength of the acid rinse will reduce contrast, while more acid causes more dye to be carried from the dye bath, increasing highlight contrast. Other controls include the amount of added chemicals, the rinsing time, and the quantity of rinse used. Colour intensity may be reduced by adding a 5% solution of sodium acetate to the acid rinse.

Dye baths may be checked by superimposing the three dye images; the result should be neutral gray. Dye contrast may be raised by adding acetic acid or lowered by adding triethanolamine. More than one transfer of a colour may be applied to intensify that colour.

As many as 100 prints can be made from one set of matrices. If the matrices were made from separation negatives, it is a simple matter to make a new set of matrices from which to continue printing. The subtle, lustrous appearance and near-archival durability of dye transfer prints continue to justify the effort required to make them, even in an age when remarkably good chromogenic prints pop out of the processor, washed and dried, in less than four minutes.

EKTACHROME Manufactured by Eastman Kodak Company, a range of integral tripack, substantive, colour transparency films and colour papers that can be processed by the user. Daylight and tungsten; roll, sheet, and motion picture; original and duplicating types are offered. Ektachrome infrared film is a false colour material for aerial, scientific, and special-effects purposes.

EKTACOLOR A range of user-processable, integral tripack, substantive, colour negative films and papers for professional use, introduced by Eastman Kodak Company in 1945. Roll and sheet formats are offered, as is an intermediate film for making negatives from transparencies.

ELECTRIC CELL A device that converts chemical energy into electrical energy. At minimum, a cell consists of an anode, a cathode, and an electrolyte. An assembly of two or more cells is a battery, although a single cell is commonly, but imprecisely, called a battery.

See also: *Battery*.

ELECTROLYTIC SILVER RECOVERY A process used to recover silver from silver-bearing solutions by passing the solution between two electrodes through which dc current flows. The silver plates out on the cathode as almost pure silver. With careful monitoring, fixer can be reused for some processes. Silver recovered by the electrolytic method is easier to handle and less costly to refine than that recovered by other methods.

ELECTROMOTIVE FORCE (EMF, E, V) The potential difference measured between two points in an electrical circuit. The term is often used interchangeably with voltage. When used, emf usually applies to the voltage generated by a source and has E for its symbol (instead of V). The unit of emf is the volt.

ELECTRON A subatomic particle of unit negative charge of electricity. One electron carries a charge of 1.602 $\times 10^{-19}$ coulomb.

ELEMENT An element consists of atoms that have a structure of electrons, protons, and neutrons that is distinct from the atoms of other elements. Each element is given a name and a symbol consisting of one or two letters. An atomic number for each element is derived from the number of protons in the nucleus (which also

contains all of the neutrons). The electrons are visualized as being in rapid motion in a cloud surrounding the nucleus.

EMULSIFICATION The first step in photographic emulsion making, called emulsification, consists of mixing a soluble silver salt, usually silver nitrate, with a soluble halide salt or salts in a water solution containing gelatin. Many procedural variations exist in this step of forming the nuclei for the light sensitive silver halide crystals.

EMULSION NUMBER The designator on a package of light-sensitive material identifying the particular production batch. Sometimes this information is also edge printed as a latent image on the film itself. For critical work some photographers prefer to purchase a quantity of film all with the same emulsion number to assure uniformity of speed, colour balance, and other characteristics.

EMULSIONS Historically, the precipitation of silver halides to prepare a photographic emulsion has been a secret operation practised in near darkness, figuratively and literally. Even in commercial practice today, skilled workers add numbered but unidentified chemicals in a prescribed order under specified conditions to continuous machines but do not know chemically what they are doing. The exasperating defects and variations of the resulting coated emulsions emphasize that emulsion making today is a scientific art, not a precise science. Quality aim points are more an average of variations, not an exact achievement every time. Published research results have helped reveal some of the basics involved in emulsion making, but secret commercial achievements often remain hidden behind a silver curtain.

Making and coating a photographic emulsion involves a progression of operations, some of which blend together:

1. Emulsification and crystal growth
2. Physical ripening
3. Separation and washing
4. Chemical sensitization
5. Finishing and coating the emulsion.

Ever since 1871 when R. L. Maddox mixed cadmium bromide with excess silver nitrate in gelatin solution, gelatin has been the preferred emulsifier, carrier, and binder for silver halide emulsions. The hardening and swelling characteristics of gelatin make photographic processing easily possible. Chemically modified gelatins and gelatin substitutes have found specific uses, but gelatin is still essential. An understanding of emulsion making and coating requires an understanding of this unique substance.

GELATIN Gelatin does not exist in nature, being derived from collagen, which is extracted from the skin,

bones, and sinew of animals. Collagen is believed to consist of three chains, each a helical coil, wound tightly around one another to produce a triple helix structure. Gelatin consists of long-chain single molecules that result when the ropelike triple helix of collagen is cleaved by the harsh lime treatment of bone or acid treatment of hides. Each gelatin chain consists of amino and amino acids joined by

linkages called peptide bonds. The general formula of the gelatin polypeptide molecule has been represented as

where n represents 500 to 1000 amino acid units or residues and R is a side chain or ring of the amino acid that contains functional groups that make the molecule reactive and soluble in water.

There are 18 amino acids in the polypeptide chain of gelatin, but 58% of the weight of gelatin is composed of 3 amino acids: glycine (27.5%), proline (16.4%), and hydroxyproline (14.1%), which make up almost two-thirds of the amino acids in gelatin. One preferred sequence of these amino acids in gelatin is

-glycine-proline-hydroxyproline-

Many of the other third of the amino acids are present as side chains that have terminal amino ($-NH_2$) or carboxyl ($-COOH$) groups.

Gelatin can act either as an acid or a base because of the many basic amino or acidic carboxyl groups. Except in highly acidic or alkaline solution, both $-N^+H_3$ and $-COO^-$ are present in the gelatin molecule. At a certain solution condition, the number of $-N^+H_3$ and $-COO^-$ are equal. This is the isoelectric point (IEP) of the gelatin, the pH

173

value where the molecule has a net charge of zero. This effect of pH on the charge of the gelatin molecule might be shown as

$\overset{+}{NH_3}-\underset{\underset{R}{|}}{CH}-COOH$ $\overset{OH^-}{\underset{H^+}{\rightleftharpoons}}$ $\overset{+}{NH_3}-\underset{\underset{R}{|}}{CH}-COO^-$

Positive charge
pH less than IEP

Neutral charge
pH equal to IEP
(isoelectric point
of gelatin)

$NH_2-\underset{\underset{R}{|}}{CH}-COO^-$

Negative charge
pH more than IEP

The charge on the gelatin molecule is important because a positively charged silver halide crystal will repulse a positively charged gelatin molecule, allowing an increase in the growth rate of the crystal.

The IEP is characteristic of the kind of gelatin, its preparation, and impurities present. It is the point at which the molecule is most contracted and least soluble. For lime-processed gelatins, the IEP lies on the acid side; for acid-processed gelatins, the IEP occurs in slightly alkaline solution.

Gelatin is a natural polymer of variable composition and contains many impurities. The tedious procedure of preparing, purifying, and blending batches of gelatin from the bones of cattle from India, or the hides of Argentine cattle, or the skins of pigs from the United States, has spurred a search for a synthetic substitute that easily can be made and purified. Polyvinyl alcohol (PVA) has found some use but interferes with crystal growth. Polymers can be used as a partial replacement of gelatin. Gelatin, itself, has been modified chemically to permit easier flocculation during the washing step.

EMULSIFICATION AND CRYSTAL GROWTH Emulsification occurs immediately after a solution of a halide (such as alkali metal or ammonium salts) and a solution of a silver salt (often silver nitrate) are mixed in a solution of an emulsifying or protective colloid such as gelatin. Instantly, the solution of the silver halide or halides becomes highly supersaturated, forming a great number of nuclei or centres that are believed to be spherical at first. The nuclei grow in size until the solution is no longer supersaturated. Some of the smaller and more soluble particles dissolve and deposit silver halide on the larger particles, by a process called Ostwald ripening. As a result, the nuclei form cubic microcrystals or grains of various shapes with cubic and octahedral surfaces. The growth of the microcrystals, sometimes called first ripening, occurs during the holding of the initial solution from 10 to about 60 minutes at 40° to 70°C with continuous

174

agitation. Coalescence and recrystallization decrease the total number of grains while the average size increases.

Two general methods of emulsion preparation are used: the single jet or double jet addition of the solutions. In the single jet method, the halide salt and gelatin are in the mixing vessel, and the silver salt is slowly added by a pipe or jet. In the double jet method, the gelatin is in the mixing vessel, and the halide and the silver salt are added simultaneously through individual jets. These methods of crystal precipitation permit almost an infinite variety of the emulsion. Slow addition of the silver nitrate solution allows a smaller number of crystals to grow to a larger size. Rapid addition produces a greater number of small crystals of similar size that do not grow rapidly. Higher solution temperatures accelerate the growth in grain size. A high degree of agitation during the crystal precipitation favours the production of smaller grains.

Generally, photographic emulsions are prepared in neutral (acid) or ammoniacal solution, but many intermediate variations exist. During emulsification, the solid silver halide is precipitated by a double decomposition reaction between an alkali halide (potassium bromide) and silver nitrate (or silver ammoniate for the ammoniacal emulsions), as shown by the two equations that illustrate the two classes of emulsions.

$$AgNO_3 + KBr = AgBr + KNO_3$$

$$[Ag(NH_3)_2]NO_3 + KBr \rightarrow AgBr + KNO_3 + 2NH_3.$$

The precipitation of the silver halide is the most important stage in the making of a photographic emulsion, as the characteristics of the emulsion are largely determined at this point. It is also the most critical stage to control and to duplicate, requiring specialized equipment and automation in industrial practice.

Simple decomposition equations like those listed previously do not describe the reality of the structure of modern emulsion microcrystals. During precipitation, silver iodide may be incorporated in the core or throughout the crystal of silver bromide. Double-structure grains, called core-shell grains, may have cores with high iodide content (up to 35 mol%) covered by a shell of silver bromide. A sequential double precipitation has been reported to be the best method of preparation for monodisperse core-shell emulsions. Increasing iodide in the core up to 10 mol% was found to increase the absorption of light energy without loss of development activity.

The importance of gelatin is often overlooked during the study of the varied results of emulsification and crystal growth. Crystal formation may occur in solutions of natural gelatins blended with gelatin modified to decrease its acid solubility. A small proportion of the gelatin, a monolayer or less, is irreversibly adsorbed to the surface of the silver halide microcrystals and cannot be removed

by hydrolysis in aqueous solutions. The protective action of gelatin keeps the microcrystals from coagulating during precipitation and protects the grain surface during chemical ripening. During crystal growth, the adsorbed gelatin envelope has been said to enlarge "like a growing cellular bag."

PHYSICAL RIPENING Excess silver halide solvents promote crystal growth during the period of the precipitation of the grains. The continued crystal growth after the precipitation stops might be considered merely an extension of the first process. The solution is held at 40° to 70°C in the same vessel. *Physical* or *first ripening* is the name given to this first holding period and provides an opportunity to add solvents or other grain modifiers to the solution.

Excess halide ions, either present from the precipitation of the microcrystals or added after, or ammonia or ammonium salts, or other silver halide solvents promote grain growth during the continued heat treatment of the solution. Grain growth increases by two mechanisms: Ostwald ripening and grain coalescence. Ostwald ripening involves the smaller grains, which are more soluble, dissolving and depositing on larger grains. Coalescence growth has been described as the union, in one body, of two or more intact crystals.

Recrystallization must occur at the point of junction, ranging from minimal to a complete loss of the original crystal form. Lattice defects, dislocations, and intercrystalline layers formed during this relocation of the silver halide largely determine the attainable sensitivity limit of the microcrystals. The illustration shows the two main mechanisms of grain growth during physical ripening. Another mechanism, recrystallization, occurs with mixed silver halides.

In the absence of ammonia, the increased solubility of silver bromide at high bromide concentrations is the result of the formation of complex ions such as $(AgBr_2)^-$ and $(AgBr_3)^=$. The presence of ammonia leads to an increase in the solubility of silver halide at low bromide concentrations. The solvent effect of ammonia is greatest in the absence of bromide ions. Ammonia increases the solubility of silver halide by forming soluble $[Ag(NH_3)_2]^+Br^-$ complexes. Ammonia also raises the alkalinity, which is thought to accelerate chemical sensitization during the physical ripening.

The size of the silver halide grains increases with time and temperature, with the concentration of the silver halide solvent, the dilution of the gelatin, and the degree of the agitation. The sensitivity of the emulsion increases with the time of ripening up to a limiting value. Gelatin inhibits crystal growth. Gelatin contains within its molecule amino acids such as cystine, cysteine, and methionine, which are natural retarders. Although retarders can be eliminated during the manufacture of

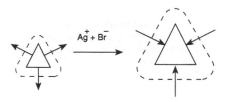

Ostwald Ripening

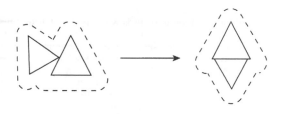

Coalescence

Physical ripening. Schematic representation of the two main mechanisms of grain growth during physical ripening. (Adapted from Sheppard and Lambert.)

gelatin, their presence is needed for certain types of emulsions (high contrast). Compounds such as cadmium or thorium salts, or benzotriazole or thioglycolic acid, may be added as retarders.

SEPARATION AND WASHING After physical ripening, the silver halide grains are in a gelatin solution that contains soluble halides and nitrites, acids and bases, as well as impurities and any other chemical addition. These compounds may fog, shorten the keeping life, or crystallize in the emulsion. The soluble salts must be removed as they interfere with the subsequent chemical and spectral treatments so necessary to produce the modern high-speed, panchromatic emulsions.

The classical method of removing the soluble salts involves adding dry gelatin to the solution after physical ripening. Sufficient gelatin should be added to make a concentration of 7–10% of the water in the emulsion before cooling. The added gelatin is necessary to minimize water absorption and swelling during the washing step. The emulsion is set to form a gel by cooling near 40°F. The solid emulsion is then shredded into fine noodles and washed in water, often from the public or special water supply. The length of the washing period depends on the concentration and kind of gelatin, the fineness of the shreds, the volume and agitation of water, the temperature, and the hardness (calcium and magnesium content) of the water.

177

The setting, shredding, and washing of an emulsion requires much time and handling. There are many other disadvantages of washing. Excessive swelling and dilution of the emulsion, bacterial and chemical contamination from the water, and continued crystal growth or loss of water-soluble components in the gelatin solution increase the uncertainties of emulsion making. These limitations have led to a number of methods for separating the solid part of the emulsion from the liquid after the first ripening step. These include salting out with double or triple-charged ions, coagulation by alcohol, centrifugation, sedimentation, dialysis, and flocculation.

One modern method involves the flocculation of the solids of the emulsion into curds with the use of acids. On the acid side of the isoelectric point the gelatin adsorbed to the grains will become insoluble if its free amino groups are no longer available to produce that solubility. Acids, such as trichloroacetic acid, will form a salt with the amino groups of gelatin, producing flocculation of the gelatin–silver halide emulsion. Many flocculating agents, such as polymeric acids or anion soaps, have been proposed, as the precipitated curds are easily soluble when the alkalinity is increased above the isoelectric point.

A more elegant method of separating the solid and liquid parts of the emulsion involves a chemical modification of the gelatin. The amino groups of gelatin are reacted with suitable acids to make a permanent modification of the amino group. This gelatin is not soluble in acid, so lowering the emulsion to just below the isoelectric point causes a curd to separate easily. The adsorption of the modified gelatin still occurs on the surface of the silver halide grains. The gelatin can be present during the precipitation of the silver halide grains or added after grain growth. The flocculated material is usually larger in volume than coagulated sediments and is easier to disperse in gelatin.

CHEMICAL SENSITIZATION Physical ripening produces enlarged crystals of increased sensitivity to light, but the ripened crystals are still relatively inefficient in forming latent images and are blind to all radiation except blue, violet, and ultraviolet. Chemical sensitization is a part of the emulsion-making process that increases the response of the silver halide crystals by chemical means. This treatment, often called *second ripening* or *afterripening*, is not dependent on crystal growth but consists of adding chemical impurities to the surface of the crystals. The emulsion is heated for minutes to hours in the presence of the chemical ripeners. Although a vast number of chemicals are added to emulsions, the sensitizers are usually classed as (a) sulphur, (b) reduction, (c) gold, and (d) spectral dye.

Sulphur Sensitization Early emulsion makers often chose the gelatin on the basis of its activity, as some gelatins gave emulsions of increased sensitivity to light. In

1923 Sheppard and co-workers demonstrated that some gelatins acted as chemical sensitizers and that silver sulphide was formed by gelatin components containing sulphur. The silver sulphide is in intimate contact with the silver halide crystal, but the exact function is subject to dispute. The net effect seems to be an increase in the efficiency of latent image formation, resulting in improved sensitivity to light.

Sodium thiosulphate is now known to act as does the natural sulphur sensitizer of gelatin. The thiosulphate may be formed by the degradation of a sulphur-containing amino acid during the treatment of the collagen. Sulphur sensitizers in gelatin are now removed to produce inert gelatin, then a few milligrams of sodium thiosulphate per kilogram of gelatin are added during the heat treatment of chemical sensitization. This produces a known and precise method of sulphur sensitization. The thiosulphate ion is believed to be adsorbed on the crystal surface of a silver halide such as silver bromide

$$S_2O_3^{2-} + 2AgBr \rightleftharpoons Ag_2S_2O_3 + 2Br^-$$

Thiosulphate ion	Silver bromide	Silver thiosulphate	Bromide ions

During the elevated temperatures of the second ripening, some silver thiosulphate, an unstable compound, is believed to decompose:

$$Ag_2S_2O_3 + OH^- \rightarrow Ag_2S \downarrow + HSO_4^-$$

Silver thiosulphate	Hydroxyl ion	Silver sulphide	Hydrosulphate ion

Silver sulphide is deposited at discrete sites on the crystal surface, acting possibly as electron traps or reacting to remove freed halogen.

Reduction Sensitization Active photographic gelatin has been found to contain reducing substances, such as aldehydes, sugars, or sulphite. Such reducing compounds are believed to produce metallic silver in unexposed silver halide crystals of enhanced sensitivity. The silver atoms may be formed by reducing agents present even in inert gelatin or by adding a reducing compound to the emulsion during the chemical ripening holding period. *Reduction sensitizing* is the name given to the production of silver that increases emulsion sensitivity.

Silver atoms are thought to be formed by the reduction of silver ions from the crystal or from excess silver salts. The location has been claimed to be in the gelatin envelope surrounding the crystal, although many feel that the sensitizing substance is on the crystal surface. The function of the silver atoms is also obscure. The silver atoms may form a subdevelopable centre. Another opinion holds that the silver atoms have the sole function of reacting with the halogen released during light

exposure. Reduction sensitizing is often combined with sulphur sensitization.

Gold Sensitization After the Second World War it was revealed that R. Koslowsky had achieved two- to four-fold increases in the sensitivity of emulsions without increases in graininess by using certain complex gold salts. Koslowsky used ammonium aurothiocyanate, $NH_4Au(CNS)_2$. Gold treatment alone is of limited value but is quite effective when homebound with sulphur sensitization. The aurothiocyanate is believed by some to replace the silver with gold in the surface development centres, either increasing the efficiency of the centre or possibly its stability. Gold sulphide or silver-gold sulphide, $AgAuS$, may be formed during gold and sulphur sensitization, but the mechanism of such chemical sensitization may be more complex than is now understood.

The great disadvantage of gold sensitizing is an increase in fog. Gold is most effective with larger grain emulsions that have low fog. The choice of gelatin is also important, as reducing the substances in the gelatin, especially aldehydes, may react with the gold, producing fog centres. Sulphur-containing amino acids of the gelatin may react with the gold and interfere with the sensitization. Because of the fog problem, an antifoggant is necessary, but it must not be so powerful as to interfere with dye sensitization. Emulsion stabilizers such as the azaindolizines are remarkably effective in preventing age fog in emulsions that have gold sensitizers. A suitable stabilizer is 4-hydroxy-6-methyl-1,3,3a,7-tetraazaindene.

Spectral Sensitization Extending the spectral response of primitive silver halide crystals by the adsorption of dyes might be considered a type of chemical sensitization. The mechanism of dye sensitization is discussed in the entry "Spectral Sensitization."

FINISHING A number of additional compounds must be added to the chemically sensitized emulsion before it can be coated on a suitable base.

Stabilizers Chemical ripening may continue at a slow and persistent rate, changing the emulsion sensitivity and producing chemical fogging. Reducing the concentration of silver ions by adding halide ions, gelatin with restrainers, or silver complexing compounds helps to restrain fog but also may decrease emulsion sensitivity. Organic stabilizers, such as the tetraazaindenes or cadmium or mercury ions, are needed to prevent the coated emulsion from changing with time.

Antifoggants Nonimage silver (fog) may be produced when a coated emulsion is developed in a very active developer, such as one with high pH. Benzotriazole and other organic antifoggants may be added to the emulsion before coating. A loss in emulsion sensitivity may result from such developer restrainers, so such compounds are sometimes added in latent form. These are not reactive until the alkalinity of the

developer releases the active form. Isothiuronium compounds are of this type.

Polyethylene Oxides Polyethylene oxides are long-chain, high molecular weight compounds that may double the normal sensitivity of high-speed bromoiodide emulsions without a serious increase in granularity. Certain polyethylene oxides are believed to be development accelerators, adsorbing strongly to the silver halide grain surface and facilitating the approach of negatively charged developing agents.

Hardening Agents Gelatin hardening compounds are added to the emulsion just before coating to minimize the extent of the gelatin swelling in processing solutions. Hardeners crosslink the gelatin chains to limit the extent of swelling of the coated layer. Aldehydes link the amino groups of two different gelatin chains. Metal ions such as chromium and aluminum form intermolecular links between the carboxyl groups of different gelatin molecules. Compounds containing vinylsulphonyl groups are said to be rapid hardeners without continued after-hardening.

Wetting Agents Because of the low water solubility of some of the hydrophobic groups of gelatin, surface active agents must be used to get the emulsions to spread in thin layers without resist spots or streaks. One end of the molecule of the wetting agent is usually water soluble, the other end having lower water solubility. By acting in the interface between the emulsion and the base, or between layers being coated simultaneously, the wetting agent produces even spreading. Saponin, a naturally occurring substance, has been used for many years but long organic molecules (with trade names for identification), not unlike household detergents, are commonly found in emulsion formulations. The molecules of the wetting agents may be positively or negatively charged or uncharged.

Other Chemical Agents Numerous other compounds may be present to change the physical character of the emulsion or aid in the coating operation, including antiseptics, matting agents, pH buffers, antioxidants, plasticizers, filter dyes, image toners, antifrothing agents, solvents, and other special-purpose chemicals. A special-purpose chemical could be a developing agent so that the exposed coating could be developed by simply immersing in an alkaline solution. Another addition to an emulsion is an oil dispersion of a coupler, making colour photography possible.

EMULSION COATING Coating an emulsion is an unpublished science that is cloaked in commercial secrecy. The melted emulsion must be homogeneous and stay so throughout the coating period. Air bubbles and mechanical impurities must not be present. The viscosity must be of a required value for the coating conditions. The rheological properties of the emulsion also must be considered. The desired amount of silver halide per unit

181

area of the support must be coated to obtain the desired characteristics of the coated product. The thickness of the coating is fixed by the viscosity of the emulsion at a given temperature and by the coating machine speed.

Many methods of applying the liquid emulsion to the support have been used, including doctor knives and jets of compressed air to limit the emulsion thickness that is coated. Dip coating involves a rotating roller that transfers the emulsion liquid from its bottom side to the support, often paper base, at the top of the roller. Modern photographic practice uses hoppers with narrow slits through which metering pumps feed the liquid emulsion of the correct viscosity. The emulsion is supplied as a continuous sheet as the support speeds by the hopper. Multiple slit hoppers, even up to six slits, are commonly used, requiring a careful selection of surfactants so that the multiple layers spread on each other. Surprisingly, the thin layers do not intermix.

Modern photographic products consist of many layers. Photographic paper is coated with a baryta layer to provide a smooth layer for the emulsion. Photographic film base resists the even spreading of aqueous layers, so a number of layers of differing hydrophilicity are coated on the plastic base. These sublayers allow the emulsion to spread and adhere to the film base. Some black-and-white films have two emulsion layers, a high speed layer coated over a slow speed layer. (The slow speed underlayer helps reduce halation and improves graininess in areas of high exposure.) Colour films have many very thin layers, sometimes 10 or more. Most photographic products have a top layer (T-coat) that protects the emulsion layer. The top coat may contain the sensitizing dye, the hardener, matting agents, and other chemicals. Lubricants, especially for motion picture film, may be added to the top layer.

The coated emulsion on the support is quickly chilled to set the gelatin, then festooned through a tunnel-type dryer, the temperature rising through the succeeding zones. The finished photographic material is truly a marvel of photographic technology but with enough defects to spur continued efforts to improve the imperfect miracle.

Books: Carrol B.H., Higgins, G.C., and James, J.H., *Introduction to Photographic Theory*. New York: John Wiley, 1980; Haist, G. *Modern Photographic Processing*, Volume 1. New York: John Wiley, 1979.

ENCAPSULATION A process of archivally preserving fragile images or documents. The item is placed between two pieces of transparent polyester film and the two film surfaces are sealed together at the edges with a special double-coated film tape. The polyester surface protects the artwork/document from moisture, fingerprints, and dirt. The process is reversible. If the material being encapsulated is likely to contain any acidic chemical substances that can deteriorate the artwork, deacidifica-

tion solutions may be used to chemically deacidify the artwork. Although this process can be used to protect photographs, photographs are usually laminated, rather than encapsulated.

See also: *Lamination*.

ENERGY The work that a physical system is capable of doing in changing from its actual state to a specified reference state; the total includes, in general, components of potential energy, kinetic energy, and rest energy. As such, energy is a basic physical quantity like mass. The law of conservation of energy states that energy can be neither created or destroyed, although the theory of special relativity ($E = mc^2$) states that mass and energy are interchangeable. In photography, the primary forms of energy of interest are the energy carried by photons ($E = hn$), the energy levels (bands) in atomic and molecular arrangements, and the thermal kinetic) energy present in substances.

ENLARGING PAPER Light-sensitive paper with speed and other characteristics suitable for projection printing, as distinct from the slower contact paper. Enlarging papers in general are much less sensitive than typical films. Although they are not rated in terms of film speed, an equivalent ISO speed would be about three.

EQUIVALENT WEIGHT Alternative method of expressing chemical concentrations that may be used for neutralization reactions. For an acid, the equivalent weight is the weight in grams that provides one mole of hydrogen ions (H^+); for a base, it is the weight in grams that provides one mole of hydroxyl ions (OH^-). Determination of an equivalent weight is useful because an acid or base may have more than one hydrogen or hydroxyl ion that must be considered in the neutralization.

ETCH-BLEACH PROCESS A solution of 1% citric acid and 1% cupric chloride in water, combined with an equal volume of 3% hydrogen peroxide just prior to use, can remove both silver and gelatin from a fully developed, fixed, and washed image. The 5-minute treatment leaves a high contrast representation that seems to be a photo drawing in relief. Lith film, processed as a positive or a negative, works well in this application. Resin-coated paper is more effective than fibre. Selected areas of the negative or print may be protected from the action of the solution with frisket, a type of rubber cement used by graphic designers. After processing, a brief soak in plain acetic acid stop bath makes the remaining gelatin more receptive to the variety of dyes that may be used.

EXHAUSTION OF SOLUTIONS The useful life of photographic solutions such as developers, fixers,

bleaches, etc., is limited by a number of factors: the active ingredients become used up or they automatically decompose in the working solution; the solution becomes contaminated with impurities produced by the decomposition of the active ingredients; and certain solutions such as developers are oxidized by contact with the atmosphere or air dissolved in the water.

EXPIRATION DATE The year and month stamped on the external package of films, plates, and some papers after which aging effects may be significant. The prudent user should test expired material before committing it to an important use.

FABRIC PHOTOGRAPHIC PRINTS Photographic images utilizing a variety of printing processes that use fabric as the image support instead of the more traditional paper support. Linen, silk, canvas, and muslin are some examples of the kind of fabrics used since the invention of photography. There are historic as well as contemporary examples on fabric using the platinum, cyanotype, and salted paper processes in the form of photo quilts and family album quilts, as well as travel souvenirs in the form of handkerchiefs, particularly from around the turn of the century. Photogravure prints were also made on fabric particularly during the early 1900s. Electrostatic imaging has been done on fabric by means of a transfer process similar to the one used to produce images on T-shirts. Commercially coated photo-linen is still manufactured today and commercially available through the Luminos Company.

FABRIC PRINTING Photographic prints can be made on fabric by dyeing the fibres of the fabric or by using the fabric as a support for the image. Ink or dye can be applied through a stencil or a screen; an emulsion can be coated on fabric, or the fabric can be soaked in a sensitizing bath.

Transparent dyes are available in solutions that are ultraviolet sensitive. They are applied to untreated natural fabrics by brushing or spraying in safe illumination and exposed in contact with a negative by a UV source or sunlight. Development is in cold running water and then warm soapy water. An iron is used to set the dyes permanently.

Printing-out fabric sensitizer that contains silver nitrate is commercially available. The fabric is treated in a sizing bath of tannic acid, sodium chloride, and arrowroot, then soaked in a 10% solution of silver nitrate. Exposure by contact causes the black-and-white image in silver to print out.

Diazotype images are formed by the light-induced decomposition of dye-forming compounds. In diazo printing, the final dye image is lightest where the most exposure has taken place; therefore, printing is by contact through a positive original. The fabric is treated in primuline, then sensitized in a solution of sodium nitrite and oxalic acid. After exposure, the developer selected determines the colour produced. For example, 1% phenol makes yellow and 0.8% sodium hydroxide forms red.

Iron-silver fabric printing employs the action of light to reduce ferric salts to the ferrous state in which they will

react with silver nitrate to form silver images. In darkness or red safelight, the fabric is soaked in a solution of ferric oxalate oxalic acid, and silver nitrate. The fabric is dried, flattened, and printed out by contact exposure. The solutions used for the cyanotype, kallitype, and Vandyke processes function similarly.

A photographic image may act as a mordant for dye. After washing, the fabric is sensitized in a solution of potassium or ammonium bichromate and then dried. Exposure is by contact in sunlight until a faint image consisting of chromium hydroxide, a mordant for dyes such as alizarine and anthracine, appears. The fabric is then boiled in a solution of the appropriate dye, cleared in sodium hypochlorite, washed in soap and water, and dried.

A silkscreen, which can be produced in many ways, makes it possible to record an image by forcing dye or ink through the screen onto fabric.

FADING The term *fading* describes a weakening of the image tones in either black-and-white or colour photographs. It is concurrent with a loss of contrast and image sharpness. Fading can be expressed quantitatively as a loss in image density. It is a result of chemical reactions of the image-forming substance with chemically aggressive materials, which may originate either from the environment or from the photograph itself. In black-and-white photographs, such chemical degradation is caused primarily by substances that oxidize the image silver. Among those originating from the environment are hydrogen peroxide. nitrogen oxides, sulphur dioxide, and compounds present in sleeves or envelopes with which the photograph is in close contact. Examples of reactive materials emanating from the photograph itself include residual processing chemicals such as sodium thiosulphate, and degradation products from inherently unstable components of the photograph. Deteriorating cellulose nitrate film is a case of a source of degradation products that in turn catalyzes further destruction of the photographic image. In colour photographs, density can be lost through chemical reactions of image-forming dyes involving pathways such as oxidation or hydrolysis. Since these are temperature-dependent reactions, they occur even in the dark, but in the presence of oxygen and humidity, both coming from the surrounding air. This process is known as *dark fading*. Dyes in colour photographs can further be destroyed slowly by exposure to light, again in the presence of moisture and oxygen. Their behaviour under these conditions is described as *light fading*.

See also: *Image permanence.*

FAHRENHEIT (°F) The name of a temperature scale, now used only in the United States, on which pure water freezes at 32°F and boils at 212°F.

FARMER'S REDUCER Named after its inventor, Ernest Howard Farmer, this chemical reducer consists of sodium thiosulphate (hypo) and potassium ferricyanide in water. When combined in a single solution it acts as a subtractive reducer, but when used with two steps, bathing in potassium ferricyanide followed by treatment in a separate hypo bath, it acts as a proportional reducer. A typical *single bath* formula is:

Solution 1	
Potassium ferricyanide	37.5 grams
Water to make	500 ml
Solution 2	
Sodium thiosulphate	480 grams
Water to make	2 litres

Just before use, 30 ml of solution 1 and 120 ml of solution 2 are combined and diluted with water to make 1 litre of reducing solution. The negative is immersed in this working solution until the desired reduction has taken place, after which the negative is washed and dried. Local areas can be reduced by applying the reducer to the wet but squeegeed surface with a cotton swab or brush. The reducer can also be used with black-and-white prints.

FERRIC AMMONIUM CITRATE Used in certain sensitizers and toners, mostly for the blueprint process. Characteristics: Brown or green crystals of slightly variable composition. Solubility: 230–0 parts in 100 parts of water at room temperature.

FERROPRUSSIATE See *Cyanotype*.

FERROTYPE/TINTYPE PROCESS The ferrotype was first described by Frenchman A.A. Martin in 1853. Its wet collodion emulsion was coated on a thin, black lacquered iron plate. Like the daguerreotype, its image is laterally reversed, but it has a duller appearance more typical of the ambrotype. The process was patented in 1856 in America by Hamilton L. Smith, and in England by William Kloen and Daniel Jones. Smith assigned his patent to William and Peter Neff, who called the plates they manufactured melainotypes. Victor Griswold named his plates ferrotypes. The public soon came to know them as tintypes. In the 1880s, the wet collodion was replaced by dry gelatin emulsions.

Because they were cheap, easy to produce, and fast, the ferrotype brought to photography a universality it had not yet enjoyed: People could have casual portraits made on the spur of the moment. The images were rugged. Itinerant photographers could develop the plates in trays inside the bellows of the camera or in containers suspended beneath slots in the bottom of the camera. Drying of the metal plate was very quick.

FERROTYPING (1) A defect called ferrotyping occurs when the emulsion side of film is held in contact with the base side of another sheet of film (or convolution of roll film) for some time. This is aggravated by higher than normal moisture content, high temperatures, abnormal pressure, or extended time. The gelatin emulsion surface pressed against the more glossy base surface produces a variation in sheen that is visible by reflected light. Sometimes this defect is also seen on a print made from the film or when the film is projected, particularly as a motion picture. It is less likely to occur with films that have some matting agent in the emulsion surface and noncurl (NC) layer. (2) A technique of producing a high gloss surface on so-called glossy papers by squeegeeing the washed print on a polished enamel or chrome surface to dry. With this procedure a defect consisting of small unglossed areas can occur because of inadequate contact of these areas with the polished surface. (3) The process of producing a glossy image by squeegeeing a washed print on a japanned metal or chrome plated metal sheet for drying. Care must be taken to ensure that the plate is cleaned and polished, and that the water between the paper and plate surface is removed without leaving airbells. The process is becoming obsolete with the increasing ability of paper manufacturers to produce papers having a high gloss without ferrotyping.

FILM A photosensitive material on a flexible, transparent support.

FILM BASE The flexible, transparent, or translucent support on which the photosensitive emulsions of sheet and roll films are coated. Cellulose triacetate and polyester are the most common materials.

FILM CEMENT A solvent used to make permanent overlap splices on motion-picture film by dissolving part of the film base and binding the two strips together as the cement dries.

FILM CLEANERS Film cleaners consist of one or more of several solvents, preferably low in toxicity, nonflammable, and noncorrosive. They are normally applied with soft fabric or cotton to dissolve any oil or grease and to remove any dirt particles from film. They are marketed in proprietary form. Because the cleaner will remove lubricating waxes or oils, they will have to be restored if low film friction characteristics are important. Motion-picture film cleaners incorporate a lubricant so that adequately low film function is achieved after cleaning. It is important that the cleaning area be well ventilated. Highly toxic solvents such as carbon tetrachloride should never be used.

FILM CLIP Any short length of processed motion-picture film.

FILM HANGER A device, such as a grooved metal frame, designed to hold a sheet of film for processing in a tank, as distinct from holders for processing roll films in tanks, which are called reels.

FINISH Surface characteristics of photographic paper affecting appearance, specifically texture, sheen, and gloss

FIXATION TEST A means of determining the extent to which the silver halides remaining in a photographic emulsion following exposure and development were removed in the fixing and washing steps. A drop of 0.2% sodium sulphide solution applied to the clear margin of a negative or print will combine with remaining silver salts to form brownish silver sulphide. The depth of the colour, which should be compared with a standard, is an indication of the amount of silver salts in the emulsion. Incomplete washing with thorough fixation can also produce a positive result.

FIXING The primary function of a fixing bath is to remove unexposed silver halides from a photographic emulsion.
 THEORY After a photographic emulsion has been developed and rinsed in water or a stop bath, it has to be fixed in order to remove all residual, unreduced silver halides and become stable to white light. In theory, any soluble compound capable of forming stable and soluble complexes with silver halides could be used as a fixing agent. In practice, only a small number of compounds are used, the rest being unsuitable for various reasons such as expense, toxicity, and attack on the silver image. The most widely used fixing agents today are sodium thiosulphate (hypo) ($Na_2S_2O_3$) and ammonium thiosulphate ($NH_4S_2O_3$).
 The fixing bath removes the residual silver halides by forming soluble argentothiosulphate complexes. The general equation can be written as:

$$m\ Ag^+ + n\ S_2O_3^{2-} \leftrightarrow [Ag_m(S_2O_3)_n]^{(2n-m)-}$$

where the values of m and n can vary. The halogen ion passes into the solution unchanged. These complexes are not particularly stable and have to be removed from the emulsion through washing. If left in the emulsion, they can break down in time to form yellowish-brown silver sulphide stains.
 As a fixing bath is exhausted, i.e., if the silver content becomes too high, there is evidence that one of the argentothiosulphate complexes formed has a tendency to adsorb to the emulsion. Its removal in the washing becomes difficult and the risk of staining increases.

CONSTITUTION OF A FIXING BATH Although a plain fixing bath containing only sodium or ammonium thiosulphate would be sufficient, a *weak acid* is usually added for most black-and-white processing. A neutral fixing bath containing only hypo is used when an acid fixer would affect the developed image, such as after colour processing. The presence of an acid in the fixing bath ends the process of development immediately on immersion by neutralizing any alkali carried over. This prevents the developer from forming stains on the emulsion during fixation and allows white light to be switched on during fixation, providing the emulsion has been immersed completely and agitated for a few seconds. An acid condition also improves the effectiveness of some hardening agents.

Most acids cause thiosulphate to decompose with the deposition of colloidal sulphur, which may contaminate the emulsion and reduce the activity of the bath. This decomposition can be avoided by using bisulphite, either sodium bisulphite ($NaHSO_3$) or potassium metabisulphite ($K_2S_2O_5$) to lower the pH.

Simple Acid Fixer

Sodium thiosulphate	8–10	ounces	200–300	grams
Sodium bisulphite or				
potassium metabisulphite	1	ounce	25	grams
Water to make	40	fluid ounces	1	litre

Although this is a cheap and easy way to obtain an acid fixer, the buffer capacity is not very great. If the pH has to be controlled within close limits over a long period of time, a sodium acetate/acetic acid buffer is most commonly added after adding sulphite or bisulphite.

To reduce possible mechanical damage during the washing and drying stage, *hardening agents* can be added to the fixing bath. Hardeners reduce the swelling and consequent softening of the emulsion layer. The amount of water an emulsion absorbs is dependent on the pH, increasing with alkalinity and contact time. Swelling occurs in the developer but it is limited because of the hardening agents in the emulsion. Considerable swelling would occur during the final washing without additional hardening. In practice, it is convenient to combine the hardening process with fixation. If less water is taken up by the emulsion during washing, the drying will be accelerated. As hardeners also raise the softening temperature of the emulsion, higher drying temperatures can be used.

The degree of swelling of an emulsion increases with temperature. Under tropical conditions the partial swelling during development can be significant. It is therefore common to harden films before development under these circumstances. Processing at elevated temperatures is sometimes used to reduce contact time, especially with colour materials.

The two most commonly used hardening agents are *potassium alum* (aluminum potassium sulphate) and *chrome alum* (chromic potassium sulphate). Chromium or aluminum ions combine with the gelatin to form cross-links that make the emulsion more resistant to water, heat, and abrasion. Both chrome and potassium alum require a pH range of about 4 to 6.5 to work properly and are therefore only used in acid fixing baths with good buffering properties.

Although both chrome alum and potassium alum are widely used, there are some differences in their properties. Chrome alum allows for a higher concentration of sodium thiosulphate (up to 40%) than potassium alum fixing baths (maximum of 30%). Chrome alum fixing baths are capable of a greater degree of hardening, important for high-temperature processing, but they may produce excessive hardening at normal temperatures. They are also more susceptible to changes of hardening ability and colour with small changes in pH.

Chrome Alum Fixer

Chrome alum	12.5	grams
Sodium metabisulphite	12.5	grams
Sodium sulphite, anhydrous	6.25	grams
Sodium thiosulphate (5 H_2O)	400	grams
Water to make	1	litre

Potassium Alum Fixer

Sodium thiosulphate (5 H_2O)	240	grams
Sodium sulphite, anhydrous	15	grams
Boric acid	7.5	grams
Acetic acid, 28%	48	ml
Potassium alum	15	grams
Water to make	1	litre

RAPID FIXER Although sodium thiosulphate is the most common fixing agent, ammonium thiosulphate is used in most rapid fixers on the market today. Its fixing rate is from two to four times faster than the rate of sodium thiosulphate, mainly because the ammonium ion also contributes to the formation of complexes. The usual concentration is about 10-20%, compared to 20-40% used in sodium thiosulphate fixing baths. However, there are some limitations to the use of ammonium thiosulphate as a fixing agent. It is less stable than the sodium compound and thus usually sold as a concentrated solution, which has to be diluted before use. Exhausted ammonium thiosulphate fixing bath can cause more staining, as the breakdown of the silver complexes is more rapid. Overfixation of prints can also have a bleaching effect on the silver image.

Ammonium thiosulphate	135	grams
Boric acid	7	grams
Sodium acetate, anhydrous	10	grams
Sodium metabisulphite	5	grams
Sodium sulphite, anhydrous	6	grams
Water to make	1	litre

Potassium cyanide is another chemical with rapid fixing properties but is rarely used because of its toxicity.

STABILIZATION Stabilization is a process where the residual silver halides are converted into more stable complexes that are not subsequently washed out of the emulsion but are left in the final image. Stabilization is commonly used today in rapid processing systems and where image permanence is not a major issue. Stabilization allows one to forgo the final wash, one of the longest steps in processing, especially with fibre-base printing papers. The material must be dried directly after the stabilization bath.

Certain thiosulphates, thiocyanates, thiourea and allied compounds are used for stabilization baths. However, the image stability is never as good as after proper fixation and washing. When a stabilized image deteriorates, two reactions can occur. The highlights first turn yellow, and finally brown, or the image silver is bleached away. Depending on the circumstances (type of compound used, illumination, temperature, and humidity), either one may dominate. However, if a stabilized image is refixed in a normal fixing bath, it can be made permanent.

RATE OF FIXING The rate of fixing depends primarily on the following factors: type and thickness of the emulsion, degree of exposure and development, type and concentration of fixing agent, temperature, agitation, and exhaustion of the solution.

Type of the Emulsion Fine grain emulsions fix more rapidly than coarse ones. As there is some correlation between film speed and graininess, higher speed films generally take longer to fix. Silver chloride emulsions fix more rapidly than silver bromide emulsions, and silver iodide emulsions take even longer. If silver bromide is converted to silver iodide as in physical development, fixing takes longer than usual. Chloride or chloro-bromide papers take less time to fix.

Thickness of Emulsion Thin emulsions fix more rapidly than thick ones. As a consequence, photographic papers fix more rapidly than film, since their emulsion layer is thinner.

Degree of Exposure and Development The amount of unused silver halides that have to be converted into argentothiosulphate complexes depends on the amount of exposure and development. The smaller the amount of silver halide remaining in the emulsion, the faster the rate of fixation. As a general rule, a material may be consid-

ered fixed after approximately twice the clearing time. Photographic emulsions appear opalescent because of the silver halides dispersed in them. As the fixer dissolves the silver halides, the emulsion becomes clear. The time required for this process is known as *time to clear* or *clearing time* and provides the basis of most recommended fixing times.

Type and Concentration of Fixing Agent Ammonium thiosulphate fixing baths have a faster rate of fixation than sodium thiosulphate fixing bath. The increase of thiosulphate concentration increases the fixing process, with a maximum concentration of about 20% for ammonium thiosulphate and 30–40% for sodium thiosulphate. Fixers for photographic print material contain usually only half the concentration of thiosulphate used in negative fixers. A stronger bath can lead to bleaching of the silver image during prolonged fixation and may aggravate the problem of removing the excess chemicals absorbed in the paper-base during washing. Resin-coated photographic papers have little or no absorption of acids and thiosulphates in the paper base, which allows for a shorter washing time. In any case, the fixing time for photographic print material should not be prolonged unnecessarily.

As the composition of commercially available fixing baths varies, it is difficult to give accurate fixing times. The following figures are therefore only approximations, as all the other factors also influence the fixing time.

Sodium Thiosulphate Fixers

Films	7–10 minutes
Fibre-base papers	3–5 minutes
RC papers	2 minutes maximum

Ammonium Thiosulphate Fixers

Films	2–5 minutes
Fibre-base papers	1/2–5 minutes
RC papers	2 minutes maximum

Temperature of the Fixing Bath An increase in temperature results in an increase of the rate of fixation. It should be noted, however, that the temperature of film fixing baths should not exceed a ±5°C limit compared to the other processing baths to avoid possible reticulation, and ±1°C is desirable for optimum results. High temperatures also encourage swelling of the emulsion. It is advisable to use a prehardener before development when processing at high temperatures.

Agitation As fixation is basically a diffusion process, the amount of agitation influences the fixing rate. The more a photographic material is agitated, the shorter the fixing time becomes. In any case, the material should always be agitated to allow for complete fixing.

Exhaustion of the Solution The composition of fixing baths, like that of developers, changes with use. The area of negative or print material that can be fixed in one bath is limited. The life of a fixer depends on the concentration of silver complexes in the solution and the dilution of the fixing bath. The increasing concentration of silver compounds in a solution makes fixing progressively more difficult, until a point is reached when the material cannot be completely fixed, even if the bath is replenished by adding thiosulphate. For film emulsions, the maximum concentration of silver in a sodium thiosulphate fixing bath is about 6.0 grams per litre, in an ammonium thiosulphate fixing bath it is about 13.0 grams per litre. The concentration of silver in a fixing bath used for print material has to be considerably lower; the fixing bath should be replaced if the concentration reaches 2.0 grams per litre. It is therefore not advisable to fix print and film material in the same fixer. A fixer that will still work satisfactorily for film may contain too high a concentration of silver for paper. There is also a danger that dissolved antihalation dye from film material may stain prints.

The fixing time will also be prolonged by dilution of the fixing bath. Carry-over from either the development or the stop bath can lower the concentration of the chemicals, and the buffer capacity may be affected. If the pH of the solution rises over 6.0, the fixing bath will not stop the development, and there is a high risk of staining. Manufacturers usually state the life of a fixing bath in terms of sheets or rolls per gallon or litre. These figures are only approximations, as it is impossible to predict the amount of silver halides remaining in a specific emulsion, given a certain exposure and development, and the amount of dilution through carryover. The following figures, however, can be taken as a rough guide:

Film Material	Number per Litre of 25% Sodium Thiosulphate Solution
135–20 film	60
135–36 film	30
120 film	30
4 x 5 inch film	100
8 x 10 inch film	30

The number of prints that 1 litre of 20–25% sodium thiosulphate solution will fix is about the same as for negatives. Although printing paper contains less silver than negative materials, the actual amount of dissolved silver a fixing bath can contain and still work satisfactorily is also lower.

Testing for Exhaustion A good indication as to when a fixing bath is exhausted is the time to clear for a known material. When the clearing time doubles, the fixing bath should be replaced. More accurately, silver concentration and acidity can be tested with indicator test papers. Silver

indicator papers are calibrated so that the amount of colouration depends on the silver concentration. Another test is to add about 1 ml of 5% potassium iodide solution to 25 ml of the fixing bath. If the solution becomes cloudy and does not clear with shaking, the fixer is exhausted. Indicator papers for testing the acidity change colour depending on the pH of the solution.

Testing for exhaustion of print material fixing baths by watching the clearing time is difficult, as clearing is not readily observable. A better method is to count the number of sheets processed or to test the fixing bath at frequent intervals.

Two-Bath Fixing The best and most economical way of ensuring complete fixing is the use of two fixing baths. In practice, the film or print material is placed in the first fixing bath for the recommended amount of time. In the second bath, any residual silver compounds are removed. When the first bath is exhausted, it is discarded. The second bath is then used as the first one, and it is replaced by a fresh bath.

Replenishing Fixing Solutions In a fixing bath, where no stop bath is used, the first properties to fall off are the acidity and the hardening power. By adding an appropriate acid mixture, which may contain a hardener, the life of a fixing bath can be prolonged. This process cannot be repeated indefinitely though, as the accumulation of silver ions in the fixer also determines its lifetime. It is therefore not advisable to replenish with thiosulphate unless some way of removing the silver is available.

SHELF-LIFE OF FIXING SOLUTIONS Freshly mixed fixing solutions, with the exception of chrome alum fixer, will keep almost indefinitely; they are not exhausted by storage as are developers. In a partly used fixer, especially if it is exposed to light, the silver complex gradually decomposes and forms a blackish sludge. If potassium alum is present, a white deposit of aluminum hydroxide may also form, especially when the acidity is low. If these precipitates are filtered out, the fixing bath can be used to full exhaustion. If fixing solutions are kept over an extremely long period of time, i.e., one year and longer, the thiosulphates may decompose to form colloidal sulphur.

FIXING BATH Only a small amount of the silver salts in the emulsion layer of a photographic film or paper is needed to produce the silver of the developed image. The unused, unwanted silver halide of the emulsion layer will darken upon exposure to light if it isn't removed in a short time, obscuring the silver image. The process of removing the undesirable silver halides from the photographic material is called *fixation*, the solution that dissolves the silver halides is the *fixing bath*, or more simply, the *fixer*.

The chloride, bromide, and iodide salts of silver are almost insoluble in water and thus cannot be washed from

the emulsion layer. A considerable number of compounds, however, adsorb to the crystal surface of the silver halides and react with silver ions to form water soluble compounds, which then diffuse with an equal number of halide ions into the solution. The silver crystals are etched away, leaving a metallic silver image in the otherwise transparent emulsion layer. The developed image has been *fixed*, that is, protected from continuing change by the removal of the unwanted silver salts.

Many compounds in solution possess the ability to etch the crystal surface of the silver halides. Certain developer constituents actually begin the etching process during the development treatment. Silver halide solvents in developers include ammonia or ammonium salts, potassium or sodium thiocyanate, sodium sulphite, sodium thiosulphate and chloride, bromide, or iodide ions. Any of these silver halide solubilizing compounds, as well as nitrogen (amine) or sulphur (mercapto) organic compounds, might be used in separate baths to complete the removal of the unused silver salts.

In actual practice, however, the choice is quite limited. Ammonia and sodium sulphite solubilize silver chloride but are slow to attack silver bromide. Potassium cyanide easily dissolves all the silver salts, even silver sulphide, but is highly poisonous. Even this did not stop cyanide from being used as a fixing bath for the early high-iodide wet plate or ambrotype processes. Organic fixing agents are costly and often toxic. When chemical activity, solubility, stability, toxicity, and cost are all considered, today s universal choices have been sodium thiosulphate $(Na_2S_2O_3)$ and ammonium thiosulphate $[(NH_4)_2S_2O_3]$.

The thiosulphate ion dissolves the insoluble silver halide crystal by combining at the surface with a silver ion, forming a complex ion. A second thiosulphate is thought to be necessary before the complex silver ion can be carried into the solution. The reactions of thiosulphate fixation may be written

$$\underset{\text{(Solid)}}{AgBr} + \underset{\text{(Solution)}}{S_2O_3^{2-}} - \underset{\substack{\text{(Adsorbed complex}\\\text{of low solubility}\\\text{and low stability)}}}{[AgS_2O_3]^-} + \underset{\substack{\text{(From}\\\text{solid}\\\text{into}\\\text{solution)}}}{Br^-}$$

$$\underset{\substack{\text{(Adsorption}\\\text{complex)}}}{(AgS_2O_3)^-} + \underset{\text{(Solution)}}{S_2O_3^{2-}} \rightarrow \underset{\substack{\text{(leaving crystal surface}\\\text{and passing into solution)}}}{[Ag(S_2O_3)_2]^{3-}}$$

$$\underset{\text{(Solution)}}{[Ag(S_2O_3)_2]^{3-}} + \underset{\text{(Solution)}}{S_2O_3^{2-}} \rightarrow \underset{\text{(Solution)}}{[Ag(S_2O_3)_3]^{5-}}$$

Note that a bromide ion (Br^-) is also released with each silver ion solubilized. Eventually an excess of bromide ions in the fixing solution will effectively compete with the

thiosulphate for the silver ions. At this point the fixing bath is said to be exhausted.

Fixing baths are not simple water solutions of the thiosulphate salts. Because developing solutions are alkaline, the fixing solutions need to be acid to inhibit further image formation. The presence of a gelatin-hardening compound in the fixing bath is desirable, but hardening agents, such as the alums, are effective only in moderate acidity. These factors dictate that the fixing solution be acidic, but such a need greatly complicates the composition of the bath.

Because thiosulphate ions are unstable in low pH solutions, the solution must be maintained so that the solution does not become highly acidic. Alum, usually potassium alum, requires a narrow range of acidity, usually that given by a buffered acetic acid solution. Sodium sulphite is needed as a preservative as well as an inhibitor of the precipitation of sulphur from the thiosulphate ions in the fixing bath. Boric acid is added to acid fixers as an antisludging agent and helps the buffering of the solution.

FIXING BATH TEST A means of determining when a used fixing bath should be replaced with a fresh bath. Depletion of sodium thiosulphate in the bath can be detected by an increase in the clearing time for a strip of unprocessed black-and-white film. Accumulation of silver salts in the bath can be determined with a potassium iodide test solution, which when added to a small sample of the bath will combine with silver salts to form a yellowish silver iodide precipitate.

FLOATING LID A processing-tank cover that fits inside the tank and rests on the surface of the contained liquid, thereby reducing evaporation and oxidation.

FOG Fog is unwanted density in nonreversal photographic materials, or a corresponding loss of density in reversal materials density that is not attributable to the action of image-forming radiation. It may be caused by unintentional exposure to light or other radiation, exposure to chemicals or gases, aging, or excessive or unwanted reactions in processing. Some fog can occur in the preparation of the emulsion, but this is minimal today. Aging, especially beyond the expiration date or with poor storage conditions, contributes to an increase in fog, and this occurs to a greater extent with higher speed emulsions. In the latter case, cosmic radiation can make a contribution.

OPTICAL FOG Unwanted light can reach the sensitized surface of film in cameras through careless handling while loading or unloading, leaks in the camera through poorly fitted or improperly closed doors, pinholes in bellows, leaks in film holder light traps, incompletely closed shutters,

lens flare, etc. Light generated by a static electricity discharge over the film can cause characteristic fog markings. Exposure to x-rays can cause markings as a result of the shadows of adjacent convolutions of film or metal parts of cassettes or magazines. These effects are most often nonuniform over the surface of the film. Fog can also result from incorrect or excessive darkroom illumination, insufficient light trapping in construction, leaks in safelamps or use of incorrect filters, and, in the case of papers, light escaping from printer boxes, poorly seated enlarger heads, etc.

DEVELOPMENT FOG Fog not due to exposure to light can be caused by the effects of development or of chemicals on the sensitized material. Excessive development during processing, improper choice or mixing of developer, or contamination can contribute to this type of fog, which tends to be uniform throughout the film area.

Dichroic fog has one colour when viewed by transmitted light and another when viewed by reflected light. It is due to the presence of colloidal silver resulting from a variety of causes involving physical development. These include developers with excessive sulphite, hypo contamination in the developer, exhausted stop bath, and presence of developer in a nearly exhausted fixer. These kinds of fog may often be removed by means of a weak chemical reducer such as Farmer's Reducer.

FOG MEASUREMENT Processing fog of unexposed photographic material can be measured with a densitometer after subtracting the density of a piece of the same material that has been fixed only. The gray base for antihalation or light piping protection is not considered to be fog. Less energy is required to produce detectable fog in exposed image areas than in the unexposed borders, an effect that should be taken into consideration when conducting darkroom safelight fog tests.

FORMALDEHYDE An irritating and flammable gas (HCHO, molecular weight 30.03) that is usually supplied as a clear, colourless solution in water that gives off poisonous vapours.

See also: *Formalin.*

FORMALIN A water solution containing about 37% formaldehyde gas by weight, usually with 10 to 15% methanol as an inhibitor of polymerization. Escaping gases from the liquid irritate and attack the eyes and respiratory system.

Formaldehyde hardens gelatin, either in coated emulsion layers or in a processing bath. Used to lower free sulphite in hydroquinone developers to produce high image contrast (lith effect).

FORMULAS, CHEMICAL A notation, called a chemical formula, lists the symbols of the elements and their number in a chemical compound. The three elements

in silver nitrate are shown as $AgNO_3$. The formula for an organic compound may show groups separately. *N,N*-Diethyl-*p*-phenylenediamine monohydrochloride, a developing agent, may be shown as $(C_2H_5)_2NC_6H_4NH_2$ • HCl.

FORMULAS, PROCESSING A photographic recipe that lists the order and quantities of chemical ingredients to be added as well as other information needed to prepare a processing solution. Published formulas are often designated by a letter/number, such as D-76, a developer, or F-5, a fixing bath.

FOXING The formation of brown, feathery spots on paper. These spots are characterized by the presence of minute iron particles and bacterial growth. The formation of foxing is aided by high humidity. It has never been reported to occur on photographic prints that were machine-made since the 1860s for use as photographic paper base.

FRENKEL DEFECT A crystal lattice defect in which one of the ions moves into one of the voids or interstices of the crystal from which it can migrate to other regions of the crystal. The resulting species is known as an interstitial ion and the vacant lattice position left behind is called a vacancy. In silver halides it is the silver ions that migrate as interstitial ions, the halide ions being too large to partake in such a process.

FRILLING Frilling is a crinkle-like defect caused when an emulsion layer expands and separates from the support at the edges. It is generally caused by high temperatures in processing, sudden changes in temperature during processing, excessive processing times, rinses or washes in excessively soft water, or extremes in pH such as going from a highly alkaline developer to a strongly acid stop bath or fixer. The problem occurs less when rinses and washes are carried out with hard water. Modern thin emulsion products seldom exhibit this problem.

FRINGE EFFECT See *Photographic effects.*

FUGITIVE DYE Trivial term for unstable dye. It is generally not used in serious deliberations on dye stability.

FUNGUS There are a wide variety of fungi whose spores exist everywhere. These may attach themselves to the gelatin surfaces of photographic materials, grow, and cause damage when the relative humidity is above 60%. Temperature has little effect. If the damage occurs on the film before processing, it causes density changes in black-and-white materials and colour changes in colour materials. It is not possible to correct for this damage. The

damage to materials that have been processed is not immediate, so that if it is detected early, corrective action can be taken before the damage is excessive. Since the effect of the fungus growth is to solubilize the gelatin, it should not be removed with water, but instead with a film cleaner. Films can be lacquered to retard the fungus from attacking the gelatin. When damage is detected, the lacquer can be removed and the film recoated with lacquer.

Fungus growth does not occur at a relative humidity below 50%. This can be maintained by burning an electric bulb in the film cabinet to keep the temperature about 10°F above the outside temperature. Dessicants can be used for smaller containers, but care should be taken to use adequate quantities and maintain them properly. Unexposed film should be kept in scaled, unopened packages.

Similar precautions should be taken with paper prints, and they present a greater problem due to the larger sizes and volume of material being stored. Fungi also attract insects.

GAMMA The slope (steepness) of the straight line of a characteristic (D-log H) curve. Formerly used as a measure of basic film and development contrast, gamma has for most purposes been replaced by *contrast index.*

GAMMA INFINITY The maximum straight-line slope of a D-log H curve obtainable with a specified film and processing chemistry. Gamma increases with development time, but after the maximum is reached it may fall because of increased development fog.

GAMMA-LAMBDA EFFECT For specific film and processing conditions, the change in gamma (a measure of the steepness of the straight line of the characteristic curve) with the wavelength of the exposing radiation. Gamma is relatively small for short wavelengths (ultraviolet radiation and blue light) and at a maximum for wavelengths near the centre of the visual spectrum, that is, in the green region. For this reason, an increase from normal development time is ordinarily needed when the film is exposed with a blue filter.

GAMMA-TIME CURVE See *Time-gamma curve.*

GAMMETER A transparent template containing a scale that when placed on the straight line of a characteristic curve shows gamma (the slope) directly.

GEL The jelly produced when a emulsoid sol coagulates or sets.

GELATIN A naturally occurring protein having many uses in photography, most importantly as a binding medium for photosensitive compounds and other emulsion ingredients. It is extracted from animal hides, bones, and connective tissues by various processes, which influence its properties. Different types of gelatin are used for different purposes. It is insoluble in cold water, but will absorb about 10% of its weight in water. (This is mainly what must be driven off in drying films after processing.) Hot solutions of gelatin will set to a rigid gel when chilled, a property useful in photographic emulsion manufacture. Gelatin is not a definite chemical compound, and a given sample may contain molecules of various molecular weights, ranging from about 20,000 to more than 100,000, and of various amino acid compositions.

An important property of gelatin is its protective colloid action towards silver halide crystals during emulsion preparation. (A photographic *emulsion* is not an emulsion in the modern usage of physical chemists, but rather, a suspension. The term, however, is too well established to displace.) The gelatin present during the precipitation reaction of silver nitrate with potassium halide influences the rate and nature of crystal growth of the resulting silver halide. In the absence of gelatin the silver halide is precipitated as crystals too large for photographic purposes. Sometimes the best type of gelatin for precipitation does not have the ideal properties for coating or for some desired property in the finished film. In such cases the first gelatin can be removed by *isoing*, that is, adjusting the pH of the emulsion to the isoelectric point of the gelatin, the pH at which it loses its colloidal protective power. The crystals precipitate, and the gelatin solution is drawn off and discarded. The crystals are then resuspended in a solution of the desired gelatin.

A property of gelatin directly connected with the actual photographic process is its role as a halogen receptor. During exposure the action of light on a silver halide leads to the formation of atoms of silver and of the halogen. If the very reactive halogen is not immediately trapped by some other substance, it may recombine with newly formed silver, thus nullifying the effect of the light. Gelatin is such a substance although other halogen receptors are also added to emulsions.

One of the earliest materials used as a binder for silver halide was collodion, or cellulose nitrate, on which the wet *collodion process* was based. In 1871, however, gelatin was found to be a good binding medium, and had the advantage over collodion the emulsions made with it were much more sensitive, and were also sensitive when dry. Not all gelatins gave equally sensitive emulsions, and the "good" photographic gelatins were found to contain a few parts per million of certain sulphur compounds. The addition of such compounds, for example, allyl thiourea, to "poor" photographic gelatins enabled good emulsions to be made. Today, photographic gelatins are of high purity and the sensitizing compounds are added in controlled amounts.

A coating of gelatin on the back of a film acts to balance the tendency of the film to curl under extremes of temperature and humidity. A thin coating of gelatin over the emulsion protects it from abrasion.

Thick, unsupported castings of gelatin emulsion were used briefly in the 1880s in place of plates for pictorial photography (Cristoid film, Fandell), and also in the 1950s (Ilford, Kodak) in stacks of such *pellicles* for recording the trajectories of energetic particles in space.

Synthetic polymers, such as polyvinyl alcohol and polyamides, have been tried as substitutes for gelatin, but none has proven completely satisfactory as yet. Where wet processing is not required, as for some direct-writing

(print-out) papers for instrumentation recording, polystyrene and similar materials have been used as the binding medium.

Aside from the silver halide process, gelatin itself plays a major role in many imaging processes where its physical properties are somehow changed by the action of light. On exposure it can combine with heavy metal ions to form insoluble products. Some photomechanical processes are based on this light-induced hardening of gelatin. For example, the action of light on gelatin containing potassium dichromate (formerly called bichromate) forms an insoluble compound. Washing with warm water removes the unexposed areas, leaving a relief image. Gelatin is also hardened by other agents including formaldehyde and the oxidation products of some developers, for example, pyrogallol.

Thin, cast gelatin films containing organic dyes of various colours and intensities are widely used as light filters in photography.

GLASSINE A thin, translucent, glazed paper widely used for the storage of negatives. Because it is not a stable material itself, it may affect the quality of the image. Its use is not recommended.

GLOSSY A surface finish available on certain printing papers characterized by the complete absence of texture. The surface then is mirror-like, smooth, and shiny. The finish is produced on fibre-base papers by glazing, also called ferrotyping (USA). Resin-coated papers produce their glossy finish merely by air drying, although the gloss is not as perfect as that obtainable by ferrotyping fibre-base paper.

The highest range of tones is possible on a glossy paper. The viewer instinctively tips the print so that some dark object is reflected in its mirror-like surface. Glossy prints are preferred for photomechanical reproduction and for all technical and scientific images. Disadvantages of a glossy surface include the more distinct appearance of grain from the negative, the greater visibility of scratches and blemishes, and the difficulty of retouching.

See also: *Ferrotyping*.

GLUE STICK Glue sticks are neat and convenient ways of applying adhesives and are similar in appearance to a tube of lipstick. The glue adhesive is water soluble, nontoxic, nonacidic, and washable. Some brands of glue sticks colour their adhesives so that they are easier to see on the back of the material being mounted. A wheat paste-like adhesive in stick form is applied by simply rubbing it on the back of whatever light-weight material is to be mounted.

GLYCERIN The clear, colourless, sweet tasting, syrupy liquid of this polyalcohol ($CH_2OHCHOHCH_2OH$,

molecular weight 92.09; also called glycerine, glycerol, or 1,2,-3propanetriol) is very soluble in water or alcohol.

Used as a humectant to maintain flexibility of photographic papers and films or to thicken water solutions as a means to control diffusion rates.

GLYCERIN DEVELOPMENT A modification of the platinum process that allows very selective control of specific areas to be developed. After exposure, the print is covered with a layer of pure glycerin and the image is then developed area by area using a brush dipped in developer. The glycerin retards the rate of development so that the photographer can slowly bring an area up to a desired tonality without allowing the developer to flow into adjacent areas. Careful brushwork is necessary to blend the various areas together for a visually cohesive result. Variations of image colour can be produced by adding mercuric chloride to the developer. Alfred Steiglitz and Hoseph T. Keiley successfully utilized this technique in the early 1900s.

GLYCIN The common name of *para*-(hydroxy-phenyl)glycine or *para*-hydroxyphenylaminoacetic acid and should not be confused with glycine (CH_2NH_2COOH, molecular weight 75.07; also called aminoacetic acid). The developing agent glycin ($HOC_6H_4NHCH_2COOH$, molecular weight 167.16) forms white leaflets from water, the water solubility being only 0.02 gram per 100 ml at 20°C, with low solubility in acetone, alcohol, or ether. Glycin is soluble in alkaline solutions, so this compound is usually added after the sodium sulphite has been dissolved in a developing solution.

Glycin developing solutions are resistant to aerial oxidation, nonstaining, but slow acting. Because of the low activity, glycin is often combined with other developing agents to produce fine grain developers.

GRADIENT The slope of a curve at a given point. It expresses the relationship between the rate of change of the dependent variable with respect to the rate of change of the independent variable. For a D-log H curve, the gradient measures the relationship between the image contrast and the subject contrast.

GRADIENT SPEED Any of several methods, mostly obsolete, for estimating the sensitivity of a photographic material based on the slopes of defined portions of the D-log H curve. The ASA speed, for example, was based on the exposure needed to produce in the toe of the curve a slope equal to 0.3 times the average slope.

GRADUATE A shortened form of *graduated cylinder*. A transparent tubular vessel marked at different levels with appropriate measures of liquid volume. A graduate

is used, for example, in the careful preparation of photographic processing solutions.

GRAIN A silver halide crystal in a photographic emulsion or the silver particle resulting from the development of the crystal. Graininess, or grain, is a subjective impression of the distribution of the many silver particles or dye clouds of the developed photographic image.

Grain is an attribute of photographic paper describing the orientation of the fibres or descriptive of the making of the textured surface of a photomechanical printing plate, ground glass, and other materials.

GRAININESS The appearance of nonuniformity of density in more or less uniformly exposed and processed areas of photographic images. Graininess is a subjective characteristic that corresponds with objective granularity. Measures of graininess are the viewing distance or the magnification at which the appearance of nonuniformity just disappears.

GRAM A unit of mass (approximately, weight) in the metric system. One pound of weight is equal to 454 grams.

GRANULARITY The objective measure of nonuniformity of density in a uniformly exposed and processed area of photographic material. Specifically, the standard deviation of density values with respect to the average density, based on a microdensitometer trace at a fixed aperture. In a given silver image, the granularity varies with the density of the area measured.

GROWTH This term has at least two similar applications in photography. In emulsion precipitation, it refers to that part of the precipitation in which no further formation of nuclei takes place and only the existing emulsion grains are growing. In latent-image formation as viewed by the nucleation-and-growth model, it refers to formation of metal nuclei possessing more than two atoms.

GUM ARABIC A sticky substance obtained from the stem of the acacia and the fruits of certain other plants. It is soluble in water, but becomes insoluble when combined with certain bichromates and exposed to light. Also used for sizing paper before sensitizing for certain processes.

GUM BICHROMATE PRINTING PROCESS One of three processes that are based on the selective solubility of bichromated colloid resulting from the action of light (the other two are carbon and carbro printing), discovered by Alphonse Louis Poitevin (1819-1892) in 1855. The gum bichromate process, also referred to as the photo-aquatint process, was first exhibited in 1894 by A. Rouillé-Ladevèze in Paris and London. The process enjoyed

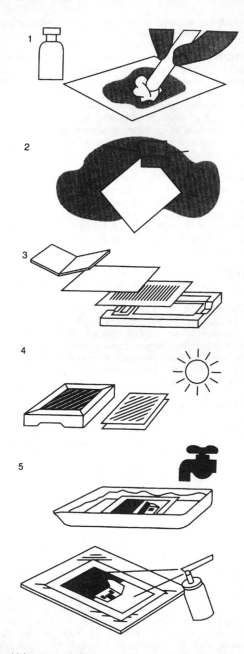

Gum bichromate printing.

immense popularity among pictorial photographers and was adopted as the process of choice in the fine art photography movement between 1890 and 1900. Popular again in the 1920s, and still used occasionally today, it is valued for the high degree of artistic control in the print-making process. A print is made by brushing onto a sheet of heavily sized paper a sensitizing solution that combines gum arabic, pigment (usually in the form of watercolour pigment), and potassium bichromate. Upon drying, it is exposed to ultraviolet radiation in direct contact with a negative the desired size of the final image.

After exposure, the print is placed in a tray of water, and the gum solution that was not exposed to light and therefore has remained soluble is slowly dissolved and washed away. The process lends itself to a great deal of hand alteration and manipulation by brushing selected areas of the surface of the print to dissolve greater amounts of the pigmented gum, thereby controlling the density of the deposits of pigment. Once dry, the print can either be recoated with the same colour gum solution, for a richer print, or other colour gum solutions can be built up layer upon layer with careful registration of the negative image to alter, deepen, or enrich the print overall or in selective areas. It was not uncommon to combine a platinotype image with the gum process. The process does not contain silver, and the image is permanent.

Books: Scopick, David, *The Gum Bichromate Book, Non-Silver Methods for Photographic Printmaking*. 2nd ed. Boston: Focal Press, 1991.

GURNEY-MOTT THEORY A theory of the way in which a latent image is formed in a sensitized silver bromide emulsion by the action of light, proposed by R. W. Gurney and N. F. Mott in 1938. The theory suggests that electrons liberated by absorbed light concentrate at one or a few active sites and that these electrons are then neutralized by the movement of an equivalent number of interstitial silver ions to form the latent image.

HALIDE A compound of bromine, chlorine, fluorine, or iodine, such as sodium chloride or silver iodide. The photosensitive element is not the metal but the halide ion.

HALOGEN The name of a family of elements comprising fluorine, chlorine, bromine, and iodine, originally derived from and named after sea salt. The light-sensitive silver salts of chlorine, bromine, and iodine have proved to be the most useful for making photographic emulsions.

HALOGEN ACCEPTOR Halogens (chlorine, bromine, and iodine) may be released in the emulsion layer during exposure of silver halide materials. To minimize the attack of these active halogens on the silver of the latent image, halogen acceptors, such as gelatin, sulphides, and other compounds, must be present in the emulsion layer.

HAND COLOURING See *Colouring*.

H AND D CURVE See *Characteristic curve*.

H AND D FILM SPEED See *Film speed*.

HANGER MARKS Uneven density near the edges of a negative or transparency processed in a film hanger, typically due to nonuniform movement of developer over the entire film surface.

HARDENER This chemical crosslinks gelatin molecules to make them less soluble in water, less susceptible to swelling in water, and thus more resistant to abrasion. Hardening agents are added to the emulsion layer during manufacture and have been included in separate baths or prebaths or in stop baths or fixing baths. Hardeners for emulsion incorporation are often organic molecules, such as aldehydes or vinylsulphonyl compounds, while those for processing solutions include dialdehydes and multivalent metal ions, such as chromium or aluminium.

HARDENER FIXER Acid gelatin-hardening fixing baths may contain salts of aluminum, chromium, iron, or zirconium to form intermolecular linkages that lower the solubility of gelatin and toughen the gelatin of processed emulsion layers. The double salt of aluminum sulphate with sodium or potassium sulphate, especially potassium

alum, $K_2SO_4 \cdot Al_2(SO_4)_3 \cdot 24H_2O$, is commonly used as the hardener in buffered acid thiosulphate fixers.

HARD WATER Water hardness is the result of dissolved salts in the water supply but primarily due to the calcium and magnesium ions of the soluble bicarbonates and sulphate salts. Calcium and magnesium bicarbonates can be decomposed by boiling the water, resulting in the deposition of a hard, insoluble scale (carbonates) inside the vessel, pipes, or processing tank. This is temporary hardness. Boiling sulphate salts does not decompose them, so this type of hardness is termed permanent. Calcium or magnesium in the water of developing solutions may result in the precipitation of carbonates or sulphites.

HEAVY OIL (1) An opaque oil paint that is sometimes used in colouring black-and-white photographs, either in combination with transparent oil colours to accent certain areas such as highlights, or to convert the photograph into an oil painting. (2) A hand-colouring procedure that uses opaque colours in a thick oil base. The colours are applied with brushes, and when the colours are applied to the entire surface of a photograph, the photograph is converted to an oil painting. Greater skill is required for colouring with heavy oils than with transparent colourants. Heavy oils can also be used locally, to accentuate highlights and shadows for example, on photographs that have been coloured with transparent colourants or even on colour photographs.

HIGH-CONTRAST FILM/PAPER Photosensitive materials of higher contrast than is normal for pictorial photography. They may be used pictorially for special stark effects, or in scientific and technical photography to enhance subtleties. These materials are often used with high contrast development and perhaps with special high-contrast lighting of the subject.

HIGH-SPEED PROCESSING A variety of techniques that permit the rapid processing of film and prints. They may employ the roller application of hot or high-energy developers, or alkaline activators, followed by stabilization rather than fixing and washing. Race tracks, hospitals, and dental facilities, instrument-recording cameras, police stations, and newspaper offices all use these processes to produce x-rays, negatives, and prints within a minute or two.

HIGH-TEMPERATURE PROCESSING The processing of photosensitive materials at temperatures well above the traditional 20°C (68°F), which is usually done because (1) it is difficult or impossible to lower the temperature of the processing solutions and wash water,

or (2) processing times can be shortened by raising the temperature. The speed with which development takes place is substantially influenced by temperature. The thermal performance of a developer is represented by a temperature coefficient, with numbers ranging from about 1.2 to 3, the factor by which developing time must be multiplied to compensate for a decrease in temperature of 10°C. Increased velocity of development to a specific gamma, or contrast index, may be achieved by using the temperature coefficient to compute the new processing temperature. Racetrack photofinish labs use 110° F developer to develop prehardened film in 12 seconds. Industrial rapid access systems use developer temperatures as high as 170°F to achieve process times as short as several seconds.

HOFMEISTER SERIES F. Hofmeister studied the effect of a number of substances on the swelling of gelatin and listed the following in order of decreasing effectiveness in suppressing gelatin swelling: sulphates, citrates, tartrates, acetates, alcohol, sugar, distilled water, chlorides, nitrates, bromides, acids, and alkalis. The most effective salt ions were said to attract the molecules of water, thus salting out the gelatin molecules from the solvent.

HOLE Refers to the vacant position left in the valence band after light absorption has promoted an electron to the conduction band. Because other electrons in the valence band can move and occupy this vacant position and thereby cause the vacant position to appear to move, the hole can be treated as a pseudo particle having mass and mobility just like the electron. In order to conserve charge, the hole is assigned a position charge.

HYDROGEN ION CONCENTRATION/pH In water an acid readily gives up a hydrogen ion (proton). The hydrogen ion (H^+) cannot exist alone in solution. Water molecules (H_2O) act as hydrogen ion acceptors; that is, water acts as a base to form hydronium ions, H_3O^+. When hydrogen chloride dissolves in water, the chlorine takes the electron from the hydrogen and exists in the solution as the negatively charged ion, Cl^-. The freed hydrogen ion then combines with a molecule of water, as shown by the equation $HCl + H_2O = Cl^- + H_3O^+$ the longer arrow pointing to the right indicating that most of the hydrogen chloride is in the form of the ions on the right of the equation.

A strong base, such as sodium hydroxide (NaOH), ionizes almost completely in water: $NaOH \rightarrow Na^+ + OH^-$. The hydroxyl ion ($OH^-$) is a strong base, accepting a hydrogen ion to form a molecule of water. The sodium ion could have been replaced by other metal ions and the compound would still act as a base, because it is the hydroxyl ion that is the hydrogen ion acceptor.

The pH and pOH Scales

Hydrogen Ions (moles per litre)	or	pH Scale		pOH Scale	or	Hydroxyl Ions (moles per litre)
1.0		0	Highly acid	10^{-14}		0.00000000000001
0.1		1		10^{-13}		0.0000000000001
0.01		2		10^{-12}		0.000000000001
0.001		3		10^{-11}		0.00000000001
0.0001		4		10^{-10}		0.0000000001
0.00001		5		10^{-9}		0.000000001
0.000001		6		10^{-8}		0.00000001
0.0000001		7	Neutral	10^{-7}		0.0000001
0.00000001		8		10^{-6}		0.000001
0.000000001		9		10^{-5}		0.00001
0.0000000001		10		10^{-4}		0.0001
0.00000000001		11		10^{-3}		0.001
0.000000000001		12		10^{-2}		0.01
0.0000000000001		13		10^{-1}		0.1
0.00000000000001		14	Highly alkaline	10^{-0}		1.0

Hydrogen Ions alternative notation (or): 10^{-0}, 10^{-1}, 10^{-2}, 10^{-3}, 10^{-4}, 10^{-5}, 10^{-6}, 10^{-7}, 10^{-8}, 10^{-9}, 10^{-10}, 10^{-11}, 10^{-12}, 10^{-13}, 10^{-14}

When a strong acid reacts with a strong base in water neutralization occurs, destroying the acidic and basic properties of the reactants, forming a salt and water. The reaction of hydrochloric acid and sodium hydroxide may be written $H_3O^+ + Cl^- + Na^+ + OH^- \rightarrow 2H_2O + Na^+ + Cl^-$ In water solutions sodium and chloride ions occur in both the reactants and products, having played no part in the overall reaction. Thus, the neutralization reaction consists of the interaction of hydrogen ions with hydroxyl ions, as shown by $H_3O^+ + OH^- \rightarrow 2H_2O$. The uncharged water molecule is neither acidic nor basic and is said to be neutral. When the water is removed, sodium chloride (NaCl) can be isolated as a crystalline solid.

The water molecule consists of a hydrogen ion (an acid) and a hydroxyl ion (a base). The reaction between two molecules of water may be written $H_2O + H_2O \rightleftharpoons H_3O^+ + OH^-$. The large arrow pointing to the left indicates that most of the water molecules are nonionized. The number and concentration of acid (H_3O^+, or simply H^+) and basic (OH^-) ions are equal, so that pure water is neither acidic nor basic. Natural water, however, may be acidic from absorption of acidic aerial gases or may be basic from dissolution of alkalis.

Water is more than an inert solvent but plays a part in the reaction. Acidity consists of an excess of hydrogen ions in the form of H_3O^+; basicity involves an excess of hydroxyl ions. Chemical reactions are greatly influenced by the hydrogen ion concentration. A quantitative measure was long needed to describe the condition of water that contains extra hydrogen or hydroxyl ions.

In 1909, S. P. Sorenson originated the symbol pH to express hydrogen ion concentration in water solutions, as

$$pH = \log_{10} \frac{1}{\text{concentration of } H^+ \text{ in moles per litre}}$$

The value of pH is equal to the logarithm (base 10) of the reciprocal of the concentration of hydrogen ions in moles per litre of the aqueous solution.

In a litre of water at 25°C there is 0.0000001 mole of hydrogen ions; there is also 0.0000001 mole of hydroxyl ions. At 25°C the pH of water is given by

$$pH = \log_{10} \frac{1}{0.0000001} = 7$$

The pH = 7, but the pOH = 7 as well, and pH + pOH = 14. Increasing the number of hydrogen ions in solution produces a decrease in an identical number of hydroxyl ions, as the product of the concentrations of the two ions is a constant. The relationship of the pH scale (acidity) and the pOH scale (alkalinity) is shown in the table.

In practice only the pH values are used as a measure of acidity or alkalinity. Acidity increases (alkalinity

decreases) by a factor of 10 for each pH unit less than 7, the neutral point; alkalinity increases (acidity decreases) by a factor of 10 for each pH unit above 7. A pH 6 solution is 10 times as acid as a pH 7 solution; a pH 5 solution 100 times as acid as a pH 7 solution. A pH 8 solution is 1/10 as acid or 10 times as alkaline as a pH 7 solution.

HYDROPHILIC Water receptive.

HYDROPHOBIC Water repellent.

HYDROQUINONE The white or off-white crystals or crystalline powder of this developing agent (C_6H_4-1,4$(OH)_2$, molecular weight 110.11; also called quinol or 1,4-benzenediol) are soluble in water, alcohol, or ether but more soluble in hot water. Photographic grade is 99% minimum. The compound oxidizes as a solid or in solution. Human exposure may result in eye injury or dermatitis.

Hydroquinone in strongly alkaline solutions produces high image contrast but when combined with Metol or Phenidone, improves image formation in areas of minimum exposure.

HYDROXIDE A chemical compound containing a hydroxyl group, which when ionized in water provides an alkaline or basic condition, readily accepting protons.

HYGROSCOPIC This adjective describes the absorption or attraction of water from the air, a property possessed by many substances. The holding of a small amount of water by a humectant can be useful but the liquefaction of an alkali, such as sodium hydroxide, can result in its degradation.

HYPO A common term for ammonium or sodium thiosulphate salts or the fixing baths made with these compounds. The term is derived from the early but incorrect name, hyposulphite of soda, given to sodium thiosulphate.

HYPO-ALUM TONER A direct sepia toner utilizing free sulphur in a suspension that results when potassium alum is added to a hypo solution. A silver nitrate *ripener* is sometimes added. The prints are toned in this heated bath, with occasional agitation, for 20 minutes to 1 hour, or until toning is complete. Toning can be accomplished at room temperature overnight (12 to 14 hours). Toned prints should be brought to room temperature and any sulphur remaining on them sponged off before washing for 15 to 20 minutes in running water.

HYPO ELIMINATOR A dilute aqueous solution containing hydrogen peroxide and ammonia that was

previously recommended for the removal of residual fixing salts such as sodium or ammonium thiosulphate, which are oxidized by this solution to harmless sodium or ammonium sulphate salts. Since the hydrogen peroxide can also affect the image silver itself, it is no longer recommended for the processing of contemporary materials.

HYPO TEST The stability of photographic silver images is largely determined by the residual thiosulphates or other fixing compounds. Various test solutions have been proposed to detect the remaining concentration of hypo and to estimate the effect on the long-term stability of the image. Hypo test methods often involve turbidity or stain measurements.

ILFOCHROME See *Cibachrome*.

IMAGE DEGRADATION The slow destruction of image-forming substances, or of the image layer itself by chemically aggressive reactants or biological contaminants.

IMAGE PERMANENCE The permanence of an image or other document defined by the dictionary as lasting or intended to last indefinitely is a somewhat elusive quality unless it is given a practical meaning. Because no object can truly be said to last indefinitely, the requirement for, or designation of, an image to be permanent seems unrealistic. In practical terms, permanence indicates a record "having permanent value," for example, a motion-picture film, or a historical still photograph. This qualification indicates the need that it be preserved, either in its original form or by copying or duplicating its contents. Another term widely used to suggest long-lasting properties is *archival*, in such expressions as archival storage conditions, archival processing of photographs, or an image having archival quality. The word *archival* is a nonscientific term that is meant to imply permanence but is unsuitable for material specifications since it does not describe a measurable property.

Life Expectancy In order to alleviate the careless use of such words as *archival* and *permanent* for attributing a certain quality to photographic images, the American National Standards Institute (ANSI) has introduced the concept of life expectancy (LE) rating for photographic records. An LE_{100} rating for an image on film, for example, indicates that it is expected to be usable for one hundred years. Specific LE ratings have been assigned to certain materials, which makes this concept practical and useful.

In general terms, permanence indicates the resistance of a material to chemical action that may result from impurities in that material itself or agents from the surrounding air. This definition is essentially one given by the U.S. Technical Association for the Pulp and Paper Industry (TAPPI) for the permanence of paper. For chemical elements and well-defined compounds, such resistance to react chemically can be expressed quantitatively. For example, the series of standard electrode potentials of metals precisely defines the energy required to oxidize elemental metals to the ionic state. For pure chemical compounds, the reaction enthalpy for a specific reaction indicates its reactivity. It has been determined for many compounds. However, neither paper nor photographic

215

records consist of pure chemical compounds, but are mixtures of many ingredients, as in paper, or possess an intricate layer structure of components with different properties, which characterizes photographic materials. While the stability of pure chemical elements and compounds can be determined quantitatively, more empirical approaches have to be taken with composite materials. Thus, permanence can indicate the ability of a material to remain usable for its intended purpose for a specified number of years. This is the purpose of the LE rating. The resistance of a photographic image to chemical action, a definition that will be adhered to throughout the following discussion, can be determined by measuring its ability to maintain measurable *mechanical* and *optical* properties, either during natural aging or after exposure to accelerated aging conditions. Tests for these properties are an integral part of many standards published by ANSI that deal with photographic records.

Besides observing the properties of photographic images throughout their history and so drawing conclusions about their stability, one can prepare such images, or other records, from known ingredients and observe their ability to maintain mechanical and optical properties under forced conditions. Such experiments allow one to draw conclusions with respect to the suitability of materials for the long-term retention of information. It can be shown that some materials are clearly superior to others with regard to their stability. This knowledge is essential in writing *contents-based* standards with material specifications for the preservation of records having permanent value.

Photographic Records So far this discussion of permanence has used the general terms *record*, or *document*, rather than focusing on photographic images. There are good reasons for this: first, it is not practical to have several definitions for permanence for different kinds of records. Keepers of collections in archives are likely to have more than photographic images to care for, for example, paper records. Secondly, photographs can have a variety of support materials, the principal ones being paper, plastic film, and glass plates. Paper is a generic term that indicates that different kinds are made from similar materials using similar technologies. A definition of permanence for newsprint should also be applicable to a photographic print. It should be applicable to plastic films as well, made of either cellulose acetate or polyester, that are used as a support for both photographic films and sound tapes.

Defining permanence as the resistance of records to chemical action means that it is not solely a property that is either built-in or lacking in the product, but also a property that is determined by its subsequent use and storage. In addition, photographic records are distinguished from other recording media by their need for

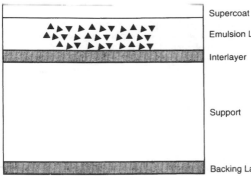

	Supercoat
	Emulsion Layer
	Interlayer
	Support
	Backing Layer

(not drawn to scale)

Photographic record cross-section. While nearly all photographs
have a distinct emulsion layer (exceptions: daguerreotypes,
salted paper prints) the antiabrasion layer, or supercoat, is
found mostly on twentieth-century materials. An interlayer,
which is located between the emulsion and the support, can be
found either in films as subbing layer, where it is transparent,
or in fibre-based prints as a gelatin layer filled with the white
pigment barium sulphate. There it is called a baryta layer. In
resin-coated papers (RC papers), the interlayer consists of
polyethylene that contains a white pigment, typically titanium
dioxide. In both types of prints, the interlayer is opaque. The
backing layer can function as an anticurl and as an antihalation
layer.

chemical processing. This requirement places a burden on
users of photographic films and papers that does not exist
for paper or magnetically recorded media. With a specific
focus on photographic images, three factors determine
their permanence:

- the manufacture, from raw materials to technology
 used;
- the processing, in particular, sufficient fixing and
 washing;
- the subsequent storage conditions and use of
 photographs.

Each of these factors can contribute to an increase in
the resistance of photographic images to chemical action.
All contemporary photographic records have three
principal components: a support, a binding agent coated
on top of the support, and an image-forming substance
held in place by the binding agent. While the most
common support materials are paper, film, and glass in
contemporary photographic records, gelatin has been used
almost exclusively for the past 100 years as the binding
agent in black-and-white and in colour photographs. Both
the support and binding agent contribute to the stability,
or lack of it in some cases, of a photographic record. The

217

principal component, however, that determines the longevity of a photographic image is the image forming substance. In *black-and-white* photographs it consists of finely divided elemental silver. The wide range of hues in a *colour* photograph are formed by organic dyes. Since the stability of these two principal image-forming substances varies widely according to their chemical nature, they are discussed separately.

BLACK-AND-WHITE IMAGES The chemical stability of image silver in *black-and-white* photographs is lower than could be expected from its position in the series of standard electrode potentials that classifies it as noble metal. In order to understand the mechanism of image degradation in a *black-and-white* photograph that manifests itself as discolouration or fading of the image, a brief introduction into the formation of a photographic image may be useful. The elemental silver present in these images is generated by two fundamentally different pathways. The first occurs by direct and sufficient exposure of a silver halide to light. The silver halide can be a chloride or bromide, or a combination of these, with small amounts of silver iodide sometimes present. It is evenly distributed throughout the image layer in the form of fine particles. Upon exposure to light elementary silver is formed, which is termed photolytic silver. Exposure times are long, typically from 30 to 60 minutes at about 300 footcandles. In practical photography the process of making photographs just described is known as the printing-out process, and photographic papers operating on the principle of producing an image by exposure alone are called *printing-out papers* (POP). After the image has been printed out upon exposure under a negative, prints are treated in a fixing bath to remove unexposed silver halide, washed, and dried. The printing-out process was the first by which photographic prints were made, and it was the predominant, although not the only, process of making photographic prints in the nineteenth century. Examples include the earliest positive photographs on paper, called salt-prints, or salted paper prints, which were in use from the late 1830s to the mid-1860s. They are characterized by the lack of a distinct image layer; the image silver particles are largely drawn into the fibres of the paper, but lie partially on the paper surface. The most widely occurring photographic print material of the nineteenth century were albumen prints. Other photographs made by the printing-out process are collodio-chloride papers and silver gelatin printing-out papers. The recently discontinued Studio Proof Paper by the Eastman Kodak Company is a prominent example.

The second pathway takes place by the chemical reduction of a silver halide crystal that has been exposed to light for a period sufficiently long to create latent image specks of elemental silver on that crystal. Chemical reducing

agents dissolved in water, known in photographers' language as developers, act upon these elemental silver specks so as to reduce the entire crystal to elementary silver. The exposure times that are necessary to form the developable silver nucleus range from fractions of a second for camera films, to a few seconds for photographic papers, at the same intensity as above. The chemical reaction that converts a briefly exposed silver halide to elemental silver is called development in normal photographic practice. Photographs made by this process are termed *developed-out prints* (DOP). Obviously, a photograph so produced also needs to be fixed, washed and dried in order to become a stable image. Photographic prints made by the printing-out process have conventionally been divided into bromide papers, first manufactured in the early 1880s; chloride papers, characterized by relatively low sensitivity, a cold-black image tone, a higher maximum density than other developed papers, fine grain, and good contrast; and chlorobromide papers, which are used in many commercial applications as projection-speed enlarging papers. In chlorobromide papers, silver bromide is predominant over silver chloride in the unexposed and unprocessed material.

The elemental silver grains present in each of the two groups of photographic prints differ from each other in their respective size and morphology. Silver particles present in printed-out photographic prints are smaller by a factor of almost two orders of magnitude than those formed by chemical development. Although the size of silver particles in either printed-out or developed photographic prints fluctuate widely, the former average around 0.02 micrometers in diameter. They are approximately spherical in shape. By comparison, the dimension of a developed-out silver grain can vary around a value of 0.5 micrometers. Developed-out silver grains can be cubic shaped, or irregularly formed grains with numerous edges and corners. Many consist of filamentary silver, which may be likened in appearance to steel wool. This variation in the morphology is built into the raw stock by the manufacturer in order to achieve specific photographic and sensitometric properties in a given film or paper. Silver gelatin photographic technology allows the manufacturer to tailor photographic images to specific applications, such as studio work, motion pictures, microfilming, x-ray films, and many others. In processed photographic films, silver grains are generally larger than in paper prints, because larger silver halide particles provide greater sensitivity to light, a desired property for negative films to be used in cameras. Experience has shown that the image-forming silver in photographic prints made by the printing-out process are more reactive towards aggressive chemicals than those in developed-out photographs. This knowledge will be useful in understanding various observations made throughout the history of photography on the stability of black-and-white photographs.

Environmental Reactants A wide-ranging body of experimental evidence and practical experience indicates that the image silver in black-and-white photographs can be oxidized by aggressive chemical compounds. Numerous reagents have been found capable of reacting with the image silver to produce silver ions. The most notorious are peroxides. In the form of hydrogen peroxide, they are also the most common reactants used in laboratory tests designed to study the resistance of black-and-white photographs to oxidizing agents. Research performed about thirty years ago at the Eastman Kodak Company showed that peroxides could oxidize individual silver particles in processed microfilms with the concurrent formation of microscopically small orange-colour spots known as *redox blemishes*, *red spots* or *microspots*. The term redox is derived from the abbreviation for *red*uction-*ox*idation, the chemical mechanism by which they are formed. Redox blemishes consist of circular spots of colloidal silver. The studies indicated that elemental silver had been oxidized to silver ions which could diffuse outward in a radial fashion before being redeposited as colloidal silver. This process could repeat itself so that circular zones of high silver concentration were followed by silver-free rings, giving rise to the visible appearance of concentric rings. They usually occur on negative films, especially camera original microfilm, because of the relatively high silver content in these images.

Since redox blemishes were found on microfilm that had been stored in cardboard boxes, the source of the peroxides was traced to the groundwood present in the cardboard. Peroxides, which can emanate from groundwood during natural aging, are gaseous compounds that can be envisaged as reactive forms of oxygen. They are, as noted, capable of chemically attacking image silver in processed films. The formation of redox blemishes is not restricted to microfilm, as they have been observed on contemporary black-and-white resin-coated (RC) prints as well.

Another source of peroxides that may cause the discolouration of black-and-white photographic prints are alkyd-based paints when drying. Extensive experiments that investigated the effects of different types of house paints on the discolouration of photographic prints showed that latex-based paints were harmless, but that during drying, alkyd-based paints produce peroxides that can react with the image of silver photographs.

Investigations carried out by the Agfa Corporation showed that certain phenol-formaldehyde resins, upon aging, can cause image degradation. Other damaging materials included ozone produced by electrostatic office copiers, exhaust gases from automobiles, and other industrial gases. Recent studies have explained the appearance of edge-fading on mounted photographic prints dating from the first ten years or so of photography. Commercially available animal glue caused severe fading

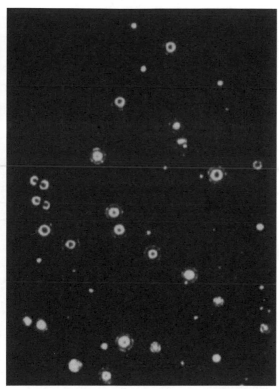

Environmental reactants. Redox blemishes on processed microfilm, magnification 50×.

of an image area when applied to the back of sample prints that were prepared for experimental purposes. The chemical compound *thiourea*, present in minor amounts in animal glue, was found to be the active ingredient capable of reacting with both photolytic silver, as in images on printing-out papers, and developed-out silver grains. The occurrence of serious edge-fading in photographic prints decreased after the first decade following the medium's invention, suggesting that photographers had developed an understanding of the danger of using animal glue for the mounting of photographs. Similar studies on the effect of fingerprints on black-and-white images revealed that the principal component of sweat produced by glands in the human skin is sodium chloride, present at a concentration of about 0.03%. A conversion of image silver to silver chloride is the most likely reaction to happen as a result of a fingerprint. The silver chloride so formed may print out when exposed to light, giving rise to the discolouration

lines in the form of the ridges and valleys on the surface of the human skin. This example illustrates well that only very small amounts of aggressive chemicals are necessary to cause visible discolouration in black-and-white photographic images. The amount of image silver, while varying throughout the technological history of photography and from one type of record to another, is in the range of 50–60 $\mu g/cm^2$. It is finely divided, finely distributed, and has a large surface-to-volume ratio, making it a reactive material. Degradation reactions of the image silver are fascinating because the amazingly small amount of silver present in a photograph requires only equally minute amounts of reactants to cause striking visual changes in the image that are described as fading or discolouration.

Other chemically reactive gases capable of oxidizing silver image particles in black-and-white photographs include hydrogen sulphide and nitrogen oxides. The latter are particularly insidious. As a reaction product of degrading cellulose nitrate film base, they can react with the image silver of other black-and-white films and papers stored in the vicinity; they can also attack the gelatin layer of these photographs, destroying its chemical structure and turning it weak and unable to perform its function.

Numerous observations and experiments have demonstrated that the presence of moisture is necessary for reactions of the image silver with aggressive chemical reagents to occur. It also accelerates most of these reactions. Since the moisture is supplied in most cases from the relative humidity in the surrounding air, the environmental conditions during experimental work, as well as in keeping photographic collections, must be controlled.

This discussion has focused so far on the nature of impurities from the surrounding air that may precipitate chemical action in a photograph. Included here are also impurities which can produce discolouration that originate from filing enclosures, envelopes, or any other materials with which a photograph may be in close contact. Prominent examples are newsprint (newspaper clippings!), the transfer of ink from inscriptions on the back of a print to the surface of an adjacent photograph; and adhesives used in the seam of filing enclosures. The exact identity of the offending substance is not known in any of these cases.

Residual Processing Chemicals Besides the possible degradation of image silver resulting from aggressive chemicals in the vicinity of a black-and-white photograph, there are other causes resulting from impurities in the photograph itself. The most notorious of these are residual processing chemicals. During processing, the unexposed and undeveloped silver halides are removed from the image layer by dissolving them in a silver halide solvent. The most effective solvent, used almost since the beginning of photography, is an aqueous solution of sodium thiosulphate, or its faster working relative,

ammonium thiosulphate. The former is known in photographers' language as fixer, or fixing solution, the latter as rapid fixer. The fixing process may be regarded as proceeding in three phases. During the first step of the fixing reaction, silver halides form a complex salt with the thiosulphate anions of the fixing solution. In the second step, the silver-thiosulphate complex is washed out of the image layer by fresh fixing solution. This is achieved by using two fixing baths in sequence, the second of which must be a freshly prepared solution. In the last step, the pure fixing solution is removed from the photograph by washing with copious amounts of water.

The fixing reactions and the washing step must be carried to completion in order to obtain a stable silver image. If a photograph is *underfixed*, complex residual silver salts may form silver sulphide stains that are visible as yellow or brown discolouration. If a photograph is *underwashed*, residual thiosulphate anions may react with image silver to form similar sulphide stains. Both reactions are generally slow. Since the potentially reactive compounds do not necessarily react with image silver at once, the results may not become visible for several years after a photograph has been processed. Experience has shown that residual silver-thiosulphate complexes and pure fixing salts can be present either in the paper base or in the image layer in a semi-stable state. For example, an insufficiently washed photographic print or fibre-base paper may show no visible discolouration when kept in controlled conditions; a change in the environment is needed to provoke a reaction. If exposed to high relative humidity coupled with elevated temperature, a reaction of the sulphur-containing residual processing compounds is triggered to produce discolouration.

Chemical Tests Since visual examination of a processed photograph alone cannot determine whether it was correctly fixed and washed, chemical tests in the form of spot tests that produce the same stains on insufficiently processed images as those that would occur over the long term in normal keeping conditions can be performed. These tests are generally done on a second sample that is processed along with the final image in order to avoid test stains on it. The test solution for residual silver salts, that is for *underfixing*, is a 0.2% sodium sulphide solution, which forms yellow to brown silver sulphide stains if the test is positive. To detect residual fixing salts, sodium or ammonium thiosulphate, a drop of an approximate 1% acidic silver nitrate solution, which forms the same silver sulphide stains, is applied to the photograph. Such tests are mandatory for fibre-base prints for two reasons: first, conventional fibre-base papers have the ability to absorb and retain processing chemicals not only in the emulsion layer, but also in the paper base itself. By contrast, glass plates and plastic film support materials do not absorb chemical processing solutions that can penetrate only into

the image layer. A second reason is the smaller grain size of image silver particles in prints in comparison to those present in negatives, which makes them chemically more reactive. Correct fixing and washing eliminates a potential reactant from the print. The foregoing illustrates the need for careful processing of black-and-white photographs, a subject that has been treated exhaustively in various photographic publications. Insufficient fixing and washing has sometimes been represented as the only serious threat to the permanence of photographic images. However, factors arising from the immediate environment are of equal significance.

Protective Toning In order to protect photographs from such impurities in the surroundings, their treatment in a toner solution is often advised. The purpose of treating photographs in a toner solution is two-fold: to change the neutral tone of an image to one desired by the photographer, for example to a sepia colour or to a cold blue tone; and simultaneously, to increase the permanence of the image. The principal idea behind such treatment is either to convert the image silver to a silver compound or to modify the morphology of silver particles, both of which would increase the chemical stability of the image-forming substance. Typical examples are treatment in a solution of gold salts commercially called gold protective solution— and in selenium salt and sulphur-containing solutions. Recent studies have shown that toner treatments should be considered mandatory for contemporary films and papers if permanent photographic images that are resistant to chemical changes are to be obtained. Some manufacturers have offered commercial toning solutions, or image protective solutions, to enhance the stability of black-and-white photographs. Examples include the Sistan solution by the Agfa Corporation, Silverguard by Fuji Photo Film Co. Ltd., and Silverlock by the Image Permanence Institute.

HISTORICAL OBSERVATIONS Many of the properties related here have been observed empirically since the beginning of photography by its practitioners. Descriptions of image stability are scattered throughout the various photographic journals. It is only during the past twenty years that studies on the permanence of photographic images have assumed a more systematic role. One of the earliest, albeit rather crude, attempts to test the stability of photographs was carried out in 1843 by a pharmacist in Hamburg, Germany, who exposed daguerreotypes, introduced just four years earlier, to hydrogen sulphide gas. The images disappeared within a few hours. Prominent among the early reports is an account of studies by a committee that had been appointed by the Royal Photographic Society (R.P.S.) in London, England, in the mid-1850s. Its full name indicated its purpose: Committee Appointed to Take into Consideration the Question of the Fading of Positive

Photographic Prints upon Paper. In its first report, published in 1855, it correctly cited "the presence of hyposulphite of soda" (sodium thiosulphate in contemporary terminology) in photographic prints *and* "the continued action of sulphuretted hydrogen and water" as predominant causes of discolouration and fading. Sulphuretted hydrogen is termed today hydrogen sulphide. The fading committee noted that "there are traces of this gas at all times present in the atmosphere," and predicted that "pictures will not remain unaltered under the continued action of moisture and the atmosphere in London." The fading committee's findings indicate that careless processing and small amounts of aggressive oxidizing chemicals in the presence of moisture are the principal reasons for the discolouration of black-and-white photographs.

The effect of relative humidity in assisting such discolouration reactions was demonstrated in 1892 in a report by a photographer working in India. The disappearance of images on bromide prints, a common photographic enlarging paper by the developing-out process, was traced to "the instigation by humidity of chemical action in the material or the paper which converts the silver into a compound that diffuses and disappears in the support." The author interpreted his observations correctly: elemental image silver is converted into a silver salt, a process that is aided by humidity. The disappearance of the silver salt into the support is probably the first observation of the migration of image silver in the process of image degradation.

Yet another empirical report from a practicing photographer emphasized the devastating effect of persistently high relative humidity on the permanence of photographic prints. Working in the Solomon Islands, that is, in a "climate of the warmth and dampness of that of the South Pacific Islands," this author in 1929 described humid conditions as a very good test of the permanence of photographic prints quite in keeping with contemporary views. The "fading to a sickly yellow in a year or so" of bromide prints was attributed "to retained sulphur or sulphur compounds in the print, which in the presence of moist heat reacts on the silver image." The source of the sulphur compounds no doubt is to be found in the fixing salts that have been left inadvertently in the print. Photographic reflection prints, made traditionally from fibrebase paper, are capable of retaining residual processing chemicals more effectively than supports made of glass or plastic film, as noted. The felted sheet of fibres that defines paper readily absorbs liquids and gases, retains them under some circumstances and allows them to migrate through the sheet in others. For example, it has been observed that cardboard mounted with a black-and-white print absorbed hydrogen peroxide, retained it for a while, then released it to migrate farther into the image layer of the

photograph. The result is visible discolouration of the image. Similarly, residual silver-thiosulphate complexes or pure fixing salts can be retained by the paper base, unless washed out carefully.

Image Degradation The mechanism of image silver degradation is now well established. The first step is the oxidation of elemental silver to silver ions. This first oxidation step is more easily achieved than the classification of silver as a noble metal would indicate. The reaction is facilitated by the extremely small size of the individual processed silver grain (as small as 5 to 35 μm in printing-out papers) as well as by its accessible surface area, which is large relative to its size. The second step is either an immediate reaction with an available anion to form a stable silver salt or a migration of silver ions away from the original silver nucleus. The water content of the gelatin—which may vary from about 4 to 9% depending on the relative humidity of the surrounding air—while possibly playing a role in the ionization step, is definitely responsible for the ability of the silver ions, once formed, to migrate away from the original silver grain.

This migration can be seen by studying silver grains using electron microscopy. This process can be repeated under laboratory conditions, using, for example, hydrogen peroxide as the oxidizing agent in the presence of humidity. The destruction of the integrity of the original developed silver grain can be driven to completion. The result is a complete loss of sharpness of the image to the eye, a phenomenon that may rarely be seen in naturally aged photographs. The migration of silver ions just described is characteristic of all degradation mechanisms in black-and-white silver gelatin images involving oxidation reactions.

The foregoing observations serve to demonstrate that the structure of photographic materials and the morphology of their respective image silver grains allow us to arrange their *inherent permanence* relative to each other. The resistance of photographic films and prints towards the effect of oxidizing chemicals *increases* in the following order: salted paper prints < albumen prints < chloride paper < bromide paper < negative films. The image silver in salted paper prints is the most reactive: image-forming silver grains in these prints are smaller than in developed-out papers by a factor of about 100. Therefore they are much more sensitive towards reactive materials in comparison to developed-out prints. The lack of a separate binding layer (termed the baryta layer in contemporary print materials) only reinforces this sensitivity, since the paper support is quite permeable for many oxidizing gases, such as hydrogen peroxide. The absence of such a protective layer further increases the danger of mechanical damage by abrasion. Consequently, modern films and papers carry a separate layer as protection against abrasion coated on top of the image layer. And finally,

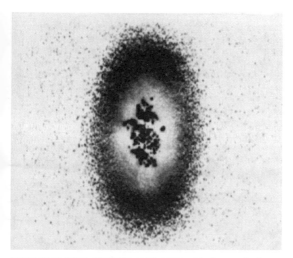

Image degradation. Naturally aged processed silver grain from a negative. The nucleus is surrounded by numerous small particles that have migrated away from it, as a result of image silver degradation. Transmission electron micrograph at a magnification of 60,000×.

early photographs on salted paper were generally made using support materials of unknown quality with the concurrent uncertainty regarding their stability.

Albumen prints, as the name indicates, carry the image particles inside a protective layer derived from the white of eggs. Chloride papers and bromide papers are both developed-out prints with silver particles embedded in a gelatin layer, which are larger than in salt prints and albumen prints. They enjoy the additional benefit of a baryta layer, sandwiched between the paper support and the image layer, that protects the image from impurities migrating through the paper support. Photographic films have traditionally had a requirement for high light sensitivity, which results in a comparatively coarse image structure and increased resistance to chemical attack.

Increasing Image Longevity Referring to the definition stated earlier that permanence of a document is not only determined by its own inherent material properties but also by subsequent processing and keeping conditions, an understanding of these characteristics points directly to specific recommendations for black-and-white photographs. *Preventing damage* to them means ensuring and maintaining their permanence. At the record creating stage, correct fixing procedures must be introduced by using two fixing baths, of which the second consists of freshly prepared solution, followed by sufficient washing. Simple chemical tests must be performed to verify both.

The longevity of the well-processed black-and-white image depends now on subsequent storage, handling, and use conditions. Keep photographic negatives and prints away from aggressive, oxidizing chemicals, as they are present in rooms freshly painted with alkyd-based paints, or around electrostatic office copy machines, which produce ozone. Use filing enclosures that are stable themselves and do not give off materials upon aging that may be harmful to the photograph inside. While sleeves and envelopes may be made of either plastic sheeting or paper, their properties should match the requirements of the American National Standards Institute (ANSI), published in document IT 9.2. Do not wrap photographs in newsprint, and do not keep newspaper clippings in an envelope that also contains original photographs.

Store processed microfilm in boxes of inert plastic or metal. A material notorious for producing chemically reactive gaseous products that attack the image silver of other photographs stored nearby is aging cellulose nitrate film base. Consequently, store all photographs in an area segregated from the storage area used for cellulose nitrate film. When mounting photographic prints, use pastes of plant origin or dry mounting tissue. Handle photographs only when wearing lintless cotton or nylon gloves in order to avoid fingerprints. Avoid attaching photographs to other documents using paper clips or staples. Do not roll up large film negatives (panorama negatives) but store them flat in map cabinets. Do not tolerate food and drinks in the vicinity of original photographs.

Well-processed silver gelatin photographic prints on fibrebase paper are essentially stable to light of normal illuminance levels, i.e., 100 to 200 footcandles, as found in homes and offices. Direct sunlight—which easily reaches levels of above 10,000 footcandles—is extremely damaging to all photographs. Keep them out of direct sunlight. Dry heat alone is not considered to be a serious threat to the stability of well-processed black-and-white photographs. Rather, any combination of the three principal factors, i.e., the presence of oxidizing substances, high relative humidity, and heat, produces a synergistic effect that will seriously affect their longevity.

It follows that a storage area for photographs should have an air-conditioning system that removes harmful polluting gases that may originate from industrial activity or automobile exhaust gases from its environment and provides stable temperature and relative humidity levels. Since temperature is not too crucial, normal comfort levels are adequate, for example 20°C (68°F), but it may well be a few degrees below or above that. It should not, however, fluctuate more than 4°C (7°F) daily. Relative humidity has been shown by numerous studies and practical experience to be of overriding importance. A level of 25 or 30%, with a variation not exceeding ±3%, is considered optimum.

These recommendations are the result of the collective

knowledge and experience of photographic manufacturers and users of photographic imagery alike. Such expertise is reflected in recommendations for the preservation and storage of photographic images published by the American National Standards Institute (ANSI). Published standard specifications for photography, originally designated PH followed by a number and year of publication, are now labeled IT, for imaging technology. Several ANSI standards are pertinent to the permanence and preservation of black-and-white and colour photographic images.

In the foregoing, the term black-and-white photograph has been used synonymously with an image that has silver as the image forming substance. Since these pictures are rarely of a neutral black-and-white image tone, but are more often variations of this ideal with the appearance of cold-blue or warm-brown tones, the term *monochrome* is also applicable especially in order to distinguish them from colour photographs.

Non-silver Images During the second half of the nineteenth century, when the potential instability of silver prints became apparent, many attempts were made to replace the silver with a more stable material, such as printer's ink or suspensions of carbon particles (lampblack) in gelatin. Several of these non-silver processes were solely developed because the resultant images had a stability superior to those made by conventional silver processes. While numerous processes were in use at one time or another, only a few have gained high rank and recognition for their superior rendering of tones and their permanence. These are the Woodbury types, carbon prints, collotypes, and photogravures, as well as modifications of these processes. Other processes that must be mentioned here are handmade, non-silver pigment printing processes such as cyanotypes (blue prints), gum bichromate prints, bromoil prints, and photographs that have non-silver metals as an image-forming substance, such as platinum prints (platinotypes) and palladium prints. Since elemental carbon (lampblack) in Woodbury types and carbon prints is chemically nonreactive, these photographs are virtually fade resistant. Since they are not susceptible to any of the oxidation reactions that black-and-white image silver may undergo, they come close to the distinction of being permanent monochrome images with truly continuous-tone characteristics, except for the potentially limiting stability of the gelatin layer into which the carbon particles are embedded.

COLOUR IMAGES The image in *colour photographs* consists for the most part of organic dyes with properties that differ in their chemical properties in several ways from the image-forming elemental silver present in black-and-white photographs. Contemporary colour photographs are produced by one of four processes with organic dyes as the image-forming substance. In addition, some individual photographers and printmakers

still make colour photographs that contain pigments not unlike those found in oil paintings. There are also colour photographs in collections that were made by now obsolete additive processes of colour formation, which will be reviewed briefly below.

The different structural and chemical properties of black-and-white and colour photographs is reflected in the kind of information that is available about them. While black-and-white photographic images are fairly similar as a generic group distinguished in their respective permanence characteristics mainly by the different size of image silver particles and by the presence and kind of a separate image layer—the stability of colour photographs is generally directly determined by the type of image-forming dyes. They may vary from one generic group to another and, within one group, may differ from one manufacturer to another. For example, factors detrimental to microfilm, such as hydrogen peroxide, are equally damaging to other silver gelatin photographs. Treatments to enhance the stability of black-and-white images, such as toning, are applicable to all black-and-white records. By contrast, colour photographic materials require detailed consideration according to the process by which they were made. Because of this variation between generic groups and manufacturers, stability characteristics of colour slides, negatives, and prints have indeed become significant factors in publicity campaigns for certain products.

By far the largest number of colour photographs today are made by the *chromogenic development* process. All photographic colour negatives, slides, motion picture films, and the great majority of colour prints are made by this process. It is therefore the most common and economically important process. The dyes that form the final image are chemically synthesized during development from colourless precursors initially present in the film layers. These precursors are known as *dye couplers*. The principle of colour formation is described as follows. An unexposed colour film or paper contains silver halides as the light sensitive agent. During development the silver halides that have been exposed to light, as in the formation of black-and-white images, are reduced to elemental silver, with the concurrent formation of oxidized developer. The oxidized developer now reacts with dye couplers to form simultaneously the three subtractive dyes: cyan, magenta, and yellow. This describes the simple processes as they were practiced 50 years ago. In contemporary colour films, additional chemical reactions occur to provide sharp images and colour balance. Such films may contain as many as 15 or more different layers with dyes and filter layers.

A second method of making colour photographs is known as the *silver dye bleach process*. In these materials preformed dyes are incorporated into the emulsion during manufacture. After exposure, the dyes are partially destroyed image-wise during processing under the

catalytic action of developed silver. The only materials of this kind manufactured at present are Ilford Professional Colour Products, such as Ilfochrome Classic, Ilfochrome Rapid, or Ilfocolor Deluxe, made by Ilford A.G., a division of International Paper Company. These materials were made between 1963 and 1991 by Ciba-Geigy A.G. of Switzerland, and were known as Cibachrome Color Print Materials. Silver dye bleach materials are positive working; a slide, that is, a positive transparency, exposed to a sheet of Ilfochrome Classic produces a positive colour print. This material has low light sensitivity, but is used for identification photographs and in colour microfilm. It is also suitable for the preparation of colour prints and positive transparencies in colour.

Widely used in amateur and specialized professional applications are photographs made by *dye diffusion transfer processes*. They are also known as instant colour photographic processes, or one-step photography. In an intricate series of chemical reactions following exposure in a camera, dye developer molecules incorporated in these images react with the developer moiety to form the three subtractive image dyes. Such materials were first produced by the Polaroid Corporation (Polarcolor; Polacolor 2; SX-70; Spectra Film; Spectra HD, etc.). Eastman Kodak Co. produced its instant colour prints under the names of PR-10, Kodamatic, Trim Print, etc., from 1976 to 1986, and Fuji Photo Film Company marketed its FI-10 system in 1981 and its Fuji 800 Instant Color Film in 1984.

In another process known as *dye imbibition process*, preformed dyes are successively built up in the gelatin mordant layer coated on a stable paper support from a printing matrix film to produce dye imbibition prints. The only such process in use in North America is Eastman Kodak's Dye Transfer Process. In Japan, Fuji Photo Film Co. provides colour prints made by a similar process known as Fuji Dyecolor. The Technicolor motion picture process, still in use today in the People's Republic of China, but abandoned everywhere else, also works on the dye imbibition principle. Finally, developments are underway to produce colour images from digitally encoded data or from display monitors. North American and Japanese companies have succeeded in perfecting *thermal dye transfer* processes with excellent image quality. Their image stability is the subject of current tests. Colour prints have also been made since the late nineteenth century, and are still made today, by printing processes that use pigments of mineral origin. Examples are tricolour carbo prints, gum bichromate prints, and Fresson Quadrichrome prints.

Fading and Stains A wealth of knowledge on the permanence of colour photographs made by chromogenic development processes has been accumulated during the past four decades. Since colour photographs are produced annually in truly staggering numbers, their stability has

become a matter of economic importance. The permanence of colour photographs, analogous to that of black-and-white images, is a function of their inherent properties, and of storage and display conditions. Dyes in colour films and prints can fade under the effect of light as well as in the dark. Since fading occurs in the two circumstances at different rates and by different mechanisms, the terms *light fading* and *dark fading* are used to distinguish between them. The dyes present in colour photographs made by the process of chromogenic development are the only dyes known to fade in the dark. There are no other coloured documents that behave similarly. This fading in the dark is largely dependent upon the temperature and relative humidity at which the materials are kept. An increase in the storage temperature will accelerate the fading rate. Researchers take advantage of this effect with so-called accelerated aging tests which allow them to observe changes in a relatively short time that might otherwise require many years to occur. The opposite is true for keeping colour films at low temperature: the rate of dye degradation is greatly reduced.

Colour photographs may also build up stain when stored in the dark; this is visually apparent in low density areas. For example, a white area may change to yellow. Dyes in colour photographs will also fade when exposed to light, as noted, as do textile dyes, watercolours, and printing inks. In addition, build-up of stains can also occur in photographs exposed to light. Consequently, the photographic industry monitors the stability of its products under dark storage conditions as well as under light fading conditions. Dark storage stability is assessed under the influence of heat and high relative humidity alone, whereas light fading and staining are monitored during constant temperature and relative humidity concurrent with exposure to light sources of known intensity and spectral distribution. The longevity of a colour photograph is defined, for experimental purposes, as the time elapsed before the limiting dye—i.e., the weakest dye—has lost 10% of its dye density. Destruction of organic dyes through chemical reactions, such as oxidation or hydrolysis, is considered irreversible. A restoration of faded colour photographs by chemical means is not, at present, believed possible. For this reason, prevention of dye fading is essential.

Three variations of chromogenic development processes were developed by manufacturers in the period from the early 1930s to the end of the 1940s. The first commercially available colour slide film was Eastman Kodak's Kodachrome films, put on the market in 1935. It was followed closely by Agfa's Agfacolor film in 1936 and Eastman Kodak's Ektachrome films in 1940. The three systems differ in the provenance of the dye coupler. In the Kodachrome process, the dye couplers are introduced from an external source, along with the developer. Consequently, no residual couplers remain in the finished

picture, a property that contributes to the image's long-term permanence. In the Agfacolor transparency films, the three different dye couplers—one each for yellow, cyan, and magenta dye images—were incorporated for the first time into three gelatin images in a multilayer structure. This incorporation was achieved by attaching longchain molecules to the couplers, thus making them immobile, or *nondiffusing*, without affecting their photographic properties. In a single development step, which could be performed by the user, all three dye images were formed simultaneously. Eastman Kodak's Kodacolor introduced the principle of dispersing dye couplers in microscopically small droplets of an oily substance, hence the term *oil-protected coupler*. Such dispersion turned out to be the more enduring system, as it has been used worldwide by all major manufacturers. With the notable exception of Kodachrome, dye couplers not used in the formation of dyes during processing remain in the image layer after processing, which has significant consequences for the stability of the image.

The difference in the behaviour of colour photographs kept in the dark and those exposed to light can be recognized visually. It was observed early that cyan generally is the least stable dye in the dark or after exposure to accelerated aging conditions at elevated temperature and relative humidity in the dark—and assumes a reddish overall cast. Under the influence of light, however, cyan dyes are generally the most stable, while magenta is weakest. Photographs faded by exposure to light therefore show a blue-green overall tone, which is caused by the predominance of the surviving cyan plus yellow dye.

Changes in the visual appearance of colour photographs are measured by monitoring their dye density. It has always been assumed that the recorded changes in physical properties, i.e., density, occur as a consequence of chemical changes. While the actual measurements can in principle be carried out quickly and easily, the necessity of performing very large numbers of density determinations make this a time-consuming task. Additional factors must be considered when recording dye density changes. Results will be different whether they are taken from a pure (single) dye patch or from a neutral density patch that contains roughly equal amounts of all three dyes. Stain formation in a minimum density area must also be determined as an important criterion of image stability. In order to predict the long term stability of dyes in colour films and papers in the dark, the materials can be subjected to accelerated aging conditions at a minimum of four, preferably five, different temperatures. From results obtained at elevated temperatures it is possible to estimate the longevity of a dye at room temperature. Such estimates are based on the Arrhenius equation, which relates chemical rate changes to temperature. The Arrhenius equation states that the logarithm of the rate

constant of a first order chemical reaction is inversely proportional to the temperature in degrees Kelvin. Research performed in the photographic industry and published in 1980 showed that the dark fading of dyes follows first order chemical kinetics and that the rate of dye fading at room temperature can indeed be predicted from results obtained in incubation tests. Fortunately, the American National Standards Institute has published a standard procedure for predicting the long-term dark storage stability of colour photographic images and for measuring their colour stability when subjected to certain illuminants at specified temperatures and humidities. Light exposure tests are not predictive; they can be used to compare the effect of different light sources or to examine the effect of a certain light source on different colour images. The document is entitled *Methods for Measuring the Stability of Color Photographic Images*, ANSI IT 9.9-1990. The study of this document is highly recommended for everyone wishing to appreciate the complexities of determining the permanence of colour materials.

Chemical Mechanisms of Deterioration Several chemical mechanisms have been found to contribute to the degradation in the dark of dyes made by *chromogenic development* process. E. Bancroft stated as early as 1813: "If a dye fades, it sometimes becomes oxidized, and sometimes reduced." Adding that sometimes a dye may become hydrolyzed summarizes the principal pathways of dye destruction. For example, the instability in the dark of azomethine and indoaniline dyes in early chromogenic colour photographs was shown to be caused by their susceptibility to *acid* hydrolysis. Reaction occurs at the azomethine bond. *Alkaline* hydrolysis can also destroy yellow azomethine dyes, the nucleophilic reactant attacking, in this case, the keto bond. Nucleophilic reagents such as hydroxyl, sulphite, cyanide, or thiosulphate anions can react with naphthoquinone-imine dyes, which leads to a loss in dye density. A very fast reaction of the addition of an oxygen to the azomethine bond occurs when a pyrazolone-azomethine dye is exposed to ozone.

A further mechanism, unrelated to the above but recognized already in the early 1950s, involves the reaction of residual pyrazolone couplers with the magenta dye formed by them. Individual reactions of this type cannot be described in detail within the scope of this entry. Their nature and mechanism have been studied extensively, and the results of such studies are published in the technical literature. It may be noted that residual thiosulphate anions can, here as in black-and-white photographs, affect the permanence of the image. Correct processing according to the instructions given by various manufacturers is therefore necessary.

During the past decade, photographic manufacturers have published image stability data about their products.

The reader will find a selection from these publications in the Books list following this entry. Typical contemporary chromogenic colour prints will survive in the dark for approximately 120 years before losing 20 percent dye density of the limiting dye, usually cyan, from an initial density of 1.0, but some recent products claim an even higher stability. Exposure to tungsten light at 100 lux will allow contemporary chromogenic colour prints to be exhibited for 10 hours per day, 6 days per week, for 75 to 100 years before a 10% loss of the limiting dye is achieved. Instant colour prints are also very stable when kept in the dark. Prints made by the dye imbibition process, and colour prints made by silver dye bleach processes, such as Ilfochrome Classic, have the highest dark storage stability of all colour print materials containing dyes: approximately 800 years before loss of 0.2 density units of the limiting dye from an initial density of 1.0.

Cold Storage Since all principal pathways of dye degradation during dark keeping of chromogenic colour photographs were recognized within a couple of decades after the development and commercial introduction of these materials, manufacturers have succeeded in improving the stability of colour photographic images by a factor of two or three magnitudes. Since dark stability is essentially determined by temperature, and to some degree by humidity, the two factors must be controlled for long-term keeping. Motion picture studios in Hollywood began storing colour negative films in the mid-1950s at temperatures between 45 and 50°F (7 to 10°C) and 40 to 50% relative humidity. Fifteen years later, researchers from the Eastman Kodak Company proposed cold storage of colour films as a long-term preservation measure, including storage in hermetically sealed containers (such as foil bags) at 0°F (–18°C) or below, or in taped cases at 0°F or below. Relative humidity was recommended to be between 15 and 30%. Another decade later, Eastman Kodak published actual figures indicating the increase in longevity, or increase in storage time to reach specified dye density losses, for a colour if it is kept at low temperatures. The time at 40% RH for a 0.1 density loss to occur from an original density of 1.0 increases by a factor of 16 if the storage temperature is lowered to 39°F (4°C) from 75°F (24°C), and by a factor of 340 if the storage temperature is 0°F (-18°C). It is necessary to control strictly the relative humidity at low temperature. It is the *relative* humidity that affects longevity. While it is not easy to control relative humidity at temperatures below 32°F, i.e., the freezing point of water, where the *absolute* humidity (the ability of air to hold a certain amount of water vapour) is limited, there are nevertheless technologies available to achieve this, and there are companies that supply this technology. A level of 30% RH is recommended. Cold storage of chromogenic colour photographic films, slides, negatives, and prints at 30 to 35% RH

is accepted today as the most efficient and cost-effective measure for the long term preservation of large amounts of colour materials. Such facilities are now available in many collections in North America, Europe, and Japan.

DETERIORATION OF SUPPORT MATERIALS

The permanence of photographic images is not only a function of the inherent stability of image-forming substances, but also of the properties of the materials that support the image. Many different materials have been used throughout the history of photography, including such unusual examples as leather, cloth, wood, or ivory. Photographs made by two processes in the beginning of photography have a metal support. Daguerreotypes, one of the earliest types of photographs, were made on copper plates. They are named after their inventor, L. J. M. Daguerre, who introduced them in 1839. Copper plates have been proven to be a stable support during the past 150 years, as no observations exist that demonstrate a detrimental effect of the support on daguerreotype stability. Another type of photograph made by the wet collodion process during the second half of the nineteenth century also used a metal support, in this case a flexible sheet of iron. They are known as tintypes. The most common base materials, however, are plastic film, paper, and glass plates; the following remarks focus on these supports.

It is no accident that the first photographic images dating from the mid-1830s by W. H. Fox Talbot were made on paper. Talbot himself had mentioned that he was in search of a method for producing mechanical drawings of landscapes or persons, without the aid of a pencil. In the instructions dating from the first decades of photography, the use of "good quality" writing paper is advised, although this latter condition is nowhere clearly specified. It had been observed early on that the raw stock for producing salted paper prints should be devoid of chemically aggressive substances, should have a certain wet strength, and must remain flat. Industrial manufacture of papers as photographic base materials began in the 1860s in Europe. Photo papers have been made since that time in high purity and with excellent strength properties. While details of their manufacture and composition remain proprietary knowledge of the industry, experience in handling and studying photographs in historical collections has shown them to be among the most permanent papers made industrially. They generally do not exhibit the normal symptoms of poor quality papers upon aging, such as yellowing, foxing (the development of brown feathery spots), or brittleness. This is achieved by a high alpha-cellulose content, the use of special sizing agents, the absence of metal ions or particles, and by appropriate manufacturing procedures.

In the 1960s, the photographic industry developed resin-coated (or RC) papers, in which the paper sheet is coated

on both sides with a layer of polyethylene. The polyethylene layer on the image side, that is the one below the emulsion layer, contains a white pigment, usually titanium dioxide. RC papers have many technical advantages: dramatically reduced processing times, less tendency to curl, and improved wet strength. Early versions of this paper could develop cracks in the polyethylene that would propagate into the image layer and so become visible. This cracking appeared to be catalyzed by the presence of titanium dioxide. Numerous successful efforts by the manufacturing industry have overcome these initial drawbacks. Chromogenic colour papers by all manufacturers have been produced for the past twenty years or so exclusively on resin-coated paper stock.

While the first photographic negatives were prepared on paper, glass plates became the predominant negative support in the nineteenth century. First used in the glass plate negatives made by the wet collodion process, they became the first supports coated with a gelatin layer containing a light sensitive silver halide. Glass's weight and fragility make it an inconvenient material. Well-known is its susceptibility to chemical attack by alkaline materials. It is otherwise a stable material; witness the large number of glass plate negatives surviving in historical collections.

Plastic film supports, first manufactured in the 1890s, rapidly superseded glass as the principal emulsion support for negatives. These first materials were made of cellulose nitrate, which has a number of properties that make it suitable for use as a photographic film base. It is now well established that cellulose nitrate is also inherently unstable, becoming weak and brittle during natural aging. Its major drawback is high flammability. Several fires have been reported that were caused by spontaneous self-combustion of cellulose nitrate film, usually in motion picture film exchanges. An additional feature of aging cellulose nitrate is the detrimental effect of gases emanating from it on processed acetate films stored in its vicinity. The gases are mainly oxides of nitrogen, which affect first the processed image silver, next the gelatin binder, and finally the safety film base itself. In the 1930s, cellulose nitrate film was gradually replaced by cellulose ester films (diacetate, triacetate, acetate propionate, acetate butyrate). While cellulose nitrate is thermodynamically the least stable of all film bases, the cellulose ester films, usually labelled "safety film" along with polyester films, have also been shown to be subject to shrinkage, loss of plasticizer, and plastic flow leading to distortion. Notorious is their low resistance to moisture. Some contemporary views hold that the instability of cellulose ester film is of the same order as that of cellulose nitrate. The latter has been studied more extensively; its tendency to degrade suddenly, to self-ignite spontaneously under specific circumstances, and the devastating effect of the

by-products of its own degradation on other photographs have given it the notoriety of being the largest source of problems in photograph collections.

By contrast, the widely accepted and confirmed stability of polyester film [poly(ethylene-terephthalate)] is the result of decades of determined effort by the photographic manufacturing industry. Current polyester films, also used in the manufacture of magnetic tape, have been shown to be chemically inert and of good dimensional stability. They have a high wear and tear resistance and low moisture sensitivity. Estimates by various sources for the longevity of polyester films under controlled conditions of 20–25°C and 50% RH range from 900 to several thousand years. Such predictions were made after Arrhenius-type testing, i.e., after aging the materials at several different temperature levels.

Other synthetic plastic materials either proposed or actually used as film bases include polystyrene supports or polycarbonates. Little is known about their stability.

DETERIORATION OF GELATIN Gelatin, a complex natural polymer of animal origin, has been used almost exclusively as the binding agent in photographic records for more than a hundred years. It has numerous properties that make it uniquely suitable as a binder for light-sensitive silver halide crystals and a host of other ingredients in the raw stock. After exposure and processing, the gelatin lends protection to he elemental silver grains and to the dyes in colour photographs. Its permanence is a function of keeping conditions. If kept dry at normal room conditions, the stability of gelatin layers is estimated to be unaffected for several hundred years. It is sensitive to alkaline environments. Its resistance to processing solutions, some of which are alkaline, may be controlled through the use of hardeners. Hardeners reduce the swelling of gelatin layers in aqueous solutions and increase its melting point, defined as the temperature at which the layer dissolves, or breaks up, in a specified alkaline salt solution. Conventional hardeners are trivalent salts of chromium and aluminium, and formaldehyde or other aldehyde derivatives. When processed correctly and kept in suitable conditions, gelatin layers do not limit the stability of photographic materials.

SUMMARY Photographic images have existed for more than 150 years. Observations made by practitioners of the art and collectors alike, scientific investigations by the manufacturing industry as well as photograph historians and conservators have collectively contributed to a firm body of knowledge on the permanence of photographs. Several processes provide stable, permanent images in both black-and-white and colour. To remain permanent, keepers of collections, in turn, must provide storage conditions conducive to longevity. For example, well-processed silver gelatin images on microfilm can confidently be expected to survive many centuries,

making them an ideal copying medium to preserve information that is printed on less stable materials, such as newsprint.

The majority of photographs in historical collections, such as museums and archives, are in excellent shape. There are exceptions, notably images on cellulose nitrate film, or those in colour made by the very early chromogenic development processes. The technical history of photography is also a history of continuous manufacturing improvements to the permanence characteristics of photographic images. Knowledge on how to handle, display, and keep photographs has increased concurrently. Amateur and professional users alike have reasons to appreciate and to trust the permanence qualities of photographic images.

Books: Agfa-Gevaert, *Agfacolor Type 8 Paper*. Technical Data A 81. Leverkusen, Germany: Agfa-Gevaert AG, 1984; Agfa-Gevaert, *Agfachrome Umkehrpapier*. Technische Daten A 82. Leverkusen, Germany: Agfa-Gevaert AG, 1986; American National Standards Institute, *American National Standard for Photography (Film), Processed Safety Film, Storage*. ANSI IT9.11-1992. New York, NY: ANSI, 1985; American National Standards Institute, *American National Standard for Photography (Film and Slides), Black-and-White Photographic Paper Prints, Practice for Storage*. ANSI PHI.48-1982 (R 1987). New York, NY: ANSI, 1987; American National Standards Institute, *American National Standard for Imaging Media, Stability of Color Photographic Images, Methods for Measuring*. ANSI IT9.9-1990. New York, NY: ANSI, 1990; American National Standards Institute, *American National Standard for Photography, Film, Plates, and Papers, Filing Enclosures and Storage Containers*. ANSI IT9.2-1991. New York, NY: ANSI, 1991; American National Standards Institute, *American National Standard for Photography (Plates), Processed Photographic Plates, Practice for Storage*. ANSI IT9.6-1991. New York, NY: ANSI, 1991; Eastman Kodak, *The Book of Film Care*. Kodak Publication H-23. Rochester, NY: Eastman Kodak Company, 1983; Eastman Kodak, *Conservation of Photographs*. Kodak Publication F-40. Rochester, NY: Eastman Kodak Company, 1985; Eastman Kodak, *Kodak Ektacolor Plus and Professional Papers for the Professional Finisher*. Kodak Publication E-18. Rochester, NY: Eastman Kodak Company, 1986; Eaton, G. T., *Photographic Chemistry in Black-and-White and Color Photography*. Third revised edition. Dobbs Ferry, New York, NY: Morgan & Morgan, 1980; Fuji Photo Film, *Fujicolor Paper Super FA Type 3*. Fuji Film Data Sheet Ref. No. AF3-723E (92.1-OB-5-1). Tokyo: Fuji Photo Film Co. Ltd., 1992; Ilford Photo Corporation, *Mounting and Laminating Cibachrome Display Print Materials and Films*. Paramus, NJ: Ilford Photo Corporation, 1988;

Polaroid, *Storing, Handling, and Preserving Polaroid Photographs: A Guide.* Toronto, Canada: Focal Press, 1983; Reilly, J. M., *Care and Identification of 19th Century Photographic Prints.* Kodak Publication G-2S. Rochester, NY: Eastman Kodak Company, 1986; Sturge, J. M., Walworth, V., and Shepp, A., *Imaging Processes and Materials: Neblette's Eighth Edition.* New York, NY: Van Nostrand Reinhold, 1989.

IMAGE PERMANENCE INSTITUTE (IPI) A research laboratory working in the field of the permanence of imaging materials and located in Rochester, New York at the Rochester Institute of Technology.

IMBIBITION PROCESS Any process for making prints by the selective absorption of dyes on a gelatin or similar surface. Typically, a hardened gelatin relief matrix is used to transfer the dye by contact. Colour prints can be made from a set of three separation positives.

INCORPORATED COUPLER Rather than add colour couplers during processing, incorporated couplers are included in the emulsion during the manufacture of many films and printing papers.

INDICATORS A chemical, usually a dye, that indicates by its colour the condition of a solution. Many dyes that change colour at definite values of acidity or alkalinity can be used to measure pH. Comparison to known colour standards for the dye can be made for solutions or for indicator dyes impregnated in paper strips. By mixing indicator dyes, a universal indicator paper will give a number of colours over a wide pH range.

INERT GASES Strictly speaking, the noble gases from the eighth column of the periodic table, i.e., helium, neon, argon, krypton, xenon, radon. These gases possess an atomic structure that makes them extremely resistant to chemical bonding, and exist almost exclusively in a gaseous, monatomic state. This is because they all have a completely filled outer shell of electron orbitals. Other gases may also be designated as inert gases for a particular purpose, such as the use of nitrogen for agitation during development, but such designations are not strictly correct.

INERT GELATIN Gelatin, a commercial product derived from the skin, bones, and sinew of animals, is normally an impure, variable product containing both sensitizers and restrainers. Gelatin that has been chemically treated to remove these impurities that influence silver halide sensitivity is said to be *inert*. During emulsion making, known amounts of impurities can then be introduced, a process called chemical sensitization.

INERTIA The exposure at the approximate start of the straight line of a negative D-log H curve, found at the intersection of the extended straight line and the base plus fog level. It was the basis for the first sensitometrically determined film speed, devised by Hurter and Driffield— the H & D speed.

INFECTIOUS DEVELOPMENT A type of photographic development during which the developing rate of silver halide grains is greatly accelerated by the partially oxidized form of the developing agent. Low-sulphite lithographic film developers containing hydroquinone exhibit this type of developing activity.

Some persons restrict infectious development to the reduction of unexposed grains in the vicinity of developing exposed grains. Developers containing hydrazine form products that are fogging agents and develop grains without regard to exposure. This type of fogging developer does not show the discrimination of the hydroquinone lith developer.

INFRARED FILM Silver halide emulsion film that has been sensitized to radiation in the 700–1200-nm wavelength range. Because such emulsions are also sensitive to radiation in the ultraviolet and blue regions, appropriate filtration is needed to record only infrared radiation.

INORGANIC A term that is descriptive of any chemical compound that is not classed as organic. Derived from mineral sources, inorganic compounds usually do not contain carbon.

INSPECTION DEVELOPMENT The use of the appearance of the image with safelight illumination as a guide to the completion of development. Contrast with time-temperature development.

INSTANT PHOTOGRAPHY Any photochemical photographic system that yields a positive print moments after the exposure is made. In the 1850s, the five-minute wait for a tintype seemed nearly instantaneous. Now, a variety of Polaroid materials can produce a finished print in a minute or less using the diffusion transfer process. The photo booths common in amusement parks produce prints on direct positive paper in about five minutes. Various digital imaging systems hold the promise of truly instantaneous photography.

INTEGRAL DENSITY For a tripack colour photographic image, a measurement of the absorption of light by a sample in which all three layers affect the result. Integral densities are useful for predicting the printing characteristics of a colour negative and the appearance of a colour positive.

INTEGRAL TRIPACK Photographic material for colour photography consisting of three differently sensitized layers on the same support. Since virtually all colour materials now used are of this type, these terms have fallen into disuse.

INTENSIFICATION Intensification is a postprocessing chemical procedure used with black-and-white negatives to increase density. The formulas and procedures for intensification are varied, but they can be divided into four general categories: (1) addition of silver to the existing image, along with sometimes changing the form and structure of the silver; (2) addition of another metal to the silver image; (3) converting the silver image to a compound of another metal; and (4) incorporating or substituting a coloured compound or dye that has a greater light-absorbing effect in the spectral sensitivity range of the printing paper.

PROPORTIONAL INTENSIFICATION The increase in density is most commonly *proportional* to the amount of silver that existed in the negative prior to treatment, thus producing an increase in contrast, or an effect similar to that which would have been attained with a longer developing time.

SUPERPROPORTIONAL INTENSIFICATION The percentage of increase in density is greater for thc higher densities than for the lower densities of the original image. There is a considerable increase in highlight density with little increase in shadow density. The overall contrast tends to be higher than that achieved with a proportional intensifier.

SUBPROPORTIONAL INTENSIFICATION A third alternative is a percentage increase that is greater for the lower densities of the original than for the higher densities to produce a *subproportional* effect. The contrast is lower than that obtained with a proportional intensifier but is higher than that of the original negative, with better enhancement of shadow detail.

ADDITION OF SILVER One proportional intensification method is accomplished by what in effect is *physical development*, that is the depositing of additional silver on the existing image. The intensified image has the same colour as the untreated image, and thus is easy to judge when printing. The technique is somewhat critical, requiring considerable skill and care. Some treatment may be required to avoid addition of silver to the nonimage gelatin areas, and the life of the solution is relatively short.

ADDITION OF OTHER METALS Another method consists of converting the silver image to a halide or combination of halide and another metal followed by redevelopment to produce an image having greater opacity. One of the most reliable of these intensifiers is that utilising chromium, which produces a proportional

result. Other metal intensifiers make use of lead, copper, tin, and uranium. Modifications of some of these procedures can be made to give superproportional or subproportional effects.

Another technique makes use of uranium to convert the silver image to a warm coloured image that has a strong intensifying effect due to its absorption of blue light to which most printing papers are highly sensitive. It is difficult to judge due to the difference between the visual appearance and the photographic result.

DYE INTENSIFICATION When a metal-hydroquinone developed silver image is converted to a halide by bleaching, then redeveloped in a low-sulphite pyro developer the dye-silver image has a greater light absorbing effect due to the added pyro stain. A silver image can also be mordanted (made to attract dye) then dyed to produce an image that has an intensified photographic effect.

FLUORESCENT IMAGE ENHANCEMENT When a developed negative is soaked in a fluorescing dye, such as Rhodamine B, the dye is absorbed strongly even in areas with minute silver. This dye negative is then subject to ultraviolet radiation to produce a fluorescent image that is then rephotographed.

INTERIMAGE EFFECTS A change of the image in one emulsion layer caused by chemical effects from an adjacent layer during the development of a multilayer photographic material, such as a colour film. Interimage effects can be beneficial as well as detrimental.

INTERMITTENT AGITATION Periodic movement of solutions rather than continuous. Often used in tank processing of roll and sheet film.

INTERNAL DEVELOPMENT After the removal of the surface latent image by oxidizing agents, such as chromic acid, the latent image in the interior of a silver halide grain can be made accessible by using a developer containing mild silver halide solvents. These latent image centres can then be developed, showing the presence of an internal latent image.

INTERNAL LATENT IMAGE Most of the latent image formed by light exposure of silver halide grains is situated on the surface of the crystal, possibly at centres formed during the chemical sensitization step of emulsion making. It has been shown, however, that latent images also exist internally through the depth of the grain. It is possible that the internal latent image forms along boundaries and along dislocation lines in the strained regions of the crystal, but it has been difficult to obtain proof of the nature of the latent image in the interior of actual emulsion grains.

INTERSTITIAL IONS Some silver ions in a silver halide crystal are located in the interstices between the other ions of the crystal lattice structure. The ability of these displaced ions to move is thought to take part in the formation of the latent image and the development of the silver image.

IODIDE A salt containing the element iodine. An iodide salt of silver was the light sensitive part of the early daguerreotype and wet plate processes and remains today part of photographic emulsions.

IODINE Violet-gray crystals (I_2, molecular weight 253.81) with a vapour that is extremely irritating to the eyes, stains skin, and attacks the respiratory tract. Slightly soluble in water but more so in aqueous solutions of potassium iodide or in alcohol, chloroform, or ether. Used as an oxidant to reduce or remove silver images, as in bleaches, reducers, or solutions for removing silver stains.

ION When a neutral atom of a metal loses one or more electrons, a positively charged ion, called a cation, is formed. The cation is smaller than the neutral metal atom because a smaller number of electrons is being attracted by the same positive nuclear charge. When a neutral atom of a nonmetal gains one or more electrons, a negatively charged ion, called an anion, is produced. The anion is larger in size than the neutral atom of the nonmetal because of the extra electrons that are being held by less than an equal number of protons in the nucleus. The attraction of opposite charges on ions increases their chemical activity and makes possible the formation of ionic crystal structures, such as the cubic form of sodium chloride.

ION EXCHANGE Calcium and magnesium ions can be removed from hard water by passing the water over complex sodium aluminum silicates (zeolites). The complex silicate exchanges its sodium ions for the calcium and magnesium ions of the water. Water-soluble sodium sulphate and water-insoluble calcium aluminum silicate are formed. By flushing with a solution of sodium chloride, the sodium salt of the silicate can be regenerated for further use.

IONIC CONDUCTIVITY The conductivity caused by the movement of ions in an electrical field. In silver halides this conductivity is due to the movement of interstitial silver ions.

IONIZATION Ionization is a type of dissociation or separation of a compound when water causes the compound to form ions that are hydrated. For example, hydrogen chloride, a gas, dissolves in water, forming

hydrogen ions, H+, and chloride ions, Cl-, that are surrounded by water molecules. Atoms of a gas can be ionized under the influence of an electrical discharge or radiation energy.

IRON PROCESSES See *Iron salt processes*.

IRON SALT PROCESSES Photographic processes utilizing the action of light on ferric salts that are reduced to the corresponding ferrous salts. The latter act as an intermediary in forming a visible image. Thus it can be converted into Prussian blue (blueprint process) or used to reduce silver salts in the emulsion to silver (Kallitype and other iron-silver processes) or to reduce palladium or platinum salts (palladiotype and platinotype). In the Pellet process, a variation of the blueprint process, the unexposed iron salts are converted into Prussian blue, rather than the exposed salts, to form the image. Yet another type of iron salt process is based on insoluble coloured compounds formed by ferric salts with gallic or tannic acid (ferro-gallic and ferro-tannic processes).

ISOELECTRIC POINT The isoelectric point (IEP) occurs at a certain solution condition at which a molecule or crystal has a net charge of zero. With gelatin in water, the isoelectric point is the pH value when the negative and positive charges on the molecule are equal in number. The molecule is then in a condition of lowest solubility and greatest compactness. The IEP of a silver halide crystal is the silver ion activity (pAg) when the net electrical charge on the crystal is zero.

ISOING In emulsion making, adjusting the pH of the emulsion to its isoelectric point so that the silver halide grains can be separated from the gelatin.

ISOTOPES Isotopes are atoms of a chemically insepa-rable element varying slightly in weight because of differ-ent numbers of neutrons in the nucleus of the atom. All natural elements are a mixture of two or more isotopes derived by different routs of radioactive decay, resulting in an automatic weight that is an irregular number.

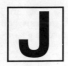

JET SPRAY Agitation in which the processing solutions are forced against the film through a nozzle in a forceful stream.

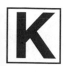

KEEPING QUALITY The stability of photographic chemicals, processing solutions, or sensitized materials with time.

KELVIN (K) A temperature scale having its zero at –273.16°C, and scale intervals equal to those of the Celsius scale. The colour temperature of light sources is given in kelvins, for example 3200 K.

KINK MARKS A kink mark is produced when a film or paper is locally stressed before processing. The strength and polarity (dark or light compared to the surrounding area) of the mark is affected by the relative humidity at the time of the stress, and by whether it was made before or after exposure to light. Kink marks commonly occur when roll film is improperly loaded on a processing reel, or when film or paper is bent sharply in a local area because of careless handling.

KINK SITE A site on the (100) surface of an ionic crystal in which three of its neighbours are missing relative to the same ion located inside the crystal. Because of the missing neighbours which would be oppositely charged, it has a net charge of $\pm 1/2$, depending on the ion at the kink site. On silver bromide surfaces the positive kinks are silver ions and the negative kinks are bromide ions. The excess charge allows the kink sites to attract electronic carriers, electrons, or holes of the opposite sign and act as shallow trapping sites.

KODACHROME (1) Pioneer colour transparency film of the integral-tripack, nonsubstantive, subtractive colour type. Invented by two musicians, Leopold Mannes and Leopold Godowsky of New York City in 1933, and introduced by Kodak in 1935. It quickly became the standard of comparison for transparency materials. It was eventually offered as 8-mm and 16-mm motion picture film, in short 35-mm rolls for miniature cameras, and in sheet sizes to 11×14 inches. Sheets were discontinued in 1955. Kodachrome film has a simple three-layer structure, each layer merely recording one of the three additive primaries, blue, green, or red. The processing, however, is very lengthy and complex. An initial black-and-white development of all three layers to separation negatives is followed, along with other steps, by individual colour development of each layer in the sequential presence of yellow, magenta, and cyan colour couplers in the solutions. The

process has varied over the years, but always involves over a dozen baths and multiple re-exposure steps hence, very few laboratories are equipped to process Kodachrome films. (2) An obsolete two-colour process intended for portraiture. Bipack negatives were made in a conventional camera, or in a special beam-splitting camera with separation filters. Primaries used were a brick-red and a bluegreen. Flesh tones were remarkably good, but the process was never commercialized (Capstaff, 1915, Eastman Kodak Company).

KODACOLOR (1) The name for integral tripack, substantive, films and papers in a negative-positive colour process primarily for making subtractive colour prints. They are the basis of a snapshot colour system. (Other similar, but not identical, materials for professional use are called Ektacolor.) Both Kodacolor and Ektacolor negatives are, like all negatives, reversed in tones: bright objects appear dark and vice-versa. Colours appear as their complements, but not exactly. The colour couplers in the film are themselves coloured in such a way as to mask unwanted absorptions by the dyes themselves. This makes the negatives difficult to interpret visually, but renders any prints made from them much truer in colour reproduction (Eastman Kodak Company, 1949). (2) An obsolete additive colour process on 16-mm lenticular motion picture film, first sold in 1928, based on the Keller-Dorian patents. Special tricolour filters in the additive primaries were placed over the camera and projector lenses. The effective ISO speed was about 0.5, and the projected image on the screen was not very bright. The colours, however, were amazingly good. There was little interest in it after the introduction of Kodachrome film in 1935.

KOSTINSKY EFFECT See *Photographic effects.*

LACQUER See *Protective coatings.*

LAINER EFFECT The action of small amounts of alkali iodides in accelerating development by low-potential developers, such as hydroquinone, apparently by partially converting the surface of silver bromide grains to silver iodide.

LAMINAR LAYER A very thin layer, especially of a developing solution in contact with a photographic material being processed. The thickness of such a laminar layer affects the rate of penetration of developing chemicals into and out of the emulsion and thus affects the rate of development. Laminar flow involves the movement of a thin sheet of a fluid, as distinct from a turbulent motion.

LAMINATION Lamination is a process by which a photograph is bound between two layers, usually clear plastic, to protect it from dirt, fingerprints, and moisture. In the case of ID cards, the lamination process also inhibits changing or altering the photograph. Several different product lines are available for laminating photographs, and, as with dry-mounting materials, laminating materials come in both cold and hot mounting press varieties. Some laminating films, in addition to physically protecting the photograph, also provide ultraviolet radiation protection. In addition to protecting photographs from ultraviolet radiation, moisture, dirt, and fingerprints, heavily textured laminating materials may also be used to enhance the aesthetic nature of a photographic image by providing a texture pattern that may enhance the mood of the photograph.

Cold laminating films are either clear or textured plastic materials with an adhesive coating on one side. These laminating materials must be applied with a professional laminating press unless the print is very small. Other types of laminating materials are designed to encase the print between two layers of the plastic laminate, one on the front of the print and one on the back of the print, which provide a better moisture-proof seal than single surface lamination. A greater degree of waterproofing and moisture protection is afforded if the laminate overlaps the print edge.

Heat-activated laminating materials are available in a variety of thicknesses and types of plastics. The type of laminating material selected determines the strength and rigidity of the photograph. The type of plastic used for

laminating will affect the permanence or archival quality of the print; polyester and polypropylene films are best. Acrylic and polyvinyl chloride laminates will not last as long. The substrate to which the print is mounted will also provide additional rigidity, moisture protection, and strength. Non-textured aluminium or Lexan plastic sheets are smooth-surfaced rigid materials that are dimensionally stable and will not harm the print chemically, and they offer complete moisture protection. Some laminating services provide a felt or velvet backing to the laminate to prevent several stacked laminated prints from rubbing against each other and scratching the laminate surface.

LATENSIFICATION Latensification, latent image intensification, and hypersensitization have as their objective the amplification of an image produced from a low luminance subject during an extended exposure. Hypersensitization is applied before exposure, and latensification is applied, as its name suggests, after exposure but before development. The techniques are similar, relying on exposure or chemical treatment. Outlined here are procedures that yield an increase in effective film speed of one to two stops.

A very low level uniform exposure to white light works selectively on the latent image. While an exposure slightly below the threshold of the film or plate does not create many new, developable points, it amplifies those parts of the emulsion that have already received an exposure above the threshold. Further, effective film speed is increased because some areas that received exposure below the threshold are raised by the intensifying exposure to measurable density. While log level necessarily increases, an exposure determined by test to fall just below the toe of the characteristic curve will intensify appreciably more than in fogs.

Chemical latensification is more convenient than chemical hypersensitization because the film or plates need not be dried after the treatment. The effective sensitivity increase may be greater if drying follows the treatment, however. Triethanolamine is an effective latensifier. Film may be soaked in 1.5% hydrogen peroxide and washed thoroughly before development. A solution consisting of 0.5% each of sodium bisulfite and sodium sulphite may be used for up to five minutes, as may 0.5% solutions of potassium metabisulphite or sodium bisulphite with lessened effect.

Chemical vapours were used in the past for latensification, but the customary mercury vapour and sulphur dioxide present health hazards. Potassium metabisulphite fumes, also used for hypersensitization, may be effective, as may forming gas.

LATENSIFICATION EFFECT See *Photographic effects*.

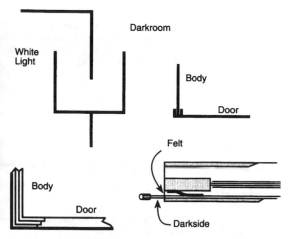

Light trap. The various light traps shown are (upper left) typical darkroom maze, (upper right and lower left) camera or magazine doors, (lower right) sheet-film holder darkslide trap.

LIFE EXPECTANCY (LE) The time expressed in years during which a photograph is expected to remain usable.

LIGHT FOG Light fog is the result of unwanted exposure of the sensitized material. Overall exposure, such as when the film or paper is used under unsafe lighting conditions, may extend uniformly over the sheet, producing a uniform fog that may not be obvious. Such fog reduces the overall contrast of the image, but in many cases it can be compensated for by adjusting exposure and contrast of the printing material.

Nonuniform exposure such as from camera leaks, faulty plate holder light traps, situations where shadows can fall on the sensitized material exposed to ambient light, and light produced by static discharges often renders the image useless.

LIGHT TRAP In a darkroom, an arrangement of walls and openings that excludes undesired light yet permits easy entrance to or exit from the room. The walls should be painted flat black to absorb light. On film holders, magazines, or cassettes, a light trap, lined with a material like black velvet, permits passage of film or dark slides but no light. Camera doors or covers are also light trapped by means of stepped-down grooves.

LIGHTWEIGHT Characterizing photographic printing papers on a support thinner than single-weight.

LIPPMANN EMULSION A silver bromide emulsion of surpassingly fine grain and extreme contrast formulated by Gabriel Lippmann for use in the colour process that bears his name, a process at once simple and elegant in concept, but very difficult in practice. The size of the photosensitive crystals is so small that there is virtually no scattering of light. Resolving powers beyond 5000 line-pairs per millimeter are estimated. Emulsions of this type have also found use in some forms of holography and special scientific applications.

LIQUID GATE Identifying an enlarger or optical printer film holder that sandwiches the film in a layer of glycerine or other suitable liquid between two glass plates, used to reduce the visibility of surface scratches and abrasions.

LITRE In the metric system (SI), a unit of volume, equal to 1000 millilitres (ml) and to 1.06 quarts.

LITHIUM BATTERY/CELL See *Batteries*.

LITH/LITHO/LITHOGRAPHIC The first two names are familiar terms for the last here referring not to the lithographic method of planographic printing itself, but to special films of extreme contrast and density range used in exposing lithographic printing plates. These films find many other uses in photography where high contrast, high density and high resolution are needed. To achieve maximum contrast and density, a special lith developer is necessary—often supplied as two solutions to be combined just before use. It is formulated to encourage infectious development, leading to the highest possible contrast. Gammas of 25 to 50 are produced with maximum densities beyond 7.0. For high but not extreme contrasts, ordinary developers can be used.

In the graphic arts, special developers and techniques, such as still development, are used for the reproduction of very fine lines without loss or breaking. Development by inspection is sometimes used, with critical examination of the dot and line images as they develop. Most lith film is orthosensitive for handling under a bright red safelight, but panchromatic versions are also supplied, permitting direct screened colour-separation negatives to be made.

LITMUS An indicator dye derived from a lichen that changes colour from blue to red under acid conditions and red to blue under alkaline conditions. The dye is available as a solid, in water solution, or impregnated in paper test strips.

LOG EXPOSURE The logarithm to the base 10 of the exposure (quantity of light per unit area) received by a photographic material. Characteristic curves of photo-

graphic films and papers are plots of log exposure as input (independent variable) on the horizontal axis versus density as output (dependent variable) on the vertical axis.

LOG-EXPOSURE RANGE The difference between the log-H values for the minimum and maximum useful points on the D-log H curve. The range varies with emulsion characteristics, with processing, and with the definition of *useful*. For negative and reversal films, the log-H range limits the scene contrast that the material can accommodate and the allowable variation in camera exposure settings. For printing papers, the log-H range (formerly scale index) varies with the paper grade and is approximately equal to the total negative contrast that the paper can record.

LOG H See *Log exposure.*

LOW-CONTRAST Identifying a lighting, film, developer, printing material, etc. used to decrease tonal separation, either to achieve a low-contrast effect or to compensate for a high-contrast effect elsewhere in the system. Also, identifying an image having less than normal contrast. Film resolving powers, for example, are determined using both high-contrast and low-contrast test targets.

LUSTRE Describes the surface finish of photographic papers between semimatt and glossy.

MACHINE PROCESSING Machine processors are the workhorses of the professional photofinishing industry. They offer a variety of advantages to the user, ranging from precise temperature control to high speed and consistent processing. Except for simple table-top models, these machines are complex and expensive—a large start-up investment is required along with continuous maintenance and supply costs.

Machine processors come in a wide variety of configurations from several manufacturers. There are five basic styles of machine processors: roller transport, dip and dunk, continuous strand, rotary, and drum. Each has its own merits as well as drawbacks, but they share common features such as automatic replenishment, speed and temperature control, and user serviceability.

With the exceptions of the rotary and drum processors, replenishment of the chemistry is automatic. External tanks of the various replenishers are connected to the processor's tanks with hoses and pumps that send measured amounts based on sensor readings or preestablished settings. Temperature probes monitor each tank, turning on heaters when the temperature falls below set points. Automatic wash water and drying are also controlled by sensors. Current processors are controlled by microprocessor computers, providing a wide variety of programmable options.

Modern legislation regarding environmental issues has forced manufacturers of photographic materials to create processes that produce little or no effluent and use less toxic chemicals. This has kept machine processor manufacturers busy designing new systems that are compatible with the ever-changing market. An additional by-product of this evolution is higher speed processes. Current colour print processes have been reduced to less than half of the dry-to-dry time seen only a few years ago. Typically, a Type "C" colour print will take approximately 4 minutes dry-to-dry, and the very latest Type "R" materials are now running in the 4 to 10 minute range.

Roller-transport machines are widely used for almost every photographic process. Colour, black-and-white, x-ray, graphic-arts films, and enlarging papers can all be processed in this type of processor. The machine contains a series of tanks with one or more racks filled with rollers. Motors drive the rollers, propelling the material through the machine. Heaters, replenishment and recirculating pumps, sensors, and sophisticated controls are all required components. The processor is usually partially enclosed by

a light-tight loading booth or darkroom. Film and paper are loaded on a feed tray and exit from the dryer stage. Constant monitoring is required to ensure that the rollers and rack crossovers are clean; otherwise, scratching can occur.

Dip and dunk processors are popular today for large-batch film processing. Roll and sheet film can be processed together by using the appropriate racks. The machine is essentially a series of large tanks with a transport mechanism for dunking and advancing racks of film. This offers the advantage of multiple film formats and all but eliminates the chance of scratching. In this type of machine the film never comes into contact with anything except the solutions and bubbles. Dip and dunk processors require a large space with high clearance for the racks as they are removed from the tanks for agitation and advancement. One additional drawback is that film at the bottom of the roll or rack receives more contact time with the chemistry. They must also be operated in total darkness because of the open tanks.

Continuous-strand processors are used for aero and cine films as well as roll paper. These machines can be roller transport or leader belt with a feed and take-up spool at both ends. Several rolls of material can be spliced together, thus giving the name *continuous strand*. The leader belt design used mostly for paper processors, employs a continuous belt that pulls the material through tanks with guide rollers at the top and bottom. Cine processors use a similar technique but with offset rollers that spiral the film through the tanks. Some older designs of cine film processors are made up of a series of long tubes and tanks that contain the chemicals. A leader is used to begin the process and the film is then drawn through. The speed of continuous strand processors is measured in feet per minute, and most are capable of processing hundreds of feet per day.

Rotary processors are quite different from the other designs. They usually have one large chamber with a shaft that circular frames are mounted on. These frames come in different sizes to hold roll and/or sheet film and prints. Once the machine is loaded, the lid is closed and the processing can be performed in daylight. Temperature-controlled tanks contain the various chemicals. The machine is run by a preloaded program, either stored on plastic cards or in computer memory. A major disadvantage of this type of processor is that the film or paper must be removed wet and dried externally. Additionally, some models dump the chemicals allowing only one-time use, which can be costly and raises environmental concerns.

Drum processors represent the most basic type of machine processor. Most of these machines are small enough for table-top use. The processor consists of a motor with rollers or a spindle to rotate the tank. Tempered water baths for the tank and the chemical

storage area are common in all but the most basic models. Most drum processors discard each chemical after a single use. Based on the size of tanks available, multiple film formats and print sizes can be processed.

MASK/MASKING Masks are supplementary neutral density images used in register with an original image to modify or adjust the characteristics of the original. The purpose may be the reduction of overall or local contrast to enhance highlight or shadow detail, correction of tone reproduction, correction of colour separations to allow for variations in the performance of dyes or inks, or the removal of yellow, magenta, or cyan ink, and the proportional substitution of black ink to get clean dark tones in photomechanical reproduction.

Masks may consist of silver or dye images, and may be gray or coloured. They may be purely electronic. They may be made on a single emulsion film, or on a film having three or more layers, producing the equivalent of five or more masks. They may be on wet process or vesicular film, sharp or unsharp, of limited or full tonal range, positive or negative. They may be made by contact printing, by a process camera, or by computer processing of a scanned and digitized input.

MASKING, DYE (1) Grainless masking image consisting of dye, rather than silver. Several dye masks may be superimposed, allowing for integral tripack applications and use with multiple masking films. A single magenta dye mask is used when colour corrected separation negatives are made from a reflection copy or a colour transparency. (2) Early form of contrast control in which black-and-white negatives were stained selectively, usually with blue dye, and printed with light filtered with complementary colours. Variable contrast papers provide a more effective alternative.

MAT/MATRIX A relief image for making dye or pigment prints by transferring colour from the raised parts of the relief to a receiver that is usually paper or plastic. Mat is commonly an abbreviation of matrix. Gelatin matrices are employed in the dye transfer printing process. After exposure, bleaching or tanning development yields selective hardening, which allows the removal of unhardened areas by washing; the gelatin relief image remains.

In photomechanical reproduction, a matrix is made of cellulose pulp impregnated with thermosetting resin, or of damp pulp. The image is cast in the surface of the matrix by pressing against a relief and heating. For rotary presses, the mats are curved before the images are set.

MELTING Melting of the emulsion layer occurs when the temperature of the developer or wash water is excessive. In an extreme situation the emulsion can even run off

the base. In most cases, however, damage occurs only in those areas that are touched by the fingers. The problem is aggravated with high pH developers. It seldom occurs with modern thin and highly hardened film emulsions.

MERCURY This poisonous element (Hg, molecular weight 200.59) exists at room temperatures as a silvery gray liquid with an insidious, penetrating vapour that can make a darkroom unsuitable for photography and affect the health of anyone who uses it. Mercury clings to surfaces and is a long-lasting contaminant that causes mottled or spotted development. For this reason, glass thermometers containing mercury should be banished from processing areas.

Mercury fumes made possible the image development of the daguerreotype process and have been used to increase the sensitivity of silver halide materials either before or after light exposure (hypersensitization).

MERCURY SALTS Salts of mercury, especially the chloride and iodide, even though very poisonous, have long been used in photography as intensifiers of the silver image. Mercuric chloride ($HgCl_2$, molecular weight 271.5, also called corrosive mercuric chloride, corrosive sublimate, mercury bichloride, or mercury perchloride) is available as a whitish powder or crystals that are soluble in water, alcohol, or ether. Mercuric iodide (HgI_2, molecular weight 454.47, also called red iodide of mercury, mercury biniodide) is a scarlet red powder that is slightly soluble in water but very soluble in potassium iodide, sodium sulphite, or sodium thiosulphate solutions. Both mercury compounds are poisonous and should be avoided.

METOL A common name (others are Elon, Graphol. Pictol, and Verol) for para-methylaminophenol sulphate $[(CH_3NHC_6H_4OH)_2 . H_2SO_4$, molecular weight 344.3. The white, crystalline powder is soluble in water, alcohol, and ether. Metol should be added to water before sodium sulphite during preparation of developing solutions. Metol is toxic and an irritant.

Metol forms soft-working developers that are nonstaining and keep well but is often combined with a contrast-building developing agent, such as hydroquinone, to obtain developing solutions that produce images having good shadow detail and contrast.

METOL POISONING Some persons develop skin irritation and blistering, called contact dermatitis, from continued exposure of the skin to photographic solutions, particularly Metol and other aminobenzene developing agents. Once sensitized, an individual's skin may swell or redden after even the slightest exposure to the chemical. The allergenic effect of amino-containing developing

agents can be reduced by altering the molecular structure to increase the water solubility of the compound.

See also: *Chemical safety*.

MINIMUM DEVELOPABLE SIZE The minimum number of metal atoms that will cause development of an exposed silver halide grain to occur, typically three to six atoms. An exact number cannot be given because the minimum developable size depends upon the type of chemical sensitization and the development conditions, including development time.

MIXING SOLUTIONS Photographic solutions are mixtures of one or more solids, liquids, or gases in a liquid. Each ingredient must be carefully measured, then dissolved in the solvent. Premeasured packaged formulations, either solids or concentrated liquids, provide convenience and simplify the preparation of processing solutions.

MONOBATH Single solution process for the developing and fixing of silver halide images. It relies on different rates of developing and fixing to be effective. Concentrated phenidone and hydroquinone work quickly. Restrainers reduce the tendency of developers to interact with fixers to produce fog. The fixer is usually sodium thiosulphate or thiocyanate, with potassium alum added as a hardening agent.

A loss of effective film speed, increased fog levels, and enlarged grain all reduce the attractiveness of the idea of the monobath for general photographic applications. It is used in rapid access systems, x-ray, microfilm, and certain motion picture film and diffusion transfer processes.

MONOCHROME Identifying an image that consists of tones of a single hue. such as blue, or of a neutral hue (gray), or a process that products such images.

MORDANT Substances that cause dye to adhere to a surface have been known since the neolithic revolution, and have been used particularly in the dyeing of fabrics. Mordants combine with dye to fix it in place. Some dyes are colourless in their unmordanted states; mordants then cause colour to precipitate, forming permanent, insoluble lakes. Mordants are often the weakly basic hydroxides of aluminium, chromium, or iron. In imbibition processes, mordants are in the receiving surface. The silver metal of a photographic image can be replaced by a coloured dye that is permanently attached to a metal salt, such as copper thiocyanate or ferrocyanide, which may replace all or part of the silver image.

MOUNTING A process of attaching a photograph or other material to a surface with any number of different

methods and materials. These materials may include wet mounting procedures that use glues and liquid adhesives, hot or cold dry mounting materials, taping and hinging, laminating, and various other encapsulating procedures.

MOUNTING PRESS An electrical device for applying heat and/or pressure to a photograph while the photograph is in the process of being attached to a mounting surface. Although a small photograph can be mounted successfully by hand with cold-mounting adhesives, a household steam iron does not work well enough to be considered a reliable mounting tool for any of the heat-activated dry-mount materials. Therefore, a dry-mount or a combination press must be considered necessary for dry mounting photographic prints with any of the heat-activated materials.

The mechanical dry-mounting press consists of a heating element within a flat metallic platen that is suspended on a system of bars and free-moving hinges. This allows the heated platen to firmly squeeze down upon the photograph during the mounting process. The press firmly holds the dry-mount tissue and mount board sandwich together, under pressure, until the adhesive melts. The adhesion becomes permanent after the print and mount-board cool under pressure. Dry-mounting presses are thermostatically controlled and allow the pressure to be adjusted in order to accommodate different types and thicknesses of materials.

Dry-mounting presses come in a variety of sizes, and they are open on three sides so that photographs can be mounted in sections. By simply moving the print along the press after each section is heated, a print of any length but only twice the press depth can be mounted. The use of a special silicone release board when mounting large prints in sections will help to prevent platen lines from creasing the print where sections overlap.

It is important to accurately control the temperature and pressure of the press. Several models of dry-mounting presses can be purchased with built-in thermometers so that the temperature can be monitored throughout the mounting process. Although all presses have a thermostat to maintain the "correct" temperature, as a press ages, there may be some fluctuation in the heating elements or in the thermostat that may cause the actual temperature to deviate from the indicated temperature. Temperature indicator strips may be used to test the temperature accuracy of the dry-mounting press; these strips have two coloured adhesive areas: one melts at 200°F; the other melts at 210°F. This temperature test allows adjustment of the thermostat dial to obtain the desired temperature.

MOUNTING TAPE Acid-free linen tape is a very strong high-quality, tightly-woven linen with a water-activated adhesive. The tape comes in a standard size and

an extra wide version. The extra wide style is designed for attaching hinges on mats and supporting very large window mats on backing boards.

Acid-free paper tape is a light-weight paper tape that has a water-activated adhesive. It is used to attach paper hinges and photo corners or to seal the back of frames against dust. The tape is removable when moistened with water. The tape is not strong enough to be used to hinge window mats to backing boards.

Adhesive transfer tape provides an instant bonding. It is a permanent synthetic acrylic adhesive on a roll. This adhesive material is temporarily attached to a removable siliconized paper liner that is separated from the adhesive when applied with a dispenser-type gun. It is similar to double-sided adhesive tape in the way it is used. The difference is that instead of the adhesive being attached to a support material, as is the case with double-sided tape, the adhesive is applied directly to the back of the print to be mounted and has no backing at all. Because this thin film of adhesive has no supporting layer, it is easiest to use when loaded into a gun-like dispenser. The adhesive bond is high tack. While ideal for paper, cardboard, textiles, plastics, leather, wood, and even glass, it is not designed for supporting heavy loads. Adhesive transfer tape softens at very warm temperatures so it should not be used for materials that will be exposed to heat. The heat from high-intensity art gallery lighting may be considered an unsafe environment.

Double-coated film tape has easy-release paper liner on each side, ideal for sealing polyester film sheets together for encapsulating fragile documents.

Hook and loop fasteners are pressure-sensitive adhesive-backed *Velcro-like* long-roll tapes or small pre-cut squares that attach to glass, metal, most wood, fabrics, and plastics. Strips of hook and loop fasteners are strong enough to exhibit framed and mounted photographs by attaching them directly to walls. Since the hook and loop strips pull apart, print exhibitions can be changed very quickly.

MQ DEVELOPERS Metol is often combined with hydroquinone to make energetic developers that act more rapidly than either developing agent alone; that is, they show superadditive developing activity when used together. Metol and hydroquinone have been used in a great variety of developers for many years, and such solutions are often called MQ (*M*etol-*Q*uinol) developers (Quinol was an early name for hydroquinone).

MULTILAYER FILM Consisting of two or more superimposed sensitive coatings on a support. In black-and-white films the layers may be of differing speeds. resulting in extended latitude and tonal range. Colour films and papers are of different spectral sensitivities and different colour-forming abilities. Some modern films have 16 or more layers performing various functions.

MULTIPLE TONING Different areas of a print may be toned by protecting one area with rubber cement or with maskoid liquid frisket while the unprotected area is toned. Rubber cement, diluted with an equal part of thinner is carefully applied to the area to be protected. The print is then immersed in the toner until the desired colour is achieved. The cement can be removed by rubbing with the balls of the fingers while the print is in the wash water. After the print is dry the process can be repeated with other toners if desired. The coloured frisket makes it easier to see the areas that have been covered. It is removed while dry by pulling it off with masking tape.

NEGATIVE An image in which tonal relationships are such that light subject tones are dark and dark subject tones are light. Films that produce negative images are sometimes referred to as negative films, negative-acting films, or nonreversal films to distinguish them from reversal films that produce positive images.

Negative colour films not only invert the light-to-dark tonal relationship of the subject but also represent subject colours as complementary colours, so that a blue area in the subject is yellow in the image. The complementary nature of the image colours may not be obvious with colour films that have dye masking layers to improve the quality of the final positive print image.

NEGATIVE-POSITIVE PROCESS Distinguished from a reversal process, a negative-positive process uses separate materials for the camera image (negative) and the final image (positive).

NEOCOCCINE A red dye that is applied to areas of a negative to absorb part of the actinic light, thus making them appear less dense on the print. The application of the dye can be controlled by dilution and control with the brush. Since the photographic effect may be different from the visual effect, prints should be made from time to time to gauge progress. This frequent proofing is needed less as experience is gained.

NICKEL-CADMIUM (NICAD) BATTERY See *Battery*.

NITRATE FILM Photographic film coated on a cellulose nitrate (celluloid, celloidin, collodion) support. Nitrate was the earliest type of flexible, transparent support. While it had many desirable properties as a support, it is no longer used because of its extreme flammability and its eventual self-destruction. It has not been manufactured since 1950.

NITROGEN-BURST AGITATION A method of agitation during processing using nitrogen gas bubbles that are emitted from an array of perforated pipes at the bottom of the processing tank. Release of the gas at appropriate intervals causes mixing of the processing bath, and the rising bubbles agitate the solution near the material being processed. Gaseous-burst is a more general term, including agitation by bubbles of air or other gas as well as nitrogen.

NONACTINIC An adjective that describes light or other radiation that does not possess sufficient energy to cause chemical change. Silver halide crystals are sensitive to violet and blue light but do not respond to the rest of the light of the spectrum, which could be identified as nonactinic light. This makes red safelights usable in darkrooms for unsensitized photographic materials, such as photographic paper for black-and-white prints. Most photographic emulsions are now spectrally sensitized by dyes to make panchromatic materials that respond to all colours of the visible spectrum.

NONCURLING Describes film with a balancing coating of gelatin on the side opposite the emulsion which causes it to resist the tendency to curl, especially in extremes of temperature and humidity.

NONREVERSAL The term *nonreversal* may refer to a process or to a light sensitive material, either film or paper. It indicates that a positive is produced from a negative, or that a negative is produced from a positive. It is distinguished from a reversal film, paper, or process in which film from the camera produces a positive image after processing, or when a positive print is made directly from a positive original. Nonreversal applies most appropriately to intermediate steps in an extended process in which it is inaccurate to say *negative* or *positive*.

NONSILVER PROCESSES For the purpose of this article, nonsilver processes refers to a broad range of diverse photographic processes that do not use silver salts for light sensitivity and that do not result in a final image consisting of silver. Besides this literal definition, since the 1960s the term *nonsilver photography* has become synonymous with *alternative photographic processes*. This implies that all processes other than silver become incidental and are grouped together without individuation. The result of this is an assumption of an ideal photographic convention being a straight or unmanipulated photographic print. It is not the purpose of this article to debate the art/photography issue or to explain the historical implications of these arguments. It is important to understand the relationship of art photography to nonsilver processes because these processes are an important vehicle by which art photography breaks photographic conventions. Certain qualities of photographic processes are generally perceived as being inherently photographic. It was common, historically, that the commercially available support materials of the day defined the convention. The gelatin silver print holds that position today and, consequently, photography questions the inclusion of other kinds of imaging processes. It is particularly interesting to pinpoint exactly where in its history photography splintered the idea of process from that of aesthetic since photography owes it existence to the

natural inclination—rooted in the nineteenth century traditions of art, science, chemistry, optics and philosophy of creating an environment of experimentation and invention. So, historically, the photographic ideal was continually evolving and being rapidly redefined, predicted on each new invention and each new discovery. It was not until debates pertaining to the nature of art and photography and the examination of the expressive qualities of the medium after the beginning of the twentieth century, that the Pictorialists challenged the supremacy of painting over photography as art. The point of departure became the print itself, whether it extended the expressive potential of the medium by interpreting the negative through manipulation or remained faithful to the record. This controversy weaves a complex web around the very nature of the relationship of photography to art that centres the debate on the intrusion of the artist's hand upon the unrelenting mechanical eye of the camera, that influences the choice of process and the way the image is interpreted through the use of specific materials.

HISTORY OF NONSILVER PROCESSES It is necessary to examine the early history of photography in order to understand how the evolving technology that brought the photograph into existence blazed a trail of immense exploration and experimentation using nonsilver processes. There were literally hundreds of processes invented between 1839 and 1885. Each practitioner of photography was required to learn how to manipulate chemicals and chemical apparatus, and the photographic journals of the day were filled with descriptions of new techniques and improvements developed by energetic amateurs. The development of nonsilver photographic processes is the very history of photography itself. The birth of photography is marked in history books by Daguerre's dramatic announcement in 1839 of his invention of the daguerreotype. However, the earliest photograph was created in 1826 in France by Joseph-Nicéphore Niépce. *View from the Window at Gras* was the first permanent photograph based on his experiments that started in 1822. It was made of a layer of bitumen of Judea, a type of asphalt that becomes insoluble when exposed to light, thinned with oil of lavender, then coated on a polished pewter plate. After exposure, the plate was washed with oil of lavender and turpentine. The areas of bitumen that had not been hardened by exposure to light were dissolved. This process became known as heliography, the first nonsilver process. What is interesting to note about this process is that it came out of Niépce's desire to duplicate visual information. Once having adhered the photographic image onto a plate, he experimented with etching and inking it like an intaglio printing plate. In 1829, Niépce and Daguerre formed a partnership and in 1839 the heliographic process and the daguerreotype were announced to the public by Daguerre and Niépce's son.

Niépce died four years after the partnership was formed, and both the heliograph and Niépce contributions were overshadowed by the uproar over the invention of the daguerreotype. The hand of the artist immediately applied itself to the daguerreotype. It was commonplace to draw, retouch, remove, and hand colour a daguerreotype to contribute or alter the mechanical eye of the camera.

Cliche-verre, literally meaning "drawing on glass," is a cameraless process invented by three English engravers shortly after William Henry Fox Talbot introduced his negative-positive process in 1839. Materials such as varnish, asphalt, and carbon from the smoke of candle, were applied to make a sheet of glass opaque. Once dry, an etching needle was used to draw, paint, or scratch away an image through the applied surface. This was then used as a *negative* to make numerous impressions that were contact-printed onto light-sensitive materials. In the 1850s, Adalbert Cuvelier updated the process by incorporating the recent photographic discovery of the collodion glass plate process with cliche-verre. Artists from the French Barbizon school, particularly JeanBaptiste Corbot, used this process as a means to produce quick and inexpensive editions of monoprints. Although this marked the heyday of cliche-verre, such notable later artists as Man Ray, Brassai, Max Ernst, Picasso, Paul Klee, Fredrick Sommer, Henry Holmes Smith, and Joel-Peter Witkin revived interest in the process in the 1960s. The number of ways that cliche-verre can be used in conjunction with other processes is limitless.

Iron Salt Process What proceeded Niépce's early experiments in France was an era of exploration of light-sensitive materials that is unprecedented throughout the history of photography. Many different metallic salts were investigated in regard to their light-sensitive properties. None, however, yielded as many successful possibilities as the ferric salts. When combined with other chemicals and exposed to strong ultraviolet radiation these salts produce a reaction in three primary ways. The first is when there is a light-hardening effect of ferric salts on a colloidal compound. The second is the ability of ferric salts to react chemically with certain metallic compounds to form images of metallic precipitate. The third relies on the reaction of iron salts with chemical compounds to form a coloured by-product that creates an image. Some of these processes, now obsolete and anticipated, were important stepping stones to the processes that followed. Catalysotype, chromatype, chrysotype, amphitype, anthotype, energiatype, and fluorotype were just some of the processes developed in the 1840s that did not survive. However, the one process that has survived from this period of time, leaving a rich body of work behind, is the cyanotype process.

Sir John Herschel, a famous English scientist, astronomer, inventor, and friend of William Henry Fox

Talbot, made numerous achievements and contributions to the field of photography and photochemistry including the discovery of a method of permanently *fixing* an image by the use of sodium thiosulphate (hyposulphite of soda) in 1819. He is also credited with coining the terms *photography*, and *negative* and *positive* for the image made in the camera and the print resulting from it, in reversed tonalities. In 1842, in a paper to the Royal Society of London entitled "On the Action of the Rays of the Solar Spectrum on Vegetable Colours and on Some New Photographic Processes," Herschel described for the first time the discovery of the printing process that used the sensitivity of iron salts to light. He also invented the chrysotype process, which depended on the exposure to light of ferric salts and the development of the ferro-image with gold and silver solutions. The cyanotype process, from the Greek meaning *dark blue impression*, also known as the blueprint of ferro-prussiate process, is an exceedingly simple process based on the reactions of two chemical compounds, ferric ammonium citrate and potassium ferricyanide. The resulting image is a combination of ferrous ferricyanide and ferric ferrocyanide. The two compounds are each separately mixed with water to form two solutions that in turn are mixed in equal parts to form the light-sensitive solution that is then coated on paper or cloth. The support is dried in the dark and is contact-printed by exposure to light through either a negative, to make a print, or an object, to make a photogram. It is then simply washed in a bath of running water to permanently *fix* the image and develop its characteristic *cyan* blue colour and matt print surface. Out of the many photo discoveries Sir John Herschel made, the cyanotype process became the most commercially successful.

The major user of the cyanotype process during Herschel's lifetime was one of the earliest woman photographers known, Anna Atkins. Her remarkable *British Algae: Cyanotype Impressions* was the first book to use photography for scientific illustration. Predating William Henry Fox Talbot's *The Pencil of Nature*, the first of her three volumes was published in 1843. These volumes combined scientific accuracy with the cyanotype process to document Atkin's, extensive research on her vast seaweed collection using actual specimens. The cyanotype process was particularly suited due to its low cost, permanence, simplicity of process, and freedom from any patent restrictions. However, its unchangeable blue image colour, particularly suitable for illustrations of seaweed, kept the cyanotype from entering the mainstream of photographic practice.

The cyanotype process became popular again at the turn of the century but was used mostly by amateur photographers. Family album quilts, using cyanotype on satin, are but one unique example of the work produced at this time. It was also at this time that architects, shipbuilders, and draftsman, began to use commercially

prepared cyanotype paper to generate fast, inexpensive copies of line drawings and architectural renderings. But the blueprints of today are actually produced using the diazo process. Paper treated with diazonium salt and a coupler compound is exposed to ultraviolet radiation, which decomposes the salts in areas corresponding to the clear areas of the transparency. The paper is processed in ammonia fumes, which makes the sensitized coating alkaline. This causes the coupler and the unexposed diazo crystals to link up forming the dyeline image. This paper may be purchased very inexpensively and is still used by architectural and engineering firms to reproduce large-scale plans and drawings cheaply and quickly, and it is available in red, brown, blue, and black.

Another process, patented in 1878, with very similar qualities to the cyanotype process, and occasionally referred to as the positive cyanotype, is the Pellet process. This more obscure process, which produced a positive image from an original positive (the reverse of the cyanotype), used gum arabic as a colloidal body to suspend the sensitizer consisting of ferric ammonium citrate and ferric chloride. The exposed material was developed in a bath of potassium ferrocyanide, which produces the characteristic blue of the print. This process eliminates the additional step of making a negative from a film positive to achieve a positive-reading print.

Herschel's idea, to precipitate precious metals by exposing ferric salts on those parts of the image where ferrosalts form, was dramatically improved when platinum salts were introduced to this process. Herschel gave an account of the reductive action of light on a salt of platinum at a meeting of the British Association of Oxford. In 1844 Robert Hunt published his own experiments with platinum in his book *Researches on Light*. But not until Englishman William Willis, on June 5, 1873, patented his new photographic printing process that was based on the use of combining ferric oxalate with platinum salts was the platinum process of printing perfected. Willis, realizing the instability of silver images, set out of develop a more permanent alternative called the platinotype and billed the process as "Perfection in the Photomechanical Process". The exquisite quality of the image, matt surface, neutral black tone, and the extraordinary permanence of the image ensured wide acceptability of the process.

Monochromatic Pigment Processes Between 1860 and 1910, there was an explosion of photographic printing processes that were invented to produce photographic images in pigment rather than silver or other metals. Some of these processes never died out altogether and are still a viable form of image making today. These processes are still taught, and prints utilizing them are supported and encouraged through the art market and within the gallery/museum structure. They were created for several reasons that addressed specific needs:

1. In early photographic processes, silver images were not completely stable. Images in pigment, however, are very stable and permanent. They are not susceptible to the fading and discolouration that have plagued the development of the silver processes.
2. The pigment processes particularly, through the various steps, allowed and encouraged at times dramatic alteration and manipulation of the image. At this time photography was trying to emerge as a fine art so that imitations of paintings, etchings, drawings, pastels, and other fine-art mediums were in vogue. This went, sometimes, so far as to completely conceal the photographic origins of the image.
3. Pigment process materials were much less costly and therefore commercially more viable that other metal-imaging materials, like platinum and gold, that could equal the pigment processes permanence.
4. The pigment processes offered some of the first feasible colour processes, because pigments, watercolours usually, were offered in a wide variety of colours. Ranging anywhere from the more neutral colours of the lamp blacks to the sepias and warm reddish browns to the realization of a polychrome image. It was also a way to introduce colour without having to have the artistic skill and control necessary to hand apply the paint.

Almost all the pigment processes utilize one of two basic methods of working. The first is where pigment is literally part of the emulsion of the print material. The process of exposure fixes or hardens the pigmented gelatin in direct proportion to the negative, and development washes away any of the unexposed pigment, which results in a positive image. The carbon and gum bichromate processes work in this way. The other method relies on exposure to make an unpigmented emulsion or surface receptive so that it will retain pigment either dusted on it or transferred by pressure to it, or attached by either a chemical reaction or an electrostatic charge. Examples of this are the bromoil process and xerographic printing.

Colour Techniques Predating the invention of photography, in 1807 Thomas Young revealed that our perception of colour is based on only three basic colours: red, green, and blue. These he called the *additive* primaries because when added together in varying amounts they can produce all the other colours found in the real world. In 1839 Daguerre announced his astounding invention—the daguerreotype—to the world in Paris. Even before the photographic process was perfected, attempts to incorporate and reproduce colour photographically were made. In 1859 and again in 1861 in London, James Clerk Maxwell gave a three-colour photographic slide presentation in which he projected images from film positives that he prepared by exposing film through a red filter, a green

filter, and a blue filter, which when superimposed in register on the screen produced what appeared to be fairly realistic colour pictures.

The second system of colour is called the *subtractive* system of colour that relies on using colourants that are complementary in colour to the additive primaries, namely cyan, magenta, and yellow. Even though the Lumière brothers devised the first practical colour system in 1907 called the Autochrome process, the colour print had to wait until the 1920s, when José Pe invented the dye-imbibition process. Colour separations were made by exposing three separate negatives of the subject, one through a red filter, one through a green filter, and one through a blue filter. From these separation negatives, film positives, called matrices, were made and developed in a gelatin tanning solution that hardened the gelatin in direct proportion to the light exposure received. After conventional development and fixing to remove the unexposed silver halides, the unexposed gelatin was washed away with hot water. The matrices were each soaked in a dye bath, drained and transferred sequentially in register onto a photographic paper coated with gelatin (an emulsion without silver compounds). The paper is prepared in a buffer solution so that the dye will migrate quickly from the matrix to the gelatin paper. The red-filter negative produces a cyan matrix, the green-filter negative a magenta matrix, and the blue-filter negative a yellow matrix. This became the basis of the dye transfer process that is still being commercially used today.

The carbon process predated the dye-imbibition process. Initially it was a monochromatic process, invented in 1855 by Poitevin, that used the photosensitive qualities of potassium bichromate to sensitize gelatin. This process became popular and practical in the late 1890s, using carbon black as the pigment of choice for the print, hence the name of the process. The logical development of this process was to substitute cyan, magenta, and yellow colourants for the black pigment, to make three separation negatives, and produce three pigmented gelatin positives which, when transferred in register, yielded a full-colour photographic carbon print. The carbro printing process further improved on this by utilizing a silver bromide print immersed in a bath of potassium ferricyanide to change the metallic silver to silver ferricyanide. When the print is placed in contact with a sheet of bichromated gelatin, the silver ferrocyanide image tans or hardens the gelatin as if it had been exposed to light. The print is then removed, washed and reused to make another colour print, and the gelatin sheet is developed in hot water and transferred to a final support in register with the other primary coloured images to complete the colour print.

Kwik Print, a more contemporary form of the gum-bichromate process, found a commercial market as a

quick, inexpensive colour-proofing system used by commercial printers to check the accuracy of their colour separations. It also found an artistic market promoted by the photographic artist Bea Nettles in her publications *Flamingoes in the Dark* and *Breaking the Rules, A Photo Media Cookbook*, in which she demonstrates ways the process can be artistically manipulated.

CONTEMPORARY TRENDS AND NEW TECHNOLOGIES The technological changes that have brought photography out of the darkroom and into the light via the computer and electronic imaging have not occurred suddenly or unexpectedly. These changes, in fact, continue the journey established early in the nineteenth century with the camera lucida, the camera obscura, and the camera. What started out based on the blending of light, alchemy, and paper to record, store, and transmit visual images is evolving into an electronic imaging system. Developing tanks, enlargers, and chemicals are being replaced by copiers, computers, software programs, and laser printers with an infinite range of possible manipulations that are based on nonsilver technology.

In their search to modulate the camera's precise and mechanical record, and in their struggle to glorify photography to the status of fine art where artistic influence was the ultimate creator of the image, the Pictorialists, which included Edward Steichen, Gertrude Kaesebier, Robert Demachy, Frank Eugene, Annie Brigman, and J. Craig Annan (to name but a few), reached its peak of popularity in 1910. The hand-manipulated printing processes that were the signature style of the Pictorialists continued to be used into the 1930s but with less and less frequency. Photographers began to respond, in Europe, and America through Alfred Steiglitz's 291 Gallery, to the abstract forms of cubism and the chaotic challenges of the surrealists, leaving the manipulative processes behind in an attempt to serve this new vision directly through the camera lens.

The straight, unmanipulated image printed on a commercially available photographic paper prevailed from the 1930s until the early 1960s. Ansel Adams, Edward Weston, Paul Strand, Imogen Cunningham—all became a part of a enduring movement in photographic history that has become the photographic convention even today, that touted the clarity of the photographic lens and the objectivity of the *photographic eye*. The 1960s was a time of great social upheaval in the United States initiated by the Vietnam War. Photography in the 1960s was also defined by a rebellion against the traditional, dominant form of photography that generated a revival of the historic nonsilver photographic processes. This renaissance of print manipulation grew out of a desire to redefine parameters and blur the boundaries of photography and art. Based on their willingness to embrace popular culture, the Conceptual art and Pop art movements, which included

artists like John Baldessari, Robert Rauschenberg, and Andy Warhol, used the photographic medium because of photography's powerful ability to define and perpetuate cultural myths and exploit the mass media. At the same time, influenced by these artists but interested in maintaining the inherent reality of the photographic image as a starting point, were photographic artists Betty Hahn, Bea Nettles, Robert Fichter, and Robert Heinecken, to name a few. Photography in the 1960s could be characterized by a radical transformation that was manifested by the willingness and insistence of artists to challenge and somehow interrupt or interfere with the accepted conventions of the medium. This period was one of great exploration that echoed the climate of diversity that had surrounded the discovery of photography itself. It differed, however, in that the struggle for recognition of photography as a fine-art form was no longer an issue. The relationship of painting and photography, specifically, and the relationship of photography to the plastic arts, in general, was less an adversarial role and more an interdisciplinary one than it was at the turn of the century.

Also at this time, a group of image makers began to explore the *new technologies* in an on-going attempt to broaden and expand the definition of photography. The straight photographer's acceptance of the limitations imposed by the mechanical nature of the camera came to be what defined the medium in its pure form, and their exploration of the expressive and metaphorical aspects is what helped establish photography's credibility as an art despite its dependency on a machine. By employing electronic-imaging systems and other commercially used processes, contemporary photographers like Sonia Sheridan, William Larson, Joan Lyons, and Sheila Pinkel continued to challenge photography's relationship to the machine through the use of nontraditional photographic materials. This reliance on the machine was no longer considered limiting or distasteful in the post-industrial society. Instead, it was seen as something with enormous potential for artistic expression. This mirrors the nineteenth-century distrust of machines vs. the twentieth-century embracing of them.

The office copier was invented to generate fast, inexpensive, and accurate reproductions of documents used in business. It is also a process that is available to almost everyone and is capable of transforming and manipulating images that can generate new visions. The use of these machines immediately brought into question the validity of photography to accurately describe what the world looks like. Copy machines for the most part act like a simple camera without a bellows adjustment. Therefore it produces a very flat, very limited depth of field that extends approximately one-quarter of an inch above the copier plane or copier glass. Black-and-white copiers use an electrostatically charged monochromatic toner that

271

forms an image on paper and that is then fused or melted onto the paper support. The more recent development of the colour copier forms an image using the subtractive system (cyan, magenta, and yellow), with each colour made up of a thermoplastic powder, called a toner or pigment, that is electronically fused onto the paper. Laser copiers are the latest and most technologically advanced development in the history of electrostatic processes. This machine relies on a scanner that reads the image and converts it to digital signals which are then transmitted to a laser printer capable of subtle colour/tonal distinctions. This machine also uses the subtractive colour system with the addition of black, which creates a more accurate sense of colour and depth of field in image reproduction.

Chester F. Carlson, in the late 1930s, invented this new technology, called *electrophotography*, then sold the patent to the Haloid Corporation in Rochester, New York. Calling the new process *xerography* it was put into practice in 1948. It did not, however, really become practically and commercially viable until 1960 with the introduction of the Xerox Copier #914 that remedied the early models' problems of being cumbersome, messy, expensive, and slow. The advantages of the present day machines are many, including:

1. Rapid, consistent, and relatively inexpensive duplication and production.
2. The ability to make a colour copy from a 35-mm slide or a 35-mm negative.
3. An amazing amount of colour control and manipulation, overall or specified areas only, of the colour reproduction, which includes a colour balance memory that can be programmed.
4. Contrast adjustment and control of reproduction.
5. Image size easily scaled up or down, including framing devices that allow the operator to frame, compose, obliterate, or segment the image and/or text, if desired, into as many as 16 segments.

Artists using copier machines to create art shattered the preconception that the copy machine's single function was to produce a facsimile of the original image. In 1979, a seminal exhibition of art created on copy machines entitled "Electroworks," curated by Marilyn McCray at the International Museum of Photography at George Eastman House in Rochester, New York, cinched the marriage of art and technology. The exhibition embodied work that combined *copier aesthetics* with every possible artistic medium including painting, sculpture, ceramics, printmaking, photography, video, film, animation, design, conceptual art, performance art, artists' books, mail art, and poetry. Installed along with the works of art were the machines themselves, with artists scheduled to generate art on them throughout the duration of the exhibition.

Due to the immovable nature of the copy machines, the photographic artist was once again relegated to the studio as the arena for the picture and art making. As in the nineteenth century when the subject was brought to the photographic artist who confined to the studio by slow film emulsions, bulky equipment, and process limitations, so the subject was brought to the machine in the twentieth century. Printing photographs on material other than sensitized photographic paper can also be traced to the second half of the nineteenth century when it was common for photographs to appear on glass, porcelain, tile, leather, and fabric.

Although called copies, the prints generated by the machines were considered original works of art conceived as unique objects, but due to the very nature of the machine art could be generated quickly, cheaply, and efficiently. This called into question the sacred artistic concept of the *original*. Artists had embraced a process that challenged the concept of creativity and brought into focus one of contemporary art's most curious paradoxes—technological processes designed for mass production but used to create singular works of art. The ability of the machine to rapidly generate images, however, is parallelled only by the use of electronic media such as electronic still photography and video.

Books: Bunnell, Peter C., *Nonsilver Printing Processes: Four Selections;* 1886–1927. Salem, New Hampshire: Ayer Company, 1984; Crawford, William, *The Keepers of Light: A History and Working Guide to Early Photographic Processes.* Dobbs Ferry, NY: Morgan & Morgan, 1979; Eder, Josef Maria, *History of Photography.* New York: Dover, 1945; Nadeau, Luis, *Gum Bichromate and Other Direct Carbon Processes from Artique to Zimmerman.* Fredericton, New Brunswick: Atelier Luis Nadeau, 1987; Nadeau, Luis, *History of Practice of Carbon Printing.* Fredericton, New Brunswick: Atelier Luis Nadeau, 1982; Nadeau, Luis, *History and Practice of Platinum Printing.* 2nd rev. ed. Fredericton, New Brunswick: Atelier Luis Nadeau, 1986; Nadeau, Luis, *History and Practice of Oil and Bromoil Printing.* Fredericton, New Brunswick: Atelier Luis Nadeau, 1985; Reilly, James, *Care and Identification of 19th Century Photographic Prints.* Rochester, NY: Eastman Kodak Company Publication No. G-2S, 1986.

NONSUBSTANTIVE COLOUR FILM A colour film having no colour-forming substances within it; those being supplied in the colour developer baths.

NORMAL SOLUTION A designation descriptive of a solution containing a dissolved substance that is chemically equivalent to 1 gram atom of hydrogen in a litre of solution. A 1 normal (1 N) solution of sodium hydroxide (NaOH) will neutralize a molar solution of hydrochloric

acid (HCl) because the acid has only 1 gram atom of hydrogen.

NUCLEATION This term has at least two similar applications in photography. In emulsion precipitation, it refers to that part of the precipitation in which the formation of nuclei takes place. The number of nuclei formed during this part of the precipitation will have a large influence on the final grain size. In latent-image formation as viewed by the nucleation-and-growth model, it refers to formation of metal nuclei possessing two atoms. This is the smallest stable size and its formation is a highly critical step in the formation of the latent image.

(100) A crystallographic designation of a plane of ions in a silver bromide crystal in which the silver and bromide ions alternate in both the x and y directions. This designation is sometimes applied to the surface of an emulsion grain. Such surfaces would define a cubic morphology for the emulsion grain and are therefore referred to as cubic surfaces.

(111) A crystallographic designation of a plane of ions in a silver bromide crystal in which all the ions are either silver or bromide. This designation is sometimes applied to the surface of an emulsion grain. Such surfaces would define an octahedral morphology for the emulsion grain and are therefore referred to as octahedral surfaces.

ON LINE In monitoring a process, an almost immediate analysis of the data collected, thus reducing the time lag between the discovery of an error and the correction of the process.

OPACITY The ratio of the light falling on a processed film sample to that transmitted by the sample. Opacity is the reciprocal of the transmittance and the antilog of the density.

OPAQUEING The selective application of a red, gray or black pigmented material, opaque, to areas of a negative to block transmission of light. This may be done to cover pin holes in a negative that would otherwise print as black spots. With continuous tone prints, the white spots are easier to fill in with spotting dye or pigment. It may also be used to block out material surrounding the image of an object, allowing it to be printed on a white background.

OPTICAL BRIGHTENER A fluorescent substance added to paper during manufacture that converts invisible incident ultraviolet radiation to light, thereby increasing the apparent reflectance or whiteness of the paper. In imaging, optical brighteners make the highlights lighter, increasing the maximum tonal range of the image.

ORGANIC Descriptive of substances derived from animal or vegetable matter, based on the early belief that such substances could be produced only by living organisms. Almost all organic compounds are now known to be made up of chains or rings of carbon atoms, usually

prepared synthetically. Today, organic refers to compounds containing carbon and their study. Simple carbon compounds, such as carbon dioxide, are considered inorganic, however.

ORTHO/ORTHOCHROMATIC The first term is the familiar term for the second term. Orthochromatic films are sensitive to all colours except deep orange and red.

OSTWALD RIPENING A stage in the manufacture of silver halide emulsions in which the fine crystals dissolve and reprecipitate on the larger, less soluble crystals. This process of physical ripening was named for W. Ostwald, who in 1900 studied the crystal growth of mercuric oxide and iodide. Ostwald ripening is usually carried out in the presence of silver halide solvents, such as excess bromide ions or ammonia.

OUTDATED Photographic materials for which their effective usage is now past the expiration date on the package, a date beyond which full performance cannot be counted on. With black-and-white films and papers, speed and contrast may be reduced, and fog may be increased. To some extent these can be overcome by adjusting exposure and development and by the use of antifoggants added to the developer. Colour negative materials may show the same troubles and also shifts in colour balance; processing changes probably will not help. Colour transparency materials also lose speed and contrast, but because of their reversal nature they manifest fog as a loss of maximum density, which is seen as smoky shadows.

OVERCOAT A thin usually colourless gelatin layer coated over an emulsion to protect it from abrasion. Sometimes a dye is added to provide colour correction to a colour emulsion.

OVERDEVELOPMENT Processing in a developer for too long a time, in an excessively active bath, or at too high a temperature and agitation rate. The result may be excessive image density (especially in the highlight areas of the negative), excessive image contrast, high graininess, and fog.

OXIDATION Originally, the name given to the effect of oxygen on other substances, such as forming rust (Fe_2O_3) or in the combustion of carbon to form carbon dioxide (CO_2). Deterioration of photographic solutions, such as developers, may be the result of the effect of aerial oxygen. A more general definition now recognizes oxidation as the process by which electrons are removed from atoms or ions, even though oxygen itself may not be involved.

PACKET EMULSIONS Photosensitive materials consisting of discrete small globules of different emulsions separated by immiscible binders. Variable-contrast papers often use such emulsions for the high- and low-contrast components.

pAg pAg represents a measurement of silver ion concentration in a solution and is defined as the negative logarithm (base 10) of the silver ion concentration in moles per litre. At the point of neutrality, the silver ion concentration $[Ag^+]$ equals the halide concentration $[halide^-]$. Below the point of neutrality there is an excess of silver ions; above the neutrality point there is an excess of halide ions. pAg values are of vital importance in the manufacture of silver halide emulsions.

PAN Familiar form for *panchromatic*. Panchromatic photosensitive materials respond to the whole visible spectrum in much the way the human eye does. Red, green, and blue regions are recorded, but also recorded are the ultraviolet that all silver halide films respond to, unless this is blocked by a UV-absorbing overcoat.

PAPER See *Photographic paper*.

PAPER BASE The support for photographic paper emulsions. Two types are current—fibre and resin-coated. The latter absorbs almost no water during processing, greatly speeding washing and drying. An older version of water resistant paper not made since the 1950s was resin-impregnated. Fibrebase papers are the classical type and may be either direct-sensitized (emulsion spread directly on sized paper, giving a dull surface) or baryta-coated (clay-coated). Most fibre papers are of the latter type, making them smoother and giving a longer tonal scale. Fibre papers absorb processing chemicals within their fibres, making them difficult to wash. They imbibe a great deal of water in the sponge of their fibres making them hard to dry. These factors militate against rapid machine processing. Resin-coated (RC) papers were designed to overcome these troubles. RC papers are a web of conventional fibre paper coated front and back with a thin skin of polyethylene or similar plastic. The emulsion is then coated on one side of that. Such papers absorb virtually no chemicals or water except those in the emulsion itself, making them ideal for rapid machine processing. Extensive washing of resin-coated papers is detrimental, since water and chemicals

eventually penetrate at the edges. Fibre-base papers are declining in use as mechanized processing becomes more widespread, but are still preferred for serious exhibition work and by the fine-art photography market.

PAPER CONTRAST GRADES Numerical designations of photographic printing papers on a scale from 0 (very low contrast) to 5 (very high contrast). What are called *soft* papers have grades of 0 and 1; *normal* contrast is designated as 2; *hard* papers have grades above 2.

The grade numbers are approximately inversely related to the scale index, which is the range of log H values over which the paper responds effectively. The scale index, in turn, is nearly equal to the density range of the negative that will print well on the paper if the exposure level is appropriate.

The experimentation that gave rise to the ASA method (now ISO) of determining film speed also involved decisions of observers about print quality. Best-liked prints almost uniformly contained as the darkest tone one well below the maximum black the paper could produce and at a point on the curve where the slope was equal to the average slope of the curve. Thus, it was clear from the experiments that perceptible shadow detail was important for high print quality. Although the preferred minimum density was more variable, it averaged out at a point only slightly above the base plus fog density.

These results were the basis for defining the useful part of the curve on which present standards are founded:

1. The minimum useful density is 0.04 above base plus fog.
2. The maximum useful density is 0.9 times the density at the highest part of the curve.

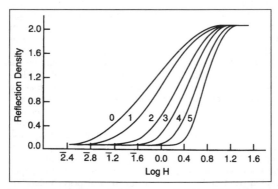

Paper contrast. Characteristic curves of photographic papers of six different grades. Each of the papers can produce the same range of tones, from the basic white to the maximum black. They differ in their average slopes and, more important, in the range of log exposure values required to give the minimum and maximum tones.

3. The log-H range, formerly known as the scale index, is the difference between the log-H values for the two points defined above.

The table shows the log H ranges and the appropriate density ranges of the negatives that fit the various paper grades. The values for the negatives differ for the two types of projection printers because of the different optical systems for diffusion and condenser enlargers.

Other printing systems, such as contact printers, may require adjustments in the paper selection process. One test method available to the practicing photographer involves the use of a calibrated transparent step tablet. When an exposure is made with the tablet in the printer, visual examination of the image can identify the desired minimum

Paper grades. *Top*: A, negative with long scale of tones from black to transparent; B, printed on hard paper; C, on medium paper; D, on soft paper. These papers reproduce, respectively, a short, medium, and full range of the negative tones, spreading them from black to white. *Centre*: E, negative of short scale of tones; F, printed on hard paper; G, on medium paper, H, on soft paper. The negative tones are increased in contrast, reproduced correctly, or flattened, respectively. *Bottom*: I, negative with long scale of tones; J, printed on hard paper to secure tone separation and high-light detail at the expense of shadows; K, exposed to secure shadow detail at the expense of highlights.

279

and maximum print densities, and therefore the density range of the tablet steps that correspond to the print tones.

PAPER GRADE Photographic paper for pictorial and most technical photography is made in a range of different contrasts. A few manufacturers use names alone extra soft, soft, normal, hard, extra hard, ultra hard—but most use numbers zero through five for these, with two corresponding to normal. The majority of negatives should print best on a number two paper. A soft negative, or one with less contrast, would need a higher grade; a hard negative, or one with more contrast, a lower one. Although international standards define the degree of contrast by grade number, there is no general adherence to their specifications. An alternative to graded papers is variable contrast paper.

PAPER-NEGATIVE PROCESS The use of sensitized paper in a camera to obtain a negative that is then contact printed, usually by transmitted light, onto another sheet of sensitized paper to obtain a positive image. Talbot's calotype process, the first viable negative-positive process, was a paper-negative process. The fibres in the negative base produced a graininess in the positive image that was generally considered to be unattractive, although some expressive photographers in later years used the process, partly for the ease with which major retouching could be done on the back of the negative, but also because they considered the graininess to be a desirable artistic effect. The early calotype prints were usually waxed on the back to enhance translucency.

PAPER SPEED A numerical value inversely related to the exposure needed to produce an excellent print. The extensive experimentation that led to the present standard for film speeds demonstrated the great importance of shadow detail reproduction in observers' judgment of print quality. For this reason, paper speeds based on the maximum useful point on the paper characteristic curve (at 90% of the maximum density) are appropriate. The formula for such shadow speed values is $1/H_{max}$ x 10,000.

The present ISO standard for paper speeds is, however, based on the exposure needed to yield a midtone value, i.e., a density of 0.60 over base plus fog. The formula for midtone speeds is $1/H = 1000$. This definition of paper speed assumes that correct reproduction of midtones is essential. Also, it eases the comparison of prints made in tests of different paper grades printed with the same negative.

Soft papers (grades 0 and 1) ordinarily have greater speeds than do hard papers (grades 3 and above). It is not unusual for a family of paper grades from the same manufacturer to have a greater change in midtone speeds

Relationship between Paper Grade, Paper Log Exposure Range, and Density Range of Negatives for Diffusion and Condenser Enlargers

Contrast Grade Number of Paper	ANSI Descriptive Term	Log Exposure Range of Paper	Density Range of Negative Usually Suitable for Each Log Exposure Range or Grade Number (Diffusion Enlarger)	Density Range of Negative Usually Suitable for Each Log Exposure Range or Grade Number (Condenser Enlarger)
0	Very soft	1.40 to 1.70	1.41 and higher	1.06 and higher
1	Soft	1.15 to 1.40	1.15 to 1.40	0.86 to 1.05
2	Medium	0.95 to 1.14	0.95 to 1.14	0.71 to 0.85
3	Hard	0.80 to 0.94	0.80 to 0.94	0.60 to 0.70
4	Very hard	0.65 to 0.79	0.65 to 0.79	0.49 to 0.59
5	Extra hard	0.50 to 0.64	0.64 and lower	0.48 and lower

than in shadow speeds. The reason is that a set of characteristic curves from each of the paper grades may nearly intersect near the shadow region but lie farther apart in the midtone region. For other papers, the contrary may be true.

PAPER SURFACE See *Photographic paper; Surface.*

PAPER WEIGHT The thickness of a photographic paper support. The usual range is light, single, medium, double, and sometimes premium weights. There is no standardization on exact thicknesses corresponding to these names among manufacturers. A given photographic paper may be made in more than one of these weights.

PARA- This is one of three structural configurations of a naming system for locating two substituents on a benzene ring. *Para-* (or *p-*) locates the substituents at the 1 and 4 positions of the ring. The relationship of *para* with the other structural arrangements is shown by

ortho meta para
abbreviated as *o–* *m–* *p–*

***PARA*-AMINOPHENOL** This developing agent (other names: Activol, Azol, PAP, Kodelon) is available as a free base ($NH_2C_6H_4$, molecular weight 109.13) or a white to tan crystalline salt ($NH_2C_6H_4OH \cdot HCl$, molecular weight 145.59). The free base is soluble in alcohol but not easily so in water; the hydrochloride salt is more soluble in water. The salt is toxic, an allergen, and a skin irritant.

Developers with *para*-aminophenol produce images free from stain with very low fog, even with strongly alkaline solution or at high temperatures. The free base is very soluble in strong alkali, making possible highly concentrated developers.

***PARA*-PHENYLENEDIAMINE** The white to tangray crystals of this dihydrochloride salt ($C_6H_4(NH_2)_2 \cdot 2HCl$, molecular weight 181.07; other names: Diamine H, P.D.H., and PPD) are soluble in water but only slightly so in alcohol. The white to yellowish white

crystals of the free base ($C_6H_4(NH_2)_2$, molecular weight 108.14, other names: Diamine or Paramine) have low solubility in water (about 1 gram per 100 ml at 20°C) but are soluble in alcohol, chloroform, and ether. Both compounds or oxidation products may cause dermatitis or bronchial asthma.

Para-phenylenediamine is a low energy, slow acting developing agent producing fine grain silver images but is often combined with other developing agents to form more energetic developers. Today, derivatives of *para*-phenylenediamine are the primary developing agents in colour photography. After developing the silver image, the oxidized form reacts with colour-forming compounds to yield the dye images of colour materials.

PASSE-PARTOUT

Passe-partout is a gummed taping material for framing pictures. The process of passe-partout framing seals a matted photograph between a sheet of glass and backing board by taping around the outer edge of the print, mat, glass, and backing board sandwich. The mat prevents the photograph from coming into contact with and sticking to the glass, and the backing board protects the back of the photograph and provides a place to attach passe-partout rings or hanging hoops. In addition to the traditional passepartout gummed tapes, there are a variety of self-adhesive fabric, polyester, and foil tapes available in different colours and styles. Passe-partout provides inexpensive artistic-looking framing that has the benefit of sealing the image and protecting it from dust and moisture.

PERCENT SOLUTION

In photography, the percentage quantity of a chemical is dissolved in a quantity of water less than 100 ml, then the volume made up to 100 ml to give a weight/volume (W/V) percentage solution, such as a 10 percent solution. A percentage quantity of a liquid may be added to a quantity of water less than 100 ml, then sufficient water added to make 100 ml of a volume/volume (V/V) percentage solution. Another percentage solution, not used in photography, involves adding the percentage number of grams to 100 ml of water.

PERIODIC TABLE

A systematic arrangement of the elements in a table that is based on the electronic configurations of the atoms and in order of increasing atomic mass. All elements in the horizontal line of the periodic table are called a *period*. All elements in a vertical column are termed a *family* or *group*. Elements in a family have similar characteristics.

PHENIDONE

The trade name for a developing agent, 1-*phenyl*-3-*pyrazolidone* ($C_9H_{10}ON_2$, molecular weight 162.19; other names: 1-phenyl-3-pyrazolidinone,

Phenidone A, and Graphidone) with a low solubility in water but soluble in alcohol. The photographic grade of the white crystals or crystalline powder assays 98.5% minimum by weight. Reported to act as an allergen and skin irritant.

Phenidone is a slow acting, nonstaining developing agent, giving good image detail in areas of low exposure. Often combined with hydroquinone to produce solutions that are similar to Metol-hydroquinone developers but less Phenidone than Metol is needed to secure equal activity.

PHOTODEVELOPMENT
The production of a visible image from a latent image without chemical processing. Dry process printout emulsions are exposed to high intensity radiation and then dry developed by subsequent exposure to low intensity radiation, often ultraviolet.

PHOTOFINISHING
Photofinishing is a word used to describe automated processing or printing of photographic film. It is typically designated to the processing and printing of film used by amateur photographers. Today's photofinishing is designed for two groups of photographers: those who require their film returned in less than two hours, and those who are less concerned about the length of time for processing.

HISTORY
Photofinishing first brought photography to the public in 1888 when roll film was manufactured to be sold to the public in a camera by the Eastman Company, of Rochester, New York, now known as the Eastman Kodak Company. This film was long enough to take 100 pictures, after which the exposed film and the camera were sent to the factory for photofinishing. Prints were made by first processing the film and then making a contact print of each negative on light-sensitive photographic paper. The camera was then reloaded and sent back to the photographer, with the 100 processed pictures ready for display. In those early days of photography, when photofinishing became an industry, it could take many hours to process the film and make the 100 prints. Modern photofinishing plants can make hundreds of thousands of prints a day. Automated printers use computers to help operators to examine and analyze each negative and expose it onto a long roll of photographic paper. The long roll of paper is processed and cut into single prints while automatically being matched with the negatives from the roll of film.

TYPES OF PHOTOFINISHING
Minilabs In the 1970s a new photofinishing service was provided for the picture-taking public. The facility offering this service was to become known as the *minilab*. These labs can handle approximately 200 rolls of film per day, are often located in retail stores, and occupy a

relatively small space. Minilabs generally provide 1-hour service, typically for a surcharge. The film is processed and then printed in an optical printer, with the assistance of an operator, onto a long roll of photographic paper. The prints are processed automatically and come out of the printer sorted for each roll of film. The negatives are matched to the prints by the operator, and packaged ready for pickup by the photographer. Minilabs have gained a wide acceptance for photofinishing. They can be found in most of the larger shopping centres or malls and in many camera stores.

Photofinishers Simultaneously, the high-volume photofinishing industry has developed many computerized pieces of equipment that allow stores that do not have minilabs to offer a convenient photofinishing service. When a roll of film is left for photofinishing by a photographer, it is sent to a centrally located laboratory. The film is first identified with the envelope in which it is received, so it can be matched to the print and order envelope when the order is completed. The film is spliced onto a long roll of film made up of rolls of film from other photographers. This bulk roll of film can be more than 100 rolls long. It is then processed in a high-speed processor to produce negatives, which are put onto a computerized printer that can make up to 27,000 prints per hour. The computer will scan each negative in the bulk roll to determine the correct amount and colour of light needed to make a quality print. The negative is exposed onto a long roll of photographic paper. As both the negative and the print are in continuous form, they can be cut and matched together after the processing. The negatives and prints are then packaged by envelope order and sent back to the stores to be picked up by the customers.

Photofinishing is now convenient and accessible to all photographers. Although only black-and-white films were available in the early days of photofinishing, the industry has now been almost completely converted to the processing and printing of colour films. Photofinishing has truly brought a new meaning to the original 1888 slogan of the Eastman Company: "You press the button, and we do the rest."

PHOTOGENIC *Photogenic drawing* was a term used by W. H. Fox Talbot to describe his earliest photographic process "by which natural objects may be made to delineate themselves without the aid of the artist's pencil (brush)."

PHOTOGRAPH An image of one or more objects produced by the chemical action of light or other forms of radiant energy (gamma rays, x-rays, ultraviolet radiation, infrared radiation) on sensitized materials. By extension, an image formed by an electronic imaging system (electronic photography).

PHOTOGRAPHIC CHEMISTRY The photographic image begins with exposure, a photochemical reaction that releases photoelectrons from the halide ions of the silver halide in the emulsion layer. A photoelectron combines with a silver ion to start the formation of a small nucleus of metallic silver, the latent image. Chemistry then amplifies the unseen image to a useful size by deposition of metallic silver on the nucleus. The branch of chemical science and technology that deals with the formation and treatment of the silver or dye image, especially the nature of processing solutions, is the field of *photographic chemistry*.

The critical part of photographic processing is development because the characteristics of the final image are determined during this chemical treatment. Much effort has been devoted to the choice, activation, and maintenance of the developing agents. After the image is formed, the rest of the chemical treatment is secondary but is ever so necessary to ensure the permanence of the developed image.

DEVELOPMENT Amplification of the latent image is accomplished by a developer, a water solution of several chemicals. Many thousands of varied formulations have been devised. Each contains essentially the same constituents: a developing agent or agents, alkali, preservative, antifoggant, and special purpose compounds.

Developing Agents Being a chemical electron donor is not sufficient to make a compound a developing agent. The critical complex for photographic development, using a Phenidone ion as the developing agent, might be shown as

| Developing agent | Latent image silver | Silver ions from crystal |

The developing agent must contact or be adsorbed to the metallic silver of the latent image. The molecule should have one end that is attracted to the metallic silver of the latent image (argentophilic); the other end should have low water solubility (hydrophobic). Once the argentophilic group is adsorbed to the silver, the rest of the molecule is water insoluble, thus forcing the molecule to adhere to the latent image. This condition greatly promotes the ease of electron transfer. Not all developing agents have this surfactant character. Hydroquinone, for example, in alkaline solution, often exists as the doubly charged ion, $^-O-C_6H_4-O^-$. Both ends of the molecule are argentophilic. When one end is adsorbed, the other end still has high water solubility. If conditions permit, the molecule may be adsorbed flat on the surface. This orientation is different

from the strongly adsorbed developing agents that are adsorbed from the argentophilic end, much like a deck of cards on end. The surfactant differences between developing agents has led to their classification based on their adsorption to catalytic sites, as shown at right.

Hydroquinone is an excellent electron donor but is a slow-acting developing agent because it is not strongly adsorbed. Developing agents with good surfactant properties, such as Metol or Phenidone, transfer electrons efficiently, but the oxidized forms then take time to move aside for unused molecules. This has led to the use of two developing agents, one of each type, such as Phenidone and hydroquinone, in developing solutions. In this case, one developing agent (Phenidone) stays adsorbed and the other (hydroquinone) provides electrons to it, thus regenerating the adsorbed molecule. The Phenidone acts as an electron transfer agent, with hydroquinone from solution providing the electrons. The Phenidone is not exhausted and need not leave the surface on or near the latent image. Only a very small quantity is needed of the strongly adsorbed developing agent.

The cooperative developing activity of two developing agents of differing surfactant properties is called *superadditive development*. Because of the increased efficiency of the electron transfer, the amount of developed silver is greater for the two cooperating compounds than the sum of the individual actions of each alone, all used under the same conditions.

Catechol

Metol

N,N-Diethyl-p-phenylene diamine

1-Phenyl-3-pyrazolidone

Hydroquinone
Not hydrophobic

Hydrophobic Argentophilic

Many of today's developing agents are related to three benzene compounds found before the turn of the century:

Hydroquinone *p*-Phenylenediamine *p*-Aminophenol

The hydroquinone molecule is still used in its original form and Metol, the *N*-monomethyl derivative of *p*-aminophenol, is a widely used developing agent. But *p*-phenylenediamine has undergone what might be called chemistry engineering.

p-Phenylenediamine is a slow, physical developing agent because it is much too water soluble. This deficiency has been modified by adding hydrophobic methyl and ethyl groups to the molecule. Although improving the surfactant properties of *p*-phenylenediamine, the charge also adds to the oil solubility of the compound, making more severe the skin irritation and systemic poisoning properties. To lessen this, the ethyl group was changed to a long water-solubilizing chain (lessened skin absorption), making an important colour developing agent:

has become

p-Phenylenediamine

Chemical names: *N*-ethyl-*N*(b-methylsulphon-amindoethyl)-3-methyl-*p*-phenylenediamine sesquisulphate monohydrate; or 4-amino-*N*-ethyl-*N*-(b-methanesulphonamidoethyl)-*m*-toluidine sesquisulphate monohydrate.

Trade Name Kodak Color Developing Agent, CD-3

288

In this century two important developing agents, and modifications, have been found that are not benzene derivatives:

L-Ascorbic acid Isoascorbic acid

and

Phenidone Methyl Phenidone Dimezone

Ascorbic acid (Vitamin C) is a sugar derivative that is a good antioxidant. Isoascorbic acid has only about one-twentieth of the antiscorbutic properties of Vitamin C. Phenidone is a 3-pyrazolidone (sometimes called 3-pyrazolidinone) that has had methyl groups added to the molecule to improve the stability in alkaline solution.

Of the many thousands manufactured, only about 10 developing agents are needed to compound the immense variety of black-and-white or colour developers in use today.

Developer Alkalis Organic developing agents are weak acids because of the OH$^-$ groups, which ionize to give off protons ($-OH \rightarrow -O^- + H^+$), or weak bases because of the $-NH_2$ groups, which accept protons. If both $-OH$ and $-NH_2$ are present in the same molecule, the developing compound is amphoteric, that is, has both acidic and basic properties. For $-OH$ groups, the form that has the greatest electron availability is when it is ionized ($-O^-$); for molecules with $-NH_2$, the uncharged form ($-NH_2$) is most electron rich. The purpose of the developer alkali is to convert the

molecule of the developing agent to a form with the highest electron density and suitably charged condition so that electron transfer to the latent image can be most rapidly achieved. Alkalis have sometimes been called activators because of their acceleration of chemical reactivity.

Some developing agents, such as hydroquinone, are weak acids. Alkalis supply hydroxyl ions (OH^-) in water solution. The caustic alkalis (sodium or potassium hydroxide, for example) have all their hydroxyl ions available. One molecule of sodium hydroxide acts first to ionize one hydrogen of the hydroquinone:

Another hydroxyl ion will then remove the second hydrogen:

The hydroquinone has been converted by the alkali from an unreactive, non-ionized molecule to the fully ionized form that is most capable of transferring electrons.

Some developing agents with —NH2 groups are weak bases that can transfer electrons, though very slowly, without the need of an alkali in solution. These developing agents also have their developing activity increased by alkali. p-Phenylenediamine combines with water to give

Uncharged –NH₃OH groups are formed but these give off hydroxyl ions, as shown by

The doubly charged positive ion is a poor electron transfer agent, being very water soluble and possessing a positive charge that might repel positive charged silver ions at the latent image site. If hydroxyl ions from an alkali are added, the neutral molecule is formed. This is the active form for electron donation.

An alkali supplies hydroxyl ions. Almost all alkalis have essentially similar effects if compared at the same pH value. The concentration of the hydroxyl ions, not the compound that is the source, is the important condition. In practice, however, the choice may be dictated by many factors. Only caustic alkalis supply enough hydroxyl ions for high-pH developing solutions. Retention of sodium carbonate in the emulsion layer may cause damaging release of carbon dioxide gas if the layer is immersed in a strongly acid stop bath. Ammonia and ammonia salts are unstable in high temperature solutions. The nature and concentration of the developing agents and other compounds in the developer often determine a specific choice of the alkaline substance.

A summary of practical alkalis is given with the equation showing the condition of the compound in water. In parenthesis following the kind of alkali is the name of the compound used as an example in the equation.

Caustic alkali (sodium hydroxide)
$$NaOH \rightarrow Na^+ + OH^-$$

Carbonate alkali (sodium carbonate)
$$Na_2CO_3 + H_2O \rightarrow Na^+ + OH^- + Na^+ + HCO_3^-$$

Borate alkali (borax)

$$Na_2B_4O_7 + 3H_2O \rightarrow 2NaBO_2 + 2H_3BO_3$$
$$NaBO_2 + 2H_2O \rightarrow Na^+ + OH^- + H_3BO_3$$

Sodium metaborate (Kodak), $NaBO_2 \cdot 4H_2O$, is the fused product of borax and sodium hydroxide.

Phosphate alkali (trisodium phosphate)

$$Na_3PO_4 + H_2O \rightarrow Na^+ + OH^- + Na_2HPO_4$$

Sulphite alkali (sodium sulphite)

$$Na_2SO_3 + H_2O \rightarrow Na^+ + OH^- + Na^+ + HSO_3^-$$

Ammonia alkali (ammonia and ammonium hydroxide)

$$NH_3 + H_2O \rightleftharpoons NH_4OH \rightleftharpoons NH_4^+ + OH^-$$

Organic amine alkali (trimethylamine)

$$(CH_3)_3N + H_2O \rightarrow (CH_3)_3NH^+ + OH^-$$

Developer Preservatives An alkaline solution of a developing agent is unstable, deteriorating rapidly because of the presence of the degraded products. In a hydroquinone developer, for example, the hydroquinone molecule can lose one electron to form a semiquinone, or two electrons to form quinone. The loss of one electron is a slow step, the loss of the second electron is more rapid. The quinone then can react with hydroquinone, forming two semiquinones, thus bypassing the slow step in the degradation of hydroquinone. The catalytic chain reaction then accelerates to degrade the unprotected developing agent.

To prevent the autocatalytic destruction of the developing agent, a chemical compound called a preservative is added to the developer. Ever since 1882, when it was proposed by H. B. Berkeley, sodium sulphite has been nearly the universal choice for developer preservative. When sodium sulphite reacts with the oxidized forms of a developing agent such as those from hydroquinone, the sulphite adds to the oxidized molecule to form a new compound. Quinone combines with sodium sulphite to produce sodium hydroquinone monosulphonate.

Sodium hydroquinone monosulphonate is a weaker electron donor whose oxidized form, quinone monosulphonate, may also react with sodium sulphite.

The disulphonate of hydroquinone is not very reactive.

The reactive oxidation products of a developing agent are removed by sodium sulphite. This action prevents the auto-oxidation of the electron donor but also keeps the developing solution clear and colourless. The formation of dark, staining reaction products, called humic acids, is prevented. The oxidized form of *p*-aminophenol (quinoneimine) and the oxidized form of *p*-phenylenediamine (quinonediimine) are also reactive with sulphite, as are other benzene derivatives that are developing agents. Ascorbic acid and Phenidone do not form sulphonates with sodium sulphite.

The reaction of silver bromide at the latent image site with an alkaline solution of hydroquinone containing sodium sulphite may be described by the equations that follow. (The oxygens of the doubly ionized hydroquinone ion have been depicted with dots to represent the reactive electrons of each atom.)

The hydroquinone transfers one electron to the silver ion of silver bromide, forming metallic silver, a bromide ion, and an intermediate form of hydroquinone that has lost one electron (semiquinone).

293

In the presence of sodium sulphite the intermediate form of hydroquinone reacts to form a sulphonate

The intermediate sulphonated form then loses another electron to the silver bromide, yielding metallic silver and hydroquinone monosulphonate. In the course of the reaction, bromide and hydrogen ions are produced. The hydrogen ions, both from the ionization of the hydroquinone and from the reaction, are neutralized by the hydroxyl ions of the alkali.

Compounds other than sulphite, or those yielding sulphite ions, act as preservatives in developers. Certain organic compounds having a mercapto group (–SH), such as thioglycolic acid, $HSCH_2COOH$, or cysteine, $HSCH_2CH(NH_2)COOH$, react in a manner analogous to sodium sulphite, preventing the colouration, staining and accelerated degradation caused by the oxidized forms of the substituted benzene developing agents. Reducing compounds such as ascorbic acid exert an antioxidant action on developer solutions.

Developer Antifoggants *Fog* is the name given to undesired silver density formed during development. The veiling effect of fog lowers image contrast and obscures image fine detail. Fog is a general term given to nonimage silver of different types resulting from a variety of mechanisms. Such image degradation may arise from the nature of the photographic material, the developer composition, and the conditions of processing, including the effect of oxygen from the air (aerial fog).

Photographic emulsions that have been too fully sensitized chemically, or become so upon aging, often show fog after development (emulsion fog). High energy developers of high alkalinity or developers with high concentrations of silver halide solvents have a tendency to produce fog (oxidative or development fog). Impurities in Phenidone and other developing agents also produce this kind of fog. Some fogs may occur at a distance from silver halide crystals, or even as a two-colour layer of metallic silver on the surface of the developed emulsion layer (dichroic fog).

The requirements are the same for the chemical development of the latent image and fog: a suitable source of electrons, a nucleated centre of metallic silver, and a source of silver ions. The development of latent image centres and the development of fog centres have the same two-step mechanism:

$$\text{Red}_{dev} \xrightarrow{\text{Ag}_n} \text{Ox}_{dev} + 2e^-$$

$$2\text{Ag}_i + 2e^- + \text{Ag}_n \longrightarrow \text{Ag}_{n+2}$$

In the first step, the reduced form of the developing agent in the presence of the silver (Ag_n) of the latent or fog image transfers two electrons, leaving the oxidized form of the developing agent. In the second step, two interstitial silver ions (Ag_i) combine with the two electrons at the silver centre of n atoms to form a new silver centre that has grown by two silver atoms ($n + 2$).

Preferential destruction of the silver of fog centres is not possible because of their similarity to the latent image centres. The modification of the source of the electrons, the developing agent, is also not a possibility. That leaves two possibilities: modifying either the source of silver ions or changing the surface characteristics of the silver of the catalytic nucleus. The mechanism of the preferential inhibition of the development of fog centres is not known with any certainty but may well involve either or both of these possibilities.

One of the practical solutions for inhibiting fog formation is to decrease the supply of silver ions. For many years this has been accomplished by the use of inorganic compounds in the developer called *restrainers*, such as potassium bromide or potassium iodide. These compounds adsorb to the silver halide crystal and form compounds of low solubility. Potassium bromide, for example, would form silver bromide having the same low solubility as the silver bromide of the emulsion layer. Although this would slow the supply of silver ions to both log and latent image centres, the restrainer is relatively more effective on the smaller fog centres than on the latent image.

A developing agent, such as Phenidone, is more strongly adsorbed than potassium bromide, thus making the restraining action of the bromide ineffective. Organic compounds, called *antifoggants* are therefore necessary. Benzotriazole and its derivatives, or 1-phenyl-5-mercaptotetrazole. are examples. Such agents combine with silver ions to form compounds of extremely low solubility. But the exact mechanism of their action is still being researched. 1-Phenyl-5-mercaptotetrazole may act by poisoning the surface of the silver centres. Effective inhibitors are said to destroy the surface of the silver or "form by flat-on adsorption a network of pseudo-polymeric bands," thus screening the silver from further activity. Such action would be more effective on the smaller, slower-developing silver centres of fog.

Special Purpose Developer Compounds Various chemicals have been added to developing solutions to improve the activity or modify the fundamental process. Sequestering agents are added to the water to prevent precipitation of calcium and magnesium compounds of

low solubility. Solubilizing agents for silver halide may be added in such concentration as to fix the silver halide at the same time it is being developed. Such solvent developers, called monobaths, feature a chemical competition between developing and fixing agents as well as the competitive results of the competition between chemical and physical development.

Undoubtedly, the most important special-purpose developer addendum is the one that converts *p*-phenylenediamine developers into solutions that form the silver image first and then, after a secondary reaction, yield a dye image. After the silver image is removed (bleached and fixed), only the dye image remains, making modern colour photography possible. The special purpose compound added to the developer is called a *coupler*, a colour-forming compound that adds to the oxidized form of the developing agent. The coupler may be contained in the developing solution but, for convenience, is often dispersed in the emulsion layers of the photographic material. Three couplers are needed, either in three developers or in three superposed emulsion layers, each resulting dye covering about one-third of the spectrum.

A molecule of a *p*-phenylenediamine developing agent, such as the *N,N*-diethyl derivative, can supply two electrons to the latent image to form two atoms of metallic silver, producing quinonediimine, the oxidized form of the developing agent. The positively charged quinonediimine and the negatively charged coupler ion may unite to form a molecular structure that is similar to a dye, called the *leuco dye*. The leuco dye may be colourless or weakly coloured. It is believed that leuco dye then reacts with another quinonediimine to form the dye, regenerating a molecule of the developing agent in the reaction. These reactions are summarized by the following equations:

Quinonediimine α-Naphthol ion

Leuco dye ion Hydrogen ion

Leuco dye ion Quinonediimine

296

Cyan indoaniline dye N,N-Diethyl-p-phenylene diamine

Two quinonediimines, one to react with the coupler and one to convert the leuco dye to the dye, are needed to produce one molecule of dye. Four silver ions were required to produce the two quinonediimines, so that the coupler is called a four-equivalent coupler.

AFTERTREATMENT OF THE DEVELOPED IMAGE Developers determine the quality of the developed image, but the image continues to form when the film or paper is removed from the developing solution. Neutralizing the alkalinity of the developer with immersion in an acid solution stops image formation. A weak acetic acid solution (1–3%), called a *stop bath*, is often used. The acid bath also conditions the processed film so it does not neutralize the acidity of the next bath, the fixing solution. Acid hardening fixing baths must be maintained in an acid condition.

The fixing bath contains sodium or ammonium thiosulphate to combine with the unused, unwanted silver halide crystals that are opaque and still light sensitive. The chemistry of complex ion formation is discussed in the entry "Fixing Bath." The silver thiosulphates formed are water soluble, thus allowing the removal of the insoluble silver halides.

When the photographic material is removed from the fixing bath, the emulsion layer may still retain some developer or stop bath chemicals as well as the chemicals from the fixing bath. Most of these chemicals are readily soluble in water, but thiosulphate or silver thiosulphate ions may interact with the gelatin or the silver image. Retention of these ions after washing in water may result in their degradation in time and an attack on the image. Washing aids are sometimes used immediately after fixation to displace the thiosulphates. Bathing in 1% sodium sulphite causes the sulphite ion to displace the thiosulphate ions, thus ensuring their removal from the emulsion layer. Dilute alkali, such as 2% sodium metaborate (Kodak), as a washing aid is also effective but may remove gelatin hardening or cause serious swelling of the gelatin layer. A thorough washing in running water, following by drying, completes the processing of the photographic image.

Even the best washing techniques have difficulty removing all of the processing chemicals from the matted cellulose fibres that make up the paper base of photographic prints. Thiosulphates and silver thiosulphates are held by powerful capillary action in the tiny channels of the paper fibres. Originally, to facilitate rapid processing, fibre paper bases were coated with a water-resistant barrier layer,

usually cellulose acetate or other cellulose ester. The baryta and emulsion layers were then coated on this water-repellent base. Recently, to reduce the volume of water needed for washing, resins have been used to coat the sides of the fibre paper base.

Although chemical retention is less, requiring much less water to wash photographic prints on a resin-coated base, the prints may not necessarily provide a longer lasting photograph. Tiny cracks may form in the coated layers from the tensions created as the paper fibres expand and contract with the daily cycles of temperature and humidity. For this reason, many prefer two-bath fixation, washing aids, and very thorough washing of fibre-based photographic prints when archival keeping is a requirement.

Books: Haist, G., *Modern Photographic Processing*, Volume 1. New York: John Wiley, 1979.

PHOTOGRAPHIC EFFECTS The term *photographic effect* refers to any of a number of results where some aspect of a photographic image is different from the image anticipated or produced under normal conditions. It is assumed, for example, that an image of the sun included in a photograph will be dark on the negative and light on a print made from the negative, but under some conditions the opposite occurs. It might also be assumed that all parts of an area of a negative or print that received a uniform exposure will have the same density, but multiple measurements made across such an area with a small-aperture densitometer reveal that complete uniformity from edge to edge would be unusual.

Photographic effects are usually brought about by changes in the light sensitivity of the photographic material or the nature of the final image as a result of either changing the conditions of exposure or processing, or the introduction of additional physical or chemical steps during processing. Although photographic effects might be subdivided into exposure effects and processing effects, both factors are involved in some photographic effects

Basic causes for photographic effects include (1) the size of latent-image specks, where a certain minimum size is required for development to occur; (2) length of time and temperature between exposure and development, where regression of the latent image can occur; (3) the distribution of the latent image between the interior and surface of the silver halide grains; and (4) development factors, such as local exhaustion of developer at the surface of the silver halide grain

Some of the following effects, such as adjacency or edge effects, are not unique to silver halide photography They manifest themselves in other imaging systems such as nonsilver imaging, electronic imaging, and human vision.

ADJACENCY EFFECTS Nonuniform densities in image areas when a region of great exposure lies next to one of low exposure. The cause is diffusion of fresh developer from a low-density area into one of high density, and the reverse—diffusion of exhausted developer from the high-density area into the low-density area.

Proper agitation during development plays only an indirect role, since the adjacency effects are associated with movement of chemicals from the thin layer of developer that adheres to the emulsion (the laminar layer) and diffusion within the emulsion itself.

ALBERT EFFECT The production of a reversal image by the following steps: (1) give the emulsion a high level of exposure to image light; (2) bleach, as with an acid bichromate solution; (3) clear with a sodium sulphite solution; (4) reexpose to diffuse light; (5) develop; (6) fix and wash. The result has sometimes been found to give better image quality than conventional two-stage duplication processes.

BORDER EFFECT At a boundary between a region of high exposure and one of low exposure where there is a greater density of the dense area immediately next to the thin area, as compared with that farther from the boundary. The cause is the difference in developer activity, which is greater at the edge than farther away where more exhaustion of the developer occurs.

BROMIDE-STREAK EFFECT Areas of underdevelopment in a film when, because of inadequate agitation, exhausted developer flows in a non-turbulent manner over the film. The effect is often seen in tank processing of sheet film.

EBERHARD EFFECT For small-image areas, less than about 4 mm in diameter, increasing image density as the size of the patch decreases, with constant exposure. The cause is greater developer exhaustion at larger image areas.

EDGE EFFECTS At a boundary between a region of low exposure and one of high exposure, enhancement of the high-exposure level next to the low-exposure level (the border effect) and a reduction of the low-density level next to the high-density area (the fringe effect). The combination of these two nonlinear effects is often called the *Mackie line*.

FRINGE EFFECT At an edge between a region of high exposure and a region of low exposure, a reduction in the density of the thin area immediately next to the dense area. The cause is weakness in the developer that is partially exhausted by action in the dense part of the image. The fringe effect is one of the edge effects.

HYPERSENSITIZATION EFFECT A process intended to increase the effective speed of a photographic material by treatment before the image exposure. Various methods have been used, such as preexposure to weak, uniform light; treatment with mercury vapour; and bathing in solutions of ammonia, organic acids, etc. Recent tests

have shown a tripling of the usual speed of films used in astronomy by heating the films in an atmosphere of hydrogen and nitrogen gases.

Hypersensitization is distinguished from latensification, which involves treatment after the image exposure.

KOSTINSKY EFFECT When two or more very small adjacent images of high exposure, such as those of stars, lie within an area of low exposure, the shape and separation of the images will change with increased development. The developing agent is somewhat exhausted in the narrow space between the images and more effective outside them. The Kostinsky effect causes problems in the measurement of astronomical images, among others.

LATENSIFICATION EFFECT Treatment of a photosensitive material after an initial exposure with the aim of increasing image density and contrast, and therefore effective speed. Various methods are used, among them a second exposure to weak, uniform light, and bathing with mercury vapour or with other chemicals, e.g., hydrogen peroxide. The effect is small or absent for very fast modern emulsions.

PRESSURE-MARK EFFECT A local area of higher density or lower density on processed film or paper due to the application of pressure to that area prior to processing. Such marks can result from bending film, such as can occur accidentally while loading roll film on a processing reel, as well as by applying pressure with a hard object. Whether the pressure has a sensitizing or desensitizing effect is influenced by whether the pressure is applied before or after the exposure and by the amount of exposure.

ROSS EFFECT Changes in the size and location of small adjacent images caused by the strains produced by the tanning (hardening) of gelatin during development.

SABATTIER EFFECT Partial image reversal associated with the following sequence: (1) less-than-normal first exposure to a scene, (2) less-than-normal first development, (3) a diffuse second exposure, (4) a second period of development, and (5) conventional completion of processing. The result is a change in the characteristic curve, and the pictorial effect is a reversal of some of the image tones and enhancement of lines. The line effect has been used in practice to increase the sharpness of spectrographic images.

The Sabattier effect is probably caused by the presence of silver formed in the first development covering the silver halide grains and shielding them from the second exposure. The effect sometimes appears when unsafe "safe" lights are used in the darkroom.

The Sabattier effect should be distinguished from solarization, which is image reversal caused by abnormally large exposure levels.

SPROCKET-HOLE EFFECT Uneven development caused by the movement of developer in patterned flow associated with the holes in the margins of motion picture and other films.

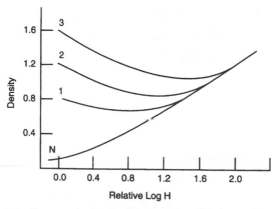

D-log H curves showing the Sabattier effect. N is the usual curve, and curves 1–3 show the results when the film received progressively less first development time.

Sabattier effect: pictorial effect.

STERRY EFFECT The reduction in contrast that results when exposed photographic material is treated with a weak (less than 1%) solution of potassium dichromate before development.

TEMPERATURE EXPOSURE EFFECT The extent of latent image formation in a photographic material as affected by the temperature at which the exposure occurs. Sensitivity is reduced at very low temperatures but may increase at high temperatures, especially for exposures to strong light for short times.

PHOTOGRAPHIC FILM

Photosensitive material consisting of an emulsion coated on a flexible, transparent base. Films for still photography can be grouped according to their formats as follows: roll films, perforated films, and sheet films (including packs). Motion-picture films are perforated materials supplied in long rolls. Other formats outside the mainstream are the specialty materials such as panoramic and subminiature. The commercially important materials are almost exclusively silver halide, but a few other materials have their special uses.

STILL FILMS

Roll Films A design that permits daylight loading of medium-format cameras. The usual form is a strip of film laid on a longer strip of opaque backing paper, which extends beyond it at both ends, and the pair are wound on a spool. The flanges of a metal spool make a light-tight seal with the paper. The leading end of the film is fixed to the backing paper with a piece of adhesive tape. The backing paper is printed in the area over the film with one or more series of numbers, which align windows in some camera backs to indicate the frame in the exposure plane, and in nonautomatic cameras to guide the photographer in accurately spacing exposures along the roll. Advanced cameras automatically space the exposures. The common 120-size film is numbered 1–8 for pictures 2–1/4 × 3–1/4 in., 1–12 for pictures 2–1/4 in. square, and 1–16 for pictures 1–5/8 × 2–1/4 in., according to the camera used. The demand for more exposures led to 220-size film. It is supplied on the same size spool as 120, but provides twice as many exposures. Backing paper does not extend the whole length of the film but is merely the leader and trailer lengths spliced onto a double length of film. (The numbers 120 and 220 are in no sense a measurement of size: they are part of a series of arbitrary numbers designating various roll film sizes.) Many other roll film sizes once popular for snapshot photography are now discontinued or are obsolescent.

Perforated Films The original film used in the first 35-mm still cameras was merely short lengths of standard motion-picture negative stock, but now films are made specially for this field. The perforation standard of the motion picture field has been taken over into still photography with the common format being a frame eight perforations long, double the motion standard. The exposure area is nominally 24 × 36-mm, usually called full-frame. A few amateur cameras use the 18 × 24 half-frame still format, which is the same as the motion picture full frame.

The usual format is a metal magazine for daylight loading holding 36 exposures. Other lengths of normal film are 20 or 24 exposures, although lengths of 8, 12, 15, and 18 are sometimes seen. For photojournalists, film on a very thin base has been supplied in 72-exposure lengths in the regular magazines. Latent image frame numbers and identifying data are exposed by the manufacturer at the very edge of the film in the perforation area. A shaped tongue at the start of commercially packaged film aids in camera loading. Long rolls, usually 100 feet, are supplied for those who load their own magazines.

In the majority of cameras, film is exposed as it is withdrawn from the magazine and wound onto the take-up spool. It must then be rewound into is original magazine before the camera back can be opened to change films. Failure to rewind before opening the camera leads to the ruining of some or all of the film. A few automatic snapshot cameras upon loading immediately run all film onto the take-up spool, then rewind exposure by exposure back into the original magazine, protecting exposures already made.

Although most perforated still film is 35-mm wide, a few other gauges are also seen. For commercially produced slides, 46-mm is sometimes used. Some technical and microfilm applications use 105-mm stock. For mass portraiture 90-mm stock is used, often unperforated. The most important size, other than 35-mm, is 70-mm.

Seventy millimetre film has much to recommend it for scientific and technical photography. Many high-quality 120 cameras also have alternative interchangeable backs for 70-mm film. Image size is usually 2–1/4 by 2–1/4 to 2 7/8 inches. The usual load consists of a magazine looking like an overgrown 35-mm magazine and containing 15 feet of 70-mm film. The film is threaded from the supply magazine, across the focal plane, and into an identical but empty takeup magazine. Unlike 35-mm, the film is not rewound in the camera after exposure.

The 70-mm format may be thought of as both the largest of the small formats and the smallest of the large formats. Because of this, a great variety of emulsions are available in it, usually in long rolls. Aerial, instrumentation, scientific, portrait, microfilm, copying, duplicating, and general-purpose emulsions are supplied in black-and-white and in colour.

Sheet Films These, also called *cut* films or *flat* films, are made in sizes to fit the popular view, press, and technical cameras. The usual packaging is in boxes of 10 to 100 sheets, which must be loaded into light-tight holders in the darkroom. To solve the problem of locating the emulsion side in total darkness, sheet films have notches along one edge. When the film is oriented vertically and the notch is in the upper right corner, the emulsion faces the operator.

A few manufacturers are offering another way of handling sheet film. Single or double sheets are supplied

in light-tight paper sleeves to fit special holders. No darkroom is needed until time for processing.

Film packs, although the base material is as thin and flexible as roll film, can be considered as sheets because they are used in cameras designed primarily for sheet films. In this format 16 films fit in a special holder not much thicker than a normal holder containing two films. The film-pack format has fallen out of favour for conventional films but is now widely used for black-and-white and colour instant-picture films.

PHOTOGRAPHIC PAPER Several physical aspects of photographic paper apply to all kinds alike. They will be discussed first. The distinct aspects of colour and black-and-white will then be taken up separately.

COMMON PROPERTIES

Base The base of support has considerable bearing on the ease, speed, and cost of paper processing. The old standard fibre base requires conventional three-bath tray processing, and extended washing and drying. It offers the greatest flexibility in process variation to alter density, contrast, and image tone. The greatest variety of textures, tints, and finishes is also available in fibre papers. RC (resin-coated) papers begin with a conventional fibre support onto which a pigmented polyethylene is extruded. The emulsion is then coated on one side of that. The support of RC papers does not absorb chemicals or water, so they are quick to wash and dry.

Weight The thickness of a photographic paper support. The usual range is light, single, medium, double, and sometimes premium weights. There is no standardization on exact thicknesses corresponding to these names among manufacturers. A given paper may be made in more than one of these weights.

BLACK-AND-WHITE PAPERS The term *black-and-white photographic paper* has become almost synonymous with silver halide enlarging paper, but even in this restricted sense there is considerable variation—fibre vs. RC, graded vs. variable contrast, tray vs. machine processable, single vs. double weight, glossy vs. matt surface. These and the alternatives—contact, printing-out, nonsilver—will be discussed.

Processing Method Papers may be grouped according to the processing method for which they are intended: manual processing in trays or mechanized processing. Any paper may be processed manually, including those with incorporated chemicals intended for mechanized processing, although only the ordinary papers without incorporated chemicals will respond to the manipulations often required in manual processing. To speed up mechanized processing, all the ingredients for a developer, except the alkali, are built into the emulsion. The first bath in the processing machine is a strong alkali, so development starts instantly and is complete in seconds. The second bath is a

fixer, followed by a washing and drying, only 60 seconds elapsing from dry to dry. Only RC papers are used in these machines. A sometimes overlooked advantage of fully mechanized processing is that prints need not be sorted out from an entire day's production. Each job is separate.

A step between manual and fully mechanized processing is stabilization processing, which uses a small machine with two baths, no wash and no dryer. Here again incorporated developer paper is used, but this time it is fibre base in most cases. The first bath is an alkaline activator, but this time followed by a stabilizer, not a fixer. The stabilizer converts undeveloped silver halide into a relatively light-stable complex salt, which remains in the paper. Prints issuing from the machine are damp, limp, and odoriferous, requiring air drying. The images have moderate stability under office conditions. To render these prints as stable as any other black-and-white prints, they should be fixed in hypo, washed, and dried.

Contrast Grade Photographic paper for pictorial and most technical photography is made in a range of different contrasts using names such as extra soft, soft, normal, hard, extra hard, ultra hard or numbers zero through five, with two corresponding to normal. The majority of negatives should print best on a number two paper. A soft negative, or one with less contrast, would need a higher grade; a hard negative, or one with more contrast, a grade lower. Although international standards define the degree of contrast by grade number, there is no general adherence to their specifications.

An alternative to graded papers is variable-contrast paper. These papers have two emulsion components, one of high contrast, one of low contrast. In the usual scheme the high contrast component is sensitive to blue light, and the low to green. By changing the colour of the exposing light with filters one can have any desired contrast between maximum and minimum.

Surface The surface of a photographic paper is a combination of its texture and its finish. Its texture may range from smooth to rough in several steps. It may also have a discernible pattern impressed to resemble fabrics, such as silk, linen, or canvas. (As paper manufacturers supply fewer of these, other methods of achieving such surfaces on a smooth print are offered by firms making embossing equipment.) Finish may range from glossy to matt in several steps.

Tone and Tint Papers vary in image tone, the colour of the image itself, not that of the paper base. To a large extent this is built in at manufacture, but it can be influenced by the choice of developer. Further major changes can be made after conventional processing by various chemical toners. Tint is the colour of the base itself, independent of image tone. White and various creams are the usual tints. In former times deeper tones, such as old ivory, were used for portraiture.

Speed Most papers today are of projection speed to enlargement, although some slower contact papers still exist. Other than their level of light sensitivity, there is little to distinguish one from the other. Although papers are not rated in the same speed system as film, it may be of interest to know where they stand with respect to each other. The equivalent speed of a typical enlarging paper might be equivalent to ISO 3; contact paper is about a tenth to a hundredth of that.

SPECIALTY PAPERS With the continuing trend to smaller negatives, the demand for printing-out papers as proofing materials has fallen greatly, but they are still available from some manufacturers. Most current uses would be in fine-arts applications and in the printing of antique negatives.

A small but lively interest remains for esoteric printing processes using nonsilver materials and nongelatin silver materials. A few of these are made by very small manufacturers, but most are prepared by individual photographers with chemicals and instructions from firms catering to the fine-arts trade.

Recording papers for various technical instruments form images by the direct action of light; first the intense exposure of a xenon arc-lamp spot swept at high speed over the paper to impress the data trace, then photolytic development as the paper prints out under ordinary roomlight conditions. The record is a bluish trace on a tan background.

COLOUR PAPERS

Materials Negative- and positive-working chromogenic papers, dye-destruction (silver-dye-bleach) materials, and dye-transfer materials provide a wide variety of routes to the final image. The great flexibility of dye transfer, with all of its possibilities of masking for colour correction and contrast control, along with all of the other systems previously mentioned, offer a rich palate of printing possibilities.

Prints from colour transparencies Reversal papers can produce prints directly from transparencies. Some of these materials are of high contrast, and since many transparencies are also of high contrast, the cascaded result is sometimes a print with too much contrast. The method does, though, have the advantages of simplicity and economy, with no intermediate needed. For technical and scientific subjects the gain in contrast is often a boon.

A route that offers control over contrast and better colour reproduction is a print on negative-working paper via an intermediate negative. When making a large print from a small transparency, obtaining some of the enlargement in the interrnediate negative will optimize image quality in the final print, e.g., a 35-mm slide to a 4 × 5-in. interneg to a 16 × 20-in. print.

Prints from colour negatives Negative-working chromogenic papers are supplied in at least two grades of contrast. Dye-transfer prints can also be made.

PHOTOGRAPHIC PROCESSES Classification of photographic processes may be made according to the chemical components and their functions, the method of obtaining a final copy, or the intended application.

Since 1800, salts of silver formed with members of the halogen family, chlorine, bromine, and iodine, have constituted the basis of most photochemical imaging. Exposure causes these salts to form a latent image that can be developed out or, with sufficient exposure, printed out. Fixing in sodium thiosulphate or ammonium thiosulphate removes unexposed and undeveloped salts, rendering the image safe in light. Silver halides are used in most colour imaging as well; they are used to form the image and are removed after dye formation in chromogenic processes, or after dye destruction in dye-bleach processes.

Some iron slats are also sensitive to light. The reduction of iron from its ferric $(3+)$ to its ferrous $(2+)$ state is the basis of the chrysotype, cyanotype, kallitype, platinotype, and Vandyke processes. The ferro-cupric and ferro-gallic high-contrast processes are also iron-based.

When a colloid such as gelatin, casein, albumen, shellac, or gum arabic is sensitized with potassium, sodium, or ammonium bichromate, the emulsion changes upon exposure to light. The colloid may become insoluble if previously soluble; it may no longer absorb water and swell up, or it may lose its surface tackiness. For example, powder processes are based on loss of tackiness, creating ceramic and photomechanical applications. The carbon, carbro, gum bichromate, bromoil and dye transfer processes also employ bichromates, as do some silkscreening techniques.

Diazo copying processes employ diazonium salts that are destroyed when they are exposed by ultraviolet, violet, or blue light. The salts can couple with aniline to form coloured compounds.

Another way of classifying photographic processes is according to the way they arrive at a final product. Of the three viable photographic systems published in 1839, W. H. Fox Talbot's was a negative-positive process, and L. J. M. Daguerre and Hyppolyte Bayard made direct positives. Reversal processing was first achieved by C. Russell in 1862. Transfer of a chemical image, a physical image or an emulsion from one support to another is the basis of dye transfer, carbro, bromoil, and diffusion transfer processes.

Colour processes may be additive, combining red, green, and blue elements, or subtractive, combining yellow, magenta, and cyan. Some record images on panchromatic black-and-white emulsions by employing linear or lenticular screens to separate white light into its primary components. Some colour processes, such as tri-colour carbro and dye transfer, rely on the assembly of a colour image from separate matrices.

Development of an image may be physical or chemical. In physical development, the silver forming the image is

supplied by the developer rather than by the emulsion, essentially silver plating the latent image specks. In chemical development, the developer reduces exposed silver halides to form metallic silver and halogen ions. Tanning developers that harden the gelatin of the emulsion must first operate chemically; it is the developer oxidation products that harden the gelatin.

Photomechanical reproduction is a distinct branch of photography that employs many of the processes described in conjunction with general purpose photography.

Letterpress line blocks are made by making a negative on lithographic film from a line drawing and exposing it by contact onto a zinc plate with a dichromated albumen coating after which the plate is etched.

Halftone blocks begin with a litho film negative made through a halftone screen. The negative is contact printed on a zinc or copper plate coated with a light-sensitive fish glue-ammonium dichromate solution; the plate is then etched.

Offset lithography also uses halftone images produced from continuous tone images by means of a halftone screen, and a plate coated with dichromated colloid, but here the hardened colloid may be used directly for printing.

Photogravure etches the image into a printing cylinder. Carbon tissue bathed in potassium dichromate is exposed through a photogravure screen and transferred to a copper cylinder where the soluble, unexposed gelatin is washed away. The tissue forms a resist that determines where the cylinder will be etched with ferric chloride.

Colour printing processes use photographically made separations to prepare plates that print yellow, magenta, cyan, and sometimes black. Specialized presses can print six or more impressions in one pass through the press, and offer the option of finish coatings over colour.

COLOUR PROCESSES

Chromogenic Development Today, most negative and reversal colour photochemical imaging systems employ chromogenic development to form dye images. The technology has its roots in the textile industry of the nineteenth century in which dye-coupling was used to form colours in the fibres of fabrics. In 1873, H. W. Vogel used dyes to extend the spectral response of silver halides, making orthochromatic collodion plates. Research by R. E. Liesegang, H. Luppo-Cramer, B. Homolka and others into dye characteristics, oxidation, and development enabled R. Fischer and H. Siegrist to patent a practical system of chromogenic development in 1912.

Negative films with conventional integral tripack emulsions form silver and dye images during the single development step. Reduction of the silver image from silver halides produces oxidation products that then react with dye couplers in each emulsion layer to form subtrac-

tive dyes. To keep the couplers from migrating into other layers, forming inappropriate colours, they may be encapsulated in shells of colloids that are permeable but not soluble in the processing solution, or they may be anchored in place by attaching them to long, inert hydrocarbon chains that make the couplers too heavy to move or too large to slip through gelatin. Yellow dye is formed in the blue-sensitive layer; magenta dye is formed in the green-sensitive layer, and cyan dye is formed in the red-sensitive layer

Colour negatives have a characteristic orange cast, which is a mask that compensates for unwanted absorptions by the cyan and magenta dye layers. One method of generating the mask incorporates yellow couplers in the magenta layer, and orange or red couplers in the cyan layer. Oxidation products form dyes that are visible in the unexposed areas of the negative.

Because developer oxidation products join with colour formers to produce dye, customary antioxidants such as sodium sulphite would inhibit dye formation. Antioxidant concentrations are necessarily kept very low, with the consequence that colour developers have very short working lives.

Bleaching and fixing remove the silver image, leaving the dye. The bleach is a complex mixture that forms silver bromide from the silver in the image, enabling an ammonium thiosulphate-based fixer to complete the task of silver removal. The bleach and fixer are often combined in one step, called blix. After washing, a stabilizer with little or no formaldehyde is used to preserve the dyes.

Chromogenic integral tripack colour reversal materials are similar in many respects to their negative counterparts. A latent image is first formed in silver halides, but the first development is black and white only, forming a silver negative image. The remaining unexposed or undeveloped areas of the emulsion are then either re-exposed to light or sensitized in a fogging bath, forming a positive latent image. The second development works like the developer in negative processing, colour couplers in each emulsion layer react with oxidation products in the developer, forming subtractive dyes, as well as a positive silver image. Bleach then converts the silver of both images to soluble compounds that are removed by the fixer. Washing and stabilization follow.

Prints can be made chromogenically from either negatives or positives. Negatives are printed on integral tripack papers and display materials that are like negatives without the compensating mask. Development follows the same steps. Positives are printed on integral tripack materials that mirror positives, requiring re-exposure to light or a reversal bath.

Modern formulations of processing solutions are made with concern for safety and environmental considerations. Because photochemical systems are in use throughout the

world, manufacturers must maintain compliance with a maze of often-contradictory regulations. There is also a need to avoid infringing on industrial patents, necessitating the search for new ways to perform old tasks.

Differential Dye Diffusion Kodachrome was invented in the 1930s by Mannes, Godowsky, and a research team at Eastman Kodak. They solved the problem of making the dyes stay in their respective emulsion layers by adding the dyes during processing. The film has three silver halide emulsion layers without colour couplers. In a highly sophisticated processor, the antihalation backing is removed; silver negative images are developed; the film is exposed to red light through the back and developed with cyan-forming developer yielding a cyan and silver positive; the film is exposed to blue light from the top and developed in yellow-forming developer, yielding a yellow and silver positive; a fogging developer forms a positive magenta dye and silver image. Bleach then converts all the silver to soluble compounds that are removed by fixer, leaving a dye image.

The skilled personnel required for the performance of these tasks, the expense and relative scarcity of the equipment involved, and the dramatic improvements in chromogenically processed reversal materials that can be processed quickly and successfully almost anywhere all call the long-term future of Kodachrome process materials into question.

Dye Diffusion Transfer The formation of colour images by means of the diffusion transfer process is, currently, the sole province of Polaroid. In the 1980s, Agfa marketed a dye-diffusion-transfer integral-colour printing material called Agfachrome Speed, and Kodak offered a line of peel-apart printing materials called Ektaflex, as well as instant colour print films. Now, Polaroid has peel-apart and integral diffusion transfer materials. They have red, green, and blue sensitive layers interleaved with metallized dye developers that form cyan, magenta, and yellow dyes. The material is exposed and passed through rollers that break the pods containing separate processing solutions for each emulsion layer. The developed dye/developer molecules are immobilized while the undeveloped molecules can migrate through the emulsion to the mordanted receiver where the positive dye image is formed.

Peel-apart materials protect the light-sensitive components until processing is complete, and facilitate the disposal of all substances consumed and no longer necessary. Integral materials enjoy no such luxuries. They protect the emulsion after exposure by generating an opacifying layer that reverses itself at the conclusion of processing. They form a pigment barrier layer between the image and the negative to conceal and isolate processing byproducts and provide a background for viewing.

Screen Processes Before effective chromogenic materials were available, systems by Joly, the Lumière Brothers, Dufay, and Finlay, as well as Kodak and Agfa,

all used screens to divide light into its primary components. Some screens were lenticular, some were coloured lines, and some were mosaic or reseau. All split the light on its way to a panchromatic black-and-white emulsion, usually reversal processed. While the details varied, most used white light projected through the back to modulate the intensity of the light reaching the screen. As the light passed through. a colour image was constructed. Currently, Polaroid Polachrome 35-mm film employs a screen in conjunction with a peel-apart diffusion transfer emulsion to produce an additive three-colour positive image.

Dye Transfer The dye transfer process is an assembly process for making colour prints from colour positives or negatives. Two kinds of matrix film are used orthochromatic and panchromatic. The panchromatic film is used when separations are to be made directly from colour negatives or internegatives onto the matrix film, eliminating the need to make separation negatives. However, significant control over the final image can be exercised while making separation negatives.

In either case, the separations are made in registration through red, green, and blue filters, eventually producing the matrices that will print cyan, magenta, and yellow dyes. The matrix film is exposed through the back because its dichromated gelatin emulsion is subject to hardening in a tanning developer where the emulsion has been exposed. The unexposed and unhardened parts of the emulsion are on the top and can then be washed away in warm water, leaving a relief image in gelatin.

The matrices are soaked in their respective dyes and applied to the print, cyan first, then magenta and yellow, in register. Multiple applications, changes in soaking and rinsing procedures, and modifications of the dye baths all provide additional controls. The intricacy of the process is a function of the degree of control it offers to the skilled practitioner. The dye transfer process is generally regarded as the foremost system of colour printing because of that control, the durability of the prints and the subtlety of the dyes that form the image.

Silver-Dye-Bleach-Process The silver-dye-bleach process is an integral tripack system with yellow, magenta, and cyan azo dyes incorporated into the blue-green-, and red-sensitive emulsion layers, respectively, during manufacture. After exposure from a colour positive, the material is processed in black-and-white developer to produce a silver image. A strongly acidic dye bleach with an added accelerator causes the destruction of the dyes adjacent to the silver image grains in proportion to the amount of silver bleached. Fixer removes the bleached negative silver image and the unexposed, undeveloped silver halide components of the positive image. The stable, luminous azo dyes that remain correspond to the original positive image.

HISTORY OF PHOTOGRAPHIC PROCESSES

Before the nineteenth century, photography existed as a phantom. Its components had been known for hundreds of years. The Greeks and Egyptians knew substances whose nature was altered by exposure to sunlight. Renaissance painters knew how to project an image onto canvas in a darkened chamber. The growing middle class wanted images of their travels and of family members, and there were scientific and industrial applications waiting eagerly for someone to figure out how to write with light.

Experimentation, discovery, and development in photographic processes in the nineteenth century were concerned first with finding workable materials that would record an image in a reasonable time. Early in the century, exposures lasted 8 hours. Before the end of the century, birds' wings and horses' hooves could be frozen in mid-action.

The impermanence of their work plagued early experimenters. In 1800, Wedgwood and Davy could not prevent their photograms from turning black in light, and the salt used by Talbot and Daguerre in the 1830s was of limited effectiveness. The "hyposulphite of soda" method for making silver halide images permanent was discovered by Sir John Herschel in 1819 and shared generally in 1839. Washing of film and paper were reasonably well understood by the turn of the century.

For daguerreotypists and ferrotypists, the lack of a sufficiently clear base on which to coat emulsions was of little concern; their work couldn't be duplicated anyway. For those who employed negative-positive processes to get multiple prints from individual negatives, paper negatives lacked sufficient translucency for successful printing, even if the paper was waxed. Glass was the next solution, and it was an admirable one except for its weight, fragility, and rigidity. By the end of the century, celluloid roll films could be loaded in daylight.

Early in the century, photographic emulsions had no shelf life at all; they were exposed wet shortly after sensitization, and their effective speed varied with a multitude of factors. Dry plates, sheet film, and roll film were manufactured to standardized sensitometric standards by century's end.

Blue skies and red clothing rendered respectively as white and black were artifacts of silver halide emulsions that were most sensitive at the blue-violet end of the spectrum and saw nothing of the red end. Vogel's discovery of dye-sensitization in 1873 laid the groundwork for orthochromatic and then panchromatic light-sensitive materials, as well as the attainment of the great goal—workable colour photographic systems.

In sum, one might argue that the thrust of photography in the nineteenth century was democratization. It started in the labs of scientists, inventors, and tinkerers, and was sold prepackaged on street comers by the end of the

century. The huge—and growing—market for photographic materials provided the profits to fuel the research projects of the twentieth century that gave us faster and more universal processing, dramatically increased film speed, reduced grain size, provided more accurate and more saturated colour, increased convenience in packaging and one-step materials, and a vast range of specialized products for medical, scientific, business, industrial, and military applications.

At the close of the twentieth century, the two principal thrusts in photographic processes are, first, reduced toxicity of the chemicals used in processing and reduced discharge of all contaminants that are produced by photographic processes, and second, a steady movement toward electronics and microprocessors in the management of photographic imaging and processing equipment, and in the acquisition, storage, and manipulation of the images themselves.

Despite the extraordinary quality of current photochemical imaging systems, their continued success depends upon the development of processes that work successfully within the confines of environmental protection. Digital imaging needs to solve storage, cost, and resolution problems, but the market is in place. The rate of transition from photochemical to digital imaging is what remains to be determined.

PHOTOGRAPHIC PROCESSES: OUTLINE HISTORY

1727 J. H. Schulze, sensitivity to light of silver nitrate with chalk

1772 J. Priestley, *History and Present State of Discoveries Relating to Vision, Light and Colours*

1777 C. W. Scheele, silver reduced by light from silver chloride; silver chloride more sensitive to some colours of light (violet, blue) than others; ammonia destroys light sensitivity of silver chloride

1800 Sir W. Herschel, discovery of infrared

1800 T. Wedgwood and H. Davy, unfixed silver nitrate and silver chloride photograms

1819 Sir J. F. W. Herschel, discovery of thiosulphates and the solution of silver halides by "hypo"

1826 J. N. Niépce, Heliography, exposed areas of bitumen of asphalt became insoluble in lavender oil, a photopolymerization process

1835 W. H. F Talbot, photogenic drawing, printing-out negative and paper sensitized with salt and silver nitrate

1839 L. J. M. Daguerre, daguerreotype process published

1839 H. Bayard, direct-positive paper process

1840 W. H. F. Talbot, calotype, developed-out negative, printed-out positive

1840 N. de St. Victor and R. Hunt, thermography

313

1842	Sir J. F. W. Herschel, cyanotype, ferroprussiate paper
1844	R. Hunt, ferrous oxalate process, ferrous sulphate development
1847	N. de St. Victor, albumen glass plates
1850	L. D. Blanquart-Evrard, albumen paper
1851	G. Le Gray, waxed-paper process
1851	F. S. Archer, collodion binder, wet-collodion process
1851	Regnault and Liebig, independently, pyrogallol developer
1852	W. H. F Talbot, photoglyphic engraving
1853	A. A. Martin, tintype, ferrotype, melainotype
1854	J. A. Cutting, ambrotype
1855	J. C. Maxwell, isolation of primary colours
1855	Poitevin, carbon-potassium bichromate print process (later Pouncy, Swan, Du Hauron)
1858	H. Anthony, ammonia-fumed albumen paper
1860	Collodion dry plate
1862	L. Ducos du Hauron, beam splitter camera for colour images
1865	Woodburytype photomechanical printing process
1868	Photolithography/collotype
1868	L. Ducos du Hauron, *Les Couleurs en Photographie*
1871	Liverpool Dry Plate Co., gelatin coated silver bromide printing paper
1873	H. W. Vogel, dye-sensitised orthochromatic collodion plates
1873	W. Willis, platinotype
1878	Gelatin silver bromide glass dry plate
1879	Photogravure
1880	W. de W. Ahney, hydroquinone developer
1880	J. Eder and Toth, pyrocatechin developer
1882	H. B. Berkeley, use of sodium sulphite as a preservative for organic developing agents
1881	Halftone screen
1883	J. Eder, developing-out chlorobromide paper
1884	Eastman, roll film system and machine coated printing paper
1884	Vogel-Obernetter, orthochromatic dry plate
1886	W. de W. Abney and P. E. Liesegang, aristotype gelatin silver chloride paper
1887	H. Goodwin, patent application for celluloid roll film
1887	G. Pizzighelli, platinum priming-out process
1888	Emulsion stripping paper roll film
1888	J. Carbutt, emulsion coated on celluloid sheets
1888	Developing-out paper, gelatin silver bromide
1888	Kodak camera, "You press the button—We do the rest."
1888	F. Hurter and V C. Driffield, actinograph
1888	M. Andresen, *p*-phenylenediamine developer
1889	H. Shawcross, Vandyke Brown print process

1889	Eastman nitrocellulose roll film base
1890	Printing-out paper, gelatin silver chloride
1890	F. Hurter and V. C. Driffield, *Photographic Researches*
1890	Gelatin silver chloride gas light paper
1890	Platinum chloride paper
1891	L. Ducos du Hauron, Anaglyphs, 3-D photographs using red-green discrimination for separation
1891	M. Andresen, use of para aminophenol, Rodinal, as developer
1891	A. Bogisch, metol developer
1891	F. Ives, Kromskop "one-shot" three-colour separation camera
1891	S. N. Turner, Kodak daylight loading film rolls
1891	G. Lippmann, wavelength interference colour system
1893	Baekeland, Velox silver chloride ammonia gaslight paper
1894	J. Joly, line screen additive colour images
1895	R. E. J. Liesegang, silver bleached away, dye image remains
1895	W. C. Roentgen, discovery of x-rays and radiography
1896	R.E.J. Liesegang, lenticular screen colour process
1899	T. Manly, ozotype carbon
1901	A. Eichengrun, cellulose acetate film base
1902	H. Luppo-Cramer, metol-hydroquinone developer
1902	Kodak gelatin anti-curl backing for film
1903	Agfa, panchromatic film
1905	K. Schinzel, dye destruction
1906	Finlaycolour additive screen plate
1906	F. C. L. Wratten and Wainwright, commercial panchromatic plates
1907	Lumière Brothers. Autochrome plate (1904 patents)
1907	B. Homolka, leuco dye colour development
1907	C. W. Piper and E. J. Wall, bromoil process
1908	Dufay, poured colour
1912	R. Fischer and H. Siegrist, colour couplers for dye formation
1914	A. Keller-Dorian, lenticular cinematographic system
1915	Technicolor dye imbibition motion picture film
1915	Kodachrome, subtractive 2-colour process, black-and-white separation negatives.
1916	Agfacolor dyed vanish screen plate film
1919	Autotype Co., carbro print process
1920	H. Luppo-Cramer, desensitization
1921	Pako automated processing machine
1921	A. Bocage, x-ray tomographs of living subjects
1923	J. G. Capstaff, Cine-Kodak reversal process motion picture film

1925	Dye imbibition
1928	Kodacolor lenticular colour motion picture film
1929	K. Jacobsohn, hypersensitization with ammonia and ammoniacal silver chloride
1930	Three-colour carbro print process
1932	Agfa lenticulated film
1933	B. Gaspar, Gasparcolor dye bleach motion picture film
1935	L. Mannes and L. Godowsky, Kodachrome 16-mm movie film, three-colour subtractive reversal film, colour couplers added to developers (1936—35 mm, 1938—sheets)
1935	Gasparcolor opaque dye-bleach printing material
1936	Agfacolor Neu, tripack coupler incorporated
1938	N. F Mott and R. W. Gurney, theory of the latent image
1938	C. Carlson and O. Kornei, dry powder pigment image-transfer copy system
1939	A. Rott and E. Weyde, diffusion-transfer copying systems
1939	Agfacolor negative-positive colour printing process
1940	Ilford multigrade variable contrast paper
1941	Kodacolor dispersed-coupler colour negative film
1942	Ilford, phenidone developing agent
1943	Kodacolour Aero dispersed-coupler colour reversal film
1946	Ektachrome reversal sheet film, user processed
1946	Kodak Dye Transfer print process
1947	D. Gabor, theory of holography
1948	E. H. Land, Polaroid black-and-white peel-apart diffusion-transfer material
1948	Kodak cellulose triacetate safety film, non-nitrate base
1948	W. T. Hanson, Kodak integral mask colour negative film
1950	Eastman colour negative and print motion picture films
1950	DuPont polyethylene terephthalate (PET) film support
1955	Kodak Type C Ektacolor paper
1955	Kodak Type R Ektachrome paper
1963	Polacolor peel-apart colour diffusion transfer
1972	Polaroid SX-70 integral diffusion transfer colour material
1976	Kodak Instant Print film
1978	Polavision Self-Processing diffusion-transfer 8-mm additive (screen) movie film
1979	Ilford Galerie paper
1979	Cibachrome "A" Pearl surface resin coated paper
1979	Olympus OM-2 Camera, which reads subject

1981	illumination on the film and controls exposure at the time it is made
1981	Ilford XP-400 black-and-white film makes use of colour technology and can be processed in proprietary XP1 chemistry or C-41
1981	Kodak Ektachrome 160 movie film introduced in 8-mm and 16-mm formats, requires new EM-26 process
1981	3M high-speed artificial-light tungsten colour film having an ASA rating of 640
1981	Kodak Ektaflex PCT one-solution colour print making system for both colour negatives and transparencies
1981	Improved Cibachrome A-II material utilizing a P-30 chemistry makes home processing easier
1982	Kodak Disc-Film camera, film, and processing system
1982	Sony Mavigraphy, a new electronic photographic system
1983	A revolutionary T-grain emulsion system makes it possible to introduce a new Kodak 1000-speed colour film
1983	Polaroid Autoprocess 35-mm Transparency system consisting of one colour and two black-and-white films, along with a compact low-contrast manual processor, slide mounter, and mounts
1983	Polaroid Polaprinter capable of making instant full-colour prints in about one minute
1982	Technidol developer for use with Kodak Technical Pan 2415 film
1984	Kodak Camcorder (camera-recorder) 8-mm cassette video system
1984	Vivitar Autofocus 200 AF lens, which works by comparing the images formed by light passing through the lens, measuring displacement of different clusters of light
1984	Kodak Elite Fine-Art Paper, a premium black-and-white enlarging paper
1986	Video cameras (camcorders) by RCA, GE, Chinon, and others
1987	Kodak T-Max developer for use with T-Max (T-grain) and other black-and-white films
1989	Kodak Ektapress 1600 colour negative film capable of exposure indexes up to 3200 with normal processing, and 6400 with modified processing
1991	Kodak Photo CD

PHOTOLYSIS The chemical decomposition of a substance by the energetic action of radiation, especially by light. Photons of light, also called *quanta* produce the latent images in silver halide crystals of the emulsion of photographic materials.

PHOTOLYTIC SILVER Photolytic silver is the name given to atoms of metallic silver produced in silver halide crystals by the energy of incident radiation, especially photons of light. A small number of accreted silver atoms, called a *latent image* serve as a centre for the development of the photographic image.

PHOTOPOLYMERIZATION A light-induced process that forms large molecules of high molecular weight from small molecules. The small molecules, called *monomers*, containing double or triple bonds, join together to form chains and cross-linked molecules of very large size and weight.

PHOTOSENSITIVE MATERIALS General term for all types of photographic material—films, papers, plates, etc.—that have been rendered sensitive to light and related radiation by being coated with an emulsion of silver salts or by impregnation with a chemical sensitizer.

PHOTOSENSITIVE MATERIALS HISTORY General term for all types of photographic material— plates, films and papers, etc.—that have been rendered light sensitive either by coating with an emulsion containing light sensitive silver salts, or by impregnation with a chemical sensitizer. The types of sensitized material vary considerably, from normal negative materials for use in a camera to special emulsions for scientific work.

For about the first 40 years of the photographic process photographers had to prepare their own sensitive material just before making the exposure. The division of labour between photographer and sensitive material manufacturer did not become general until about 1880, although dry-collodion plates had been put on the market as early as 1856.

EARLY PROCESSES Workable photographic processes were made public in 1839, almost simultaneously by Louis Jacques Mande Daguerre in France and William Henry Fox Talbot in England. It is correct to honour Fox Talbot as the inventor of photography as the modern processes stem in a direct line from his work. Daguerre's process, although it enjoyed considerable popularity, did not prove capable of further development. Both the calotype, as Talbot called his improved process of 1841, and the daguerreotype are real picture-making media and in skilled hands are capable of good results, though the nature of the processes limits their applications. Professional photography was founded on the daguerreotype, while the calotype was originally preferred by amateurs who were attracted by the lower cost of the materials.

In the daguerreotype process a highly polished silver plate, or silver-faced copper plate, was sensitized by exposing it in the dark to the action of iodine vapour or, in a

later method, to bromine and iodine. After exposure in the camera, which might take several minutes in a good light, it was developed by the action of mercury vapour, which was allowed to condense on the surface of the plate and delineated the image. After fixation in a solution of common salt, or later hypo, the image was toned in gold chloride. Fine detail was well reproduced, and the daguerreotype had an attractive, jewel-like quality. The process, however, was expensive and not well adapted for the production of copies—an essential for a popular process.

In Talbot's calotype process, paper was coated with silver iodide by successive immersions in solutions of potassium iodide and silver nitrate, and exposed in the camera while wet. After exposure it was developed in a physical developer containing gallic acid and silver nitrate, and fixed in hypo. The vitally important step of using a developer was due to a suggestion from the Rev. J. B. Reade. The negative so obtained was printed onto similar paper so that multiple copies could be obtained and in this respect it was a great advance on the daguerreotype. The process was better for showing broad effects than for fine detail, but could be used in portraiture. The series of portraits made by D. O. Hill and R. Adamson of Edinburgh in the 1840s was particularly famous.

WET PLATES The next important step was the introduction of the wet-collodion process by Frederick Scott Archer in 1851. This process consists of coating a sheet of glass with a solution of nitrocellulose containing a soluble iodide, and sensitizing the plate by immersion in a solution of silver nitrate. While wet, the plate is exposed in the camera and is physically developed in pyrogallol or a ferrous salt. As the collodion layer must not be allowed to dry, it is a most inconvenient process to use but the results are excellent. Wet collodion has survived to this day for certain applications in the graphic arts field.

With the introduction of the wet plate a sensitive material suitable for topical photographs had arrived, for although the manipulation is exacting, failures are few and for small pictures the speed is adequate for snapshots in good light. News photography dates from the wet plate, notable early examples being Roger Fenton's photographs of the Crimean War and Mathew Brady's pictures of the American Civil War. It was also the medium for a great expansion in portrait photography; compared with the daguerreotype it was cheap and copies were easily made. Dagron's greatly reduced copies, used in the pigeon post that was operated from Paris during the siege in the Franco-Prussian War, were made by means of the wet plate.

Numerous attempts were made to modify the wet-plate process so that the sensitized plates would keep. The introduction of collodion emulsion by Sayce & Bolton in 1864 was one of the more successful, but the sensitivity was low, and the method was not popular.

DRY PLATES In 1871 Richard Leach Maddox, an English physician, produced the first workable, though slow, plate using gelatin as the medium to hold the silver bromide. The discovery, after improvement by others, proved outstanding, gelatin dry plates having a great advantage over wet collodion. The plates can be prepared weeks or months before exposure; the sensitivity is far higher, the processing is simple, and there is no need to develop the plate immediately after exposure.

It was no longer necessary for the photographer to make his own plates—very soon after Maddox's discovery he could buy them boxed and labelled ready for use. In 1873 gelatin emulsion was being offered for sale by Burgess. In 1867 the Liverpool Dry Plate Company was making plates in England, this being the second factory making sensitive material. By 1878 there were four dry plate manufacturers in England. Johann Sachs of Berlin is reputed to be the earliest manufacturer in Germany, and Carbutt of Philadelphia, 1879, the first maker in the United States. He was soon followed by Eastman, who founded in Rochester the enterprise now known as the Eastman Kodak Company. By the end of the century sensitive material manufacture had been established on a considerable scale in most advanced countries.

COLOUR-SENSITIZED PLATES In 1873 a discovery of the greatest importance was made by H. W. Vogel in Berlin. While testing some plates which had been dyed to reduce halation he found that they were sensitive to green light. He concluded correctly that this property was due to the dye, which was probably corallin, and set to work to examine a number of dyes. As a result he found several which could act as sensitizers, and predicted that it would in time become possible to photograph even by infrared rays, with dye-sensitized plates.

In 1884 the first colour-sensitive plates were offered for sale. In the same year, Eder discovered the sensitizing properties of erythrosin, which was used in the manufacture of orthochromatic plates for many years. In 1906 the first satisfactory red sensitizing dye was discovered by Homolka working at Hoechst, and was sold as pinacyanol. This dye was used in the first panchromatic plates manufactured in England by Wratten & Wainwright, and continued in use for many years.

The discovery of a great number of new types of cyanine dyes from 1926 onwards let to the introduction of the supersensitive type of panchromatic materials that of recent years have displaced colour blind emulsions almost completely for ordinary photography and have made possible the production of fine-grained colour-sensitive emulsions, which are essential for miniature camera work.

Plates were used for radiography in the year of Roentgen's discovery of x-rays. In 1920 the plate was replaced by double-coated film, and x-ray films are now made in great quantity and variety.

Photosensitive materials. Manufacture of sensitized materials. While production details depend on the particular manufacturer as well as on the product, this flow chart gives a simplified idea of the stages by which, for example, sheet film is produced. (1) Essential raw materials: silver and nitric acid. (2) These are used to make silver nitrate. (3) and (4) Further raw materials; gelatin and sodium or potassium bromide and iodide. (5) Mixing of the emulsion under carefully controlled conditions. (6) Cooling to jellify the emulsion. (7) Shredding the jelly. (8) Washing of the shredded jelly to remove unwanted salts (mainly sodium and potassium nitrate) resulting from the formation of silver halide. (9) Melting of the jelly and digestion (ripening) of the molten emulsion to build up speed and contrast. (10) Addition of colour sensitizers, stabilizers, plasticizers, hardeners, spreading agents,etc. (11) Coating on the film base. (12) Chilling to set the emulsion. (13) Drying. (14) Cutting of the continuous roll of film into required sheet film sizes. (15) Final inspection and packaging. Various intermediate stages are not shown, including backing of the film base to provide antihalo protection and counteract curling, and application of supercoat.

In the early years of the twentieth century slow process plates were produced for use in the photomechanical production of pictures. A range of special sensitive materials is currently made for the graphic arts industry, an

important item being the *lith* type emulsion introduced about 1938, which gives negatives of remarkably high contrast when used with a suitable developer containing formaldehyde.

FILMS Fox Talbot used paper as a support for his negative material, but later glass became universal. Warnerke introduced a stripping film for hand cameras in 1875, and in 1889 Eastman started making films on a nitro-cellulose base. The flexible film base was a great advance as it made possible the construction of light daylight-loading cameras and led to the development of cinematography—1895 onwards. Nitrocellulose or celluloid was widely used until about 1930, when the much less flammable cellulose acetate began to displace it. On account of its good mechanical properties, however, nitro-cellulose remained in use for 35-mm cine film as late as 1947, when it was replaced by cellulose triacetate base.

PRINTING PAPERS The development of sensitive material for making prints proceeded on similar lines to negative materials. The plain paper impregnated with silver chloride introduced by Talbot was replaced about 1850 by albumenized paper, which remained in use for over 30 years. It was inconvenient to use as it had to be immersed in a bath of silver nitrate and dried before being printed in daylight. Used with a strong negative, such as is obtained with the wet plate process, it gives good prints when gold toned.

Collodion chloride paper was introduced in 1868 and gelatin chloride printing-out paper was manufactured commercially in 1885. The first bromide paper was introduced by the Liverpool Dry Plate Company as early as 1873 and also by the firms of Morgan & Kidd and Mawson & Swan in 1880. Silver chloride and chlorobromide development papers date from 1883. In the years 1880 to 1914 the platinum process (which depends on the sensitivity of ferric salts, though the image is formed in platinum), and from 1866 on the carbon process (which depends on the sensitivity of chromate) were used to a great extent but are now obsolete. Silver halide development papers, particularly those based on silver chloride or chlorobromide and often dye-sensitized to increase the speed, are now the only important papers in photography.

Sensitized paper coated with diazonium salts, which is produced in great quantities for printing engineers' drawings and similar applications, derives from the discovery of light-sensitive diazo compounds by Green, Cross & Bevan in 1890, although the first practical application was by Koegel in 1923.

In recent years various special papers have been introduced. Among them variable-contrast papers dating from 1940, direct-positive (Herschel effect) papers dating from 1947, papers for the image-transfer process dating from 1950, and papers such as those introduced in 1952 that yield a direct positive by chemical fogging when used with a special developer.

Hybrids between colour and black-and-white negative films were introduced in the 1980s by Agfa and Ilford. These are for monochrome photography, printing on conventional black-and-white paper, but the negatives are to be processed through the same steps used for colour negative films, a convenience to many, since one-hour labs are ubiquitous in many countries. Extended exposure latitude and variable speed/grain ratio are claimed.

Advances continue to be made in speed/grain ratio. Tabular silver halide grains have long been known, but practical application to commercial products proved elusive. In the mid-1980s this was overcome by several manufacturers, resulting in about a two-stop increase over the previous speed-grain ratio, e.g., a new film of ISO 400 speed could be made with the image structure—resolving power, granularity of a previous ISO 100 film. Photographers could choose among several new films, selecting either the same speed they previously had, but with finer grain, or they could select the same grain they previously had, but enjoy higher speed. Compared to cubic grains, tabular grains present more surface area for a given volume, providing more area for the absorption of sensitizing dyes, and thus being more effective targets for photons. T-Max films use this technology. (Eastman Kodak Company, mid-1980s).

The gap in quality between substantive and nonsubstantive colour slide films was considerably narrowed in the late 1980s with the introduction of new films by Fuji for the E-6 process. The use of development-inhibitor-release (DIR) couplers by several manufacturers allowed colour enhancement without upsetting the film's neutral balance. DIR couplers in the emulsion release chemicals during development that migrate vertically to other colour-forming layers to inhibit dye production in those layers.

The former rich variety of photographic printing papers—both enlarging and contact—with their various stock tints, image tones, surface textures, and surface finishes, has shrunk considerably. With the continuing trend to the smaller film formats, the term photographic paper has become virtually synonymous with enlarging paper.

Various new formats for snapshot photography were aimed at extending the times and places where an unsophisticated camera user can get satisfactory snapshots, and at simplifying the film loading procedure. Two popular systems using drop-in cassettes were introduced by Kodak in the 1960s (26-mm square, size 126) and 1970s (13 × 17-mm, size 110) using film with backing paper in plastic cartridges. Another system introduced by Kodak in the 1980s using a disc of film and taking negatives only 8 × 10-mm produced pictures too grainy for many customers. The coming of the drop-in loading, fully automatic 35-mm cameras from many Japanese

manufacturers quickly retired most of the 25 million disc cameras that had been sold.

Snapshot cameras are no longer the simple devices limited to sunlight conditions; they are quite sophisticated in their automatic mechanisms for focus, aperture/shutter control, and flash illumination. Aiding this is the DX coding system for 35-mm film magazines. It is used by most manufacturers and consists of a pattern of electrically conducting and insulating patches on the metal wall of the magazine itself. Contact points in the camera body read these patches to learn film speed, type, and exposure latitude. These are automatically fed to the control circuits of the camera.

Snapshot photography has gone dramatically from colour slides to colour prints made from colour negatives. Small, one-hour processing labs for colour negative films and prints are numerous in many parts of the world. The distinction between film and camera is somewhat blurred by the increasingly popular film-with-camera, or throw-away camera. This is a simple fixed-focus snapshot camera loaded with one roll of film. It must be damaged to some extent to remove the film for processing and cannot be reloaded by the purchaser. Regular, wide-view, and water-immersible models are made, some with electronic flash. Devoted amateurs still use colour slides, but they now tend to be colour negative users also. Colour negative film in 35-mm format now offers image quality formerly found only in larger formats.

Amateur home movies have almost totally been displaced by home video. It remains to be seen if electronics will have a similar effect on still snapshot photography.

Along with the increasing awareness of the effect of industrial chemicals on the environment and on human health during the 1980s came increased attention to the effluents of photographic processing and manufacturing. Restrictions on organic solvents, heavy metals (especially silver, cadmium, and chromium), oxidants, aldehydes, and other chemicals were imposed by government bodies in many countries. Chemical safety in the workplace has taken on new importance. With these in mind, one shudders to think of photography's early days in the 1800s with their fumes of mercury and bromine, their potassium cyanide, gun-cotton, and explosive solvents.

Books: Boni, A., *Photographic Literature* (2 volumes). Dobbs Ferry, New York: Morgan and Morgan, 1962, 1972; Bunnell, P. and Sobieszek, R., *The Literature of Photography*. New York: Amo Press, 1973; Eder, J.M., *History of Photography*. New York: Columbia University Press, 1945 (reprint edition, Dover Publications, NY, 1978); Gernsheim, H. and A., *The History of Photography: From the Camera Obscura to the Beginning of the Modern Era*. New York: McGraw-Hill, 1969; Jenkins, R., *Images and Enterprise: Technology and the American Photographic Industry, 1839-1925*. Baltimore, Maryland:

John Hopkins, 1975; Mees, C.E.K., *From Dry Plates to Ektachrome Film.* New York: Ziff Davis, 1961; Newhall, B., *The History of Photography from 1839 to the Present.* New York, Museum of Modern Art, 1982; *Pioneers of Photography: Their Achievements in Science and Technology.* Springfield, Virginia: Society of Imaging Science and Technology, 1987; Roosen, L. and Salu, L., *History of Photography: A Bibliography of Books.* London: Mansell, 1989; Rosenblum, N., *A World History of Photography.* New York: Abrams, 1989,

See also: *Cameras; Development; History of photography.*

PHOTOSENSITIVE MATERIALS MANUFACTURE

Early photographers made their own photosensitive materials not just because there was as yet no industry to supply them, but because the nature of those early processes demanded that the sensitive materials be made within minutes of use. When first the manufacture and use could be separated by a reasonable length of time, an industry for supply developed, with sensitized plates becoming commercially available in 1874.

Today's photosensitive materials consist of suspensions of microcrystals of silver halides coated on film, paper, or glass. The long-established term for these suspensions is *emulsions* although in the current vocabulary of physical chemistry this is not correct. *Emulsion* is ingrained by more than a century of usage and will persist. (Incorporated-coupler materials actually depend in part on true emulsions, but to avoid confusion, these are called dispersions.)

SAFELIGHTING Light sensitivity begins the moment silver nitrate solution reacts with an alkali halide solution, requiring special measures to ensure that the newly formed emulsion is not fogged in manufacture. Any illumination used in the manufacturing areas must be weak and of such a colour as not to affect the emulsion, while providing maximum visual brightness. This is the science of safelighting. In general, the same principles apply to manufacturing areas and processing darkrooms.

While emulsions have some degree of light sensitivity beginning with their initial reaction, it is relatively slight and limited to the blue and ultraviolet spectral regions. Bright red or even yellow light could be used in some cases. (All emulsions are less sensitive when they are wet.) In later steps of emulsion making, after sensitivity has been heightened and extended to the full visible spectrum, much less light can be tolerated. At this point advantage is taken of the shift of human vision under very dim lighting conditions to the scotopic mode, with its peak of sensitivity near 520 nm. Dense green filters passing a narrow band centred on this wavelength are used in safelights for the most sensitive panchromatic materials. Orthochromatic materials, being insensitive to red light, may be handled under dim red light.

In manufacturing rooms light is allowed to fall on the sensitive material only where it is absolutely necessary to control the operations. Lights at foot level are frequently used to guide workers through the rooms; if the sensitive material is carefully shielded, the lights can be relatively bright.

Another approach to safelighting is to use special electro-optical viewing devices (somewhat like a bulky pair of binoculars) and lamps that emit infrared radiation only. These devices are related to the military "snooperscopes," used at one time as night vision devices.

EMULSION MAKING A sequence of chemical and physical processes is involved in making an emulsion ready for coating on a support. Intensive research over the years has changed what was once an art into a science.

Precipitation Ingredients of high chemical purity are essential for the preparation of photographic emulsions, since trace amounts of certain impurities have large sensitometric effects. The silver nitrate and the alkali halides (salts of potassium, sodium, lithium, and ammonium) used are among the purest chemicals commercially available. Inert reaction vessels are needed, special stainless steel is now used, but old emulsion makers nostalgically remember solid silver kettles.

The other most important raw material, gelatin, is in many respects considerably purer than that used as food. Gelatin is an animal protein derived from the bones, hides, and connective tissue of such animals as cows, water buffaloes, and pigs. These are extracted by acids or alkalis for periods up to 18 months. Different processes produce gelatins with differing properties. The solution resulting after prolonged cooking is concentrated by vacuum evaporation and chilled to *set*. This, when evaporated still further, is reduced to flakes or powder containing about 15% water. The type of gelatin that may be ideal for the emulsion precipitation reaction may not be best for coating or for some other part of the manufacturing process. Gelatins in emulsions may be exchanged by *isoing*, that is, by adjusting the pH of the emulsion to its isoelectric point, the pH at which the gelatin can no longer protect the crystals from settling out. After filtration, they may then be resuspended in a solution of another gelatin.

The various silver halides have differing sensitivities, and they are selected individually or in combinations for the type of material being manufactured. Silver bromide with a few percent of iodide serves for the faster films and plates, silver chloride for slow contact papers, and silver chlorobromide or straight bromide for enlarging papers. These are formed in the presence of about one percent gelatin in water by the reaction of, typically, silver nitrate and potassium bromide to yield insoluble silver bromide and soluble potassium nitrate. It is the presence of the gelatin, a protective colloid, the prevents the insoluble

silver bromide crystals from settling out or clumping together, keeping them in suspension.

Ripening The emulsion crystals, or grains, are then grown in size to increase their sensitivity. The process is known as ripening or cooking, and consists of prolonged heating in the presence of a mild solvent for silver halide. The substance of the smaller grains is in effect dissolved and redeposited on the larger grains. When this is optimum, the temperature is reduced and more gelatin is added to about seven percent.

Chilling, Shredding, and Washing The ripened emulsion is chilled, whereupon it *sets up*, into a condition familiar to anyone who has ever made gelatin dessert. This is then forced through a perforated plate to produce *noodles*, or otherwise subdivided to expose a great amount of surface area. The noodles are then washed in cold water to dissolve out the potassium nitrate, from the precipitation reaction, and other unwanted substances. Gelatin swells but does not dissolve in cold water, becoming permeable to soluble substances. This same phenomenon is used to advantage during processing.

Digestion The washed noodles are then melted and the emulsion heated again, in a treatment known as digestion or afterripening. No appreciable grain growth takes place now, because no silver halide solvent is present, but sensitivity increases because of the addition of sensitizers, particularly gold and sulphur compounds. Extending the digestion process for high sensitivity also tends to increase fog, so compromises must be made for an optimum balance between building speed and keeping fog to a reasonable level.

The emulsion is *finished* by the addition of various chemicals; spectral sensitizing dyes to extend the native UV-blue sensitivity to the green, red, or infrared regions as desired; stabilizers to impart good keeping properties; hardeners to improve abrasion resistance; plasticizers to keep the coated emulsion supple; spreading agents for uniformity of coating; antistatic agents to prevent sparking as film is unwound; biostatic agents to prevent growth of fungus and mould, etc. The emulsion is now ready for test coating. If all is satisfactory, the production coating is scheduled; if not, further changes are made.

Colour Emulsions The foregoing sequences traces the making of a black-and-white emulsion, but with one major addition it stands for a colour emulsion also. That addition, used in both negative and positive substantive colour emulsions, is a dispersion of a colour-forming coupler. In the case of positive transparency emulsions, the coupler itself is colourless, but capable of reacting with oxidized colour developer to form a coloured dye. Each coupler chemical itself is specific to a particular emulsion layer. The coupler that will produce a dye to modulate the amount of red light must be placed in and remain in the red-sensitive layer and the same with the green- and blue-

modulating couplers. These chemicals by themselves are prone to diffusing to other layers, muddying the colours in the developed picture. Ways are needed to anchor them in their assigned layers. Chemical ballast groups attached to the couplers provide one way. Entrapment of minute amounts of an aqueous solution containing the coupler in microscopic oil droplets is a common way. (Such dispersions are true emulsions, as the term is used by physical chemists.) The dispersions are mixed with the sensitive emulsions before coating. A water-miscible organic solvent in colour developers opens the oil droplets when the couplers are needed for colour forming. The colour couplers of most camera negative colour materials are themselves coloured. Although these impede visual assessment of colour negatives, they provide a valuable masking effect that increases the colour quality of the final print.

Since all silver halide emulsions have a native sensitivity to blue light, the green- and red-sensitive emulsions of colour films must not be allowed to see blue light. This is often done by coating them below a yellow filter layer, which absorbs blue. The yellow layer must be decolourized during processing for the image to be seen in its true colours. This is often achieved by making the filter of minute particles of silver which are of a size to absorb blue light exclusively, after the formula of the English chemist Carey-Lea. Such layers, called Carey-Lea silver or CLS layers, are automatically decolourized in the bleach step of colour processing, and removed in the fix and wash baths.

EMULSION COATING Most bases must be prepared to receive the photographic emulsion by the application of a *subbing* (short for *substratum*) layer to provide good adhesion.

Films and papers are coated by moving a wide, continuous web of film or paper base past a coating head where the warm, melted emulsion flows in a thin layer of precise thickness. Modern coating heads are capable of laying down several layers of different emulsions at one time, expediting the production of colour films, which may have 15 or more different layers. The moving web next passes over a chilled roller or under a current of cold air, which causes it to set. If more layers are required, a second coating head is next. Over the topmost sensitive layer an overcoat (topcoat, supercoat) of clear, hardened gelatin serves as a protection against abrasion, or it may contain a pale dye to make a subtle adjustment to the colour balance of a film. The film or paper next passes into a chamber flowing with dry air, which removes most residual water from the emulsion. The film or paper is rolled up, ready for finishing into various shapes and sizes. The dried thickness of an emulsion is about 10% of the wet thickness as coated.

Glass plates are coated by running the melted emulsion through a slit onto a slowly moving procession of plates

butted one against the next, riding on a continuous web of carpet. Chill-setting is done in line, but then the plates are removed individually and stacked in racks for drying in a room filled with clean, warm air.

SUPPORTS FOR PHOTOSENSITIVE MATERIALS

Film Base Flexibility and transparency are the chief characteristics of a film base, but other properties—static electricity production, halation protection, resistance to light piping, performance at high and low temperatures, tensile strength, absorption of water and chemicals, dimensional stability, resistance to changes upon aging—are also important.

The two important film bases in current use are cellulose triacetate, usually called acetate, and polyethylene terephthalate, also called polyester. There are no trade-names in popular use for acetate, but Estar (Kodak) and Cronar (DuPont) are in use for their polyester films. (In the 1930s cellulose diacetate base was briefly used, but it proved to be chemically and dimensionally unstable.)

Cellulose triacetate is made in huge quantities for film, rayon, and other plastics by the esterification of cellulose derived from wood or cotton. For film making it is dissolved in a mixture or organic solvents—alcohols, esters, ketones, chlorohydrocarbons. Plasticizers are added, and the viscous "dope" is extruded through a slit onto the surface of a very large, polished, chromium-plated wheel. The slow-turning wheel is heated to drive off the solvents, leaving the cast film ready to be stripped from the wheel in a continuous operation. Different thicknesses are made: about 0.0035 in. for roll film with backing paper and for pack film, 0.0055 in. for motion picture film and 35-mm film in magazines, and 0.009 in. for sheet films. Acetate base absorbs some water during film processing. The tendency to curl with changes in temperature and humidity is controlled to some extent with a balancing coat of gelatin on the side opposite the emulsion. Acetate is optically isotropic, thus films on acetate support can be used in projection systems using plane polarized light. Acetate films out-gas considerably in vacuum, loosing water and residual solvents. Scrap acetate is more easily recycled than polyester.

Polyethylene terephthalate is synthesized from petroleum stocks. For film manufacture it is extruded from the melt and stretched laterally and longitudinally while being cooled. The thicknesses most often found are 0.004 inch for roll films and 0.007 inch for sheet films. Where great lengths of film must be contained in little space, thicknesses (or thinnesses) of only 0.0025 and 0.0015 inch are used. No solvents are used in the manufacture of polyester film, which recommends it for instruments requiring high vacuum, such as transmission electron microscopes. It is optically anisotropic, which may interfere in illumination systems using polarized light. It absorbs virtually no water during processing, which hastens drying.

A strand or ribbon of polyester plastic conducts light as does a fibre-optic light guide. When this is used for photosensitive film base, there is danger of fogging a considerable length of film if the end is exposed to light. This danger may be eliminated by incorporating a small amount of a light-absorbing material in the plastic itself. This amount is scarcely visible when the film is viewed perpendicular to its surface, but the attenuation quickly becomes enormous when measured along the length of a roll of film. For example, a film 0.004 inch thick having a perpendicular optical density of 0.1 will have a longitudinal density of 25 after 1 inch, indistinguishable from total opacity. Such film is often labelled AH, for antihalation.

Paper Base Impatience with the protracted processing (especially washing) time of classic fibre-base photographic paper led to the development of its rival, resin-coated (RC) paper.

Photographic fibre-base paper is usually manufactured in mills devoted to that purpose. Softwood pulps high in alpha-cellulose are desirable. Freedom from chemical contamination is of highest priority. Iron and copper are particularly injurious to emulsions. In addition to high whiteness, photographic paper stock should have high wet strength. Few papers now are direct sensitized, that is, have their emulsion coated directly on the sized paper itself. Most fibre papers have a baryta (or clay) coating under the emulsion for brilliance and texture. This is somewhat of a misnomer, since the mineralogist thinks of barium oxide as baryta. In photographic parlance, though, the baryta layer is a suspension of barium sulphate crystals in a little gelatin, providing a highly reflective surface to support the emulsion. A small amount of bluish dye overcomes any slight yellowness. Fluorescent brighteners are often added for extra apparent reflectance. The baryta layer can be made extremely smooth or a texture can be added by passing the baryta paper through textured rollers. Conventional fibre-base papers—baryta coated or not—have a vast amount of surface area in their mat of tangled fibres. This provides an unwanted sump for the absorption of water and chemicals. Most of the hour spent in washing double-weight papers is not to free the emulsion, but to free the base of chemicals.

Resin-coated papers are a good alternative to fibre where mechanized processing and rapid access to a fully processed and dried image is wanted. Some processing machines do this whole cycle from dry to dry in one minute. RC base is made by extruding thin membranes of polyethylene onto both sides of a conventional fibre paper. The resin on one or both sides may be somewhat opacified and whitened by incorporation of a white pigment such as titanium dioxide. The oleophilic nature of ordinary polyethylene resin is repellent to an aqueous emulsion. For better bonding, the terminal methyl groups on the surface are oxidized to the more hydrophilic aldehyde and carboxylic acid groups.

Plate Supports Plates provide the ultimate in flatness and dimensional stability. Ordinary soda-lime glass is by far the most common support for plates. Glass is selected for freedom from seeds and blisters. The degree of flatness and surface parallelism may be specified by the customer for exacting applications. Thicknesses from 0.030 to 0.250 inch are usual, with thickness being somewhat proportional to the overall plate size. Large plates, though, are sometimes coated on very thin glass when they must be bent, as in some spectrographs and astronomical instruments. Where an even-lower coefficient of thermal expansion than glass is required, or where UV transmission is needed, fused quartz plates are used. Emulsions coated on plastic plates, sheets of methyl methacrylate resin (Lucite, Perspex), can be cut and machined with ordinary tools. Because of the relative ease and economy with which small batches can be produced, plates are the format of choice for exotic emulsions and special imaging applications.

FINISHING AND PACKAGING The long rolls of coated film and paper must be finished into sizes to fit exposing equipment and packed into convenient quantities. Slitting and chopping machines reduce the master rolls to usable sizes. Other devices measure length, count sheets, perforate, code notch, edge mark, spool, wrap, seal, box, and label. The high speed and panchromatic sensitivity of so many films makes the doing and inspection of these tasks increasingly difficult. The lower sensitivity of most papers eases this somewhat. Open or coded information on labels or as latent image edge marking identify emulsion batch, mast roll, slit, and date and shift of manufacture to aid in the tracing of complaints of defective performance.

Most photosensitive materials are packaged in equilibrium with 50% relative humidity, and sealed in packaging materials that provide a vapour barrier. The packaging material, like everything else the sensitive material comes in contact with, must be photographically inert. The effective equivalent of the former *tropical packaging* is now provided by the use of sealed plastic packaging for almost all goods, no matter what the sales destination. Many manufacturers have discontinued expiration dates on papers, but retain them for most films and plates.

PHYSICAL DEVELOPMENT
The process of developing a visible image by silver intensification of either a faint image formed by chemical development or a latent image consisting of silver specks—which can remain following fixation of an exposed emulsion in a nonacid fixing bath. The silver that forms the image is supplied by the developer, not by the silver halide grains in the emulsion as in normal (chemical) development. Advantages of physical development are fine grain and high resolution but at the expense of a considerable loss of film speed.

Physical developers that selectively deposit conducting or magnetic metals such as copper, iron, nickel, and cobalt on latent images formed on photosensitive resist coatings can be employed as an alternative to selective etching techniques in the production of printed circuits. The physically developed images are built up to the required thickness by electroplating.

PHYSICAL REDUCTION Reduction in density of a silver image by rubbing a fine abrasive over the surface with a tuft of cotton, or by scraping the surface with a sharp knife, taking care to blend with the surrounding detail.

PIGMENTS (1) Insoluble colourants. (2) Colourants in the tissues or cells of animals and plants.

PINACRYPTOL A dye powder that can be put into solution and used to desensitize panchromatic film before processing so that it can be developed by inspection. Pinacryptol green and pinacryptol yellow dye powders are soluble in alcohol and slightly soluble in water.

PIPE PROCESSING A procedure for processing 35-mm film in which the container is a long narrow cylinder having an inside diameter slightly less than the film width, such as a suitable length of plastic pipe or a golf-club tube, with a rubber stopper for each end. After inserting the film, developer is added to within about 2 inches of the top. Agitation consists of tilting the stoppered tube so that the bubble of air moves from end to end in alternating directions, with the developer flowing in the opposite direction to produce uniform agitation.

PITMARKS Pitmarks are characterized as small deformities in the emulsion or base surface of photographic materials, often the result of a processing failure that is chemical or physical in nature. While related to small blisters, pitmarks have a more amorphous appearance. They may also be the result of some mechanical action on the material, and may be repetitive in nature, such as when film passes over a sprocket or roller having a burr.

PLASTICIZER A substance added to a film base or other plastic material to increase its flexibility and its resistance to cracking when bent.

PLASTICS Plastics are very long chain molecules made up of smaller molecules joined end to end. If there is no cross linkage between the molecules, the resin is said to be *thermoplastic*, that is, it will soften and flow when heated, then harden when cooled to a solid with essentially the same physical properties. If there is cross linkage between the long chain molecules, the resin is said to be

thermosetting, giving a hard solid that may not soften with heat. Thermosetting plastics are preferred over thermoplastics where greater strength, higher heat resistance, and greater inertness are required.

Thermoplastic materials contain organic substances, called *plasticizers*, that modify physical characteristics, such as flexibility, hardness, strength, and water absorption. Plasticizers are often lost with time and may leach out to influence the results of photographic processing. Antioxidants, called *stabilizers*, are added as preservatives to maintain the plastic.

Glass resembles a plastic material but actually represents a vitreous condition that lies between the solid and liquid states. Glasses are composed of silica and boron trioxides combined with the oxides of metals. When heated, glass has some of the properties of a liquid, but when cooled quickly, the melt does not crystallize and the increasing viscosity traps a random arrangement of the molecules. Transparency and hardness are properties that have made glass a longtime choice for the lenses of photographic as well as other optical equipment. Plastic lenses, which can be moulded and are less expensive to make, are replacing glass lenses in a steadily increasing number of uses.

Glass also gained acceptance in the early days of photography as the support for the wet plate collodion emulsions. Collodion is cellulose, a long, chain of glucose units that has been treated with nitric and sulphuric acids to give cellulose nitrate or pyroxylin (gun cotton). Just over two of the three hydroxyl groups per glucose unit of cellulose have been nitrated. Dissolved in organic solvents (ether and alcohol, 3:1) the solubilized pyroxylin, now called collodion, served as the liquid carrier of the light-sensitive silver salts to coat the glass plate. The image had to be developed as soon as possible after coating and exposure as the solvents evaporated quickly, leaving a thin, tough layer that water could not penetrate. Rigid nitrocellulose products were made of this plastic for the home and elsewhere, often sold under the Celluloid trademark.

Adding plasticizers, such as camphor, to the nitrocellulose made possible thin films of suitable flexibility as a plastic support for photographic emulsions. In 1889 Kodak introduced nitrocellulose as the transparent base for its first roll films. This film base had good dimensional stability and was water resistant, but the base had a tendency to decompose spontaneously and burn ferociously.

Cellulose was treated with acetic anhydride, glacial acetic acid, and sulphuric acid, then hydrolyzed so that each glucose unit had about 2½ acetyl groups (38 to 40%). The cellulose diacetate, dissolved in acetone and with a plasticizer present, formed transparent, flexible films when coated on a heated surface to drive off the solvent. This plastic base made possible the slow-burning safety film needed to introduce amateur home motion pictures in 1923.

The diacetate film base was inferior to the nitrocellulose film in toughness and dimensional stability. Cellulose triacetate, with acetyl content slightly reduced for manufacturing purposes, had improved physical properties over the diacetate. Cellulose triacetate has found general use as a plastic film base from after the Second World War until the present time.

Acetyl esters of cellulose absorb moisture, swell, then do not return to the original dimension. Other materials were studied. Polyvinyl chloride-polyvinyl acetate (90% 10%) were tried but still had deficiencies. A film base, polyethylene terephthalate, was made by polymerizing ethylene glycol and dimethylterephthalate and then biaxially orienting the molecules by stretching the film in both directions under high temperature conditions. Polyethylene terephthalate film base has excellent dimensional stability and toughness, making it a premier film support since 1955 (Du Pont Cronar and Kodak Estar are examples).

Film base is probably the most important use of plastics in photography. The use of plastic for other purposes, from camera bodies to stirring rods, is increasing. Acrylics, polyesters, polyethylenes and polypropylenes, polystyrenes, and vinyls are a few of the types that have been studied. Plastic materials should be carefully tested, especially for processing equipment, as chemical resistance and chemical absorption vary greatly with plastic composition.

PLATE (1) Among photosensitive materials, a relatively thick, rigid, transparent support for a photosensitive coating. Glass is the most common material, ranging in thickness from 0.030 to 0.250 inch. Glass plates are chosen where extreme flatness or dimensional stability are needed. Some very specialized photographic emulsions are available only on plates. Methyl methacrylate sheets are sometimes used, and, rarely, fused quartz. (2) In camera technology, a flat member for locating the film in the image plane; also pressure-plate.

PLUMMING Plumming refers to the change of colour and density produced when some photographic papers are dried by means of high temperatures that cause a deterioration of the image whereby the maximum density is lowered and the high densities take on a purplish, plum, or bronze colour. The effect is sometimes referred to as *bronzing*. The filamentary silver particles are transformed into more rounded particles having lower covering power. Appropriate chemicals are added to paper emulsions to minimize this defect, and further control may be achieved with a stabilizing bath before drying.

POISONS Poisonous substances have always been a peril to the health and even the life of human beings. Photographic processing, like daily living, involves

hazards. Some photographic chemicals are poisonous to all; other chemicals may be injurious only to susceptible persons. Safe handling of acids, bases, and heavy metal salts involves only careful laboratory practices, but special care is needed for substances that are poisonous gases or are liquids or solids that emit gases, fumes, or vapours.

Identification and knowledge of specific poisons is necessary. The following substances are of a dangerous nature.

MERCURY The element mercury occurs in nature as a pure metal and as natural compounds, such as cinnabar. The liquid metal, called *quicksilver*, describes how it looks and acts, especially if spilled on a hard surface. Even at room temperature, the liquid metal gives off vapour into the atmosphere. Mercury poisoning is insidious; the effect of minute amounts may take months to show up, usually as damage to the human brain and kidneys. Continued exposure causes insanity, unconsciousness, paralysis, and death. "Mad as a hatter" is an old saying that refers to hat makers who had been poisoned by the mercury in felt used to make hats.

Mercuric chloride and mercuric bromide (corrosive sublimate) have been widely used in intensificating solutions for the silver image, as the insoluble mercurous salt reinforces the image. Mercury vapour has been used to increase the sensitivity of film materials (hypersensitization). Mercury occurs in batteries, thermometers, dyes and inks, fluorescent lights, plastics, and many other materials encountered in photography.

Avoid the chemical use of mercury metal or its compounds. If mercury metal is spilled, vacuum it up immediately and dispose of at once, calling a poison control centre for details. Do not discard in landfills. Mercury poisoning should be treated by a physician. If mercury is ingested, giving egg whites may help. The compound BAL (2,3-dimercapto-1-propanol) is the antidote for mercury poisoning.

CYANIDE Cyanide is a white granular powder or pieces having a faint odour of almonds that dissolves in water to produce a very alkaline solution (around pH 11). On exposure to humid air, cyanide solid reacts with carbon dioxide, liberating a gas. Both the solid and the solution may give off hydrogen cyanide, a colourless gas that is intensely poisonous. Exposure to hydrogen cyanide at 150 parts per million in air for 1/2 to 1 hour has been reported to endanger human life. The average fatal dose of the solid is said to be 50-60 mg.

A solution of potassium cyanide is an excellent solvent for silver salts of low solubility, such as for the removal of silver sulphide stains. Cyanide was the preferred fixing agent for the silver iodide of the early wet plate process. It is used as an ingredient (as sodium cyanide) in the blackening solution for silver image mercury intensifiers (as in Kodak mercury intensifier In-1).

Do not use cyanides if possible. Do not add acids or acidic solutions, metallic salts, or oxidizing compounds to solid cyanide or its solutions, even during disposal, as the poisonous hydrogen cyanide gas may be liberated. Sodium nitrite or sodium thiosulphate have been used as antidotes.

POISONOUS GASES Special attention should be given to substances that may exist in gaseous form. Solids and liquids containing such gases are often unstable, easily releasing the gases, fumes, or vapours. Some of these potential poisons are discussed in the following sections.

Ammonia, Ammonium Hydroxide, and Ammonium Salts Ammonia is a colourless and pungent gas that can irritate and burn. Do not mix ammonia with chlorine bleach. If taken internally, give lemon juice or diluted vinegar.

Formaldehyde and Formalin (37% in water) A colourless, irritating gas that attacks the eyes, skin, and respiratory system and can cause coma and death. If swallowed, induce vomiting with a glass of water containing 1 tablespoon of ipecac syrup.

Acid Gases Hydrogen bromide, hydrogen iodide and iodine, hydrogen chloride, hydrogen sulphide, and nitric acid are either poisonous gases or water solutions that give off irritating and corrosive fumes that are dangerous to the skin or eyes or if inhaled or swallowed. Hydrofluoric acid is especially insidious as it does not burn when contacting the skin, only becoming painful after some hours. Glacial acetic acid, a liquid with a pungent odour, can cause severe burns.

ORGANIC SOLVENTS Acetone, amyl acetate, benzene and xylene, carbon tetrachloride, ether, methyl, and ethyl alcohol, various amines, and other solvents are often volatile, flammable, and poisonous. Avoid their use if possible, but they may be needed for their unique solubilizing properties for photographic chemicals. Carbon tetrachloride and other chlorinated solvents may be carcinogenic. Methyl alcohol is flammable and a poison; ethyl alcohol causes human impairment and inebriation. Benzene and xylene are flammable liquids that have acute and chronic poisoning effects. The volatile organic amines are often flammable.

HANDLING POISONS Avoiding the use of poisonous substances is to be preferred. If such substances must be handled, protection against contact with the skin or eyes, breathing gases or vapours, or ingestion is necessary. Be certain to read the referenced entries listed below, especially the one dealing with chemical safety.

POLACOLOR Proprietary diffusion transfer system of photography. A positive dye image is obtained about a minute after the material is exposed in a Polaroid camera or a dedicated camera back.

POLYESTER A plastic film base material, usually polyethylene terephthalate, of high dimensional stability

and stiffness, which has replaced acetate film base and even glass plates in some graphic arts and photogrammetric applications.

POLYMER A *polymer* is a gigantic molecule formed by the bonding together of many small molecules called *monomers*, either of the same or different kinds. Polymers are either naturally occurring, such as cellulose, starch, and proteins, or produced synthetically, such as many kinds of plastics. Radiative energy promotes the formation of these macromolecules, so photographic processes can be based on the polymerization of monomeric substances.

POP/PRINTING-OUT PAPER Photosensitive paper intended for prolonged exposure to intense light. The image is produced entirely by photolysis; no development is used, although some wet processing may be involved to render the image stable.

POSITIVE (IMAGE) An image in which the tonal relationships are such that light subject tones are light and dark subject tones are dark. Positive photographic images are commonly produced by printing camera negatives onto negative-acting (nonreversal, positive) printing materials. Positive images can be obtained without the printing process by using reversal-type film in the camera.

POST-FIXATION DEVELOPMENT See *Physical development*.

POSTPROCESSING Postprocessing refers to manipulation of the negative or print after the normal steps of the process have been completed. In the case of ordinary monochrome photography, these normal steps refer to developing, fixing, washing and, sometimes, drying. The unmanipulated image has often been referred to as *straight*, while the treated one is called *manipulated*, *modified*, or *retouched*. Such steps as mounting, framing, packaging, display, and so forth are not generally referred to as postprocessing.

 TYPES OF MODIFICATION The postprocessing treatments may modify or enhance the image or preserve the image without modification. They may, for example, change the physical characteristics of the article, thus making it more attractive to display, or to perform better in display equipment, projectors, and printers. The treatment may be such as to make the image more stable to the ravages of environment or time.

 On the other hand, these treatments may be applied to the negative or print to modify the tonal nature of the image itself. Modifications of the negative will be translated to subsequent prints, while those made in the print affect that image alone (unless the print is copied to make a new negative for subsequent prints).

Physical characteristics may be changed by chemical or physical treatment. Image characteristics may be changed by optical, as well as by chemical and other physical methods.

MODIFICATION OF PHYSICAL CHARACTERISTICS The value of a photograph is affected by its physical characteristics such as curl, brittleness, friction, hardness, and abrasion sensitivity; therefore, postprocessing techniques are used to enhance performance in these areas. Many of these techniques involve the final rinse after the wash that follows processing, and thus this bath may include a variety of components to serve a variety of purposes.

Curl One important physical characteristic of photographs is absence of curl. Curl can vary on a single sheet due to uneven drying resulting in *buckle*. Excessive curl can be annoying in single sheets but becomes a catastrophe when dealing with a stack of prints. This is less of a problem with modern materials made with thin emulsion coatings and resin-coated bases, but the problem still exists with fibre-based papers. One solution is to stack prints that have been faced, and place them under pressure such as that in a letter press, for from several hours to days. Treatment with humectants (hygroscopic materials like glycerin that attract and retain moisture) in the final rinse after washing may also be of some help.

See also: *Curl reduction.*

Brittleness Another problem is a tendency for cracking of the emulsion, referred to as brittleness, which in extreme cases can cause shattering of the film base as well. Again, this is less of a problem with modern thin emulsion coatings. A final rinse with a humectant solution, for example glycerin, may help. Also, control of drying conditions, such as lowering temperatures after the cooling effect of evaporation has ceased, can minimize the problem.

Film Friction The coefficient of friction of the film surface(s) affects mechanical performance in equipment such as high-speed cameras, VCRs, and motion-picture projectors. A high coefficient of friction can affect the steadiness of the projected image, can influence the occurrence of scratches and abrasions, and can be mistaken for brittleness when the film is damaged in cameras or projectors because of excessive resistance to transport. Waxes and lubricants can be used to control film coefficient of friction.

Hardening Another contributor to minimizing abrasions is hardness of the surfaces. Fixing baths that incorporate hardening agents are usually sufficient in most instances. In some circumstances, however, where the film or paper is subjected to repeated handling or passage through printers, projectors, or other machines, additional hardening treatments may be required.

Dimensions Dimension is a physical characteristic that may affect registration of images during printing, perfor-

mance in projectors or other equipment, and the fit in storage devices. Control of temperature and relative humidity may be essential to maintenance of the desired dimensional stability of films. Since excessive stress can permanently deform sprocket holes used to transport film, control of film friction may be important.

Water Spots When droplets of water cling to the surface of film after washing, they may cause water-spot blemishes due to the stress of uneven drying and shrinkage of the gelatin resulting from the extended drying time in the area of the droplet. These droplets can be eliminated by using a final rinse containing a wetting-agent surfactant that reduces the surface tension of the water so that it is spread evenly over the surface.

Static When relative humidity is low, an electrostatic charge can be induced in films, thus making them susceptible to attracting dust, hair, and other particles from the atmosphere. This can occur even as the films are drying in a current of air, particularly those made with bases having low conductivity or a high dielectric constant. A final rinse after washing, in a bath containing a conductive agent that is adsorbed on the surfaces or absorbed in the surface layers helps to alleviate this problem. An antistatic agent may (1) lower the coefficient of friction, (2) increase surface conductivity, or (3) increase the dielectric constant of the system, or a combination of all three.

Ferrotyping The process of squeegeeing glossy gelatin-coated papers to a japanned metal or chrome plated surface for drying to achieve a high gloss surface is no longer necessary. Resin-coated papers are now available that give a high gloss with normal air drying. A spotty ferrotyping of a film emulsion surface due to prolonged and intimate contact with the base side of an adjacent convolution in a roll is sometimes a problem. Manufacturers may prevent this by means of a coating containing fine mineral or other particles on the base side. A post-treatment with a lacquer or other coating containing fine particles may solve a problem with existing materials.

Embossing The surface texture of paper prints can be changed by means of embossing rollers engraved with a variety of patterns such as "silk," "linen," "tapestry," and others less representative of familiar materials. During manufacture of the paper rawstock, embossing is sometimes accomplished before it is coated with sensitized emulsion. Photographers sometimes use embossing rollers to impart a pattern of this type on the surface of prints after they have been processed and dried.

PHYSICAL MODIFICATION OF THE IMAGE The negative or print *image* may be modified by physical methods, as distinct from those accomplished by chemical means. Typical procedures include the abrasive reducers, airbrushing, colouring, dyeing, neococcine, retouching, and spotting.

Abrasive Reducers Abrasives retained by a tuft of cotton are used to reduce the printing density of local areas of negatives, thus rendering them darker in the print. The abrasive material must be finely divided and free from any coarse material that would result in scratches or blemishes. This type of reduction is often supplemented by controlled etching of areas by scraping with a sharp knife. This procedure can be used to accentuate shadows, eliminate some kinds of blemishes, and so on.

Airbrushing Prints are airbrushed with colourant or opaque material to cover unwanted detail, alter colours, or to enhance details or contrast. This technique requires considerable artistic capability and manual skill.

Colouring Monochrome prints are coloured by hand with dyes or oils to produce a colour image. Prints coloured in this way are not like those from direct photography since the monochrome image desaturates the colours applied over them. Oil colouring usually requires treatment of the print with a special medium before applying the colours. While not difficult, good oil colouring technique requires some experience.

A heavy oil technique makes use of more opaque colours much like those used for oil painting and may considerably modify the image. They are commonly applied with brushing techniques that are allowed to show. While somewhat transparent, opacity can be increased by adding white pigment, which is sometimes used to enhance highlights or other details.

Black-and-white motion-picture films are sometimes coloured by electronic video methods that allow specific contiguous density areas to be treated individually.

Dyeing The whole image may be dyed to suggest a mood or have some other aesthetic effect. Before the advent of sound motion pictures (where the dyes would attenuate the light actuating the photoelectric cell), fire scenes in black-and-white motion pictures were dyed red, moonlight was represented by blue or cyan, interior fireside scenes by amber or yellow, and so on. Similar colours have been used with prints for reflection viewing and with transparencies.

Neococcine Neococcine dye can be applied to local areas of a negative to absorb light and make these areas appear relatively lighter in the print. Some experience is required to judge the appropriate dye density because of its pink colour, and the beginner is advised to practice with old or spare negatives that can be sacrificed.

Retouching Negatives of portrait or other subjects are retouched with a sharp pencil or pointed brush and liquid dye to modify features or reduce blemishes. While some films are manufactured with a *tooth* on the emulsion or base side, or both, to accept the pencil lead, it is often necessary to apply a special retouching fluid to impart a surface that accepts the retouching. Intermediate tones of gray are obtained by making a pattern of small figures that

blend at a normal viewing distance, somewhat like the dots in a halftone reproduction.

Spotting Prints are spotted by means of local application of dye or pigment to obliterate light spots caused by dust, dirt, hairs, etc. that may have been on the negative when the print exposure was made. Etching (or chemical reduction) techniques are required to remove dark spots on prints as the result of clear spots on negatives. When the offending density is removed by etching, however, the etched area can be seen by reflected light. It is usually better to apply opaque to clear spots in the negative before printing so that normal spotting techniques can be used.

Colour prints are spotted with subtractive colour dyes whose absorption characteristics are close to the dyes making up the image. It is important that the work be done under illumination having a high colour-rendering index. One advantage of dye transfer is that prints can be spotted with the same dyes as those used for printing.

CHEMICAL MODIFICATION OF THE IMAGE

Reduction and Intensification Chemical treatment of negatives includes *reduction* and *intensification* of the image. These may involve changes in contrast or gradient as well as of density. If the negative has been dried, it is necessary to make sure it is thoroughly rewet and that no finger marks or other spots that would interfere with penetration of the chemicals are present. Local application of chemicals can sometimes be used, but this requires skill and if incorrectly done may ruin the negative. Local reduction is best done by abrasive reduction, and the local intensification by application of neococcine. Prints can also be treated by total reduction, or by local reduction of specific areas, usually with no significant change in image tone. On the other hand, intensification of prints may result in stain, unsatisfactory image colour, or variation in image colour between treated and untreated areas.

See also: *Farmer's reducer; intensification; Proportional intensification; Reduction, chemical; Subproportional; Subtractive reducer; Superproportional intensification; Superproportional reduction.*

Toning Toning methods that change the colour of the silver deposit are used to enhance the visual images of prints and transparencies. If it has been dried, the print should be rewet to obtain uniform toning. Any of a wide range of toning formulas can be used. *Direct* toning solutions act on the silver deposit to produce coloured compounds such as brown or sepia, blue, green and red. For *indirect toning*, the image is first reconverted to silver halide in one bath, then redeveloped in a chemical solution that forms a coloured compound. *Dye toning* techniques involve treating the silver image with a bath that forms a mordant at the same time the image is bleached. This is then bathed in a dye solution that is mordanted to the image.

Colour Images Photographic colour images may be modified by means of dye bleaches or the application of dye. Bleaching can be applied to the whole area or to selected areas of the image. Likewise, dye can be applied to the whole area or to selected areas. Dry dyes can be applied to selected areas until the desired effect is achieved, then fixed by exposure to water vapour (steam). Depending on the method used, the bleached dyes may have a tendency to regenerate in a relatively short time. This may not be important if the image is used as an intermediate image from which plates for publication are made.

POTA DEVELOPER A developing solution, formulated by Marilyn Levy, consisting of 1.5 grams of Phenidone and 30 grams of sodium sulphite in a litre of water, that had given silver images of superior grain and sharpness when used to develop very high contrast, fine grain films. POTA is an acronym of Photo Optics Technical Area (U.S. Army Electronics Command).

POTASSIUM BROMIDE A white crystalline solid (KBr, molecular weight 119.00) that is readily soluble in water but only slightly so in alcohol. Used as a restrainer to suppress fog during development with polyhydroxy developing agents, as a major constituent in the making of photographic emulsions, and as a rehalogenizing agent for bleached silver.

POTASSIUM DICHROMATE Potassium dichromate, also called potassium bichromate ($K_2Cr_2O_7$, molecular weight 294.19), is available as orange-red crystals, granules, or powder that is readily soluble in water. This strong oxidizer causes skin and eye burns and is harmful if absorbed through the skin or swallowed (30 grams have been reported to be fatal).

It can be used as a light sensitizer to selectively harden colloid binders, such as in screen printing or making resist for etching metal or other surfaces. Potassium dichromate makes both reducing and bleach baths or intensifying solutions for silver images. It insolubilizes gelatin so dichromate solutions are used for hardening solutions and hardening fixing baths.

POTASSIUM FERRICYANIDE The bright red crystals or powder ($K_3Fe(CN)_6 \times 3H_2O$, molecular weight 329.26), freely soluble in water to produce a yellow solution, should not be confused with the yellow crystals of potassium ferrocyanide ($K_4Fe(CN)_6 \times 3H_2O$, molecular weight 422.39). Used in bleach baths, toning, and dye toning solutions and combined with sodium thiosulphate to form Farmer's reducer.

PQ DEVELOPER The combination of *P*henidone and hydroquinone (*Q*uinol, an early name for hydroquinone)

developing agents to form PQ developers has provided formulations that meet almost every photographic need. Together, the two developing agents in PQ solutions give a rate of development that is greater than the sum of the rates of the two developing agents alone, that is, they exhibit superadditive development.

PRECIPITATION Exceeding the solubility of a substance in a liquid results in the separation of a solid substance from the solution. Precipitation is the first stage in the manufacture of a photographic emulsion, forming insoluble silver halide crystals in the presence of gelatin. Unwanted precipitations may occur from photographic processing solutions from the presence of ions that form compounds of low solubility.

PREMIUM WEIGHT Used by some photographic manufacturers to designate a thickness of paper base heavier than double weight.

PRESERVATION See *Image permanence*.

PRESERVATIVES Developing agents in alkaline solution are unstable, often degrading into coloured, staining substances that are useless. A compound called a preservative is added to a developing solution to inhibit undesired chemical interactions. Sodium sulphite has gained universal use as the preservative ever since 1882 when H. B. Berkeley used it to reduce the staining by the oxidation products of a pyrogallol developer.

ANTIOXIDANT Oxygen from the air is readily absorbed into the water used to make developing solutions and will take electrons from (oxidize) the developing agent. Sulphite, often present in large amounts, effectively competes for the absorbed oxygen, forming colourless, harmless sulphate. If possible, the sulphite is added to the water before the developing agents are added. Some developing agents, such as Metol, must be added to the water first, as they are not soluble in large concentrations of sulphite ions. In this case, a pinch of sodium sulphite can be added first and the remaining quantity added after the Metol has dissolved.

INHIBITION OF SELF-OXIDATION Once started, the destruction of a developing agent may accelerate because of the presence of the oxidized forms of the developing compound. Sulphite ions remove these catalytic compounds, thus decreasing the rate of the degradation. This chain-breaking action is effective with the benzene derivatives that are developing agents but not with ascorbic acid or Phenidone, which do not react with sulphite ions,

STAIN PREVENTION Oxidized developing agents may be still chemically reactive, staining and/or hardening

the gelatin layer of the photographic material. Sulphite interacts with these to form colourless, water-soluble products that still may possess some developing activity. The decolonising action of sulphite also helps to protect the hands of photographers from discolouration.

OTHER SULPHITE EFFECTS Sulphite ions act as silver halide solvents, promoting fine-grain development. Physical development, that is, the formation of image silver from silver ions from the developing solution, also occurs. The etching action on the silver halide crystals raises the effective emulsion speed of the material by increasing the rate of development in areas of low exposure of the silver halide crystals. Sodium sulphite is mildly alkaline, sometimes sufficiently so that it can be used as the sole alkali in gently acting developing solutions.

Many compounds can act as preservatives but may not be as versatile as sodium sulphite. In some cases, even moderate concentrations of sodium sulphite are objectionable, such as in lithographic, tanning, or colour developers. In these developers, the oxidized form of the developing agent is necessary for a further chemical reaction. Hydroxylamines, hydrazines, and ascorbic acid exhibit preservative action in colour developers. In low sulphite solutions, developing agents or related compounds often find use when present in small quantities compared with the primary developing agent. Hydroquinone or related polyhydroxybenzenes can help protect active developers containing agents such as amidol.

Lithographic developers produce high contrast images by allowing the intermediate oxidation product of hydroquinone to accelerate the development rate. The free sulphite ion concentration must be kept very low. Certain aldehydes or ketones react with sulphite ions, forming complexes that act as sulphite buffers, maintaining the low concentration of sulphite ions in the solution. This provides some preservative action to protect the hydroquinone in the solution. Sodium formaldehyde bisulphite, for example, is a water-soluble, colourless compound that has found wide usage as a preservative for special purpose developers.

PRESSURE MARKS Pressure marks are a form of physical stress produced mainly by pressure applied over a small area of film or paper. Extreme pressure is required to produce even a minimal effect if applied over a large area. The mark may or may not produce an actual abrasion of the surface and may appear as a form of local fog or as a decrease in density in an area of an existing latent image. Even though no external pressure is applied to the surface, distorting film or paper can cause internal pressure that produces such effects as kink marks.

PRIMARY CELL/BATTERY Any of a number of electrochemical sources of voltage that cannot be recharged.

PRINT FINISHING Category of nonphotographic procedures applied to a photographic print to improve or alter its appearance:

Drying A wet fibre-base print may be ferrotyped, emulsion side toward a heated drum, to produce a high gloss finish, or air dried to give a low gloss surface. Curling may have to be removed. Resin-coated papers dry essentially flat as manufactured.

Spotting Dyes or opaque pigments may be applied to a print with a fine brush to hide the white spots caused by dust and scratches on the negative.

Etching A small, sharp knife or razor can be used to break the gelatin surface of the print and remove the silver black spots caused by pinholes in the negative.

Retouching Pointed pencils and brushes may be used to apply graphite, pigments, and dyes, usually to negatives, to correct small defects.

Texturing Lacquers, waxes, or other materials may be applied to the print to change its surface or form a protective coating or texture may be embossed on a print with a roller under pressure.

Hand colouring A wide variety of materials may be employed to colour a black-and-white image realistically or with expressive intent.

Trimming The edges of the print may be removed to eliminate distracting elements and tighten composition.

Mounting A print may be dry mounted by using a heat-sensitive tissue or peelable adhesive sheet to fix it permanently to a mat board. Wet mounting employs liquid or spray adhesives for permanent mounting. Archival procedures use acid-free tape to fasten a print to a board impermanently. If the board is damaged, the print may be saved.

Framing A window overmat is prepared and the assembly is placed in a frame for formal display.

PROCESSING Processing can be broadly defined as performing a systematic series of actions to achieve some end. In photography, processing refers to the actions taken after exposure of sensitized material to produce a visible, stable, and usable image. Processing of black-and-white films and papers normally consists of developing, rinsing, fixing, and washing, but may include additional steps such as presoaking film before development, using a washing aid between fixing and washing, and intensifying, reducing, or toning the image.

Because stabilization printing papers contain a developing agent in the emulsion, processing is reduced to two steps—treating the paper with an activator to develop the image and applying a stabilizer as a substitute for fixing

and washing. Greater permanence can be obtained with stabilization prints, when desired, by fixing and washing them in the usual way anytime before evidence of deterioration appears. With silver-halide printing-out paper, the visible image is produced by exposure, but prints that are to be preserved may be treated with a toning solution to alter image colour and a sodium thiosulphate solution to remove remaining silver halides before washing the prints to remove processing chemicals.

Processing of *nonreversal* chromogenic colour films and papers includes development in a developer that produces both a silver image and a dye image. The silver image is then converted to a silver halide by a bleach, and all remaining silver halides are dissolved by a fixing bath, which may be combined with the bleach as a blix bath, and the dissolved chemicals are removed by washing. *Reversal* chromogenic colour materials are processed in two separate developing solutions, the first to produce a negative silver image and the second, following fogging of the remaining silver halides, to produce positive silver and dye images. The negative and positive silver images are bleached and removed in the same manner as with the nonreversal colour materials, leaving the positive dye image. Processing with dye-bleach (chromolytic) colour printing processes, which produce positive images from positive transparencies, consists of (1) developing a negative silver image in each of the three emulsion-dye layers, (2) bleaching the silver images (which also bleaches the dyes in areas that are in contact with the silver grains, leaving positive dye images), and (3) removing remaining silver compounds and unwanted by-products with fixing and washing.

Monobath processing of black-and-white films involves the use of a single solution that contains both developing and fixing agents. Because development and fixation occur simultaneously, the process is carried to completion, and contrast is controlled by the composition of the monobath rather than by developing time.

With the diffusion-transfer process, a monobath-type processing solution is sandwiched between the exposed sensitized material and a receiving sheet that contains a nucleating agent. As a negative silver image is being developed in the exposed sensitized material, the unexposed silver-halide grains are being dissolved. The dissolved silver halides move to the receiving sheet by diffusion, where the nucleating agent causes them to become developable, and produce a positive silver image.

The procedures for processing nonsilver materials vary considerably, depending on the material. Water is all that is required to remove unexposed sensitized material with the blueprint process, where exposure produces an insoluble printout image, and the gum bichromate process, where exposure hardens the sensitized material containing a colourant. Dry processing is used with some nonsil-

ver processes. With the diazo process, ammonia fumes react with diazonium salts in unexposed areas to produce a positive dye image. No fixing is required because sensitivity is destroyed by the exposing radiation in the exposed areas. Heat, usually from an infrared lamp, is used to form the image with thermographic materials, where decomposition or softening occurs in the heated areas. Dry processing is also used with the xerographic process, where dry toner particles temporarily adhere to the unexposed areas of an electrostatically charged surface and are then transferred to a sheet of paper and fused with heat.

Processing was more of a challenge for early photographers than it is today. With the daguerreotype process, the exposed plate was developed by placing it in a box with a dish of heated mercury, where the mercury fumes adhered only to the exposed areas. The developed plate was then fixed, washed, and dried. It has been reported that the health of some of these photographers was adversely affected by the mercury fumes. With the wet-collodion process, it was necessary to sensitize the plate immediately before it was exposed, to expose the plate while still wet, and to process it before it dried, which required taking a portable darkroom along when photographing on location.

Dramatic progress has been made over the intervening years to shorten processing times, reducing processing costs, and improve the quality of the results. The use of resin-coated printing papers, for example, has reduced the time required for fixing, washing, and drying to a fraction of that required for fibre-base papers. Roller-transport and other automatic processing machines for films and papers that provide dry to dry processing in a few minutes have revolutionized large-volume processing as required in photofinishing and custom-finishing labs and other large photographic organizations. Instant-picture materials produce finished pictures in seconds, and video and still electronic photography provide immediate viewing following exposure, without chemical processing.

Although contemporary processing materials do not present the same type of health hazard that mercury fumes did to early photographers working with the daguerreotype process, photographers are advised to provide adequate ventilation in areas where processing solutions are prepared, stored, and used and to avoid direct contact with the solutions. Safety goggles and rubber gloves are recommended when mixing or pouring photographic solutions.

PROCESSING DEFECTS See *Defects*.

PROCESSING EFFECTS Processing effects are errors in development of exposed images caused by inappropriate local concentrations of developing agents. The chemical changes in the development process result

in reaction products that diffuse only slowly out of the emulsion. Movement of fresh developing agents into the exposed areas is similarly limited. The results are failure of highly exposed areas to be fully developed and nonuniformity of development in uniformly exposed areas.

PROCESSING TESTS See *Fixation test; Fixing bath test; Hypo test; Stop bath test; Washing test.*

PROCESSOR Typically an automatic or semiautomatic device that contains processing solutions in the appropriate order for the production of finished images from exposed sensitized materials, often including a final wash and drying.

PROPORTIONAL In image intensification and reduction, specifying a change in density equal to a fixed percentage of the original density in each area of the image. Such a change is equivalent to that caused by an increase or decrease in the original time of development.

PROPORTIONAL INTENSIFICATION Intensification in which the percentage of density increases is constant at each density level in the original negative. Most common intensifier formulas produce a proportional effect. Exceptions are those intended to enhance high contrast negatives and positives such as in graphic arts work (superproportional), and those that add a larger percentage (but not a larger amount) to the thinner areas than to the denser areas (subproportional).

PROPORTIONAL REDUCERS Proportional reducers remove a given percent of image silver at each density level, thus lowering the contrast of the negative. It is thus the choice for correcting negatives that have been overdeveloped, and where it is desirable to reduce contrast as well as density.

PROTECTED COUPLER A colour former (coupler) in chromogenic films and papers immobilized in its proper layer through some method such as dispersion of its solution in a water-immiscible liquid or as an insoluble salt. Protected couplers reduce colour contamination in images.

PROTECTIVE COATINGS
FIXATIVE A protective spray used to protect pencil and pastel artwork from smudging. Various manufacturers use different chemicals as fixative, so care should be exercised in choosing one for photographs. Chemicals used include plastic, varnish, shellac, and lacquer. Be attentive to where you use them since they are usually volatile and toxic. Fixatives are available in bulk or in convenient spray cans. The artwork should be

held vertically (straight up) when the fixative is sprayed on the surface of a print. Stand about 12 to 18 inches away from the print and spray at right angles, covering the entire surface as quickly as possible. Two light coats of fixative are better than one coat that is applied too heavily.

LACQUER Lacquer retouching sprays are available in a variety of types for initially preparing the surface of a photograph for retouching or to protect photographs that have been retouched. Dull or matt sprays provide a retouching tooth for protecting both glossy photographic papers and/or pencil, pastel, and paint retouching media while working on the print. In addition to surface preparation for retouching photographs, lacquers provide scuff protection, moisture and dirt protection, and ultraviolet radiation protection. Print lacquers are also used to embellish photographs with a variety of different surfaces such as, matt, semimatt, heavy texture, and high-gloss coatings. Brush or spray textures are companion retouching compounds that are formulated to show brush marks, which gives a photograph a hand-painted appearance. Other varieties of texture compound emulate linen, leather, weave, and pebble, and may be applied over retouching lacquers.

PROTON A proton is a positively charged particle found in the nucleus of all atoms, having a mass of 1836 times that of the electron. Protons and electrons arc equal in numbers in the atom but are opposite in charge. The third particle of the atom, the neutron, is found only in the atomic nucleus, being essentially the same mass as the proton.

PURITY In chemistry, the extent to which a chemical is free of other substances.

PVA GLUE PVA (Polyvinyl Acetate) glue is a strong, nonvolatile, thick liquid adhesive that bonds to paper and other porous materials. PVA glues can also bond to some plastics. Testing will provide the most practical and reliable information about specific plastic materials. This adhesive is white in the bottle but dries clear and remains flexible, unlike "all purpose" white glues, which are hard and brittle when dry. PVA glue won't deteriorate or contaminate paper. Because PVA glue is adversely affected by cold temperatures, it must not be subjected to freezing temperatures.

PYRO/PYROGALLOL/PYROGALLIC ACID Pyrogallol, originally called pyrogallic acid and now often referred to as pyro [C_6H_3-1,23-$(OH)_3$, molecular weight 126.11)], is available as a white crystalline solid soluble in water, alcohol, and ether. Severe poisoning may result from absorption through the skin or if swallowed or inhaled.

Pyro forms active but unstable developers, producing a residual yellow-brown stain image and hardening (tanning) the gelatin. Used as a tanning developer for dye transfer matrices.

QUALITY CONTROL A set of procedures used to monitor a process to detect departures from the desired result. Statistical techniques are often used, such as those involved in control charts. The phrase *quality control* is in fact a misnomer, because a process cannot be controlled in the ordinary sense.

Variability always exists, even in a manufacturing or processing system using the most reliable and up-to-date technology. Methods of quality control are intended to identify changes in the system that lie beyond those that are inherent. So-called assignable causes produce errors in the output that are correctable. Random, or chance, causes must be accepted, or the process must be redesigned.

Accurate test methods are essential to quality control. Calibration and routine testing of thermometers, densitometers, and so on, must be carried out.

The first stage of quality control requires extensive testing of a newly established process. A rule of thumb is that a large sample size must be initially obtained, *large* meaning 30 or more measurements. A plot of the frequency distribution will indicate whether or not the data probably come from a population having a normal distribution, i.e., one controlled by chance. The computed mean of the data will show whether or not the process average is sufficiently close to the desired result, the sample standard deviation is a powerful indication of the variation in the process, and thus the extent to which it meets specifications. Such a costly and time-consuming test procedure is reliable only if the process has operated normally, without detectable errors. If something has gone awry, the system must be collected and the test procedure redone on the modified system.

Once the data indicate that the information has been obtained from a stable, correctly operating process, information is periodically obtained in order to detect future errors. Control charts are customarily used for this purpose. Usually, samples of small size are used, and the sample averages and ranges (differences between largest and smallest values) or standard deviations are plotted in sequence. Upper and lower control limits show the region within which plotted data will fall with high probability if the process continues to operate in an unchanged manner. Points lying outside the limits indicate the need to correct the process. Other indications of a needed process change are: (1) a sequence of points all lying above or below the process average (five or more such points are usually

considered evidence sufficient to cause an examination of the process); and (2) a sequence of points all rising or falling, even though none of the points is outside the limits.

QUINOL See *Hydroquinone*.

RACK AND TANK A processing method in which films are attached to a support that is immersed sequentially in a series of containers holding processing baths.

RADICAL A radical is a group of two or more atoms that react as a unit, often being incapable of a separate existence. When hydrogen, with its electron, is removed from a hydrocarbon compound, a hydrocarbon radical is formed, as when methane, CH_4, is converted into a methyl radical, CH_3.

RANDOM VARIABILITY Chance-caused differences in observed data. Grains in a photographic image are normally randomly distributed. The separation of limit lines on a process control chart should be determined by random effects.

RANGE (1) The arithmetic difference between the largest and smallest numbers in a set of data, often used as a measure of variability in setting limit lines on process control charts. (2) The quotient found by dividing the largest number in a set of two by the smallest. The range of luminances in an outdoor scene may, for example, be 150 to 1. (3) The distance to an object in a scene, often measured with a rangefinder in order to ensure proper focus.

Syn.: *Ratio, the preferred term.*

RAPID ACCESS When substantially increased speed in the processing of black-and-white film or paper is required, elevated temperatures, concentrated solutions, and eliminated steps can reduce dry-to-dry times by as much as 75%. These procedures fall into the general category of rapid processing. When even more speed is required, a group of mechanized industrial processes, generally described as rapid access systems, can provide dry-to-dry times of less than one second per frame.

Cell and chamber processors permit the contact of small amounts of processing liquid with the emulsion side of the film. The film is located one frame at a time over a sealing frame and is held tightly in place by a pressure plate. Small metered volumes of solutions, less than 0.5 ml, are used. They are selected on the basis of the emulsion used and the image characteristics desired, and are forced into the chamber. Development takes 1.5 seconds. Fixer pushes the developer into the waste container and completes its task

in 0.5 second. Washing takes 1 second, and a hot, high-velocity air stream dries the film in 2 seconds. Process temperatures may range up to 130°F.

Viscous-layer applicators are used to process 16-mm black-and-white positive films at 36 feet per minute with a dry-to-dry time of 1 minute at 125°F. A coating hopper applies a viscous developer to the emulsion for 2.5 to 7 seconds, depending upon contrast requirements. A high-velocity water spray jet removes the developer; a coater applies fixer for 12 seconds; a 15 second spray wash removes the fixer, and an air dryer finishes the job in 20 seconds.

Porous rollers or plates made of sintered stainless steel granules can be used to apply thin layers of solution to the emulsion. The solutions are pumped through a series of plates as the film moves past. Jet-spray processors use compressed air forced through venturis to atomize solutions. In aircraft, slot processors produce images with an access time of 5 seconds at 40°C by drawing film past three narrow slots: developer, pressure barrier, and fixer. Nonporous roller applicators feeding solutions from a tank process cine film at 100 feet per minute. Saturated web applicators absorb chemicals and process film as it comes in contact with the web.

A typical highly active developer for the processors described might contain sodium sulphite, potassium carbonate, hydroquinone, phenidone, sodium hydroxide, benzotriazole, and water. The fixer is usually ammonium thiosulphate.

The diffusion-transfer and stabilization processes are capable of providing processing times near the speed of some rapid access systems and might be considered before examining more elaborate machinery.

Although no colour film processing equipment is as fast as the black-and-white units mentioned here, a colour print processing system widely marketed as *rapid access* produces washed and dry conventional prints in less than 4 minutes.

RAPID PROCESSING Methods of processing that enable exposed photosensitive materials to be processed in considerably less time than is normally required. Rapid processing may include the use of special developers, elevated temperatures, and other deviations from normal processing conditions.

RECIRCULATION The forced movement of a processing solution through a tank, for example, to provide agitation, replenishment, temperature control, etc.

RECOMBINATION Refers to the process in which electrons and holes recombine. This is an inefficiency of the photographic process and photographic scientists continually strive to minimize it.

RECYCLE To reuse, as in the recycling of wash water or heated air during photographic processing.

REDEVELOPMENT Applies specifically to the process of converting the silver salts of a bleached negative or print image back into metallic silver by a second development. The term is commonly, but inappropriately, used to describe the second development in reversal processing in which silver halides that were chemically fogged or re-exposed to light are developed for the first time.

Negatives may be bleached and redeveloped in white light to alter density, graininess, or contrast. Observation of the process permits close control of final negative density. Graininess is reduced by redevelopment in a paraphenylene diamine developer instead of a metol-based one. Contrast is reduced by bleaching and redeveloping to a lower contrast index.

Prints are bleached and redeveloped to improve print colour. In the carbro process, the matrix print may be used five or six times if it is redeveloped after each impression.

REDOX POTENTIAL Reduction-oxidation potential (redox potential) is the measure of potential of the electric current flowing between two electrodes placed in a solution in which electron transfer can occur. By using a hydrogen half-cell (assigned zero potential), half-cell potentials can be determined for many elements and compounds, permitting a prediction of whether electrons will flow from reducing agent to oxidizing agent.

RED SPOTS Red spots (also yellow or orange in colour) sometimes seen on microfilms and motion picture films are often colloidal silver resulting from the oxidation of the silver in the vicinity of contamination particles after periods of storage in the presence of moisture. The contamination is most often seen at the beginning and ends of rolls and is probably due to handling contamination, not the manufacture of the film stock or its processing. Important records should be carefully inspected at regular intervals and rewashed at the first signs of defects.

See also: *Image permanence.*

REDUCING AGENT A reducing agent transfers one or more of its electrons to another atom, thus reducing that atom. The reducing agent itself is oxidized when it gives up its electrons. The compound receiving the electrons is called the *oxidizing agent* and is itself reduced. Both reducing and oxidizing agents are necessary if a reaction is to occur. The latent image of an exposed silver halide crystal is the site for a developing agent (the reducing agent) to transfer electrons to silver ions (the oxidizing agent), forming metallic silver of the photographic image. The silver ions have been reduced (gained

electrons); the developing agent has been oxidized (lost electrons).

REDUCTION Reduction is the lowering of densities in a negative or positive, usually by chemical methods. Reduction is used to lower densities of an overexposed image to reduce printing time, modify negatives that have been overdeveloped to reduce contrast, and remove fog from thinner areas of a negative or positive. The treatment is generally applied by immersing the whole negative or print after it has been thoroughly rewet, but some formulas allow local reduction of specific areas of the image. Reducing techniques are less used today because the photographer has better control of exposure and processing than in the past.

The chemistry of reduction generally involves converting part of the silver to a soluble compound that is washed away. In the case of Farmer's reducer, the silver is first converted to silver ferrocyanide, which is then made soluble by the presence of sodium thiosulphate (hypo). Other reducers such as those made with manganese, chromium, or copper salts convert the silver directly to a soluble compound that can be washed away.

The action of the reducer throughout the density range of the image depends on its formulation and concentration as well as on the kind of emulsion used to make the negative and the size distribution of the silver grains making up the image. For a given density, small grains present a greater surface area for chemical reaction than do large ones. The reducing action can be characterized as subproportional, (which includes *subtractive* or *cutting*); *proportional*; or *superproportional*.

SUBPROPORTIONAL REDUCERS Subproportional reducers remove a smaller percentage (but not a smaller amount) of silver from dense areas than from thin areas. A subtractive or cutting reducer, one type of subproportional reducer, removes equal densities at all density levels, and thus does not change contrast. It is appropriate for some types of overexposure where lowering of density without change of contrast is desired. Farmer's reducer is typical, but when diluted produces some loss of contrast.

PROPORTIONAL REDUCERS A proportional reducer removes a given percentage at each density level, thus lowering the contrast of the negative. It is used to correct for overdevelopment where it is desirable to lower the contrast as well as density.

SUPERPROPORTIONAL REDUCERS A superproportional reducer has a greater percentage effect at high densities than at lower densities, and is used where the desired contrast reduction is greater than that achieved with a proportional reducer.

An important consideration in selecting a reducing method is the capability of assessing the degree of reduc-

tion. Some formulas continue to cause a reducing action even after the negative has been removed from the bath and washing has started. It is thus better to halt the treatment before the anticipated result. If further treatment is required, it can then be resumed.

REDUCTION, CHEMICAL Chemical reduction is the name of the process by which electrons are added to ions or atoms. Chemical reduction is part of the reduction and oxidation processes, which occur simultaneously in a reaction. The reducing agent supplies the electrons and is oxidized. The oxidizing agent acquires the electrons and is reduced.

REEL A spiral device for holding roll film for processing in a tank.

REEXPOSURE Applies particularly to the reversal processing of positive materials, such as colour transparency films and printing papers designed to make prints directly from colour transparencies. To reverse the tones in exposed reversal film to obtain a positive image, they are reexposed to light after the first development. This reversal exposure creates new developable areas in the emulsion that, upon second development, will yield a positive image. Current reversal processing systems substitute chemical reversal, called fogging, for reexposure.

REFLECTION DENSITY The logarithm of the reciprocal of the reflectance of a print sample area. For example, if the sample receives 100 units of light and reflects 50 units the reflectance is 50/100, or 0.50; the reciprocal is 1/0.50 or 2.0, and the density is the log of 2.0 or 0.30. Often the computation is performed with reference to the reflectance of the base taken as 1.0.

REGENERATION Procedure for restoring a processing bath to fitness for continued use. As fixer is used, the concentration of free thiosulphate ions decreases, the concentration of silver increases, the acidity may decrease, and the concentration of iodide increases. Regeneration must address each of these factors. Fixing baths may be electrolytically regenerated, removing accumulated silver and reconverting complex silver salts to thiosulphate. The silver may be precipitated by the addition of sodium sulphide or sodium hydrosulphite. Iodide may be removed by adding a thallous sulphate solution that precipitates thallous iodide. The thiosulphate concentration may then be restored by adding sodium thiosulphate, and reacidification achieved by adding sodium bisulphite, sodium metabisulphite, potassium metabisulphite, or acetic acid.

In metol-hydroquinone developers, metol becomes oxidized during the reduction of the silver halide image. Hydroquinone regenerates some of the oxidized metol to

metol. In phenidone-hydroquinone developers, all the oxidized phenidone is regenerated, yielding a longer working life. The practice of replenishing developers by adding compounds to replace exhausted components is not regeneration because it does not remove accumulated contaminants.

In colour processing, partially exhausted bleach solutions may be regenerated by oxygenation. Air is bubbled through the solution, returning the ferrous iron ions (Fe^{2+}) produced in the conversion of metallic silver to silver bromide, back to the ferric state (Fe^{3+}).

REGRESSION The atoms of metallic silver in the latent image of an exposed photographic material are susceptible to chemical attack. Loss or regression may occur during latent image formation, and an oxidative attack during keeping after exposure can result in a loss of silver atoms.

REHALOGENATION A developed metallic silver image can be converted to a silver halide, that is *rehalogenated*, by treating the metallic silver with an oxidizing agent and a halide salt. Potassium ferricyanide and a soluble halide (usually bromide or chloride) will change the metallic silver to silver halide. This technique can be used to reduce negatives that have been correctly exposed but overdeveloped.

RELATIVE HUMIDITY (RH) The amount of water vapour present in a gas (especially air) expressed as a percentage relative to the maximum amount of water vapour the gas could contain. Relative humidity is dependent on the barometric pressure and temperature of the gas. As a gas gets warmer or denser, the amount of water it is capable of containing in vapour form increases. For example, if a gas with 50% RH is warmed, the relative humidity decreases even though the amount of water vapour present remains constant. Relative humidity is most useful for determining the equilibrium water content that will remain in a substance (such as a photograph) when exposed to the air. Low relative humidities tend to be drying, and may improve the keeping properties of photographs but may also cause curling.

RELATIVE LOG EXPOSURE For sensitometric tests, a situation in which the actual log exposure values are not known but the relationship between the various log H values is known. Relative log H information can be obtained by the use of a gray scale (transmission or reflection) or from measurements of the luminance values for different subject areas. If one subject tone gives a luminance reading twice that of a second, the log exposure values for the two tones differ by the log of 2, or 0.30. In practice, camera flare somewhat lessens the computed value.

RELIEF IMAGE A three-dimensional image produced by any of various methods including differential hardening of gelatin and removal of the unhardened gelatin with hot water, and the selective etching of a metal surface on the basis of variations of exposure. Letterpress printing plates have relief images.

REM-JET Shortened from removable jet, a type of antihalation coating containing carbon particles in an alkaline-softenable organic binder. It requires scrubbing for removal. It is remarkable for its efficiency in preventing reflection, and is effective even in the infrared.

REPLENISHER A solution that is added to a photographic developer, fixer, or other processing bath to stabilize the activity of the bath as it is used. During development, soluble bromide accumulates in the developer and the replenisher formula typically differs from the developer formula primarily in having little or no bromide restrainer. Fresh fixer can be added to a used fixing bath to replenish it, but the extent to which this can be done is limited by the accumulation of silver compounds unless these are periodically removed by an appropriate form of regeneration.

REPLENISHMENT The process of adding replenisher to a processing solution to replace the active chemicals that are used up during processing and to replace solution carried out of the bath by the film or paper being processed. Processing machines, such as roller-transport processors, are commonly programmed to add the correct amount of replenisher according to the surface area of the film or paper that has been processed.

RESIDUAL-HYPO TEST See *Washing test.*

RESIDUAL-SILVER TEST See *Fixation test.*

RESIN-COATED (RC) Identifying a paper fibre support with pigmented polyethylene resin extruded onto both sides. Since such support does not absorb water or chemicals, RC papers can be processed and dried quickly.

RESTRAINERS Chemical restrainers or antifoggants are added to the photographic emulsion or to the developing solution to restrain or minimize the formation of nonimage silver (fog). Potassium bromide and iodide are typical inorganic restrainers added to developers. Organic compounds, called antifoggants, are fog restrainers also and may be present in the emulsion or in the developing solution. All of these compounds are thought to work by reducing the availability of silver ions or by adsorption of the surface of the silver halide crystal or the latent image.

RETICULATION Small-scale random wrinkling of the emulsion, usually caused by abrupt changes of temperature during processing. Reticulation is sometimes introduced deliberately for pictorial effect, but is rare with modern well-hardened emulsions.

RETOUCHING Photographic retouching is the process of applying transparent or opaque materials to local areas of negatives, transparencies, or prints, or removing density locally by physical or chemical means. The purpose of retouching is to correct flaws or to otherwise enhance the image. Skillful retouching can greatly improve a photograph, but clumsy retouching can destroy a photograph.

From the earliest days of photography, however, there have been purists who have objected—some vehemently—to any type of modification of the photographic image. Beaumont Newhall notes in *The History of Photography* (NY: Museum of Modern Art, 1982, p. 70), that despite these protestations and a lack of interest in retouching by most of the early photographers, "retouching became routine because sitters now demanded that the often harsh, direct camera records of their features be softened, facial blemishes removed, and the wrinkles of age smoothed away." Heavy retouching became the norm for still publicity photographs of Hollywood motion-picture stars during the 1940s and beyond, a practice also followed by many professional portrait photographers. Now the practice is to soften lines and blemishes rather than remove them.

Black-and-White Negatives Negatives are retouched on a transparency illuminator (retouching desk) that provides uniform illumination of appropriate colour quality. A colour temperature of 5000°K is specified for retouching colour images. The traditional method of retouching portraits with a needle-sharp pencil is giving way to the use of a pointed brush and liquid dyes. Considerable practice is required with pencil retouching in making a pattern of fine marks, in the form of the letter "c" or "s", for example, that blend in smoothly so they are not evident on enlarged prints. For professional production work, retouching machines are available that produce an appropriate small-scale vibrational movement of the negative to simplify the retouching task.

Brush retouching consists of using a properly diluted liquid dye with a sable brush that has been blotted to remove excess dye, and pointed. Advantages over pencil retouching include the ability to use different concentrations of dye to obtain the desired density on the negative, and the greater ease of developing the necessary skill.

Density can be removed from local areas of black-and-white negatives by physically shaving away the silver on the emulsion side using a razor-sharp etching knife.

Abrasive reduction can be used on larger, less well-defined areas by applying a reducing paste with an artist's stump or wad of cotton, although retouchers now prefer to use liquid reducer, such as Farmer's reducer, to remove silver density evenly, though the negative must then be washed and dried following this treatment.

Colour Negatives Colour negatives are more difficult to retouch since the altered area must match the surround in colour as well as density. Dyes (and pencils) are provided in a range of basic colours including skin tones and primary and secondary colours. To remove a minus-density cyan spot on a negative, for example, requires the addition of a red colourant. Visibility of the retouching colourant can be increased by viewing it through a contrast or separation filter of the complementary colour.

Colour Transparencies Retouching colour transparencies is more difficult than retouching colour negatives even though the image is positive; there are no masking dyes as there are on colour negatives, and the choice of retouching dye colour is more obvious.

Removing density physically from colour negatives and transparencies is impossible due to the layered positions of the cyan, magenta, and yellow dye images. Dye reducers that selectively bleach the colours are used, however, in transparency retouching.

Black-and-White Prints The most common retouching of prints consists of adding density to small light areas by applying a liquid colourant with a pointed brush. Density can be controlled by diluting the retouching colour as well as by making repeated applications. Different retouching colours are required for warm-tone and cold-tone papers to obtain a close match with the surrounding areas. Etching and abrasive reduction are seldom used on prints due to the effect they have on the surface sheen, but chemical reduction can be effective. In some situations it is easier to completely remove a dark defect and then add retouching dye to match the surrounding area than it is to stop the bleaching action at the proper time.

Colour Prints Cyan, magenta, and yellow spotting colours can be mixed in different proportions to match any print colour, although it is sometimes more convenient to use certain other standard retouching colours such as neutral and skin colour. Accidental excess application can be removed with clear household ammonia followed by swabbing with distilled water.

Cake-type dyes are available for application of colours to larger areas with a dry cotton swab. These colours are set by applying steam, but they should not be used with water.

Opaque colourants can also be used on colour prints by first spraying the print with a retouching lacquer (with adequate ventilation and use of a respiratory mask as health and safety precautions). Opaque retouching media include colour pencils, chalks, oil colours, and opaque colourants applied with an airbrush.

Most professional photographers possess some basic retouching skills, such as retouching dust spots on prints, but the more difficult retouching tasks and large-volume production retouching are usually delegated to a retouching specialist.

Electronic digital imaging has raised retouching to a new level, where images can be altered on a pixel-by-pixel basis to produce undetectable retouching, in addition to making it possible to completely alter images, for example, by adding and removing objects and changing the colours of objects and backgrounds.

REVERSAL PROCESS/MATERIALS The reversal process produces a black-and-white positive by developing a negative image on exposed sensitized material, then removing the negative image and developing a positive one. Direct positive processes achieve a similar result by other means.

After black-and-white film is exposed, development forms a negative silver image that is removed by bleaching. The remaining silver halides in the emulsion, constituting a positive image, are then sensitized and developed. Once colour film is exposed, the first developer forms a negative silver image. Chemical fogging or re-exposure forms a positive latent image that is chromogenically developed, yielding both silver and dye images. Bleach and fixer remove the first and second silver images; the positive dye record remains.

The earliest successful reversal of an image in processing was achieved in 1862 by C. Russell. In 1899, R. Namias removed the negative image formed in first development with an acid solution of potassium permanganate, re-exposed his plate, and developed the positive. The Lumière brothers applied this strategy to the processing of the panchromatic emulsion layer of their Autochrome screen film of 1907. Louis Dufay used Namias' system for his printed tri-colour screen film of the 1920s Dufaycolor. Cine-Kodak, an amateur 16-mm motion picture film requiring volume reversal processing, was introduced in 1923. Kodachrome, a complex integral tripack subtractive colour reversal material, was introduced as a 16-mm motion picture film in 1935. The following year, Agfa released the first coupler-incorporated reversal film, Agfacolor Neu. Kodak's first user-processible reversal film was Ektachrome, introduced in 1946.

In black-and-white reversal processing, relatively contrasty materials with thin emulsions and an even distribution of large and small silver halide grains give the best results. The larger, more sensitive and developable grains form the first silver image, which is removed. The second, positive image then consists of finer grains. Thicker emulsions may not permit exposure and development to go all the way through to the base; very thin emulsions may not have enough silver left for second development.

First developers for black-and-white reversal processing must be caustic and energetic to produce clean highlights. A rinse prevents the staining and sludge formation that results from contact of developer with bleach. While fixers remove silver halides without harming metallic silver images, bleach must remove silver without changing silver halides. Bleach employs an oxidizing agent such as potassium permanganate or potassium dichromate with sulphuric acid to convert metallic silver to silver ions for removal. Re-exposure to light is difficult to achieve with many configurations of processing equipment, so chemical fogging combined with second development has become standard procedure. In colour reversal processing, sequestering agents, preservatives, buffering compounds, restrainers, antifoggants, and accelerators all contribute to the formation of clean dyes during second development. Bleach and fix are often combined as *blix* to save a step and some time.

Reversal materials have very limited exposure latitude, especially when compared to negative-positive materials. Too much exposure causes too much of the emulsion to be used by the first image; the positive image will be too thin without remedy. Too little exposure results in excessively dense positive images. Reversal materials are therefore exposed for highlights, the limit being the sensitization of almost the entire coating of silver halide in a given area.

RINSE A brief treatment of photographic material in a liquid during processing. A water rinse may be used to reduce contamination of a following bath, or as a substitute for a thorough wash in rapid processing. An acid rinse (stop bath) may be used to stop the action of a developer preceding a chemical treatment (typically, fixing).

RIPENING Ripening is an essential stage in emulsion making in which precipitated silver halides are heated and stirred in gelatin solution. Silver halide solvents, such as ammonia or excess bromide ions, are usually present during the long holding period. During the ripening, silver halide grains increase in size whereby smaller crystals dissolve and deposit on the larger crystals, and individual crystals coalesce.

ROLLER TRANSPORT/ROLLER PROCESSOR
In automatic processing, the use of rotating cylinders to move film or paper through the process, simultaneously providing agitation.

ROLL FILM A strip of photosensitive film protected by a strip of opaque paper and wound on a spool for daylight loading of medium-format cameras.

RUBBER CEMENT A liquefied rubber adhesive that can be used either for temporary or permanent bonding

of materials. It is nonstaining and is easily removable when used as a single-coat adhesive. There is also a one-coat rubber cement that requires only one of the bonding surfaces be coated. For permanent bonding of two items, such as a photograph to a mount board, each surface is coated with rubber cement and allowed to dry. To allow for accurate positioning of the print, a slip sheet (any piece of smooth paper) is inserted between the print and mount board surface. The print is brought into contact with a small area of the mount board, and when the print is positioned accurately, the slip sheet is withdrawn slowly. This allows the two rubber-cemented surfaces to come into contact with each other; the resulting bond is "permanent." Permanence for rubber cement is only a year or two, after which the bond weakens. The two surfaces will eventually separate; heat and chemical residues will speed up the drying-out and decay process. Keep in mind that rubber cement yellows as it ages. It will eventually damage photographs and is not archival.

SAFELIGHTS Light-sensitive materials, when removed from their protective packaging, must be handled in darkness, or under a *safelight* that emits a colour of light to which the photographic paper or film has little or no sensitivity. Extended exposure to safelight illumination will generally produce objectionable fog. Most darkroom safelights are therefore of relatively low intensity, or must be used at a suitable distances to reduce the illuminance to an acceptable level.

TUNGSTEN SAFELIGHTS A low-wattage tungsten-filament bulb behind a filter that absorbs the colours of light that the specified material is most sensitive to is the oldest and most popular safelight configuration. The normal practice is to use interchangeable filters, but safelights have been made with a filter turret that allows the desired filtration to be conveniently dialed in. In either case, most filters eventually fade and safelights should be periodically tested.

Conventional black-and-white enlarging papers are sensitive to blue light, and therefore require a yellow, orange, or red filter (which absorbs blue light). Variable-contrast black-and-white papers are sensitive to blue and green and require a different safelight filter. Orthochromatic film materials are also sensitive to blue and green light. Colour enlarging papers, and panchromatic black-and-white papers, can be handled safely only for a limited time under a dim amber safelight. Panchromatic films are too sensitive for continued safelight exposure, but a very dim green safelight can be briefly used after development is half completed to see if more or less than normal development is needed to compensate for inaccurate camera exposure. This is not because the film is insensitive to green but because the eye is more sensitive to it.

With black-and-white materials, photographers are often unaware of safelight fog since it lowers image contrast before it becomes evident in the unexposed margins. In colour printing, safelight fog produces different colour balances in the highlight and shadow areas of the print, which cannot be corrected by adjusting the enlarger filtration. Tungsten lamps have instant-start characteristics and can be plugged into darkroom timers that switch off the safelight during the enlarging exposure, reducing safelight exposure and making dodging and burning-in easier.

LINE-SPECTRUM SAFELIGHTS Sodium vapour lamps in safelights provide a considerably brighter darkroom

for black-and-white print processing, and a somewhat brighter darkroom for colour-print processing. Their main disadvantage is that they do not have instant-start characteristics and require a warm-up period before use. A typical low-pressure sodium vapour lamp's spectral energy distribution chart will show a main spike of high intensity at about 589 nanometres, near the peak sensitivity of the eye. A filter can remove low-energy spikes at different wavelengths. An electroluminescent lamp can be made to emit a line spectrum by phosphor selection. One for black-and-white enlarging has a single 585 nanometre line-spectrum band, adjustable intensity, and instant-start characteristics.

Light-emitting diodes (LEDs) manufactured in various colours also emit radiation in narrow bands, for example, at 590 nanometres for colour enlarging. Individually, they do not produce much light but can be mounted in arrays to produce a broad, brighter illumination source. A removable filter allows bright light for black-and-white processing. The light output is generally proportional to current, so LEDs can be easily dimmed for use at various distances and to adjust the brightness control when testing for fog. LEDs have a very long life, can be switched rapidly on and off, and use little electricity. However, like other line-spectrum safelights they are expensive when compared to incandescent types.

FLUORESCENT SAFELIGHTS Fluorescent tubes are often used in darkrooms with fixture filters, or the lamp is inserted into a *tube* filter. Some nonsilver contact-printing materials can be handled in normal room light since their low sensitivity is limited mostly to ultraviolet radiation. UV-absorbing filter sleeves can be used with fluorescent tubes to decrease the danger of fog.

PORTABLE SAFELIGHTS Since safelighting may be restricted to key working areas, a portable safelight is useful. A filter over a flashlight is an economical solution, and several commercial pocket safelights can be used with some black-and-white and colour materials. Infrared viewers are expensive but provide a bright greenish image. They are worthwhile in photofinishing operations where they can solve problems such as jammed processors without using normal lighting, or to monitor the safety habits of new employees. They come in two main types, hand-held units that look like small video cameras and those worn on the head to allow freedom to use both hands. Both consist of an infrared transmitter and viewing portion; the combination may be called an *infrared scope*.

SAFETY See *Chemical safety*.

SAFETY FILM Film support not readily flammable. Contrast with highly flammable cellulose nitrate base, made for some purposes until 1950. Safety film is virtually synonymous with cellulose triacetate, although polyester base is also safe.

SALTED PAPER The earliest form of silver halide contact printing paper, dating to the mid-1830s. Artists' paper was imbibed with a solution of common salt and dried. This paper was sensitized under candlelight by floating it on a solution of silver nitrate and dried in the dark. Sunlight exposure behind a negative produced a strong visible image, which was toned in gold or platinum before fixation in hypo.

SALT EFFECT An increase in developed density when unreactive chemical substances, such as sodium sulphate, are added to the developing bath. The cause of the density increases is thought to be a change in the electrical charges on the gelatin of the emulsion.

SATURATED SOLUTION A solution is said to be *saturated* when the rate at which a solid substance dissolves in a liquid equals the rate at which the dissolved substance returns from the solution to solid form. A saturated solution contains the maximum amount of the solid substance that will dissolve at that temperature and other conditions.

SCALES (LABORATORY) See *Balance*.

SCHOTTKY DEFECTS A crystal imperfection in ionic crystals that involves pairs of ions missing from their lattice positions. In contrast to Frenkel defects, the missing ions are not in interstitial positions, but actually missing from the crystal itself.

SCHUMANN EMULSION Photosensitive emulsion characterized by silver halide crystals held to the substrate with minimal gelatin (by crude analogy, likened to sandpaper.) Invented by V. Schumann in 1892 for spectrography in the deep ultraviolet, it denudes the grains of gelatin that would otherwise absorb the shortwave radiation.

SCRATCHES See *Abrasions*.

SCUM In a processed image or on processing tanks, etc., a whitish deposit, typically associated with incomplete washing or incomplete compounded (or overworked) solutions. The problem often arises with hard water.

SECONDARY CELL Any of a class of electrochemical sources, the energy of which can be restored by recharging it with electricity.

SELENIUM An element (Se, molecular weight 78.96) that is available as dark red crystals or powder insoluble in water but soluble in hot solutions of sodium sulphide or sodium sulphite. Selenium compounds are toxic and may irritate eyes, skin, or the respiratory tract.

Selenium is used as a toning bath to convert silver images into reddish tones. Slight treatment may improve the resistance of silver images to attack and degradation. Selenium acts as the light sensitive element in photoelectric cells, such as exposure meters, and electrostatic devices.

SELENIUM TONER Selenium toners convert the silver image to silver selenide, which has a more reddish brown colour than does the silver sulphide image formed by sulphur toners. Selenium is difficult to get into solution, but the metal can be dissolved in hot solutions of sodium sulphite, sodium sulphide, or both. Selenium toners work best on warm-toned chloride or chloro-bromide papers, but a modification in which the image is first converted to a halide before toning makes it possible to tone some papers that are otherwise difficult to tone. Proprietary liquid selenium toners are available, which simplify the process for most photographers. Avoid skin contact, due to toxicity.

Like sulphide images, selenide images have good permanence, and even partial toning with selenium renders an image more stable. With some papers, selenium toning increases the maximum density with only a small change in image colour.

SENSITIVE In photography, capable of responding to radiation, such as the reaction of photographic materials to light, or to other forms of energy, such as heat, pressure or atomic particles.

SENSITIVITY A general term for the extent to which a photographic material, or other photosensitive element (such as a photocell), responds to light or other radiation. Historically, film speed was at first intended to be a measure of sensitivity; now speed numbers are considered to be index values useful in determining the camera settings that will yield an acceptable result.

SENSITIVITY SPECK A term used in early studies of the photographic process to refer to active sites on the emulsion grain surface where a latent image forms. We now refer to these sites as sensitizer centres because they form during the act of chemical sensitization. But early studies used materials that were simply heated to improve their sensitivity and the mechanism was unclear. We now know that the gelatin used was capable itself of sensitizing the grain.

SENSITIZE Sensitize refers to the act of making a material respond to radiation, or extending the range of radiation to which a material is sensitive, or increasing its sensitivity. Chemical sensitization increases the light

response of silver halide emulsions by treating the crystals to the action of sulphur, gold, or metal salts during the afterripening period of emulsion making. Spectral response can be expanded by adding sensitizing dyes to the silver halide crystals, increasing the response of the emulsions to all wavelengths of light.

SENSITIZED MATERIALS See *Photosensitive materials.*

SENSITIZERS In photomechanical reproduction, chemical compounds such as salts of iron, silver, and chromium, dyes, and diazo and acrylic compounds that are used to make organic photographic and photomechanical coatings light sensitive.

SENSITIZING DYES Untreated silver halide crystals of photographic emulsions are sensitive only to the ultraviolet, violet, and blue regions of the spectrum. Sensitizing dyes adsorbed to the surfaces of the crystals can extend the sensitivity throughout the visible spectrum and into the infrared. Some of the more important sensitizing dyes, such as the various cyanines, are long carbon chains that exist as absorbed, aggregated resonance hybrids. These aggregates absorb light energy and transfer it to the silver halide crystal, forming a latent image.

SENSITOMETER An apparatus used in testing photographic materials that produces a series of known exposures on a sample. Since exposure equals the light level multiplied by the exposure time ($H = I \times t$), a sensitometer may be either of two types:

1. The instrument produces a series of different light levels at a fixed time—an intensity-scale sensitometer.
2. The instrument produces a series of different exposure times at a fixed light level—a time-scale sensitometer.

Intensity-scale sensitometers expose the sample in a manner conforming to practice and therefore are more suitable for test purposes.

See also: *Sensitometry.*

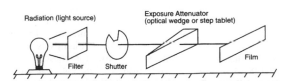

Sensitometer. Schematic of an intensity-scale sensitometer.

SENSITOMETRIC CURVE See *Characteristic curve.*

SENSITOMETRIC TABLET See *Optical wedge.*

SENSITOMETRY The complex process of determining the response of photographic materials to light (and other radiation) and processing. Begun in the late nineteenth century by Vero Driffield and Ferdinand Hurter, the initial aim was to develop test methods that would enable comparison of different films with respect to their sensitivity as expressed by emulsion speed values. During the past century, methods have been developed for emulsion testing that are essential to the operations of manufacturing and processing of photosensitive materials and that are useful to consumers of photographic products as well.

Sensitometry involves (1) the selection of samples to be tested; (2) proper storage of samples; (3) exposure to suitable radiation; (4) development and other processing; (5) image measurement; (6) data analysis.

SAMPLE SELECTION Samples of photographic materials to be tested for quality must be representative of the entire set (the population) from which the samples are chosen. For example, in manufacturing, rolls of film coming from the coating apparatus are normally several feet wide and many feet long. It is tempting to take samples that are conveniently located, as from the ends or the sides of the roll. It is necessary, however, to assure by extensive sampling that easily secured samples are indeed characteristic of the entire product. If they are not, other steps must be taken to obtain suitable test samples.

SAMPLE STORAGE Environmental conditions may alter sample characteristics. For processing control, samples of an especially selected test material may be kept for extended periods of time. High temperature and humidity are damaging. Therefore samples should be well wrapped and refrigerated, then removed from storage so that they come to reasonable temperature before use.

EXPOSURE In the exposing device—a sensitometer—choice of the correct energy source is essential. It must supply an appropriate spectral energy distribution. For much testing, the rule *conform to practice* must be obeyed. If the photographic material is to be used in a normal outdoor environment, then the sensitometric light source should be that of the present standard, i.e., having a continuous spectrum equivalent to that of standard daylight at a colour temperature of 5500 K.

Other standards exist for the exposure of medical x-ray films to fluorescent screens and for films used in studios and exposed to tungsten lamps. No standards exist for such sources as flashlamps and fluorescent lamps used for general illumination. The same is true for photographic papers as exposed in most printers. For such uses, the consumers of the product must establish their own test procedures.

A set of different exposures is produced at the sample in the sensitometer by the use of a step tablet, i.e., a semitransparent strip consisting of a series of patches that absorb different amounts of energy from the source. Step tablets must be nearly neutral in their absorption of energy of different wavelengths.

A typical sensitometric step tablet consists of 21 patches that give a total ratio of exposures of 1000 to 1, or a log exposure change of 3.0. From one patch to the next the exposure changes by a factor of 1.4, a log change of 0.15, equivalent to one-half stop in camera exposure settings.

To avoid reciprocity effects (changes in the response of a photographic material with fixed exposure but changed exposure time and illuminance), the time of exposure needs to be close to that expected in practice. A typical time for available sensitometers is 0.1 second, selected to be neither exceptionally short nor long.

PROCESSING Development conditions must be carefully controlled. Of the major factors in development—time, temperature, developer composition, and agitation—the first two are easily monitored.

Effective agitation is needed to supply fresh developer to every area of the sample and to remove reaction products that would interfere with proper development. What is needed is turbulent movement over the film or paper surface to remove the laminar layer of developer, i.e., that solution that adheres to the emulsion surface, and it must be removed as effectively as possible. There are many methods of agitation, including rocking or shuffling one or a few sheets of film or paper in a tray; spinning the reel in a tank holding a roll of film or inverting and swirling the tank; lifting and draining sheet film holders in a tank; introducing bursts of nitrogen gas into a large tank; and squeezing the film by the use of rollers. All these methods need to be checked for uniformity of agitation using test samples sensitometrically exposed and measured.

The developer used for sensitometric purposes should have the following characteristics: (1) stability—freedom from deterioration with storage; (2) selectivity, which is freedom from the production of development fog; and (3) freedom from staining, so that the image will be as nearly neutral as possible. For most applications, the developer formula must follow the conform-to-practice rule, although there are international standards for some uses.

MEASUREMENT Processed sensitometric samples are measured with an instrument called a densitometer; which causes a known light level to fall upon the sample and records the light transmitted or reflected from the sample.

DATA ANALYSIS A sensitometric test sample usually consists of 21 areas that have received different levels of exposure. Analysis of the results is usually made

371

by plotting a graph of the density values against the corresponding log exposure data. The result is the characteristic curve, also called the D-log H (formerly D-log E) curve.

From such a curve, the following information is obtainable:

1. The base plus fog density found from an unexposed area of the sample. This value is a measure of the selectivity of the developer.
2. An estimate of the speed of the material, usually based on a density slightly above the base plus fog level.
3. A measure of development contrast, found from the slope (steepness) of the curve well above the minimum point. In process control, development contrast is often found from the difference in density between two selected patches near the centre of the sensitometric strip.

ALTERNATIVES TO SENSITOMETERS When a sensitometer is not available, or when precision data are not required, transmission or reflection gray scales may be used as substitutes with a camera or a printer. Calibrated gray scales usually supply only relative log exposure information, but they satisfy many aims.

Reflection gray scales are useful in practical tests of camera performance. Such a scale may be placed in the scene being photographed and illuminated carefully to avoid glare reflection. Camera flare to some extent changes the log H values assigned to the steps of the tablet, which therefore gives only approximate exposure data. The use of this tablet, however, gives useful information about the performance of the system.

Transmission gray scales or step tablets may be used in a printer to give a set of light levels of known increments on the print material. If the printer illuminance is measured without the step tablet in place, actual, rather than relative, log H data can be obtained. Uniformity of light without the step tablet is essential. When such a step tablet is used in a projection printer, flare becomes a problem as it does in a camera. Masking down the area to be exposed is important. The effects of the optical system can be eliminated by placing the step tablet in contact with the print material.

In the absence of even these aids to testing, subject luminance data may be used as the input. Log luminance ratios are equivalent to relative log exposure intervals. For example, if different areas of the subject give luminances of 6.5, 13, 25, 100, and 400, they form in effect a five-point gray scale. The four successive luminance ratios are 2, 2, 4, and 4. The logs of these ratios are 0.3, 0.3, 0.6, and 0.6. These numbers can be used as relative log H intervals and will yield an approximate five-point characteristic curve when the image densities are measured.

SEQUESTERING AGENT An organic or inorganic compound that when added to a photographic developer removes the harmful ions in the solution, especially calcium, by forming stable, soluble complex ions. Polyphosphates, such as the polymeric form of sodium hexametaphosphate sold as Calgon, or nitrogen-containing tetra-acids, such as ethylenediaminetetraacetic acid (EDTA) and its salts, are examples of sequestering agents that remove ions before insoluble compounds are precipitated

SHEET FILM Also *cut* or *flat* film. Photographic material on a stiff but flexible transparent support, cut into individual rectangular pieces. For use it is loaded into light-tight holders in the dark or under a safelight. Each sheet is normally used to make a single exposure. A notch in the edge in a conventional position locates the emulsion side.

See also: *Notch code*.

SHEET-FILM HANGER Typically a grooved rectangular frame with a hinged edge designed to hold one or more sheets of film vertically in a series of tanks of processing solutions. A long top bar rests on opposite edges of the tanks, and the bars serve as handles so that the hangers can be lifted at intervals to drain the film as a means of providing agitation.

SHELF LIFE The time during which a sensitized material, chemical, or chemical solution, can be used effectively and safely before it begins to break down. It usually applies to darkroom chemicals. When used with reference to sensitized materials, the term *expiry* or *expiration date* is preferred.

SHRINKAGE A reduction in dimensions of photographic materials associated with drying, or, in films, with loss of residual solvent. Fibre-base papers shrink less in the *machine* direction (the direction of paper motion in the paper-making machine) than in the *cross* direction. Shrinkage of resin-coated (RC) papers is very small. Shrinkage of motion picture films could result in mechanical difficulty or damage to printing and projection equipment. Shrinkage of photogrammetric films would result in inaccurate maps and misregister of colour would be the result of shrinkage in graphic arts films, both of which have been greatly reduced by the introduction of polyester base and are virtually eliminated by glass plates.

SHUFFLE AGITATION In tray processing of sheet film, continuous agitation involving carefully bringing the bottom sheet in the stack of film to the top, and then the next one, and so on, typically throughout the process.

SILICA GEL A modification of silicic acid that, in granular form, is capable of absorbing various vapours. It is used as a drying agent in desiccators and for moisture control in storage boxes and compartments.

SILVER A lustrous metal (Ag, molecular weight 107.87) that forms light-sensitive salts, making photography possible. Latent images in light-exposed silver halides consist of aggregates of silver atoms. After development, the photographic image consists of metallic silver, whose colour is dependent on its size, shape, aggregation, and the condition of its surface. The silver is removed in colour photography to leave a dye image.

SILVER HALIDES A family of elements called halogens (fluorine, chlorine, bromine, and iodine) combine with silver to produce silver halides, the most light-sensitive salts of silver. Silver chloride, silver bromide, and silver iodide are the most useful of the silver halides and are often present in mixed combinations in photographic materials.

SILVER HALIDE SOLVENT A chemical that converts water-insoluble silver halides into water-soluble compounds. Such solvents are used during the manufacture of the photographic emulsion or in processing solutions to form or treat the silver image. Sodium or ammonium thiosulphates are the common silver halide solubilizing compounds for processing solutions. Thiosulphates are found in fixing baths, reducers, toning solutions, bleach-fixing baths, monobaths, and many other solutions. A great number of other chemicals can act as solvents for the insoluble silver halides, including ammonia and ammonium salts, halide salts, and many organic sulphur-containing compounds.

SILVER NITRATE Dissolving metallic silver (98–99% pure) in nitric acid and then purifying by electrolysis and recrystallization gives silver nitrate that is better than 99.9% pure. The white crystals ($AgNO_3$, molecular weight 169.87) are soluble in water and slightly so in alcohol and ether. Avoid contact with the solid or solutions as eye or skin burns may result. Do not get on clothing. Swallowing can cause death.

Highly purified salt is used to prepare photographic emulsions; less purified salt is used for silver intensifiers and other solutions, such as physical developers.

SILVER RECOVERY Less than 25% of the coated silver of light-sensitive photomaterials is used to form the developed silver image, and all the silver is removed from colour films and papers. This valuable metal can be recovered by a number of reclamation techniques: precipitated by chemical agents (such as sodium sulphide), precipitated

by a nonselective compound (such as sodium hydrosulphite), displaced by less noble metals (such as zinc, copper, or iron), deposited by electrolysis or galvanic silver recovery units, or separated by ion-exchange methods.

SILVER SULPHIDE A metallic silver image can be converted into silver sulphide (Ag_2S, molecular weight 247.8), producing a brownish image of great stability. Various sulphide toning baths have been formulated for this purpose. Silver sulphide is also formed during the chemical sensitization of silver halide emulsions before coating.

SILVER-DYE BLEACH PROCESS Instead of relying on the reaction of oxidized developer components with colour couplers to form dye images as in chromogenic development, the silver-dye bleach process, also called dye bleach or dye destruction, is an integral tripack system with yellow, magenta, and cyan azo dyes incorporated into the blue-, green-, and red-sensitive emulsion layers during manufacture. The resulting image dyes are more stable in light and in acidic gases than the dyes formed in chromogenic development.

The process is based on the 1897 research of R. E. Liesegang into the softening of the gelatin around a silver image, and the 1899 research of E. H. Farmer into the tanning of that gelatin. In 1905, Karl Schinzel proposed an integral tripack colour print process that used hydrogen peroxide to destroy unwanted dyes near silver image components by oxidation. Utocolor, introduced in 1910, used light to bleach dyes exposed under a colour transparency. The destruction of the dyes by reduction with sodium hydrosulphite or stannous chloride was proposed by J. H. Christensen in 1918.

The principal proponent of dye bleach in the 1930s and 1940s was Béla Gaspar. Gasparcolor, a dye destruction motion picture film, was introduced in 1933, and his first material for making prints was shown in 1935 and was used until 1952. The idea was revived by Ciba-Geigy in 1963 with Cibachrome, for prints from transparencies, and Cibacolor, for prints from negatives. They were renamed Cilchrome and Cilcolor, then reverted to their original names. The negative printing material was discontinued, and Cibachrome has become Ilfochrome.

Cibachrome's three silver halide emulsion layers contain complementary colour azo dyes, formed before being added to the emulsion and carefully selected for spectral absorption properties. After exposure, the material is developed in black-and-white developer to produce a silver image. A strongly acidic dye bleach with an added accelerator causes the destruction of adjacent dye molecules in proportion to the amount of negative silver image formed in that area. The dyes that remain

correspond to the original positive image. The negative silver image is bleached and removed, as are the unexposed, undeveloped silver halide components of the positive image. The print is washed and dried.

SINGLE JET One variation of making a photographic emulsion that involves the introduction of a silver nitrate solution as a stream through a single tube (single jet) into a large volume of gelatin solution containing potassium bromide or mixed halides. If mixed halides are present, silver iodide is believed to precipitate first. Grain growth is accelerated by the excess halide in the gelatin solution. The rate of the addition of the silver nitrate, degree of stirring, temperature, and many other variables influence the nature of the crystals during the emulsification and crystal growth.

SIZE/SIZING A colloidal substance, perhaps with filler, for coating the surface of photographic or photomechanical paper to provide smoothness.

SODIUM SULPHITE The anhydrous form of this white, granular compound (NA_2SO_3, molecular weight 126.06) is readily soluble in water but insoluble in alcohol. Available also as white crystals (NA_2SO_3 x $5H_2O$, molecular weight 252.04), containing only 50% sodium sulphite. A desiccated form is essentially equivalent to the anhydrous form. The photographic grade is 97% minimum pure by weight. Do not confuse sodium sulphite with sodium sulphide.

Used as a preservative or mild alkali in developing solutions and as a constituent in fixing baths, intensifiers, and other photographic solutions.

See also *Anhydrous*.

SODIUM THIOSULPHATE A silver halide solvent that exists as colourless crystals or a white powder in an anhydrous form ($Na_2S_2O_3$, molecular weight 158.11) or a hydrate ($Na_2S_2O_3$ x $5H_2O$, molecular weight 248.18), both highly soluble in water at room temperature but insoluble in alcohol. The photographic grade is 97% minimum purity by weight. Sodium thiosulphate or the fixing bath containing it are commonly called *hypo*, as is ammonium thiosulphate and its fixing bath.

Except for rapid fixing baths, sodium thiosulphate is used universally as a solubilizing agent for silver halides, such as in fixing baths, solvent developers, monobaths, reducers, and in the diffusion transfer process.

SOL A *sol* is a stable dispersion of a solid substance in a liquid or solid. A *gel* is a special type of sol in which the particles or molecules are randomly joined to form an open, rigid framework. Gelatin forms a gel when it sets.

SOLARIZATION See *Photographic effects*.

SOLARIZATION EFFECT See *Photographic effects*.

SOLUBILITY A solution is a homogeneous mixture of the particles (ions, atoms, or molecules) of two or more chemical substances. Each portion of a solution has the same chemical composition and physical properties as another portion. In most cases, the two substances cannot be mixed in all proportions. The component that is present in the larger proportion is called the *solvent*, the lesser component is called the *solute*. A solution consists of a solute uniformly dispersed in a solvent.

A solution can be achieved only if the substances are similar in composition or if the substances can interact chemically. As the number of particles of the solute in the solution increases, there is a point at which the number of particles entering the solution equals the number leaving the solution. This is the equilibrium point, and the solution is said to be *saturated*. A solution containing less than this amount of solute is *unsaturated*.

Solubility of one substance in another is influenced by the temperature. More of the solute can dissolve at a higher temperature. If a heated, saturated solution is cooled, an unstable solution is formed that will hold more solute than would be normally possible at the lower temperature. This is a supersaturated solution that will begin to deposit the solute, or crystallize, when a suitable nucleus is available. A small crystal or a dust particle, even a scratch on the side of the container, can serve as a site for the excess solute to be deposited .

Solutions are sometimes classified by the proportions of the solute and solvent present. If a large amount of the solute is contained in a unit volume, the solution is said to be *concentrated*. A *dilute* solution has only a small amount of the possible solute per unit volume.

Miscibility is used to describe the mutual solubility of two liquids. If two liquids are soluble in all proportions, the liquids are completely miscible; if only mutually soluble to a limited degree, the liquids are partially miscible. *Immiscible* is the term given to two liquids that do not appreciably dissolve in each other.

Solubility is the quantity of a solute that can be dissolved in a solvent under specific conditions. Exact measures are needed to specify the amount of an added chemical that is less than the solubility limit. These precise measures usually involve weight per weight, weight per volume, or volume per volume relationships.

Molar (weight per volume), molal (weight per weight), and percentage (both weight per volume and weight per weight) solutions are frequently used measures of the concentration of a solute in a specific amount of the solvent.

- A molar solution (*M*) contains 1 molecular weight in grams of the solute dissolved in a total of 1 litre of solution.

- A molal solution (*m*) contains 1 molecular weight in grams of the solute in each 1000 grams of the solvent.
- A percent by weight solution (%) represents the weight of either the solute or solvent divided by the sum of the weights of the solute and solvent (\times 100), giving the percentage by weight of either the solute or solvent in the solution.
- A photographic percent solution (%) has come to mean the number of grams of the solute contained in 100 ml of total solution, a weight per volume relationship. A volume per volume percent solution is also used.

The photographic percent solution is the one used in photography but can be confused with the percent by weight solution.

A solid, liquid, or gas can be dispersed homogeneously without chemical interaction in another solid, liquid, or gas. A solid solution is thus possible, such as with glass or certain metal alloys.

SOLUTION A solution is a homogeneous mixture of the atoms, ions, or molecules of two or more substances, which can vary in the concentration of the components. Although each part of a solution is identical to every other part, the components can be separated physically. A solution consists of two parts: the solute and the solvent. The solute, the substance present in the smaller quantity, is dissolved in the solvent, the substance present in the larger quantity. Photographic processing baths are water (solvent) solutions of several chemical ingredients (solute).

SOLUTION PHYSICAL DEVELOPMENT In silver halide imaging, a silver image formed by using a silver halide solvent in the developer that partially dissolves silver salts from the emulsion. The deposit is a form of intensification that amplifies the weak, initial silver image formed by the dilute developer. The image is very fine grained, but the process involves a substantial loss of effective film speed.

SOLVENT TRANSFER A simple way to reproduce commercially printed and photocopied images. Pictures from magazines printed on poor-quality, thin paper will transfer more easily than those on heavier, better-quality paper. Coat the back of the printed image with either a liquid solvent such as turpentine, lighter fluid, mineral spirits, etc. or with a gel-based solvent such as the oil-based transparent silk screen base. Allow the solvent to penetrate and saturate the paper fibres. Place the print image-side down on the desired transfer material and rub the back of the image with a blunt instrument like a wooden spoon or butter knife using even pressure.

SOUP (1) A developing bath. (2) To process exposed photographic film or paper.

SPECIFICATION A prescribed procedure or result, such as time of development or agitation technique in photographic processing, or necessary contrast index. Most specifications (specs) include tolerances, i.e., permitted variation in the specs.

SPECIFIC GRAVITY The weight of a volume of a substance as compared to the weight of an equal volume of water. The metric system is designed to make the calculation of specific gravity simple in that the weight of water (at standard temperature and pressure) is defined to be 1 kilogram per litre or 1 gram per millilitre (cubic centimeter). The specific gravity of a liquid (and hence in many cases the concentration of a dissolved substance) can be measured using a hydrometer.

SPECTRAL SENSITIZATION (also Optical sensitization) A chemical treatment that increases the response of silver halide crystals of a photographic emulsion to wavelengths of light longer than the natural sensitivity. Spectral sensitization is accomplished by organic dyes that absorb to the surface of the silver halide crystals. The dye becomes excited by the absorption of light energy and transfers the energy to the crystal, forming a latent image.

The chloride, bromide, or iodide salts of silver are sensitive to light but respond only to violet, blue, and ultraviolet radiation. These wavelengths of radiation have sufficient energy to eject a photoelectron from the halide ion of the silver salts of the photographic emulsion layer. Green, yellow, orange, and red light have less energy, so silver salts have almost no response to these colours of light. Photographic films and papers made with pristine silver halides are colour-blind to most of the visual spectrum.

A chance observation by Hermann Vogel in 1873 provided the clue for increasing the limited spectral response. While testing dry collodion plates, which the manufacturer had secretly treated with a yellow dye to reduce halation, Vogel noted that the plates were green sensitive. After some clever detective work, Vogel established that the yellow dye was responsible for the extended spectral sensitivity. This major advance was rejected by some of the noted photographic authorities who were unable to sensitize the gelatin dry plates that contained less iodide than the collodion plates.

The first spectral sensitizer for green light was eosin, a dye discovered by J. Waterhouse in 1875, but the related dye, erythrosin, was the first to find commercial use. Such dyed photographic materials were said to be orthochromatic (*ortho-*, meaning correct), that is, sensitive to ultraviolet, violet, blue, and green but still insensitive to red

light. In 1884 Vogel found that a blue dye, cyanine, was a weak sensitizer for red light, but there would be many human lifetimes of work and devotion before suitable dye sensitizers would make practical panchromatic sensitization (*pan-*, meaning all) possible for all colours.

Present-day spectral sensitizers are of the polymethine type that are vastly different from the early dyes. Cyanine dyes, for example, consist of an alternately single and double bonded chain of carbon atoms that are attached at each end to ring structures having nitrogen atoms, one of which is positively charged. This might be represented in a simplistic schematic as

Ring structure containing pentavalent nitrogen (+)	$-CH = (CH-CH=)_n-$	Ring structure containing trivalent nitrogen

where $n = 0, 1, 2, 3, 4, 5$.

Many, many variations of cyanine dye structures have been made. These include the important merocyanines having an equal number of carbons in the chain that is connected to rings at each end, one containing a nitrogen, the other a sulphur or oxygen atom.

The complex molecular structure of sensitizers is necessary because the dye must be capable of two energy states: (1) a ground or unactivated state, and (2) an excited state after absorbing light energy. The efficient dye molecule requires atoms such as nitrogen, which can exist in different states, joined by a chain of carbon atoms whose alternate single and double bonding provides a means to transfer or resonate a quantum of electronic excitation energy throughout the molecule. In a cyanine dye with a nitrogen atom in the ring of atoms at each end of the chain, one nitrogen is electron attracting, the other electron donating. The two nitrogens can, however, rapidly exchange their condition. A dye sensitizer exists in a state of shifting electronic character, a state capable of being excited when light energy is absorbed.

After excitation, the dye molecules, which often exist in aerated form on the surface of the silver halide crystal, transfer an electron to the crystal. A latent image is then formed in the same manner as when the crystal is struck by actinic radiation. Thus, light absorbed by the sensitizer on the crystal surface results in spectral sensitization of regions beyond the normal effective light absorption of the silver halide. Almost all sensitizers cause a decrease in sensitivity in the region of natural light absorption, but efficient dyes more than compensate for the desensitizing action.

SPLIT TONE A split tone is a tonal defect, or enhancement, depending on point of view, in which the colour of a tone changes with the density of different image areas.

It can be produced intentionally by incomplete toning of a black-and-white print. It may sometimes be the result of failure of the toning process.

SPOTS Black or white spots occur on photographic negatives or prints as a result of a variety of causes. Black spots on a negative will result in white spots on a print, and vice versa. Chief among the causes of spots are dirt, dust, and other particles on the surfaces. Contamination from organic or inorganic particles can also cause coloured spots or spots of higher or lower density than the surrounding area. Pinholes in protective coverings can cause black spots due to light exposure. These would be white spots in the case of reversal materials. In rare instances latent black or white spots can exist in the photographic material prior to exposure and processing. They may also be the result of handling or the effect of contamination after a period of aging. *Spotting* refers to the act of retouching or correction of spots on negatives or prints by the photographer. Since retouching is time-consuming and costly, and not always effective, care should be taken to avoid the presence of dust, dirt, or other contamination.

SPOTTING Spotting refers to correction of local density or colour defects in prints, usually as the result of dust or other materials on the sensitized surface at the time it was exposed or on the processed film when it was printed. However, the defects requiring correction may have been due to retouching work done on the negative or transparency, or even to unwanted objects in the scene at the time the film was exposed, such as scraps of paper or gum wrappers. It is generally preferable to correct for as many of these problems as possible before exposing the print.

 BLACK-AND-WHITE PRINTS Black-and-white prints are usually spotted with a small brush loaded with a diluted spotting dye that is available in various hues for work on neutral black, blue black, and sepia images. With these spotting "colours," the surface sheen of the print is not affected after they have been dried. Spotting can also be done with opaque pigments that are moistened as required. This type of spotting can usually be seen on the surface by reflected light, however, especially on glossy print surfaces. Minor spotting of prints with a matt or semi-matt surface can be accomplished by means of a lead pencil using a technique similar to that for retouching of negatives. An advantage of opaque pigments is that dark spots can be lightened to match the surrounding density.

Dark spots may be bleached out and then spotted with diluted black dye. Small spots may also be removed with an etching knife, although the surface will be disturbed. This will be less apparent with matt or semi-matt prints. The sheen may be corrected to some extent by applying a small amount of oil or wax.

Although not technically spotting, large areas of a print may be modified by airbrushing techniques. With an opaque colourant, spots will be obliterated in airbrushed areas.

COLOUR PRINTS The principles of spotting of colour prints are generally similar to those for black-and-white, although they are more complex because of the need to balance the three dye images. A wet-brush technique using cyan, magenta, yellow, or combinations of these dyes in solution is generally used for spotting of colour prints, especially in areas not approaching maximum density. In darker areas, the neutral dyes such as those used for black-and-white may also be used.

If the prints are to be used for viewing only, the choice of dyes is not critical, providing the spotting is done under the illumination that will be used for viewing the prints. Because this condition may not always be relied upon, the absorption characteristics of the dyes should match those forming the three coloured images of the print. This is especially important when the print is to be reproduced photomechanically. Dye transfer prints can be spotted with the same dyes used for making the print.

While less suitable to spotting than to treating larger areas, the dry dye technique may also be used. The dye from the dry-dye cake is taken up by a small cotton swab and applied to the area to be corrected until the desired effect is achieved. Then the print is steamed to set the dye, as in retouching. This procedure may not be successful with small clear spots in the print.

SPRAY ADHESIVE Spray adhesive is very similar to a one-coat cement, which is a weak bonding tacky cement, such as rubber cement. Most spray cements are low tack, which allows the mounted material to be removed and repositioned. However, some spray cements may bond permanently if they are allowed to stay in contact for long periods of time. Because of the chemical nature of the spray adhesives, they should only be used with adequate ventilation. Cover the surrounding areas, such as walls, floors, and counter tops with a protective paper covering to make clean-up easier.

SPRAY BRUSH In electronic imaging, to add a specific colour to designated image areas, analogous to manual airbrushing with a colourant.

SPRAY PROCESSING A method of supplying fresh solution (especially developer) to a photographic material by forcing the solution through a nozzle in a fine mist, directed forcefully against the material being processed. Used in some rapid-access development techniques.

SPROCKET-HOLE EFFECT (1) See *Photographic effects*. (2) Streaks on processed film associated with

perforations. Such streaks are an indication of an uneven movement of developer across the emulsion surface during agitation.

SQUEEGEE In photography, typically a rubber blade with a handle used for removing water or other liquid from the surface of processed photographic materials. An air squeegee, or air knife, consisting of a jet of air from a slit aperture close to the surface, is used for this purpose in some automatic processors.

STABILIZATION PROCESS Military, news, and law enforcement agencies often need to have photographic prints produced as quickly as possible. Water and working space are commonly in short supply, but the prints needn't last long. This application is well served by the stabilization process, which yields damp-dry black-and-white prints in 15 to 60 seconds.

Stabilization papers have developer crystals incorporated in their emulsions or surface coatings. Development is performed in the first bath of a roller transport processor that contains a concentrated alkaline-sulphite activator, such as sodium hydroxide with sodium sulphite. The paper then passes directly into the stabilizer, the second bath in the processor. Because the print will not be washed to remove substances remaining after processing, the stabilizer must not only render the image stable in light, but also convert all undeveloped silver halides to colourless, transparent compounds. In addition, the unreacted stabilizer residue must not cause staining or oxidation, nor may it damage the silver or the gelatin of the print, and it should air dry tack-free. Common stabilizers of manageable toxicity levels are based on sodium thiosulphate, thiourea (used by A. Bogisch for washless processing in 1893), or ammonium thiocyanate. Antioxidants, hardening agents, and compounds that protect the image from degeneration caused by residual thiocyanate are added to the basic stabilizer.

Stabilized prints are chemically active; they may last from several weeks to a year or more, depending upon storage conditions. The prints are sensitive to humidity, heat, and light and should be kept away from fully processed film and prints. After their use for photomechanical reproduction or briefing purposes, they may be reprocessed for permanency by fixing and washing conventionally.

STABILIZERS Emulsion stabilizers, usually organic molecules with sulphur or nitrogen present, are thought to restrain the continued chemical ripening of the silver halide emulsion after coating. The mechanism of action is obscure. Some stabilizers may form insoluble silver compounds of less solubility than the silver halides. Others may inhibit the growth of the latent image, especially

partially formed silver specks. Metal ions, such as cadmium or mercury, also act to limit the changes of the emulsion with time.

Stabilizing agents that form soluble or insoluble compounds with silver ions are used in processing baths. These convert unused, undeveloped silver halide into compounds that are relatively inert to heat, humidity, or continued exposure to light. Stabilized photographic materials need not be washed in water, but the image is not permanent.

STAIN In black-and-white images, especially prints, an unwanted hue, often yellow caused by use of exhausted developer, contamination, or by incomplete fixation or washing. In colour prints, a faint hue, such as pink, in areas that should be white. Analogous to fog.

STAINING Staining indicates a density increase of an image, or part of an image, above that of the original tone. It happens concurrent with a discolouration of the original tone, for example, from a light neutral gray to a yellow or brown tone. It is technically the opposite of fading, and may occur in both black-and-white and colour photographs. Most noticeable in the highlight areas, it is often caused in black-and-white negatives and prints as a result of incorrect fixing or insufficient washing. It may also be caused by external sources of reactive chemicals. In all cases the image silver in highlight areas forming delicate gray areas in a continuous tonal range is converted to silver salts that are yellow or brown, and so trigger the stain formation. In colour photographs, stain formation is most often precipitated by exposure to light that results in residual coupler print-out. Coupler print-out occurs fairly evenly across the whole image. It, too, is accompanied by discolouration, which is most visible in delicate white highlights that may turn yellow.

STANDARD (1) A specification, test method, recommended practice or glossary of terms approved and published by a recognized standardizing body. (2) The basis of a set of measurements. The standard of length—the meter—was formerly the distance between two marks on a platinum bar kept in Paris. Now the standard of length for the meter is the distance occupied by a specified number of wavelengths of a specified colour of light. The standard for light emission—the candela (formerly candle)—is the light emitted by a black cavity of specified size at a specified fixed temperature. (3) A publication of the American National Standards Institute (ANSI) or the International Standards Organization (ISO), which describes methods of photographic processing, film and paper dimensions, testing procedures, and so on. (4) The structure in a view camera that holds the front or back of the camera in the proper position on the runner.

STANDARD DEVIATION (σ, s) The most useful measure of the random (chance-caused) variation within a set of data. It is the square root of the average of the squares of the deviations of the individual numbers from their mean (arithmetic average).

The basic formula is

$$\sigma = \sqrt{\frac{\Sigma(X_i - \mu)^2}{N}}$$

where σ is the standard deviation, Σ is the sign of summation (i.e., add all the following items), X_i includes all the members of the data set, μ is the population average, and N is the number of items. This formula implies that all possible members of the population are included.

Since the whole population can rarely be tested, the formula for the standard deviation found from a limited sample is slightly modified to read

$$s = \sqrt{\frac{\Sigma(X_i - \overline{X})^2}{n-1}}$$

Now, s is the sample standard deviation, an approximation to the population standard deviation, \overline{X} is the sample mean, and n is the number of items in the sample. The value of n is reduced by one in the calculation since theory and experience show that without this correction the sample standard deviation is smaller than the population value.

AN EXAMPLE OF THE COMPUTATION. Five temperature measurements of a processing bath—75°, 77°, 76°, 74°, and 75°—give a mean of 75.4°, and the following table:

$(X - \overline{X})$	$(X - \overline{X})^2$
0.4	0.16
1.6	2.56
0.6	0.36
1.4	1.96
0.4	0.16
	5.20

The value $5.20 \div 4 = 1.30$; $\sqrt{1.30} = 1.14$ or, rounded off, 1.1°F, the value of the sample standard deviation. Note that in the calculation of s the mathematical sign of the difference $X - \overline{X}$ is irrelevant, and that the s-value has the same unit as the original data.

SIGNIFICANCE OF s If two conditions are met, the value of s is a good approximation to the population standard deviation σ and thus is a valuable measure of the variability of the data set. These conditions are: (1) s is computed from a representative sample; i.e., the sample is properly selected and evaluated; (2) differences among the members of the population are caused by chance and not by any factor other than chance. Although both of these

requirements are difficult to meet, they are often sufficiently well approximated. They can be tested by taking a large sample and plotting the data to see whether or not the pattern comes close to that of a normal distribution. If it does, then the following statements are true: about 68% of all the population data will lie between $\pm1s$ from the mean; about 95% within the $\pm2s$ interval; about 99.7% within $\pm3s$.

Referring to the temperature example above, if the data were properly collected and if the temperature in the bath varied only by chance, then the following inferences could be made: about 68% of all the temperature values lie between $\pm1.1°F$ from the mean of 75.4°F, or between 74.3° and 76.5°F; about 95% lie between 73.2° and 77.6°F, and 99.7% between 72.1° and 78.7°F.

APPLICATIONS

Conformance to Specifications The size of the process standard deviation must always be much less than the variation allowed by specifications. For example, suppose that processing directions call for a temperature of $75\pm1/2°F$ If the standard deviation is $1/4°F$, then the allowable temperature difference is $2\ s$, and 95% of the bath temperatures will fall within the specified range but only if the process temperature is exactly centred on 75°F. Even then, 5% of the temperatures will fall outside the requirements. Only if the s value is less than 1/2 will the temperature error be less than 1 in 100 if the average is precisely on target. Clearly, process variation and specifications must be closely related.

Control Charts When a process is being monitored, successive measurements of the process performance are often plotted against time in order to detect undesired results. One method involves a graph showing the process mean and limit lines set at distances based on the process standard deviation. If $\pm3s$ limits are used, 99.7% of the data from an unchanged process will fall within the limits, and only 0.3% (i.e., 3 in 1000) will fall outside. Thus, if the decision is made that the process is awry when a point falls outside the lines that decision will be in error infrequently. It is impossible to set the lines so far apart that *all* measurements from an unchanged process will be within the limits; thus, some risk of error is always present.

Tests of Hypothesis Many experiments are performed to see whether or not a change in manufacturing or other conditions causes a change in the results. If the measured exposure index changes to 110 from a previous mean of 100, for example, the apparent increase of 10 must he compared with the process standard deviation. Only if the s value is much less than 10 is it safe to suppose that an increase in the index has actually occurred. Many kinds of hypothesis tests are possible, depending on the process being tested and the nature of the experiment.

STANDARD OPERATING PROCEDURE (SOP)

A normal, broadly accepted sequence that attends to the

safe, accurate, and repeatable operation of equipment. For example, it might include a well ventilated and secure environment, chemical preparation in accordance with manufacturers' material safety data sheets (MSDS), an orderly start up to include densitometer-checked test strips as necessary, periodic checks on process controls, and shut-down, cleanup, and chemical disposal, once again conforming to material safety data sheet specifications. Densitometers and other devices may require calibration, and electronic studio flash equipment, for example, must be operated in a strict sequence.

STATE OF THE ART The best currently available device, process, or system. The development of a better method advances the state of the art.

STATIC Short for static electricity.

STATIC ELECTRICITY Electrical charges at rest as distinguished from electrical charges in motion (current electricity). The ancient Greeks knew that amber when rubbed would attract bits of paper and other light objects. We have since learned that rubbing or simply separating two surfaces in intimate contact will cause a transfer of electrical charges from one surface to the other. One surface is charged with an excess of electrons (negative charges), leaving the other surface with an excess of protons (positive charges). To store the electrical charges the material must be a good insulator. Photographic film and paper are both good insulators and can therefore cause static electricity problems in a photolab.

When unprocessed film or paper is unwound from a reel, the separation of the surfaces can generate static electricity. If the voltage between the surfaces of the reel and the web is high enough, a spark will occur between the surfaces. This spark will expose the film or paper in an easily distinguishable pattern.

Electrostatic charges on negatives will attract dust and dirt particles, which if not removed before printing will degrade the quality of the print. The electrostatic charges on the film can be neutralized by the use of a static eliminator.

Walking across a carpeted room on a dry winter day can generate many thousands of volts.

STATIC ELIMINATOR Any of a number of devices used to neutralize electrostatic charges. A common type of static eliminator consist of a high-voltage transformer whose output winding is connected to electrodes with very sharp points. The voltage gradient at the points ionizes the air and produces a blue glow known as a *corona*. The free-moving negative ions neutralized the positive charges on the film; the positive ions neutralize the negative charges.

See also: *Antistatic*.

STATIC MARKS Static marks on film are the result of exposure produced by discharge of static electricity in the vicinity of the surface. Static electricity may be generated, for example, when a roll of film is unwound, or a person with a charge touches any film, especially in very dry weather. In the darkroom it can be recognized by a cracking sound and often seen as faint blue sparks that can produce a developable image on the film. Static marks commonly appear as streaks, black spots, smudges or tree-like markings on the processed film.

Static electricity often makes it difficult to remove dust from film and glass surfaces since the charge attracts the dirt particles again after they have been wiped off. Proprietary dopes and dusters, electrical charge modifying devices, and grounding of enlargers can be used to dissipate the charge. Films made with polyester and other nonconductive bases have a greater tendency to hold a charge than acetate bases. These high dielectric constant bases also may attract dust after processing while drying in an unfiltered current of room air. Dust on film during exposure or on negatives and transparencies when they are being printed produces small light or dark spots on the prints.

STATISTICS The complex body of mathematical theory and application that includes methods of data collection, analysis, and interpretation. Statistical methods are used, for example, in monitoring the manufacture of photographic materials and equipment and in processing plants.

KINDS OF DATA Objective data come from measurements. They include concentrations of materials used in processing solutions and characteristics of films and papers such as contrast and speed. Subjective data come from judgments made by observers concerning image quality. Although subjective data are difficult to obtain, they are basic to the assessment of the success of the entire photographic process, from manufacture to viewing conditions. Objective measurements of image quality must be shown to be equivalent to subjective judgments.

All kinds of measured data, however seemingly precise in nature, are subject to error. Therefore, the estimate of error is a fundamental part of the statistical analysis of data.

SAMPLING The entire set of possible measurements in a given situation is called the *population*. An example would be the entire production of a given lot of film, consisting of very many square meters of product. A sample is a small lot used for determining the quality of the whole production of a given kind.

The number of samples is, for practical purposes, necessarily limited. A sample of over 30 measurements of the same kind is usually considered large. Often judgements must be based on samples as small as 2 or 3 in size.

To avoid bias in the collection of the sample, random selection is often used. In taking a sample from a large roll of film, one is tempted to use only the ends or the edges of the roll. Such a sample may well not be representative of the rest of the product, unless tests show that it is. Various techniques are used to randomize the sample selection, such as tables of random numbers.

If there is reason to believe that the population is not well mixed, i.e., that it is stratified so that different portions of the population are significantly different from others, it is necessary to take random samples from the different strata. In a large processing tank, if the solution is not thoroughly stirred, there may be systematic or other differences in temperature or concentration from top to bottom. In this case, samples would have to be taken from different positions in order to avoid incorrect judgments.

MEASURES OF CENTRAL TENDENCY

1. The *mean* is the arithmetic average of a set of data. It is the most commonly used measure of the value around which the members of a data set are symmetrically distributed if they differ only by chance. For such a distribution, called normal, the mean lies at the centre, the highest point of a plot of such a data set.
2. The *median* is the value that divides a set of data into two parts having equal numbers of members. It is a useful measure of central tendency for a set of data that are grouped together except for a few widely separated ones.
3. The *mode* is the most frequently occurring value in a set of data. It is used when many of the data have nearly the same value and others of the set are widely different.

If the data are representative of a population that is chance controlled, the mean, the median, and the mode very nearly coincide.

MEASURES OF VARIATION

1. The *range* is the difference between the largest and smallest members of a sample. Although simple to calculate, the range has limited use, in part because the size of the range is determined by only two members of the set. The range is often used for samples of small size and especially for the preparation of limit lines for control charts.
2. The most powerful measure of variation within a set of data is the *standard deviation*. It is found by determining the difference between the mean and each member of the set, squaring the differences, averaging them, and taking the square root of the quotient. The standard deviation gives equal weight to all members of the set. It is used in some control charts, in tests of conformance to specifications, and in tests intended to detect a difference between two populations, known as *hypothesis tests*.

STEP One of a series of baths or procedures used in processing exposed photosensitive materials.

STERRY PROCESS Procedure for reducing the contrast of prints made from negatives too contrasty for the paper they are being printed on. After exposure, the paper is bathed for about a minute in a solution of 1% potassium dichromate or potassium ferrocyanide and then developed. Print colour changes from cool black to warm black with a greenish tinge. The developer must be changed frequently because the contamination causes staining and exhaustion.

STILL DEVELOPMENT Processing film without any agitation. Used especially for photolithographic materials, alter a few seconds of development. The purpose is to enhance the edges of an image.

STOCK SOLUTION A photographic solution, usually in concentrated form, from which working strength solutions can be made by dilution with water or by mixing with other solutions, e.g., HC110 developer.

STOP BATH An acid processing solution, also called a *shortstop*, that stops image formation by neutralizing the solution alkalinity immediately after the development of silver halide materials. Dilute solutions of acetic acid are commonly used for this purpose, but certain other acids are effective also.

STOP BATH TEST A means of determining when a used stop bath should be replenished or replaced. Bromocresol Purple, an indicator dye that changes from colourless to purple when the acidity of the stop bath falls below the safe level, can be used to test a small sample of the stop bath, or can be added to the entire stop bath. Under yellow safelight illumination, the stop bath will appear dark when the dye changes colour.

STORAGE DEVICES (FOR PHOTOGRAPHS) Carrying cases for photographs are available in different sizes. Typical features include reinforced handles, metal corner protectors, rubber feet, lockable latches, and an acrylic-impregnated fabric exterior. The interior is usually acid-free and lignin-free card stock.

Document boxes are flip-top upright archival acid-free and lignin-free board storage files for letter and legal-sized papers. These boxes have pull strings on the reinforced double-thick box bottoms to help in retrieving them from the storage shelf.

Flat storage boxes are acid- and lignin-free board construction. These boxes are available in a variety of sizes and are constructed with reinforced metal edges.

Foldover presentation mats have a professional appearance and allow photographs to be quickly mounted for presentation. A mylar pocket with a transparent front and matt back allows for nonglare viewing. A black cover mat is secured in place with corner locking slits.

Manuscript boxes are two-piece boxes made from acid-free and lignin-free board covered with an acrylic-impregnated fabric. The adhesives used are low-sulphur content, pH-balanced, and buffered.

Museum cases are similar to portfolio boxes but they are more sturdy. Constructed of low-resin basswood, these cases are covered with acrylic-impregnated, heavyweight, book cloth. Chrome-plated closure latches provide security, and a chrome-plated label holder provides a place for an identification label. A polypropylene web strap with a padded grip is available to carry the case.

Polyethylene bags are excellent protection for prints that need to be handled constantly. These bags can be written on with print and film marking pens.

Portfolio boxes are manufactured with acid-free and lignin-free board, lining, cover fabric, and adhesive materials. They have drop spines so that they lie flat when opened. The clamshell design allows prints to be transferred from one side to the other when showing the photographs, while providing a dustproof closure for storage. Pressure-sensitive label holders provide a place for identification of the contents.

Shipping cases are typically constructed of fibreboard, have heavy steel corners and a reinforced handle and are used for carrying photographs around or shipping photographs through the mail. These cases have heavy duty web straps with pull-tight buckles to provide security and closure. A slot to insert a shipping label card is an added convenience. Shipping cases are available in archival and nonarchival versions.

Transview sleeves are polypropylene sleeves with a clear front and either a clear or frosted back, used for storing and viewing transparencies.

STORAGE OF PHOTOGRAPHS

The conditions under which photographic images are kept determined to a large degree their long-term stability. Aside from built-in properties, which make one type of photograph inherently more permanent than others (for example films on a polyester support are superior in that respect to films made of cellulose nitrate), the storage of photographs is the most important factor in their preservation. It is also one that the user, or keeper of collections, can control. This role is reflected in four publications by the American National Standards Institute that recommend specific storage conditions for photographic plates, prints, and films, and also for the quality of filing enclosures with which a photograph is in close contact while in storage. The factors that generally have the largest effect on the long-term stability of

photographs are the purity of the surrounding atmosphere, its relative humidity and temperature, and the properties of the filing enclosures in which they are kept. Although the level of air purity ranks high in its role of determining the longevity of photographs—the degrading effect of oxidizing gases in the air on the stability of photographic images having been demonstrated many times—no maximum permissible threshold values have been given in the ANSI standards that might indicate below what level of concentration a given pollutant, such as hydrogen peroxide, will become harmless. However, research is presently being carried out in that field. Photographic manufacturers indicate that the level of air purity in areas where light-sensitive films and papers are manufactured is such that concentrations of any of the well-known gaseous pollutants are so low as to be beyond the ability of analytical techniques to detect them. Any present air pollution is below the detection limit of modern analytical instrumentation.

Current ANSI standards regarding the storage of processed photographic materials address mainly temperature and relative humidity levels.

ANSI PH1.45-1981
Practice for Storage of Processed Photographic Plates

	Storage Temperature (°C)	Relative Humidity (%)
Recommended:	15–25 (59–77°F)	20–50
Preferably:	<20 (68°F)	<40

Recommendations are set at realistic levels. The wide temperature range within which photographic plates can be kept indicates the slight effect that temperature alone is expected to have on their stability. While a relative humidity of below 40% is preferable, any level between 20 and 50% is acceptable. However, a level of 20% is considered by some experts as too low, as it may cause forces, created by the contraction of the gelatin layer, to prompt its separation from the glass support.

ANSI PH1.48-1982 (R 1987)
American National Standard for Photographs (Films and Slides), Black-and-White Photographic Paper Prints, Practice for Storage

	Storage Temperature (°C)	Relative Humidity (%)
Acceptable:	15–25 (59–77°F)	30–50
Never:	>30 (86°F)	>60
	Avoid daily cycling of 4°C (7°F)	

Recommended environmental conditions are similar to those for photographic plates. The maximum permissible threshold value of 60% relative humidity is significant. A

high moisture content of the air is conducive to mould growth, which can completely destroy the image in time. Daily cycling of more than 4°C should also be avoided.

Specifications for the storage of processed *photographic film* are divided into one set for medium-term and another for extended-term keeping. *Medium-term* storage can be used for film that is suitable for the preservation of records for a minimum of 10 years. It should have a Life Expectancy (LE) rating with a minimum of 10 years. *Extended-term* storage conditions should be used for films having higher LE ratings.

ANSI IT9.11-1991
American National Standard for Photography (Film)
Processed Safety Film—Storage
Recommended Relative Humidity and Temperature for Storage[a]

| Sensitive Layer | Medium-Term Storage | | Extended-Term Storage | |
	Relative Humidity Range (%)	Maximum Relative Temperature (°C)	Maximum Humidity Range (%)	Temperature (°C)
Silver gelatin Heat-processed silver Vesicular Electrophotographic Photoplastic Diazo	20–50	25	20–30	21
Colour	20–30	10	20–30	2

[a]Film includes all types, such as microfilm, motion-picture film, x-ray film, and photographic negatives.

This material is reproduced with permission from American National Standard IT9.11, copyright 1991 by the American National Standards Institute. Copies of this standard may be purchased from the American National Standards Institute at 11 west 42nd Street, New York, NY 10036.

While earlier versions of this standard featured recommendations for separate relative humidity levels for different film bases, for example, those made of cellulose esters and of polyester, the current recommendations are applicable to the various types of films mentioned in the first column regardless of the nature of the film support.

Because few photographic collections could afford several storage areas with different RH levels for various materials, the current arrangement facilitates the selection of a single optimum RH level beneficial to a variety of photographic films. That level should be 30%, plus or minus 3%, in line with the most recent recommendations for the storage of paper records in archives and libraries, and significantly lower than the 50% RH recommended a decade ago for the storage of such materials.

The storage temperature of 2°C for colour photographs, recommended by ANSI standard IT 9.11-1991, may be considered to be conservative. More than a decade ago, researchers from the Eastman Kodak Company published two significant observations that demonstrated the following: first, colour photographic images can safely be stored at temperatures below 32°F (0°C), the freezing point of water. Storage temperature can be as low as 0°F (–18°C). Second, the published figures indicate the enormous decrease in the rate of dye fading by a factor of 10^3 if colour photographs are stored at 0°F compared to storage at room temperature. Relative humidity must be controlled tightly at low temperature storage and be kept at a level of 30±3%.

Regarding the quality of filing enclosures, the pertinent ANSI standard discusses products made of paper and of plastic materials. Materials used in manufacture must be free of acid and peroxides and must be chemically stable, Adhesives in seams must be free of sulphur, iron, and copper; and printing inks must not bleed, spread, or transfer. Paper envelopes, in particular, must have a high alpha-cellulose content (minimum of 87%); be free of highly lignified fibres (ground wood); have an alkali reserve of 2%; contain a minimum of sizing chemicals; and should be free of waxes and plasticizers that may transfer to the photographic record during storage. These recommendations are accompanied by references to specific test procedures that can be used to evaluate the envelope material in terms of the specifications. One such test is the photographic activity test, which can be carried out with relatively modest laboratory equipment.

Books: American National Standards Institute, American National Standard for Photography (Plates): *Processed Photographic Plates, Practice for Storage.* ANSI PH 1.45-1981. New York, NY: ANSI, 1981; American National Standards Institute, American National Standard for Photography (Film and Slides): *Black-and-White Photographic Paper Prints, Practice for Storage.* ANSI PHI.48-1982 (R 1987). New York, NY: ANSI, 1987; American National Standards Institute, American National Standard for Photography (Film): *Processed Safety Film, Storage.* ANSI IT9.11-1991. New York, NY: ANSI 1991; American National Standards Institute, American National Standard for Photography: *Film, Plates, and Papers, Filing Enclosures and Storage Containers.* ANSI IT9.2-1991. New York, NY: ANSI,

STREAKS Streaks are linear markings in the machine direction of a roll of film. They are rarely caused in the manufacture of the sensitized product but tend to be the result of some difficulty when processing in a continuous machine. A build-up of some material in the path of the film may provide contamination or other interference, the effects of which can he seen in the image area of the final product. They can also occur in drying due to insufficient

squeegeeing of water across the strand. There may or may not be visible physical damage to the film surface.

Streaks can also be caused by a fibre or other intrusion in the image-forming path of the camera, printer, or recording instrument.

STREAMERS A more or less regular flow of developer over film that is processed with inadequate agitation that results in uneven development and streaking.

STRIPPING FILM A graphic-arts material wherein the emulsion is not coated directly on the base but on a thin (usually cellulose nitrate) skin coated on the base. Care is taken in manufacture so that there is sufficient adhesion of the skin to the base to withstand processing but not enough to prevent deliberate peeling afterward. Stripped negatives, or portions, can then be combined with others on a new support. An alternative use is for lateral reversal, since the stripped skin can be laid down on the new support with either side up.

STRUCTURAL FORMULA A form of chemical notation, often used for molecules containing many carbon atoms, that attempts to show the bonding and spatial arrangement in the molecule. A colour developing agent is used as an illustration in the example below.

SUBBING (1) The process of coating a support (film base, glass) with a material promoting adhesion of a following, usually photosensitive, layer. (2) Also called *sub*, shortened from substratum. Denoting the coating described in (1).

SUBPROPORTIONAL Less than proportional, a subproportional intensifier produces relatively smaller density increases in the heavier density areas of a negative (highlights) than in the lower density layers (shadows). The resulting contrast, while higher than that of the untreated negative, is not as high as that achieved with a proportional intensifier.

A subproportional reducer removes a smaller proportion (but not a smaller amount) of density from higher densities than from the lower. When the reduction in density is equal for all densities, the effect is referred to as *subtractive* or *cutting* reduction.

SUBSTANTIVE This adjective describes a class of dyes that have an affinity for a substance without prior use of a mordant. A number of substantive diazo dyes are benzidine or diaminodiphenylamine derivatives, such as Congo red.

SUBSTANTIVE COLOUR FILM Integral-tripack colour film in which the couplers are incorporated in

non-wandering form in the emulsion layers during manufacture. Distinct from non-substantive colour films, which contain no couplers themselves but which must be developed in developers that contain the couplers (Agfa, 1937).

SUBSTRATUM A binding layer that helps the emulsion adhere to the film or glass support.
See also: *Subbing*.

SUBTRACTIVE COLOUR PROCESSES System of colour reproduction in which the reddish, greenish, and bluish thirds of the spectrum of a white illuminant are modulated by varying the amounts of cyan, magenta, and yellow colourants, respectively. The subtractive colour process is used in colour photography and in graphic arts reproduction.

SUBTRACTIVE REDUCER A subtractive reducer removes equal amounts of silver from all densities of the negative; thus, the contrast is not changed. Its use lowers the printing time for a negative without requiring a change in paper contrast. This type of reducer is also sometimes referred to as a *cutting reducer*, and is a type of subproportional reducer.
When a print is overexposed and then is treated with this type of reducer, an increase in highlight contrast results.

SULPHIDE TONERS Sulphide toners include a number of chemical procedures that change the normal black-and-white silver image of a print to one composed essentially of silver sulphide. The colour of the image is generally referred to as sepia, but it may cover a wide range, depending on the nature of the original silver image and the toning procedure. Sulphide toned images are more stable than untoned ones.
With some cold-tone printing papers it may be necessary to convert the silver image to a silver compound with a bleach-and-redevelop toner in order to obtain a satisfactory image colour.

SUPERADDITIVITY This name is given to the cooperative action in which two developing agents produce more silver from exposed silver halide materials than the sum of the silver developed by the agents used individually. The primary developing agent of the pair is thought to be strongly adsorbed to the silver halide grain and to be regenerated by the second agent. Metol-hydroquinone and Metol-Phenidone are examples of superadditive developing agent combinations.

SUPERCOAT Also *topcoat, overcoat*. A coating of unsensitized, sometimes hardened, gelatin on top of the

sensitive layers of any photographic material, primarily to prevent abrasion, which could occur when film or paper is wound in rolls, or transported through cameras, printers, processors, and projectors.

Films and plates for far-UV imaging never have a super-coat since gelatin would absorb UV radiation, nor do papers for the bromoil and similar processes, where it would interfere with the ink-acceptance of the image.

SUPERPROPORTIONAL INTENSIFICATION Super-proportional intensification produces large density increases in the dense (highlight) regions of a negative with little or no increase in the shadows, thus greatly increasing the contrast of the negative. It is appropriate for correcting negatives of a low contrast subject that have been underdeveloped, or other negatives in which high contrast is desired.

SUPERPROPORTIONAL REDUCTION Superpro-portional reduction occurs when the ratio of density loss is larger for the denser, highlight areas, than for the less dense shadow areas of a negative. The contrast is thus lowered, and the reducer may be referred to as a *flattening* reducer. This treatment is appropriate for negatives of a contrasty subject that have been overdeveloped.

SUPERSATURATED SOLUTION An unstable solution that contains more dissolved substance than a saturated solution at the same temperature. Crystallization of the excess dissolved substance will occur if nuclei are introduced. A small crystal of the dissolved substance or even dust may cause instant crystallization. Sometimes even a slight jar or shaking can cause a precipitation from a supersaturated solution.

SUPERSENSITIZATION The process by which the spectral response of dye-sensitized silver halide emulsions can be increased by the presence of a second dye, called a supersensitizer. This second dye may be spectrally sensitizing or nonsensitizing. A nonsensitizing dye can cause an increase in the spectral region not sensitized by the first dye, or it can cause an increase in the region of spectral sensitization that is greater than the sum of the effects of the dyes used individually.

See also: *Saturated solution.*

SUPPORT The material on which a photosensitive layer is coated. Transmissive supports such as films and plates are used for images that are to be optically projected or viewed by transmitted light. Reflective supports such as paper are used for images viewed by reflected light. Translucent supports such as milk-white plastics may be considered as either, depending on design. A given image on a translucent support will have about

half the contrast and density upon transillumination that it has upon reflection.

SURFACE (1) The sheen, texture, and tint of a printing paper. Sheen ranges from glossy to matt in several steps. The surface determines the range of tones a paper can produce; for glossy, smooth papers the luminance ratio may be above 100:1, whereas for matt, 30:1 or less. Its texture may range from smooth to rough in several steps. It may also have a discernible pattern impressed to resemble fabrics, such as silk, linen, or canvas. (As paper manufacturers supply fewer of these, other methods of achieving such surfaces on a smooth print are offered by firms making embossing equipment.) Tint is the colour of the support, not that of the image. Tint is most detectable in the highlights, image tone in the midtones and shadows. (2) Specifying a latent image that can be developed with a developer containing no silver halide solvent. It is believed that such an image is on, rather than within, the silver halide crystals. Also, identifying such a developer formulation. (3) In perception, an object seen in reflected light, distinguished from one seen as a source of light. The term *lightness* is applied to surfaces, *brightness* to sources.

SURFACE DEVELOPMENT A latent image is formed when silver halide emulsions are exposed to light. The image is invisible and undetectable by any means, except development, which destroys it. The unseen image is thought to be small clusters of metallic silver atoms aggregating at various sites in each exposed silver halide crystal. Those silver atoms on the surface of the crystal are called the *surface latent image*; all the others, buried just under the surface or deep in the interior, are the *internal latent image*.

The distribution of the latent image has been the object of intense study by many theoretical scientists. One investigator, G. W. W. Stevens, has found that many of the crystals in an undigested emulsion have only internal latent images. In conventionally chemically sensitized emulsions, given normal light exposure, internal latent images seemed to be formed only in those crystals that also had surface latent images. In practical photographic materials with long exposures of low light intensity, the latent image was situated mostly on the surface of the crystal, apparently because of the effectiveness of the chemical sensitization. With light of high intensity and short exposure times, more latent images were formed in the interior of the crystal.

Studies on the latent image distribution are based on the nature of two different kinds of developers: a surface developer that contains little or no silver halide solvent and a developer containing a silver halide solvent, such as sodium thiosulphate or potassium iodide. The solvent developer is used after all the surface latent image has

been removed by an oxidizing agent, revealing the contribution of the internal image only. The distribution of the latent image is thus being denied from the results given by two different processing solutions, and such results may be subject to differing interpretations and assumptions.

Various surface developers have been formulated with little or no silver halide solvency, often free of sodium sulphite. Ferrous oxalate, glycin carbonate, Metol-ascorbic acid, and Phenidone-ascorbic acid are examples of such surface developers. The ferrous oxalate developer consists of equal parts of (a) 25% potassium oxalate and (b) ferrous sulphate crystals (25 grams), and citric acid (1 gram) in 300 ml of water solution. A sulphite-free glycin (*p*-hydroxyphenylglycine) developer is composed of glycin (30 grams) and anhydrous sodium carbonate (45 grams) in 1000 ml of water solution. Another developer contains Metol (2.5 grams), isoascorbic acid (10 grams), sodium metaborate or Kodak (35 grams), and potassium bromide (1 gram) in water to 1000 ml.

Most modern developer formulations contain solvents for the silver halide crystals, as do solutions for revealing the internal latent image. This ensures that the maximum sensitivity of the photographic material is achieved. Physical development, that is, deposition of solubilized silver ions from the developer on the latent image, occurs, and this action can increase the size of the developed silver particles. Solution physical development may adversely affect the graininess and definition of the developed image.

The need to achieve every bit of emulsion speed has become less urgent as modern photographic materials with high sensitivities have become available. Lower graininess and higher definition are needed more as the negative image size has decreased, especially with the popularity of the 35-mm format. This need has led to sacrificing some emulsion speed by increasing surface development. Fine-grain development and high sharpness development are not possible with the same solution. A practical compromise, starting with today's finer grained photographic film, involves diluted developer solutions of low alkalinity. Such a high-definition developer is used once, then discarded.

Developers promoting surface effects can be made by dilution of a known formulation (such as Kodak developer D-76) or by using a special, one-use solution. A popular developer of this type is that of Willi Beutler, consisting of two stock solutions. Solution A consists of Metol (10 grams) and sodium sulphite (50 grams) in 1000 ml of water; solution B has anhydrous sodium carbonate (50 grams) in 1000 ml of water. In use, solution A and solution B (50 ml each) are added to 500 ml water. Many dilute variations of Metol-sodium sulphite and Phenidone-sodium sulphite developers have been made.

SURFACTANT Surfactants (surface-active agents or wetting agents) lower the surface tension of a liquid by

reducing the cohesive forces that hold together the molecules of the liquid. These agents act in the interface between a liquid and a solid or between two liquids. Surfactants are important in the coating of photographic emulsions as well as in the solutions for their processing. A typical use of a wetting agent in the darkroom occurs just before the film is dried after processing. The surfactant, such as Photo-Flo, helps the water run off the surface of the film rather than adhere in drops, which can cause spots.

SUSPENSION A suspension is a heterogeneous mixture of particles in a liquid that can be separated by filtration. Such mixtures separate into different phases when left standing. A colloidal dispersion is a suspension of very fine particles that do not settle. These colloidal particles have adsorbed molecules or electrical charges that keep the particles from settling.

SWELLING The increase in volume of gelatin when it is wetted with water or water solutions. Swelling facilitates the penetration of processing solutions but makes emulsions softer and more susceptible to damage.

TANKS AND TANK PROCESSING Tanks provide a convenient method for processing a variety of film types and sizes. Tanks are broken down into two basic categories—roll film and sheet film. They share the common feature of resistance to the corrosive nature of photographic chemistry.

Roll-film tanks come in a many sizes based on the film format and length. These range from single reel 35-mm tanks, to multireel 120/220 tanks, to a cylindrical tank for sheet film. Specialized tanks for processing cine and aerial film are available, although their use is not common except in commercial labs. For many years, stainless steel was the standard material for tank construction, but now plastics have become popular. Film reels have also followed a similar trend. Plastic tanks act as an insulator to keep the chemical temperature stable. Stainless steel tanks offer the ability to adjust chemical temperature during processing. Sound arguments can be made for the use of either material.

Roll-film tanks provide the convenience of daylight processing. Once the film has been loaded onto the reel, it is placed in the tank, which has a light-tight lid. The lid has a light-tight spout, providing a way to add and remove chemicals. Although not widely used today, 35-mm daylight load tanks are also available. These tanks allow the transfer of film from the cassette directly into the tank in full daylight.

Reels for roll film tanks have two basic designs: stainless steel and plastic. Stainless steel reels are spiral with a clip in the centre that grips the film. To load, the film must be gently bowed so that it will fit inside the reel. Once attached to the clip, the reel is slowly rotated while the film winds through the spirals. If too much pressure is used while winding, the film may come into contact with the layer below. When this happens there will be areas of the emulsion that will not be properly developed. This type of reel must be handled with care; any warping or misalignment of the reel will result in emulsion contact.

Plastic reels usually work in a ratchet fashion. One side of the reel is rotated back and forth on the connecting spindle. The film is started at the outside or top of the reel and is pulled inward by the ratchet action. This type of reel is popular because it requires less practice by the user. These reels are also quite sturdy and rarely suffer from warping.

Some plastic tanks are equipped with a stirring rod that provides agitation. More commonly used is a simple

inversion and/or rotation of the tank at the specified intervals. It is recommended that tanks be gently tapped after the addition of each chemical to remove any air bubbles from the film. Certain roll film tanks also provide the benefit of rotary processing in table top or drum processors. Consistent agitation and temperature control make this an attractive alternative to hand processing.

Sheet film tanks, commonly referred to as deep tanks, provide a method for processing multiple sheets of film. These tanks are usually made of hard rubber (ebonite) or stainless steel. The common sizes are designed to process 4 × 5-inch, 5 × 7-inch, and 8 × 10-inch film. Commercial labs may employ larger sizes designed for batch processing. Stainless steel hangers or racks keep each sheet of film from coming into contact with other films or the sides of the tank. These hangers are built in a variety of configurations to hold single or multiple sheets. When using 8 × 10-inch tanks, two 5 × 7-inch, or four 4 × 5-inch films can be placed in each multiple film hanger. Because the tanks are open, the processing must be performed in total darkness.

Agitation is performed by lifting the hangers or with gaseous bursts. Lifting the film holders by hand provides a simple method of agitation for smaller sized applications. The recommended technique is to immerse the hangers in the solution and gently tap them to dislodge any air bubbles. At one-minute intervals the hangers are lifted out of the tank and tilted at a 90 degree angle to the right. The hangers are quickly returned to the solution and the process is repeated with a 90 degree tilt to the left. The hangers are then left undisturbed until the next cycle. This helps to provide a random pattern to the agitation. Without sufficient random agitation, uneven processing or streaking of the films will occur.

Gaseous-burst agitation is usually employed in the more elaborate sink lines of commercial labs. An aerator tube at the bottom of each tank sends a burst of bubbles up through the chemicals, providing a random agitation pattern. Nitrogen is normally used to provide the bubbles because it is inert and does not oxygenate the chemicals. A timing mechanism is used to release the gas at the correct intervals. These *sink lines* also incorporate a water jacket for precise temperature control.

TANNING DEVELOPMENT Tanning is the hardening of gelatin, rendering it insoluble. Exposure causes tanning in potassium bichromate emulsions. In silver halide imaging, a tanning developer hardens the gelatin of the emulsion in proportion to the amount of silver deposited during development. The silver is removed by bleaching and fixing, and the unhardened gelatin is washed away in warm water. A relief image remains. Various transfer and relief processes, such as dye transfer, use matrix films processed in tanning developers.

TECHNICOLOR Colour motion picture process in which the final positive prints are made by dye transfer or imbibition. Introduced in 1915, its earliest form was a two-colour material exposed in a beam splitter camera. The original film was replaced by a bipack material that produced two-colour negatives. In the 1930s, Technicolor became a three-colour process with the availability of a beam splitter camera exposing a bipack film and a single emulsion film. Later, a three-strip Technicolor camera exposed three separate films at once. Cartoons were photographed on single strip film, three frames for each drawing, through tricolour filters to make the appropriate separations. In its final iteration, introduced in the early 1950s, the beam splitting cameras and the complexity of shooting a motion picture in Technicolor were replaced by conventional cameras and integral tripack negative film. The separations were made in a subsequent step.

In all cases, the three-colour final prints were made by imbibition printing in precise registration from yellow, magenta, and cyan matrices to a mordanted, gelatin coated "imbibition blank" film. A moderate density silver image was incorporated in the final print to enhance definition and shadow detail.

Although a few colour movies were made in the 1920s, and some were made even earlier by such processes as hand colouring each frame, Technicolor was the first commercially viable system for the production of colour motion pictures. In 1932, Walt Disney used it to make the animated short *Flowers and Trees*. The first feature film in Technicolor was *Becky Sharp*, released in 1935. Like the many Technicolor movies that followed, it consisted of more than 130,000 pin-registered, dye-transferred frames at the cinematic standard 24 frames per second.

See also: *Dye-inhibition; Dye transfer.*

TEMPERATURE A measure of the energy or heat present in a substance that considers primarily the molecular motion occurring in the substance (see *absolute temperature*). Temperature should be distinguished from energy or heat in that a given amount of energy input to two different substances will not necessarily raise the temperatures of the substances by the same amount. For example, a thermometer may read 20° C for a body of water and the surrounding air, but the water will feel much colder due to its greater ability to absorb heat from the body. The water and the air, however, will not exchange energy since they are the same temperature.

TEMPERATURE COEFFICIENT Factor by which the development time of a developer must be multiplied to compensate for a drop in temperature of 10°C (18°F). The figure varies according to the developer—usually from 1.25 to 2.8.

TEMPERATURE CONVERSION See *Appendix H.*

TENDENCY DRIVE A method of moving film through a processor or projector without the use of sprockets, with automatic control of film tension.

TENSILE STRENGTH That property of a material that prevents it from being torn or pulled apart. Tensile strength is important in photographic film base, which must keep its integrity while being run through photographic mechanisms. It is possible to have too much tensile strength. Apparatus-handling polyester films often contain mechanical devices to relieve excess stress in case of malfunction, lest the great tensile strength of the film destroy the machine. High wet strength of photographic papers is essential for the processing of long rolls in continuous processors.

TEST (1) An experimental procedure used to obtain specific information about a material, process, or device, such as a lens resolution test and a chemical test of a developing solution. (2) In picture making, a preliminary trial to check the components of a system, such as exposing and processing a short length of film before beginning production on a motion picture.

TEST PAPER Strips of absorbent paper that have been impregnated with chemicals for making quick tests of the approximate chemical condition of a photographic solution. Test papers can indicate the degree of acidity or alkalinity of a solution, or test strips can be employed to detect the presence of silver ions.

TEST STRIP An exposure series on a single piece of photosensitive material, used especially in projection printing, made to determine the correct exposure time and to check other image attributes such as contrast, colour balance, and sharpness. By exposing through a transparent device that contains a calibrated neutral-density step tablet or set of colour filters designed for testing purposes, the desired variations can be introduced using a single exposure time. There are also test strip holders that allow for testing the same area of the image, such as a person's face in a portrait, by moving the light-sensitive material under a stationary aperture.

T-GRAIN Tabular grains (T-grains) of silver halide in photographic emulsions have a high surface-to-volume ratio that provides increased sensitivity, reduced granularity, and increased sharpness in the developed silver image. The thin, flat plates of T-grains, when coated, provide a high photon cross-section area per unit volume of silver halide.

THERMAL COEFFICIENT The change in a characteristic of a material per degree change in temperature. The thermal coefficient of expansion is of importance in the design of a camera film holder to accommodate temperature changes.

THERMOMETER A device for measuring temperatures, as for example, of photographic solutions. Basic types include the following. (1) A glass tube partially filled with a liquid such as mercury or alcohol. As the temperature rises, the liquid expands and the liquid level indicates a position on a scale. This type of thermometer tends to be fragile, and mercury thermometers are not permitted in some labs because of the danger of contamination of photographic materials with mercury from a broken thermometer. (2) Bimetallic thermometers, based on the difference in thermal expansion of two metals bonded together in the form of a coil. A temperature change causes an expansion or contraction of the coil, which produces movement of a pointer near a scale. (3) Bimetallic thermometers based on the thermoelectric effect, whereby heat is directly converted into electric energy. Electronic thermometers normally provide a digital readout, and those equipped with cords allow the display to be located some distance from the sensing probe, which may of necessity be in a dark area. (4) Infrared-sensing thermometers, whereby measurements are made from a distance by aiming an optical probe at an area of interest. The heat energy radiated by the selected area of the object is focused on a heat sensor, and the temperature is presented on a liquid crystal or other digital display. This type of thermometer can be used, for example, in manufacturing operations involving molten glass or metal.

Thermometers used to monitor photographic processing must be instruments of great precision.

THERMOSTAT A temperature-sensitive switch. A common type utilizes a bimetallic strip that bends under the influence of temperature. The movement of the strip either directly closes or opens a set of electrical contacts or actuates a sensitive snap-action switch. The latter type is preferred, especially for dc circuits, because the contacts open and close fast and thereby reduce the damaging effects of arcing that occurs with creep action thermostats. The temperature at which the thermostat operates when the temperature is rising is different from when it is falling. The difference between these temperatures is known as the temperature differential. The smaller the differential, the better the ability of the thermostat to maintain constant temperature by reducing the size of the overshoots.

THRESHOLD EXPOSURE The minimum exposure given to a photographic material that produces a

just-noticeable increase in density above the base-plus-fog density that is produced with no exposure.

TIME-CONTRAST INDEX CURVE A plot of the contrast index (the average slope of a D-log H curve over the most-used portion) versus time of development. Such a graph is useful for determining the necessary time of development for a desired development contrast.

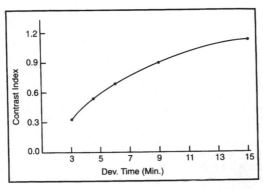

Time-contrast index curve. The change in contrast index with time of development.

TIME–GAMMA CURVE A plot of the slope of the straight line of a D-log H curve versus time of development. Formerly such a graph was used to determine the necessary time of development for a desired film straight-line contrast.

TIMER A device used to monitor the duration of activities such as photographic exposure and processing. Features found on various timers include the automatic control of printing exposure time, turning a safelight off when an enlarger is turned on for focusing, and emitting audible signals at selected times. Some electronic timers can be programmed to time a sequence of processing steps of varying durations.

TIME-TEMPERATURE (1) Specification of development by objectively measured factors, as compared with development by inspection. In the first case, one processes, for example, for 5 minutes at 20°C, other factors being constant; in the second, one processes until the image appears correct. (2) Followed by "*chart,*" a graphical means of finding the correct time of development at a temperature other than standard.

TIME-TEMPERATURE CURVE A graph showing the relationship between the time of development for a

fixed film contrast and the temperature of the processing solution. In situations in which the processing temperature cannot be brought to standard, the graph assists in finding the correct development time at a nonstandard temperature.

TINTING The practice of colouring prints, positives, lantern slides, or even black-and-white or colour negatives, usually with dyes or photo oils. The effect is most clearly discerned in highlight areas and of little consequence in shadow areas. Daguerreotypes were often hand tinted in a pseudo-realistic manner. Later, tinting was commonly designed to counterfeit the impression of colour material. With the development of accurate colour processes, tinting has become, typically, more disjunctive in its intent.

TINTYPE Popularly accepted name for the ferrotype. Originally, in the 1850s, its black lacquered plate had a wet collodion emulsion, replaced in the 1880s by dry gelatin. It played a substantial role in the democratization of photography.

TONE (1) An area of uniform luminance or density in a subject or image. A high-contrast image might have only two tones, black and white, and gray scales have a limited number of tones, such as ten, whereas most subjects and continuous-tone images have many tones. (2) A slight hue in a monochrome image, such as warm-tone (brownish) and cold-tone (bluish). (3) (Verb) To chemically alter the hue of a photographic image.

TONE-CONTROL PROCESS The aim of tone control is to produce a range of densities in the final product that is either subjectively appropriate or objectively correct. To achieve this end, the original exposure may be biased to enhance highlight or shadow detail. The conditions of development may be altered, as may printing material and technique, and enlarger characteristics. Intermediate negatives and positives and masks of various types may be used to alter specific tonal values. Viewing conditions have a substantial influence on perceived tone representation.

TONERS Colourants used in xerography. Dry toners are comprised of a colourant in a resin binder. Depending on the application, additional components may include additives to control the charge level, surface additives to control flow and cleaning, and waxes to aid toner removal from the fuser roller. The most common colourant is carbon black. For colour applications, phthalocyanines are used for cyans, azo compounds for yellows, and quinacridones for magentas. Charge-control agents are added when the toner does not have either an adequate charge level or rate of charging. Low-molecular-weight

waxes are frequently added to prevent adhesion of the toner to the fuser roller during fusing. In liquid toners, the colourant is dispersed in a nonconducting liquid. The colourant is usually a colloidal dispersion of pigmented resin particles. A wide range of aliphatic and aromatic hydrocarbons, chlorofluorocarbons, and selections can be used as dispersants. To control the surface charge, ionic surfactants or metal soaps are frequently added.

TONERS/TONING

With few exceptions black-and-white silver prints have a colour approaching neutral. The image can be chemically modified to achieve a more pronounced colour that is more appropriate for the aesthetic effect desired. This post-printing process is known as *toning*, and a wide variety of toner formulas have been concocted over the years.

Toning Methods A *direct toning* formula converts the metallic silver image to a compound of silver that is coloured. *Indirect toning* involves first converting the silver to a halide by means of a *bleach*, then *redeveloping* it with a solution that converts the image to a silver and metal compound having the desired colour. *Double toning* procedures involve toning by one method followed by a second treatment to produce a colour that is different from that produced by either of the formulas alone. *Area toning* is achieved by blocking off part of the image with a protective coating such as rubber cement or a *frisket*. The unprotected area then responds to the toner, after which the coating is removed. *Dye toning* involves converting the silver image to a mordant, a compound that attracts dye from a solution with which the print is treated. While it does not come under the heading of toning, *dyeing* of the entire print is sometimes used alone or in conjunction with a toner to produce a desired effect.

Toning Formulas Sepia toning is one of the most common methods, usually incorporating the compounds of sulphur, selenium, and sometimes mercury, or gold in various combinations. The resulting tone is usually considered to be more stable than the silver image alone, and selenium and gold toning, even if not carried to completion, have been used to produce archival prints.

Toners using other elements such as iron, copper, or uranium produce compounds with little or no silver that yield pleasing blue or red colours, but these images are not as stable as the silver images alone. The stability of dyed images depends to a great extent on the particular dye used, but in general, dyes are less stable than the metallic compounds.

Standardization The tone achieved with a given formula is influenced by the type of paper used for making the print and its processing. Therefore, to achieve consistent results, it is necessary to standardize these factors. A single choice of paper should be made, and the processing should be carefully standardized. The final tone is modified by the choice of developer, the length of time of

development, and the degree of exhaustion of the developer. For uniform results, the exposure should be such as to require a specific developing time, and the developer should be renewed often.

It is wise to make a number of prints from a representative negative and tone them by the methods one is considering. Such a set of toned prints can then be used to select the toning method that will produce a given desired result.

Problems Problems with toning arise from improper choice of sensitized paper, inadequate control of processing of the print, and inadequate fixing and washing, where required. Some procedures leave the emulsion less hardened than with ordinary processing and it may tend to be easily abraded before drying. Also, heat drying often changes the colour of the toned image considerably. To avoid this, prints should be air dried at room temperature.

TONGS A pickup tool, commonly made of stainless steel or plastic, used to handle prints during processing so that the hands can remain dry.

TOOTH (1) Receptivity of a surface to retouching media, such as ink or pencil. Photographic materials lacking tooth may be improved in this regard by the application of retouching fluid. (2) A pointed projection on a sprocket wheel that engages a film perforation to transport the film at a controlled rate through a mechanism.

TOXIC PHOTOGRAPHIC CHEMICALS Certain photographic chemicals have a harmful effect on human health if the chemical is breathed, swallowed, or absorbed through the skin or eyes. Toxic chemicals may have a local effect at the point of contact or a systemic effect at a site different than the point of contact. Some photographic chemicals known to be harmful to human beings include cyanides; chromium, mercury, and thallium salts; aldehydes; poisonous gases and vapours from ammonia, iodine and sulphur dioxide; and strong acids and bases. Some amino-containing developing agents, such as p-phenylenediamine and its derivatives and toners such as selenium may cause contact dermatitis, an inflammation of the skin, in susceptible individuals.

See also: *Poisons.*

TRANSFER, IMAGE Any process by which an image is removed from its original support and transferred by contact to a new backing. Examples include the dye transfer and diffusion transfer processes.

TRANSFER PRINTING PROCESSES Refers to wide variety of printing processes including: oil, bromoil, pigment, dye transfer, acrylic, and solvent transfers, that literally *transfers* an image from one support to another. In early photographic literature the term referred to inked

images that were transferred to a gelatin coated paper. The main reason for their popularity is the forming of the image in light-sensitive materials that are decidedly more permanent than silver.

TRANSFER PROCESSES Processes involving the transfer of an image from one emulsion or support to another. The transfer often involves physical reversal (left—right) and may involve tone reversal (negative—positive). There is a variety of such processes working on fundamentally different principles and used for a wide range of purposes. They fall into the following general groups: chemical image transfer, physical image transfer and emulsion transfer.

Chemical image transfer: the image is transferred by chemical diffusion from one emulsion layer to another placed in intimate contact with it. The image is in fact generated in the second emulsion; the only physical movement taking place is that of the chemicals generating the second image. The latter may be silver (as in various reversal transfer processes) or hardened gelatin (as in bromoil, carbro, and similar processes).

Physical image transfer: most of these processes involve the transfer of a pigment or dye image absorbed or adsorbed on a gelatin matrix to a plain or gelatin coated paper or similar support. Examples are bromoil transfer (pigment ink), dye transfer (dyes), and various photomechanical and document copying processes.

Emulsion transfer: here the whole emulsion or a gelatin matrix is stripped from one support and transferred to another. This may be necessary with many matrix processes in order to obtain a laterally correct image—i.e., one that is not reversed left to right or to ensure that the matrix has a firm support e.g., if the gelatin of the matrix is hardened from the top, the gelatin next to the support would be dissolved on development so the whole layer must be transferred to a temporary or permanent support first.

Another application of emulsion transfer is the preparation of photographic templates. Here the unexposed emulsion is transferred on to the material to be worked, and exposed and developed there.

TRANSMITTANCE (1) Same as transmission factor, especially as applied to light. When applied to light, the radiation can be measured in terms of the energy incident and transmitted, or in terms of the light incident and transmitted (irradiance with and without the sample, or illuminance with and without the sample). It is also frequently useful to determine transmittance as a function of wavelength, or with respect to a particular source. (2) For a film sample or filter, the ratio of the luminous flux passing through a sample to the flux it receives. $T = I_t/I_o$, where I_t is the light level after it has been affected by the sample and I_o is the initial light level. Transmittance is the reciprocal of the opacity.

TRANSPARENCY An image, usually positive, on a transparent or translucent base, intended to be viewed directly by transmitted light or indirectly as a projected image, or to be reproduced photographically, photomechanically, or electronically. Photographic images on transparency film have a considerably larger density range than photographic images or reproductions on white opaque bases, so that the luminance range of transparency images viewed directly or by projection, under the proper viewing conditions, is closer to that of the subject, thereby producing a perception of greater realism.

TRANSPARENCY MATERIALS Photographic materials on a transparent support for making positive images either for direct viewing or for projection. In current usage *transparency material* is virtually synonymous with *colour reversal film*. For still photography other forms of transparency materials include colour negative print films, black-and-white print films, direct positive films, direct reversal films, and projection (formerly lantern) slide plates. Some confusing nomenclature causes ambiguity: (1) A material labelled *positive* may actually be a negative-working material with characteristics designed for printing from an existing negative. (2) The image on a reversal material is not reversed, it resembles the original in tone (and if colour, in colour). Most of the early photographic processes produced negative images, which had to be printed onto another negative material to produce a positive. A material in which the original negative image could be reversed to a positive without reprinting was called a reversal material.

Colour transparency materials may be divided into positive- and negative-working films. Positive-working films are the reversal films that form the positive image in one step, using a reversal process, for example, Kodachrome, Fujichrome, Agfachrome. Negative-working films are printed from existing colour negatives, for example, Ektacolor slide film. These print films, unlike most colour negative films, have no coloured masks.

Because unprocessed nonsubstantive emulsions are free from colour-forming agents, their granularity is very low. This aspect and their high resolving power made these films, particularly Kodachrome, for many photographer s the reference standard of image quality. Substantive films, those with incorporated couplers, especially the very early ones, were considerably lower in resolving power and higher in granularity, but because more technology was built into the film, the process could be much simpler. Early Agfacolor transparency (later called Agfachrome) and Ektachrome films were of this type. Present-day incorporated-coupler films can be processed by the user in about 30 minutes using only four solutions. In recent years with the introduction of new incorporated-coupler films by Fuji, Agfa, Kodak, and others, the gap of quality between

the incorporated-coupler and the Kodachrome films has been narrowed to the point of virtual disappearance.

Black-and-white transparencies may be made by printing existing negatives on a film such as fine-grain positive, a negative-working film despite the name. For glass slides in either 2 × 2 inch or lantern size, 3-1/4 × 4 inch (American) or 3-1/4 × 3-1/4 inch (British), projector slide plates are used. For slides without negatives, a conventional negative film may be reversal processed, or one of several special films may be used. These last have special emulsions that give a positive image with ordinary develop-stop-fix processing. They are made in normal and very high contrasts, and have ISO speeds of far less than one.

The filmstrip is a transparency format used mainly in elementary and secondary education. It is an economical medium when a large number of copies of a multi-frame program are to be produced. A negative printing master is usually formed into a loop and printed on a motion picture printer.

TRAY PROCESSING A method of processing exposed sensitized materials by immersing, in sequence, in a series of processing solutions in shallow containers. With a single sheet of film or printing paper, agitation may be provided by lifting and reimmersing the film or paper, or by lifting the edges of the tray to produce movement of the solution, preferably in alternating directions. With multiple pieces, a common procedure is to continually remove the bottom sheet and reimmerse it on top.

TRIACETATE See *Acetate film base*.

TRIBOLUMINESCENCE The transformation of mechanical energy (such as friction) to light at low temperature (below those required for incandescence). A common example of triboluminescence is the light produced by removing some kinds of adhesive tape from surfaces in a darkroom.

TRILINEAR PLOT A graphical display used to show the direction and extent to which the colour balance of an image differs from that of an aim point, typically a neutral, using a grid containing three sets of parallel lines placed at angles of 120 degrees to each other. The three lines that radiate from a central aim point represent red, green, and blue additive primary colours. Extensions of these three lines beyond the aim point represent cyan, magenta, and yellow subtractive primary colours. The plot can be used, for example, for quality control purposes in colour processing and printing labs. Densitometer readings made with red, green, and blue light provide the data needed for plotting.

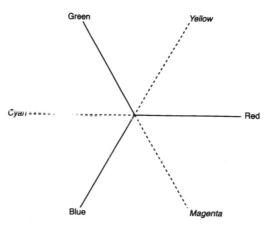

Trilinear plot

TROPICAL PROCESSING Identifying processes (especially developing and hardening) designed to prevent excessive softening of the emulsion (and possible damage) when processing film at elevated temperatures, as under tropical conditions.

TUBE PROCESSING See *Agitation; Pipe processing.*

TUNGSTEN A metallic element with a high melting point that makes it the primary filament in tungsten and quartz-halogen lamps. Carbon, which has a higher melting point of 3700°C compared to 3410°C for tungsten, was an early filament but evaporates rapidly and was discarded when a method of softening and moulding tungsten was discovered. Spectral energy varies with temperature of the heated filament but it has useful radiation intensities through the visible spectrum. Also used as an adjective— e.g., tungsten lighting, tungsten films.

TURBIDITY Cloudiness. Especially, that characteristic of a photosensitive layer that causes scatter of exposing energy in that layer and has the effect of reducing sharpness.

TURBULATION The type of agitation produced by nitrogen-burst (gas-burst) units where bubbles of gas are released at intervals through a grid of tubes at the bottom of a processing tank.

TWO-BATH DEVELOPMENT A method for reducing the overall contrast of a negative by using two separate stages of development. In the first stage the film emulsion

is saturated with developer, and in the second stage the film is placed in a water or alkali bath where the development is allowed to continue to exhaustion of the developer.

Water-bath Development In the first stage, the developer is allowed to soak into the film emulsion, and then the negative is transferred to a water bath solution and allowed to rest with no agitation. Because there is only a fixed amount of developer absorbed by the negative from the first bath, the developer in the areas of high exposure (highlights) become exhausted more rapidly than those in the areas of low exposure (shadows). With no agitation and no fresh developer, the reaction products of development (especially in the high exposure areas) restrict and exhaust development. In the meantime, the areas of low exposure are still developing. The result is a negative in which contrast has been compressed, with less density in the highlights and normal density in the shadow areas.

This process does not work as well with newer emulsions that are thinner and therefore do not absorb as much developer. However, the process should work well with special films that have a thick layer of emulsion such as x-ray film.

Water-bath development can also be used to lower the contrast of prints made from very contrasty negatives. To obtain a noticeable effect in practice, it is necessary to use a hot water bath for prints, transferring the print to the water bath as soon as an image begins to appear.

The effect of water-bath development depends on the amount of development allowed to take place in the first developer stage. The sooner the negative or print is transferred to the water bath, the greater the compression of the highlight densities.

Alkali-bath Development Similar to water-bath development in principle and practice, in alkali-bath development the developer contains little or no alkali and the water bath is replaced by an alkali bath, such as a 1% solution of borax or sodium hydroxide.

A suitable first bath is a metol-hydroquinone developer made up at about 2 to 4 times its normal strength with little or no alkali. The film emulsion is allowed to soak in the developer, but little development occurs until the negative is placed in the alkali bath. As development proceeds, the heavily exposed areas of the negative exhaust at a much faster rate than the shadow areas. The result is a negative in which development of the highlight areas has been reduced without reducing development of the shadow areas.

One of the advantages of the alkali-bath method is that neither time nor temperature is critical. Immersion in the first bath should last about 3 to 4 minutes, after which there is little to no increase in the amount of developer absorbed by the film emulsion. The time in the alkali bath should be about the same. By that time most of the devel-

Water
Bath

Developer Water

Alkali
Bath

Developer Alkali

Two-bath development. Two methods of water bath development.

oper has been exhausted or has diffused out of the emulsion, and extended time would only tend to soften the emulsion. Since development stops automatically, the negative cannot be overdeveloped. Fresh solutions should be used each time film is processed.

Fine Grain Two-bath Development Fine grain developers such as D-76 and D-23 can be used for two-bath development with a borax or Kodak solution as the second (activator) bath. Ansel Adams tested Tri-X sheet film developed in D-23 followed by an immersion in a 1% solution of Kodak. His procedure was to immerse the film in D-23 for 2 to 3 minutes with constant agitation The film was then placed in the Kodak solution for a minimum of 3 minutes with no agitation. The result was a very soft negative with fully developed shadow areas and a slightly higher than normal filmbase-plus-fog density level.

Books: Adams, Ansel, *The Negative*. Boston: New York Graphic Society, 1981.

TWO-BATH FIXATION The use of a pair of tanks or trays of fixing solution, the second of which is relatively fresh. When the first bath is near exhaustion, it is replaced by the second, and a fresh bath is then used for the second treatment. The method improves the keeping characteristics of prints, especially, and is more economical than the use of a single bath.

ULTRASONIC CLEANING Sound waves having frequencies far above the audible range, generated in a liquid to provide efficient cleaning action on films. Frequencies and energies chosen are limited since high frequencies at high power can be dangerous and destructive.

UNDERDEVELOPMENT Processing film or paper for too short a time, at too low a temperature, with insufficient agitation, or in a weak or nearly exhausted developer. The effect is lower-than-normal image density and contrast, and sometimes lower effective film or paper speed.

UNEVENNESS Unevenness refers to variation of density in an area that represents a uniform subject tone or a variation of colour in an area that represents a uniform subject colour. While often less easily detected, it may modify areas of modulated density and colour.

Unevenness of a processed photographic image may be due to a number of causes. The defect is often masked by detail in images of scenes that do not contain large areas of uniform tone. Other subject matter may be very critical of this kind of defect. One cause of unevenness is improper agitation of the film during processing. Another cause might be the presence of a film of oil or other water-repelling material on the surface of the film at the time it is processed. A malfunctioning camera focal plane shutter may cause uneven illumination across the film plane.

When the film is printed, an improperly adjusted enlarger or contact printer may be the cause of uneven illumination of the sensitized material at the time of exposure.

USEFUL LIFE The length of time during which a device or processing solution can be used with only unimportant loss of quality. For example, the useful life of a tungsten lamp is approximately half its total lifetime to burnout.

VALENCE Valence is the combining capacity of an element or a radical (group of atoms of elements acting inseparably) to unite with other elements or radicals to form molecules. Valence is essentially the number of single bonds that an atom or radical can form. An atom of oxygen combines with two atoms of hydrogen to form water. Oxygen is said to have a valence of two. Hydrogen has a valence of one.

VALENCE BAND The lowest-energy band of a crystal that is filled with electrons. Electrons are promoted from this band to the next higher band, either by thermal radiation or absorption of photons.

VARNISH See *Protective coatings.*

VISCOUS PROCESSING Application of chemical agents in a thick fluid, used in some soundtrack development and in some rapid-access photography.

WARM-TONE An image that is slightly brownish, reddish, or yellowish, as distinct from neutral or cold-toned—slightly bluish.

WARM-UP Refers to the time required for equipment or material to reach a stable condition before use. Depending on the size of film and paper packages, several hours may be required to reach room temperature after removal from refrigerated storage. Some electronic densitometers may need a 30-minute warm-up time for all of the components to stabilize at a constant operating temperature.

WASHED-OUT Identifying an image or area of an image that appears to have too little density. Thus, a washed-out highlight would lack detail, and a washed-out print would appear to be too light in all areas.

WASHERS AND WASHING Although plain water is not involved in any of the chemical reactions that occur during the processing of photographic films and papers, it does perform important processing functions. Rinsing and washing are used to prevent the contamination of subsequent baths and to ensure the complete removal of any chemicals that could attack the image, the emulsion, or the base of a photographic negative or positive.

 RINSING BETWEEN PROCESSING STAGES It is advisable to use a rinse between some processing steps to avoid contamination from one bath to another, especially between developer and fixer. This process not only greatly reduces the risk of staining in the emulsion, it also prolongs the life of the subsequent processing solution. For production processing, acetic acid is normally added to the rinse to neutralize the alkaline carry-over developer. (See also: *Stop bath.*)

 FINAL WASHING Final washing is performed after all the other processing steps to ensure image stability. The removal of residual silver complexes and thiosulphate (hypo) through washing after fixing is a diffusion process. If the fixing bath is fresh, most of the silver complexes will diffuse out of the emulsion during fixation. Washing is therefore mainly concerned with the removal of residual thiosulphate. Hypo diffuses out of the emulsion until the water has the same thiosulphate concentration as the gelatin. If no fresh water is supplied, the diffusion process stops. It is therefore absolutely necessary to ensure a fresh water supply until the thiosulphate concentration in the

emulsion falls below the level required for the desired image stability. The diffusion process with film and RC-paper is exponential, which means that most of the thiosulphate is removed in the early stages of washing. With fibre-based paper, the rate of washing is determined by the removal of the residual hypo from the base, which is a longer process. The thiosulphate ions have to pass through the cell walls of the paper fibre, which are usually protected by sizing material. The washing rate depends on the nature and thickness of the paper, double-weight paper taking longer than single-weight.

If an excessive amount of residual silver complexes are left in the emulsion of a photographic material, they would soon decompose and cause brown stains, which would first be seen in the highlights. Residual thiosulphate reacts much slower, but eventually attacks the silver image, transforming it to silver sulphide in the presence of air. It is impossible to remove all thiosulphate, so washing is usually continued to the point where the remaining thiosulphate concentration in the emulsion does not exceed the limit for the desired image stability. In general, the allowed concentration is less for paper than for film material, as paper emulsion usually are thinner and the silver images consist of finer particles. (See also: *Image permanence*.)

WASHING WITH SALT WATER Films and papers can be washed in seawater, which actually speeds up the removal of residual hypo. Tests have shown that under similar conditions, film needed only about one-third and paper one-fifth of the normal washing time necessary with fresh water. However, to prevent any chemical reactions harmful to the image caused by the sodium chloride in seawater, the material should be washed for 2 to 5 minutes in fresh water at the end.

WASHING AIDS Thiosulphate removal can be accelerated by the use of hypo-clearing agents and made more complete with hypo eliminators. Hypo-clearing agents consist of a salt that acts on the thiosulphate, replacing it with a radical that is more easily washed out. A 2% sodium sulphite solution has proven to be very effective, but other salts such as sulphates and citrates could also be used. The material is rinsed thoroughly to remove any fixing solution, then soaked for a few minutes (2 minutes for film, 3 minutes for paper) in the washing aid, followed by a wash. The washing time can thus be reduced to about a third of the normal time.

Hypo eliminators oxidize the residual thiosulphate to sulphate, which is more easily removed by washing. They are used at the end of the washing process to remove the last traces of thiosulphate. They are usually only used with fibre-based paper.

CHANGES OF WATER Where no running water is obtainable or where water is scarce, films and prints can be washed satisfactorily in successive baths of fresh water.

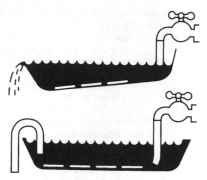

Washing sheet film negatives

The tray or tank is emptied, drained, and refilled with clean water at intervals of about five minutes. This process has to be repeated 4–5 times for RC-paper. 8–10 times for films, and 12–15 times for fibre-base papers, if no hypo-clearing agents are used.

WATER TEMPERATURE The higher the water temperature, the faster the residual thiosulphate is removed. A change in temperature from 18.5°C (65°F) to 26.5°C (80°F) decreases the washing time of film by about 15%. However, to avoid any excessive swelling of the gelatin and possible reticulation, sudden changes in temperature should be avoided.

FIXING The composition of the fixer, the rate of exhaustion, and the fixing time have an influence on the required washing time. Films and papers fixed in acid-hardening fixers usually require longer washing. The silver complexes obtained when fixing in an exhausted solution are much less soluble and are harder to remove. If the fixing time is too long, more thiosulphate is absorbed in the paper base, necessitating longer washing. (See also: *Fixing*.)

WASHING TIMES The washing times of photographic material are dependent on many factors, including water temperature, water composition, desired image stability, washing system, and the use of washing aids. Generally, the following times ensure sufficient washing for commercial use, using running water and moderate water temperature, with and without washing aids:

	Without Hypo-Clearing	With Hypo-Clearing
Films	20–30 min	5 min
RC-paper	4 min	Not rec.
Single-weight fibre-based paper	60 min	10 min
Double-weight fibre-based paper	120 min	20 min

Washing roll film

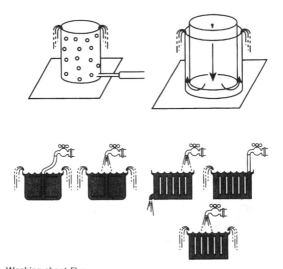

Washing sheet film

It is important to remember, however, that the washing time effectively starts after the last print or film is put into the wash water. Subsequent additions of material recontaminate the wash.

TEST FOR EFFICIENT WASHING To determine the effectiveness of washing, the residual thiosulphate concentration is measured. This procedure tends to be rather complicated and inefficient in production environments. For an approximation, a drop of acidified silver nitrate can be placed on an unexposed area of a print or film. Silver nitrate reacts with thiosulphate to form a yellowish-brown stain of silver sulphide. The darker the

ensure that no pockets of water remain stationary. The rate of flow has to be adjusted so that the whole volume of water renews itself every three to five minutes. The renewal time can be easily tested by adding one-half to one ounce of deep-coloured dye or a potassium permanganate solution to the washing tank and measuring the time required for the colour to disappear.

If the washing apparatus is not designed to keep the films and prints separated, such as with tray washing, the rate of flow must be sufficient to cause enough movement and turbulence to keep the material separated and to guarantee that fresh water is continually supplied to the whole surface of the material being washed. The stream of water should never flow so rapidly as to damage the film or print.

The size and depth of the washing apparatus is very important and should be selected according to the quantity and size of the films or prints to be processed. They must be allowed to move freely and separately.

Small particles of grit or other solid matter present in the water supply should be filtered out before the water enters the washer.

Washers should be cleaned periodically to remove the slime that tends to accumulate at the bottom. The use of normal household detergent is usually sufficient to remove any stains.

PRINT WASHERS If only a few prints are processed, they can be washed by placing them in a try or sink of clean water that is emptied and refilled periodically. Siphons that can be attached to the processing tray or plugged into the drain of a sink insure automatic draining whenever the water reaches a certain level.

As the sink or tray fills up, the water level also rises in the open arm of the siphon. When a certain water level is reached, the water starts emptying through the tube. The draining continues as long as the opening of the siphon is below the water surface. If the water level falls below the siphon opening, the flow stops and the cycle starts again.

To ensure that the prints do not bunch together, fresh water can be supplied by a perforated pipe at the bottom of the sink. The pipe should be placed at an oblique angle to the sink and the water velocity should be relatively high to ensure a swirling and uplifting motion.

Depending on the volume and sizes to be processed, commercial print washing tanks are produced in different sizes. The water enters in a series of jets at the bottom of the tank, preventing the prints from sticking together and ensuring a constant flow of water over the surface of the prints. A siphon automatically drains the tank every few minutes.

Cascade print washers consist of two or three trays, arranged so that the water flows from one tray to the other. The prints are first placed into the bottom tray and then transferred against the stream of water, receiving

cleaner water as they proceed. Cascade washers are also available with jet water distribution to allow for a greater circulation of water.

Another print washing system consists of a tank where prints are kept separate by inserting them into a rack. In some, the water flows in at the top and drains at the bottom. The constant in-flow causes the rack to rock backwards and forward keeping the prints in constant motion and ensuring a continuous fresh water supply. In others, water enters at the bottom through aerator pipes and the rising bubbles agitate the prints.

A self-agitating cylindrical tank that relies on the velocity of the incoming stream of water to keep the prints in constant movement has a water pipe that is wound around the tank so that the jets of water enter from all sides and move the prints around. As the water is moving constantly, there is no need for a siphon, the excess water overflows into the sink. This type of tank has the advantage that it is always full, and there is no danger of the prints being crumpled by the siphoning off of the water. Another version of this design incorporates a stationary water inlet and a perforated rotating cylindrical drum. The water pressure from the inlet or a motor may be used to keep the drum in motion, thereby agitating the prints.

Automated print processors usually allow for more efficient washing and correspondingly shorter washing times. The water temperature can be better controlled and the prints are efficiently separated, allowing free access to the wash water. Squeegees may also be used to remove the excess fixing solutions from the print surfaces before they are transported into the wash section of the processor.

WASHING AID Typically, a sodium sulphite solution used as a rinse after fixing and before washing that increases washing effectiveness without reacting with the hypo or other fixing agent.

WASHING TEST A means of determining the extent to which the fixing agent has been removed from prints and films in the washing step. Silver nitrate in the test solution combines with sulphur in residual thiosulphates to form a brownish silver sulphide stain that can be compared with a standard set of colours.

WASH-OFF Exposure decreases the solubility of some materials. In the 1820s, Niépce recorded images on bitumen of Judea which, upon exposure, becomes insoluble in oil of lavender. Unexposed areas wash away. Early incarnations of the dye transfer process used separation positives made by the wash-off relief process.

WASTE DISPOSAL In photography, waste disposal refers primarily to getting rid of used processing solutions

in an environmentally safe manner. This is especially important for labs that process large volumes of photographic materials, but all photographers should be familiar with and adhere to local codes. Some processing solutions can be replenished or otherwise rejuvenated to extend their useful lives.

WATER Although water is not an active ingredient in most photographic chemical reactions, it is the most universal solvent for photographic solutions; it serves an important function in swelling the emulsion gelatin in sensitized materials to facilitate processing; and it is essential for the removal of processing chemicals from films and papers. The water supplied by municipal water systems is almost always sufficiently pure for most photographic purposes. Additional treatments that may be desirable or necessary in some situations include: (1) temperature control, to heat or cool the water to a temperature that is within acceptable limits, (2) filtering, to remove solid particles, (3) purification, by means of softening, deionizing, or distilling.

WATER BATH DEVELOPMENT Method for reducing contrast during the development of black-and-white negatives or prints. After a reduced period of development, the negative or print is placed in a tray of water for up to 4 minutes without agitation. The water bath permits the developer to become exhausted in the high density areas, the highlights of the negative or the shadows of the prints, while development continues and details are enhanced in the low density areas, the shadows of the negative or highlights of the print. Prints may be observed under safelight for the duration of this process, but panchromatic films must be examined by safelight at a considerable distance for short periods. The process may be repeated several times before sufficient density is generated. Agitation in the water bath would wash developer out of the emulsion, ending differential local development.

WATER-BATH TEMPERATURE CONTROL Surrounding a tray or tank of solution in which film or paper is being processed with a larger tray or tank of water at a control temperature. For example, if film is being processed at 20°C, then the water-bath temperature would be the same to help keep the developer at that temperature.

WATER JACKET See *Water-bath temperature control.*

WATERPROOF PAPER A precursor to resin-coated (RC) papers developed during the Second World War for military purposes, used where rapid access was needed, or where washing water was scarce. The fibre base was

426

impregnated with a lacquer. It is now discontinued in favour of RC paper, which provides the same advantages of rapid processing and drying, with a more paperlike feel.

WATER SOFTENER Any of a group of substances that cause calcium and magnesium ions in water to precipitate or change their usual properties, thus rendering the water more suitable for some uses.

WATER SPOT See *Drying; Drying mark.*

WAX ADHESIVE Wax may be used as an adhesive for pasting up artwork, text, and photographs, and for positioning mechanicals for reproduction processes. Hot melted wax is applied to the back of the artwork with a wax coater. a hand-held or table-top device that melts wax bars and distributes the melted wax evenly on the back surface of the artwork. The wax is low tack and easily repositioned. Unfortunately, the adhesion is destroyed if you move the work too many times. Wax that remains on the artwork too long is impossible to remove, and any residue left on the mounting surface will pick up dirt and smudges.

WEDGE, OPTICAL In sensitometers (photographic exposing devices), a filter that has varying absorption characteristics at different positions, which can produce a series of different exposures on photographic material for testing purposes. In visual densitometers an optical wedge allows the matching of densities, and therefore their measurement. Optical wedges come in two types: continuous, with smooth changes in absorption from no density to great density; and stepped, on which the tonal scale is divided into a number (10, 20, etc.) of precisely changing steps from no density to great density in evenly changing amounts.

WEIGHT MEASURE CONVERSION See *Weights and measures.*

WEIGHTS AND MEASURES Two systems of weights and measures are still used in the world. (1) The Système Internationale (SI), usually called the *metric system*, is almost universally employed, the exception being in the United States. It originated in France, after the French Revolution, and was intended to be based exclusively on physical quantities available everywhere. It is often called the cgs system standing for centimeter, gram, second. (2) The U.S. customary system is symbolised by *fps*, coming from foot, pound, second. These ancient units are based primarily on tradition.

In the United States, the use of the SI is voluntary and is gradually being adopted, especially in scientific and technological contexts. It is used in many photographic

applications, such as film sizes (as in 35-mm film), lens focal lengths, and processing formula specifications.

FUNDAMENTAL SI UNITS There are seven SI base units and two supplementary units (numbers 8 and 9 below) from which all other quantities are derived.

1. The *metre*, the unit of length, was originally based on a fraction of the earth's circumference, but inaccurate measurements in the eighteenth century caused an error in the result. Later, the standard was a distance marked on a metal bar kept at the International Bureau of Weights and Measurements near Paris. Now, the definition of the meter is 1,650,763 wavelengths of a specified line in the spectrum of the element krypton-86.
2. The *kilogram* is the unit of mass (approximately, weight). It is based on a cylinder of metal kept at the International Bureau.
3. The *second* is the unit of time, formerly 1/86,000 part of the mean solar day. Because of variations in the length of the day, the second is now defined as the time required for 9,192,631,770 vibrations associated with the spectrum of the caesium-132 atom.
4. The *kelvin*, the unit of temperature, is equal to 1/100 part of the interval on the Celsius (formerly, centigrade) scale between the freezing point and the boiling point of pure water under standard conditions. One kelvin is equal to 1°C, but zero on the Kelvin scale corresponds to –273°C.
5. The *candela* (formerly, candle), a measure of the intensity of light from a source. It is defined as 1/60 part of the intensity of an ideal blackbody radiator having an area of 1 cm^2 held at the temperature of the freezing point of platinum.
6. The *mole* is a measure of the amount of pure substance that is equal to its molecular weight in grams. This measure is often used in specifying the amounts of concentrations of chemicals.
7. The *ampere* is a measure of electrical current.
8. The *radian*, a measure of plane angle, defined as that angle subtended at the center of a circle by an arc equal in length to the radius of the circle.
9. The *steradian*, which is the solid angle at the centre of a sphere subtended by a surface area equal to the radius squared.

Hundreds of other units are derived from these nine units. Derived from the candela, for example, are:

1. The *lumen*, the measure of flux, i.e., the flow of light. One lumen is equal to the light passing through a specified solid angle and originating from a light source having an intensity of 1 candela.
2. The *lux*, a measure of illuminance, the light received by 1 m^2 of surface when the flux is 1 lumen.

PREFIXES In the metric system (SI), prefixes are used to indicate units larger and smaller than the basic ones.

Prefixes for Basic Metric Units

Prefix	Power of 10	Equivalent
tera-	10^{12}	Trillion
giga-	10^9	Billion
mega-	10^6	Million
kilo-	10^3	Thousand
hecta-	10^2	Hundred
deka-	10^1	Ten
deci-	10^{-1}	One-tenth
centi-	10^{-2}	One-hundredth
milli-	10^{-3}	One-thousandth
micro-	10^{-6}	One-millionth
nano-	10^{-9}	One-billionth
pico-	10^{-12}	One-trillionth

CONVERSIONS
Inches \times 25.4 = millimetres (mm)
Feet \times 0.305 = metres (m)
US Quarts \times 0.9464 = litres
US Gallons \times 3.7853 = litres
US Ounces (fluid) \times 29.6 = millilitres (ml)
UK Gallons x 4.546 = litres
UK Pints x 0.568 = litres
UK Ounces \times 28.4 = millilitres (ml)
Ounces (weight) \times 28.4 = grams (g)
Pounds \times 0.454 = kilograms (kg).
(Fahrenheit temperature $-$ 32) \times 5/9 = Celsius (centigrade) temperature (°C).
(Celsius temperature \times 9/5) + 32 = Fahrenheit temperature (°F)
Angular degrees \div 57.3 = radians.

WET COLLODION PROCESS Method of making negatives using a glass plate coated with iodized collodion, potassium iodide with, perhaps, potassium bromide in a nitrocellulose and pyroxylin mixture. The plate was sensitized in a silver nitrate solution and exposed while still wet or, actually, sticky, which gave the photographer about 20 minutes, depending upon ambient temperature and humidity, to make the exposure. The orthochromatic plates were developed in red safelight.

The process was introduced by Frederick Scott Archer in 1851 and commonly called *wet plate*. It was inexpensive and much more sensitive than other available materials, as long as the plate did not dry. Exposures lasted from one to 15 seconds. Despite the nuisance of wet exposure and the need to travel with a darkroom, the many attractions of the wet plate were sufficient to end the era of the daguerreotype and sustain the wet collodion process for over 30 years until the advent of commercially available dry plates in the 1880s.

WETTING AGENT Chemical that reduces the surface tension of water or a water solution when added in very small amounts, such as one part in 1000. This, in turn reduces the risk of air bells and increases uniformity of development. A trace of wetting agent in a final rinse for film makes the water drain off the surface more uniformly, thereby avoiding water spots upon drying.

WHEAT PASTE A vegetable water-soluble adhesive that can be applied to the back of fibre-based photographs for wet mounting onto most porous surfaces. Since wheat paste is water soluble, it is possible to "unglue" the print from the mount if necessary.

WHITENER See *Optical brightener*.

WORKING SOLUTION Applied to a bath ready for use; usually prepared by diluting a stock solution to a given stock-solution-to-water ratio. For example, 1 part stock solution of developer to 2 parts of water.

WRITING ON PHOTOGRAPHS There are several ways of writing on or marking photographs. Some searching and testing may be required to find the appropriate marking medium, and this may depend on whether the marks are to be temporary or permanent. One of the "china marker" variety of pencils may provide a means of making temporary markings on films and the image side of paper prints, as they can be wiped off quite easily. For permanent marking, some ballpoint and felt-tip pens will write on the emulsion side of negatives and papers other than those with glossy surfaces. Special inks designed to write on glass, plastic, etc., work well for writing on the base side of resin-coated paper prints. A gold foil tape can be written on when in contact with the surface of a print, and the gold is thus transferred. India ink can be used with a pen to write on clean films without oil and on most papers. Care must be taken that the ink is dry before stacking or other contact between the sheets.

Some inks and markers have a destructive effect on images, and this should be taken into consideration when deciding to write on photographs.

Appendices

APPENDIX A

Transmittance (T), Reflectance (R), Opacity (O), and Density (D) Relationships

T(R)	O	D	T(R)	O	D	T(R)	O	D
0	∞	∞	.080	12.5	1.10	.380	2.63	.42
.001	1000	3.00	.085	12	1.07	.390	2.56	.41
.002	500	2.70	.090	11	1.05	.400	2.50	.40
.003	333	2.52	.095	10.5	1.02	.410	2.44	.39
.004	250	2.40	.100	10	1.00	.420	2.38	.38
.005	200	2.30	.105	9.5	.98	.430	2.33	.37
.006	167	2.22	.110	9.1	.96	.440	2.27	.36
.007	143	2.15	.115	8.7	.94	.450	2.22	.35
.008	125	2.10	.120	8.3	.92	.460	2.17	.34
.009	111	2.05	.125	8.0	.90	.470	2.13	.33
.010	100	2.00	.130	7.7	.89	.480	2.08	.32
.011	91	1.96	.135	7.4	.87	.490	2.04	.31
.012	83	1.92	.140	7.1	.85	.500	2.00	.30
.013	77	1.89	.145	6.9	.84	.520	1.92	.28
.014	71	1.85	.150	6.7	.82	.540	1.85	.27
.015	67	1.82	.155	6.5	.81	.560	1.79	.25
.016	62	1.80	.160	6.3	.80	.580	1.72	.24
.017	59	1.77	.170	5.9	.77	.600	1.67	.22
.018	56	1.74	.180	5.6	.74	.620	1.61	.21
.019	53	1.72	.190	5.3	.72	.640	1.56	.19
.020	50	1.70	.200	5.0	.70	.660	1.52	.18
.022	45	1.66	.210	4.8	.68	.680	1 47	.17
.024	42	1.62	.220	4.6	.66	.700	1.43	.15
.026	38	1.59	.230	4.4	.64	.720	1.39	.14
.028	36	1.55	.240	4.2	.62	.740	1.35	.13
.030	33	1.52	.250	4.0	.60	.760	1.32	.12
.032	31	1.50	.260	3.9	.58	.800	1.25	.10
.034	29	1.47	.270	3.7	.57	.820	1.22	.09
.036	28	1.44	.280	3.6	.55	.840	1.19	.08
.038	26	1.42	.290	3.5	.54	.860	1.16	.07
.040	25	1.40	.300	3.3	.52	.880	1.14	.06
.045	22	1.35	.310	3.2	.51	.900	1.11	.05
.050	20	1.30	.320	3.1	.49	.920	1.09	.04
.055	18	1.26	.330	3.0	.48	.940	1.06	.03
.060	17	1.22	.340	2.9	.47	.960	1.04	.02
.065	15	1.19	.350	2.86	.46	.980	1.02	.01
.070	14	1.15	.360	2.78	.44	1.0	1.00	0
.075	13	1.13	.370	2.70	.43			

Transmittance (T), Reflectance (R), Opacity (O), and Density (D)

$$\text{Transmittance or Reflectance} = \frac{\text{Light transmitted or reflected}}{\text{Incident light}}$$

Opacity = 1/T or 1/R
Density = log 1/T or log 1/R or log opacity
Example: If transmittance (or reflectance) is 0.50 (50%)
Density = log 1/.50; = log 2; = 0.30

APPENDIX B

Temperature Conversion Scale

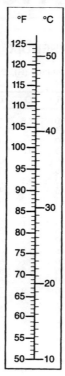

Temperature
Conversion
Scale

$0°C = 32°F$ $0°F = -17.8°C$ $0°C = 273\ K$

Formulas for converting from
°C to °F, from °F to °C, from °C to K.

$°C = (°F-32) \times 5/9$ $°F = (°C \times 9/5) + 32$ $K = °C + 273$

APPENDIX C

Area Conversion Table

AREA MEASURE

U.S. Customary	Metric
square inch (0.007 sq. ft.)	6.452 square centimetres (cm^2)
	645.16 square millimetres (mm^2)
square foot (144 sq. in.)	929.03 square centimetres (cm^2)
	0.092903 square metre (m^2)
square yard (9 sq. ft.)	0.83613 square metre (m^2)
square rod (30.25 sq. yd.)	
square mile (640 acres)	2.59 square kilometres (km^2)

Metric	U.S. Customary
square millimetre (mm^2)	0.00155 square inch (sq. in.)
square centimetre (cm^2)	0.155 square inch (sq. in.)
square metre	10.764 square feet (sq. ft.)
square kilometre (km^2)	0.38608 square mile (sq. mi.)

Metric to U.S.		
square centimetres	x 0.16	= square inches
square metres	x 1.2	= square yards
square kilometres	x 0.4	= square miles

U.S. Metric		
square inches	x 6.5	= square centimetres
square feet	x 0.09	= square metres
square yards	x 0.8	= square metres
square miles	x 2.6	= square kilometres

APPENDIX D

Graphical Formula for Diluting Solutions

A Simple Formula for Diluting Solutions

An easy method of figuring dilutions is by the criss-cross method. Place at A the percentage strength of the solution to be diluted and at B the percentage strength of the solution you wish to dilute with (in the case of water, this will be 0). Place at W the percentage strength desired. Now subtract W from A and place at Y. Also subtract B from W and place at X. If you take X parts of A and Y parts of B and mix, you will have a solution of the desired strength W.

For example:
To dilute 99% Acetic Acid to 28%.

Take 28 parts of 99% Acid and 71 parts water.